ACADEMIC KEYWORDS

ACADEMIC KEYWORDS

A Devil's Dictionary for
Higher Education

Cary Nelson and Stephen Watt

Routledge
New York and London

Published in 1999 by
Routledge
29 West 35th Street
New York, NY 10001

Published in Great Britain by
Routledge
11 New Fetter Lane
London EC4P 4EE

10 9 8 7 6 5 4 3 2 1

Library of Congress Cataloging-in-Publication Data

Nelson, Cary.
 Academic keywords : a devil's dictionary for higher education / Cary Nelson
 and Stephen Watt.
 p. cm.
 Includes bibliographical references (p.) and index.
 ISBN 0-415-92202-X (hardbound). — ISBN 0-415-92203-8 (pbk.)
 1. Education, Higher—Terminology. I. Watt, Stephen, 1951– . II. Title.
LB2324.N45 1999
378'.001'4—dc21 98-29067
 CIP

CONTENTS

Academic Keywords: The Dictionary

PREFACE

As the allusions in the title and subtitle for our dictionary suggest, we have produced a book that falls somewhere between Ambrose Bierce's infamous *Devil's Dictionary* (1911) and Raymond Williams's influential *Keywords* (1976). When Williams returned to Cambridge after World War II, he found that the terms underlying the campus sense of community no longer meant quite what they had before he had left. Their values and energies altered and refocused, invested in different agendas and projects, he and his classmates no longer used key terms in the same way. Concepts like *culture*, *democracy*, and *class* had acquired different meanings. So too on our own campuses and across the country we find that fundamental notions like what makes up a *faculty* can no longer secure shared values and commitments. Some of this uncertainty, to be sure, originates in a concerted effort to seize the meaning of terms like *affirmative action* or *sexual harassment* or *merit*. But the economic system of higher education has changed so drastically in a generation that material conditions no longer resemble those of a few decades ago.

Willingness to admit those altered material conditions—and to recognize who has gained and lost as a result of them—is often blocked by a vocabulary that reinforces various forms of false consciousness. In *The University in Ruins*, for example, Bill Readings argues that the appeal to something lionized as "excellence" both "marks the fact that there is no longer any idea of the University" and too often "protects the unrestricted power of [an institution's] bureaucracy." Excellence, in short, too often serves the purpose of rationalizing the corporatization of the university. Similarly, we show that the concept of a graduate student's *apprenticeship* allows many faculty and administrators to defend or ignore unacceptable conditions of employment and the increased debt into which many student-employees are slipping. We highlight the problem by giving **debt** a separate entry.

In trying to speak the truth in an academic culture of self-deception we have also drawn on the satiric inspiration of Bierce's renowned dictionary. We thus mix respect with skepticism, analysis with humor, praise with criticism. We have devoted our lives to higher education and admire our colleagues' often badly compensated devotion to it. Yet we also think colleges and universities have work to do in repairing damage both internal to their institutions and external in the world of public opinion. So we defend teaching and research but criticize unwarranted administrative perks and the creeping corporatization of the academy. *A Devil's Dictionary for Higher Education* is not only a dictionary and a handbook but also a critical polemic on the state of the professoriate and the contemporary university.

Our *Devil's Dictionary* includes both full-length essays and short entries that make one or two points economically. The length of the entries does not reflect their relative importance but rather their current social and political status and what length seemed appropriate and necessary if we were to intervene in the relevant ongoing debates. **Sexual harassment,** a term that is unstable, contentious, and quite differently understood by different people, receives detailed analysis. The **corporate university,** a concept widely used but still unfamiliar to most academics, also required a detailed entry. Concepts undergoing major redefinition, sometimes without people being entirely aware of it, like the very notion of what it means to be a *faculty* member, are also examined at greater length. On the other hand, *affirmative action* in higher education, while intensely debated, is at least reasonably well understood within the academic community; the public may think affirmative action in faculty hiring means quotas, but faculty members know it does not; so there we felt a concise, principled statement highlighting key problems was more appropriate.

There is also considerable need—little understood and largely unrecognized—to redefine familiar terms for each new generation, to rearticulate them to new conditions. Many of us make the additional mistake of assuming academic culture will automatically socialize new members and familiarize them with key concepts. If that was ever true, the changing academic workforce makes it true no longer. We suspect that the number of graduate students who could readily give persuasive accounts of concepts like academic freedom may be quite small.

We also bring different kinds of evidence to bear on different topics. The entries on *debt* and *tuition* are largely statistical, because either recent or long-term figures carry the news that people need to hear. The entries on *sexual harassment* and *part-time faculty,* on the other hand,

rely heavily on individual stories to ground their arguments. Some of our evidence is factual, therefore, some anecdotal.

Some of the topics we address in a few pages have themselves been the subjects of entire books. In some cases, the subjects of our short essays have a long history of research and debate. The combined scholarly and popular literature about affirmative action alone, for example, constitutes a huge bibliography. We have not tried to cite most of the previous work on each of our topics but rather limited our own references to the books and essays that have had the most influence on us. We believe, moreover, that it is possible to intervene in some of these debates by way of focused position statements, which is what we have done here. We also think it is immensely useful to place all these controversial issues on the table at the same time, to take them up in relation to one another. That too is what we have attempted to do.

The terms we define and discuss highlight the changing nature of and climate for higher education in the new millennium. The terms include many that are the subject of current debate and others whose centrality and pertinence are often repressed. Through our dictionary, then, we hope to make an intervention in the struggle over the course of higher education in America; the book is designed to help people think critically about both our present condition and the uneasy future we face. It makes no claim to being definitive. As a guide to the language we should be speaking and the issues we should be debating, it is necessarily only a work in progress; it must be expanded by its readers.

Distance learning, for example, would not have been a recognizable term even a few years ago. It was but a few decades ago that no one would have thought an entry for *sexual harassment* should appear in such a book; indeed, until the 1970s the term was essentially unknown, though you could find discussions of *male chauvinism* as early as the 1930s. But no one would now argue about whether sexual harassment is one of the defining issues in academic life. With some of our other entries it is another matter. *Cafeterias* would be a prime choice for recognition among those who work in food services, but perhaps an irrelevant or invisible subject for many students and full-time faculty. Because two of our aims are to identify and to examine some of the sites of change and controversy in the contemporary—and emergent—university, we want readers to recognize what college cafeterias tell us about the university of the future.

A book that redefines familiar concepts and tries to make unfamiliar terms and concepts central to our picture of the academy is thus also a book devoted to consciousness-raising and reeducation. Hence, to return

to one example, while we try to discredit the now largely empty fiction that graduate study is a form of apprenticeship, we also try to educate a wide audience about the little-known work that goes into mentoring graduate students. Each definition wields the power of naming in a project urging readers to see the world of higher education differently. As readers move through the book both serially and by way of its interconnections, a detailed portrait of a strong but imperiled institution emerges.

From *cafeterias,* readers will be led to entries on *outsourcing* and *the corporate university.* Those entries in turn make other points of contact with the book's web of connections. The system of cross-references has several purposes: to help readers make contact with related issues, to make it clear that there are clusters of related entries in the book—such as the group of entries about academic organizations (*disciplinary organizations, the American Association of University Professors, the Modern Language Association,* and *the National Association of Scholars*) and the group of entries about academic labor (including *apprentices* and *part-time faculty*)—and finally to suggest how interconnected *everything* finally is in higher education. Much of academic culture militates against making such connections. Many of us work in our individual departments and disciplines, often ignorant of the most basic principles governing work, advancement, and compensation in the building next door. Faculty too often leave university governance to administrators and boards of trustees, a practice that worked well enough when budgets were flush and faculty were sought after. Now that funds are limited and Ph.D.s are a dime for several dozen, leaving the business of the university to business executives is proving immensely destructive. We do not want the bottom line to be the bottom line.

We hope *A Devil's Dictionary* will help provide a wake-up call for those both inside and outside academia. It is a call for active engagement in the whole life of the university. Despite its occasional satiric and irreverent thrust, it is in fact a program for a recommitment to first principles. As Ernst Bloch asserts in *The Principle of Hope,* "informed discontent" properly "belongs to hope," not despair. This book aspires in a number of ways to examine present conditions in the academy so as to promote concerted discussion on how to improve them in the future. It does so by challenging the categories we use to represent the academic workplace. Indeed our first purpose is to gain agreement that academia is indeed a workplace more than an ivory tower. To do so we have interviewed part-time teachers across the country and intensively researched the increasingly corporatized university.

Throughout the book our practice was for one or the other of us to take individual responsibility for writing the first draft of each entry. Then we sent the essay to the other for comments and suggestions. Often we added passages or made other changes. We have each also found it helpful to use the first person from time to time. A number of the entries are based on personal experience. Between us we have five decades in academic life, including both short and extended visits on many other campuses. That has been an important resource for the book, although not every colleague or every school will feel happy with the results. So, when the first-person voice is central to an entry, we have identified the primary author with initials at the end of the essay. That convention, we hope, will help make sense of unmarked references to place, like "here" or "on my campus."

There are several high-visibility topics we have not taken up here because one or the other of us has addressed them before. The economics of book publishing (see **scholarly books**) made it impractical to reprint all those essays here that have already seen book publication. Cary Nelson's *Manifesto of a Tenured Radical* (1997), for example, includes essays on campus hate speech codes, cultural studies, multiculturalism, political correctness, and the experience of the academic job market. His *Repression and Recovery: Modern American Poetry and the Politics of Cultural Memory, 1910–1945* takes up the issue of canonization in detail. Some terms that do not receive independent entries here do get discussed and defined along the way. The index will point readers, for example, to the places where we discuss flexibility, a piece of corporate vocabulary that has made its way into academia. Similarly, although we do not have a separate entry on the problems academic libraries face, the index will point readers to the entries on **outsourcing** and **scholarly books** for our comments on the crisis in library funding. Some topics, on the other hand, like the problem of part-time faculty, recur throughout the book. There again, the index will direct readers to passages beyond the relevant main entries. A few of the pieces in this book have appeared in *Academe*, the *Chronicle of Higher Education, the minnesota review,* and *Social Text.* We have also adapted some passages from essays appearing in *Against the Current, Profession, Workplace,* and the collection *Will Teach for Food: Academic Labor in Crisis* (1997), edited by Cary Nelson.

Finally, we should say that we make no apology for and offer no retreat from the very bleak, even apocalyptic, portrait we paint of higher education's prospects. When part of this book was presented at the University of Chicago, a distinguished faculty member there rose to say, "Well,

you've heard Mulder's version of the story; now let me give you Scully's."
We rather enjoyed the reference to television's *X-Files*, but we nonethe-
less believe higher education is in genuine trouble. There is no conspiracy
to uncover, but there are multiple, uncoordinated forces working to alter
higher education for the worse, not the better.

As for Chicago, well, the faculty there seemed happy with the state of
things. When we met privately with graduate students, it was another
matter. We have never encountered such rage from students. Because of
Chicago's high tuition and the limited money made available for support,
some graduate students there went into debt for $20,000 to $30,000 for
their first year alone. Even those who did not go so deeply into debt were
outraged at a culture that disposes of so many students so casually after
the master's degree. They felt that Chicago used its reputation as bait to
capture their tuition dollars, after which they were cast aside. A capri-
cious judgment by one faculty member often determined whether they
were admitted to a doctoral program. The witty dismissal of Chicago's
Scully seems more to reflect the condescension of privilege than any
sober assessment of reality.

Unfortunately, Scully's view prevails among many tenured faculty. If
we have given such views rough treatment here, it is because we believe
they are seriously misguided. The introductory essay, "Between Meltdown
and Community: Crisis and Opportunity in Higher Education," gives an
overview of our take on the present shape of academia and the emerging
university of the future. The failure of the professoriate to recognize that
the academic workplace is deteriorating is central to our perspective, as
is the increasingly corporatized campus climate. Yet the introduction also
lets us make clear at the outset where we think there is ground for
hope—in organized collective action.

Collective action does not necessarily have to take the form of union-
ization. At small liberal arts colleges where shared educational values and
a common sense of mission unite faculty and administrators, other partic-
ipatory forms of community may well be better. At large institutions
where corporate values dominate the engineering college and shape
administrative decisions, while humanistic goals prevail in departments
across campus, sweet talk about community may merely be delusional or
mystifying. There are few institutions, moreover, where graduate students,
part-timers, or secretaries can effectively represent their group interests
without the formal right to negotiate binding contracts covering salaries,
benefits, and working conditions. For lower-grade employees unionization

is the only realistic solution. They can only be full "community" members once they are paid fairly and gain a voice.

Many faculties, on the other hand, desperately need a legally binding contract limiting the percentage of non-tenure-track teachers the college can employ; they need legal language giving the faculty, not the administration, control over distance learning initiatives and corporate partnerships. To win these rights faculty need to be able to exercise collective force; they need to reallocate *power* on campus. Those who quail at "adversarial" or "confrontational" tactics in this context are simply rationalizing their impotence. A civil confrontation over faculty rights need not destroy collegiality. The changing nature of higher education will eventually compel many faculty to rethink their attitude toward unionization.

The introductory essay shows broadly why we believe this is the case; it thus provides the historical and political underpinning of the rest of the book. Along the way it also takes up some issues that do not have their own entries but are central to our perspective. The dictionary follows; it should help shed light on the concepts that guide us both consciously and unconsciously. Altogether, *A Devil's Dictionary* urges a revolution in how we participate in the university of the future.

Books conventionally include expressions of thanks to those who helped. We may both certainly thank our academic partners, Paula A. Treichler and Nonie Watt, for their advice on the manuscript, their companionship, and the myriad sharing of their own university experiences. Now we come to a problem. We have about four dozen friends and confidants at various schools around the country. This book would not have the detail it has without their stories, without their help in interviews, and without the letters and documents they have sent us. And they have all—with varying degrees of passion—volunteered a willingness to remain unnamed. Given the information they have shared with us and their desire to continue doing so, maintaining the confidentiality of our sources seems like a good idea to us as well. A spy once known is of no further use. More surprising perhaps was the appearance of the same pattern among our *readers*. Most of those who read portions of the manuscript and helped us with their suggestions preferred to remain anonymous. Naming only a few of our readers seemed misleading, so we decided to name none. This is thus a book without an "Acknowledgments" page.

Introduction

Between Meltdown and Community: Crisis and Opportunity in Higher Education

As United Parcel Service (UPS) workers in the summer of 1997 took up the struggle to gain some control over their segment of American labor, a number of us in higher education realized it could be a story about us as well. Like many American industries, United Parcel Service has seen its part-time workforce grow rapidly while the percentage of full-time workers decreased. The future of work at UPS seemed clear—a small core of highly paid employees surrounded by vulnerable and underpaid part-timers. We need to stay flexible and competitive, pronounced UPS management, sounding much like a late-night infomercial for an exercise machine. Flexible and competitive. Sounds healthy. Must make sense. Just a matter of discipline.

Of course, many part-timers in academia would welcome the health benefits UPS offers its lower-grade employees. And they might welcome as well the union representation and solidarity, however fragile, that made a strike and a victory possible. Unlike academia, UPS has not seen its full-time work force dwindle; they remain a growth industry. If the corporate university should come on growth times, its managers will choose to grow as UPS has grown, in a spreading marginalized workforce.

We hear phrases like *flexibility and competitiveness* in academia as well, in part because they represent the only knowledge base corporate executives serving on boards of trustees are interested in bringing to bear on higher education. What this rhetoric actually means is another matter. *Flexibility* certainly means something to people hiring academic

1

professionals on soft money, but the term has little meaning when applied to the lower-division courses most adjuncts, part-timers and graduate assistants teach. We're not likely to drop composition courses because our splendid high schools have made such courses superfluous. In the end, *flexibility* is the hallmark of an institution devoted to serving the semester-by-semester training needs of corporations. When a local corporation calls up St. Thomas University in Minneapolis and asks for a new course, the university sets it up in months. When corporate needs change, the part-time faculty who teach the course can be sent packing. Flexibility does therefore mean a loss of intellectual freedom for academics, since it makes it easy to fire teachers. As Gary Rhoades and Sheila Slaughter put it, "flexibility is a trope (and trump) for power. Its repeated invocation is a means by which to legitimate changing the balance of power between faculty and administration, altering faculty's professional terms of employment" (17). Flexibility also points to an area of easily forgotten coincidence between UPS and higher education. UPS says it needs flexibility to deal with uneven seasonal employment needs. But most of us in academia—from cafeteria workers to faculty—are also inherently seasonal employees, something part-timers already know well. They don't need us in the summer; some corporate managers in academia are tired of the largess of year-round employment.

As for *competitiveness,* we have a consistent two-tier pricing system in the form of public and private education. The top Ivy League schools consider it a point of honor not to underprice one another, while public education, at a fraction of the cost, as we point out in the entry on **tuition,** remains a relative bargain. The rich should pay more to educate their children, the poor less. Meanwhile, we certainly seem able to market American higher education to the rest of the world, so downsizing or increasing flexibility for the sake of competitiveness seems to make little sense and to present a real danger. Indeed, many U.S. graduate and professional programs are heavily dependent on international students, so maintaining sufficient program quality to attract them is essential. Within a given price range, what competes is quality, prestige, convenience, glamour, and mystification.

Meanwhile, the winnowing away of tenured faculty lines is a genuine threat to the quality of higher education. Although many of them have been trained not to do so, tenured faculty nonetheless have the protection they need to speak frankly and controversially if they choose to do so. Along with campus unions, they can offer an effective counterbalance to administrative power. And many have the experience and institu-

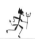

tional loyalty necessary for curriculum development, recruitment, and long-term planning. At the same time, the exploitation of part-timers, graduate employees, and campus support staff has already critically eroded higher education's moral status. It is hard to idealize a robber baron university.

From the vantage point of the City University of New York, on the other hand, UPS looks positively utopian. In 1974, as Karen Arenson reported in the *New York Times,* adjunct faculty amounted to less than a third of CUNY's teaching staff; there were 4,924 adjuncts and 11,268 full-timers. By the fall of 1997 the number of tenure-track faculty had plummeted to 5,505, while across CUNY's seventeen campuses part-timers had grown to 7,500. Many of the part-timers by then were teaching a full-time load; they just weren't getting a full salary for doing so. One of us went out to dinner with a group of CUNY adjuncts in 1998. We wandered the streets of midtown Manhattan for an hour, looking for a restaurant they could pretend to afford. "Ethnic," a broad term these days, was the obvious choice, and a Portuguese restaurant looked like a good bet. A scout was sent forward to check out the menu while we crowded the doorway. "Main courses are about $14." "Too expensive." "No way." We headed out again, ending up at a Chinese restaurant where everything was à la carte and where two of the part-timers settled for a bowl of soup. As Gappa and Leslie point out in their classic study, part-timers are a diverse group; but many are increasingly underemployed Ph.D.'s, and many depend on part-time teaching for their entire income.

What can we do for these people? Unfortunately, public support for faculty privileges is not strong enough now to wage a major national battle in defense of tenure, but we do not believe we will have to do so. Strong local efforts within institutions that still have a significant percentage of tenure-track faculty can often beat back power plays by boards of trustees, as has been the case in Minnesota at least for now. Such victories are likely to be temporary, but at least they can be waged successfully. Meanwhile, the American Association of University Professors (AAUP) continues to negotiate key cases and censure institutions that wantonly undermine academic freedom. The organization also continually disseminates the case for tenure and keeps that discourse in the air to counter the regular attacks tenure receives.

The UPS strike provides several key lessons for academia, however, because the union helped create broad public understanding of the problems of part-time work and the desirability of full-time employment. Since the most important way tenure is being undermined is by shifting

tenure-track lines to adjuncts and part-timers, the best defense for now may be a campaign to resist part-time work in academia. It is a case where parent/student self-interest can join with the ethical issue of fairness to the campus teaching staff. That is not necessarily a battle we can easily win, since transferring public sympathy from part-time UPS workers to part-time teachers will take work, but it may be at least a battle we can take up productively, an argument with productive points of articulation with other public beliefs.

If the issue of part-time work, then, is one key lesson, another is surely the solidarity between full- and part-time UPS workers. Management assumed such solidarity was impossible, that divergent interests and wages, sometimes different gender or racial identities, would keep these groups divided. But instead they joined in a common cause. It may be far more difficult for many academics to recast their identities to encompass full- and part-time workers, but the UPS strike at least shows us the benefits of doing so. And we have had warnings to alert us to the necessity of rethinking the relationship between supposedly secure and insecure employment in academia. Here and there across the country—there are cases in Arizona, Florida, and Illinois—a few institutions in financial crisis are abandoning tenure and some are being founded without tenure or full-time employment. There academic freedom is fragile at best.

Meanwhile, corporate and political America apparently view higher education as either a profit-making enterprise or a structure to move students through courses. That's all. Parents care above all about its credentialing function. Community colleges offer the best model of how to do this cheaply, but it's hard to combine community college staffing with Ivy League prestige. Parents understand that not all credentials are equal, but they often do not understand the relationship between distinguished faculty and institutional prestige. So much of higher education is drifting toward the community college model.

But there are still worse models out there. For something close to the nadir of ersatz postsecondary commodified education, read James Traub's "The Next University: Drive-Thru U" in the *New Yorker.* It's a chastening piece about the University of Phoenix, a substanceless, credentialing institution with, as Traub puts it, no campus life and no intellectual life. There are no tenured faculty, and no serious demands are made of the students. You can earn credit long distance or attend short courses taught at night by local business people and high school teachers. You will not be challenged, you will not need to think. You buy a degree and pick up a

school mug and blazer at what pretends to be the campus bookstore. One administrator there expressed discomfort with the way a new course in comparative religion was being taught; the right way to approach such a topic, he allowed, was to show how the same product could be marketed to multiple denominations. The Hartford Insurance Company, which once hired Wallace Stevens, prefers to get its M.B.A.'s from the Wharton School of Business, but Sonny's Tire Service or its equivalent—six outlets in the Southwest and growing—would be proud to hire a Phoenix graduate to help manage its accounts.

Part of what passes for education at Phoenix is simply job training, but it turns out it is hard to justify requiring a sufficient number of short job-oriented classes to accumulate enough credits for a degree. So students fill out their degrees by earning credit for life experiences. Parenting, Family Life, and Loss and Bereavement were among one student's retroactive "courses." Credit for being born is no doubt next. Phoenix's on-site "courses" meet for only six weeks. New classes begin monthly, all through the year. Nothing is taught in them unless it can be put to use on the job the following day. As an administrator at another adult education program remarks in the far more upbeat assessment of Phoenix offered by Mark Fischetti and his coauthors, these students "want a very streamlined, utilitarian, and narrow education" (51). Columbia University's Arthur Levine found that students in such programs often "wanted the kind of relationship with a college that they had with their bank, their supermarket, and their gas company. They say 'I want terrific service, I want convenience, I want quality control. Give me classes twenty-four hours a day, and give me in-class parking.' These are students who want stripped-down classes. They don't want to buy anything they're not using."[1]

Phoenix has some fifty-nine "campuses," small learning centers, and distance education bases in Arizona, California, Colorado, Florida, Hawaii, Louisiana, Michigan, Nevada, New Mexico, Oregon, Utah, Washington, and Puerto Rico. Its corporate customers include AT&T, Kodak, IBM, and General Electric. Applications in other states are pending. Eighteen other schools, mostly small religious institutions, have contracted to offer Phoenix-style courses in seven other states. Phoenix stock sold for $2.45 in 1994. It's now worth over $40 a share. Some think other schools should climb on the bandwagon.

Ten years from now we'll be significantly farther along that path than we are now. Perhaps we may offer our own version of a faculty contract in the hypothetical corporate university of the future:

<div style="border:1px solid black">

MOBILe OIL
brings you
MASTERPIECE CLASSROOM THEATRE

The Corporate University's Principles of Governance:

1) The student consumer is always right.

2) Contract faculty will maintain a cheerful and friendly demeanor at all times.

3) Contract faculty will avoid challenging, threatening, or upsetting student consumers.

4) All courses will be graded on the basis of clear, universally achievable goals. Divisive notions of excellence and quality will play no role in evaluating consumer performance.

5) All products of faculty labor are the property of the corporation.

6) Termination without notice is available for faculty noncompliance or insubordination.

7) All faculty members are provided with course syllabi and textbooks without charge. Management is responsible for course content.

8) All faculty possess presumptive redundancy. The need for their services will be reassessed each term.

9) All faculty must submit an annual report detailing how they can better serve the corporation's mission.

10) Faculty members have full academic freedom to accept these principles or to resign.

</div>

In many ways this is the world adjuncts and part-timers *already* inhabit. This dystopian satire is no more than daily life for many academics, and those in tenured positions who feel sorry for themselves need to see their own working conditions reflected in this cultural mirror. Many part-timers have little freedom to design courses, no role in governance, no job security, no power to defend themselves from irrational student complaints, and are subject to summary dismissal for the most trivial, confused, or flatly inaccurate reasons. Some work in fear or resignation, knowing their livelihoods depend on not offending administrators or

challenging their students. And they work for wages comparable to those in the worst illegal sweat shops in the country.

If this is to be the typical model of higher education in little more than a decade, some of the forces fueling this development will be demographic. The college-age population of eighteen- to twenty-four-year-olds in 1981 rose to a level of 30.3 million. It then declined to a low of 24.7 million by 1997. By 2010 it will have climbed back to its 1981 high. As Carol Frances points out, the traditional (and we would add, disastrous) way to predict the need for college faculty is to multiply the college-age population by the projected percentage of high school graduates expected to attend college. Then you divide the expected number of students by the typical student/faculty ratio and—*voilà*—you know how many faculty members we'll need. Yet as the last three decades have shown, there are other ways to meet this need—by graduate student and part-time labor.

The other demographic force at work is the dramatic increase in the number of faculty who will be eligible for retirement over the next half decade. Some have predicted that removing the mandatory retirement age for faculty members means these folks will continue teaching beyond age sixty-five or seventy. We believe that is not true. We think the overwhelming majority will retire. For one thing, the performance of the stock market in the 1990s has meant that many faculty enrolled in TIAA/CREF can now afford to retire. Even in the humanities some faculty members will have retirement accounts of over a million dollars; in exceptionally well paid fields like medicine, law, and business, faculty members will have multimillion-dollar retirement funds. Furthermore, the changing climate of higher education—including the shift from teaching to job training and the increasing surveillance of faculty labor—will lead many faculty to bail out. We are likely to have a shortage of faculty with long-term institutional memories and experience in governance. Managers will fill the vacuum, making higher education still less appealing.

By 2005, then, a surge in the need for *instructional services,* not necessarily college teachers—produced by the new wave of college-age baby boomer children and by retirement of faculty veterans of the Vietnam era—will provide a devastating opportunity simultaneously to further instrumentalize higher education and to increase drastically the percentage of part-time and adjunct faculty. Then the game will be over, and we can spend the next two generations squabbling about how to rebuild the educational system we thoughtlessly dismantled. If Levine is right, the long-term picture is worse. He predicts that in a few generations we'll end up with only a few residential colleges and a few research

universities; "most of the rest will disappear." In that context the answer to the question "Is there a future for the Ph.D.?" is clearly "No."

That is a longer time frame than we can address confidently, but we suspect our actions in the short term will make Levine's prediction more likely. Thus the news that a new wave of undergraduates is about to flood our classrooms will lead many sleeping faculty to surface and spout glad tidings. "The end of the job crisis is in sight." No one who makes a serious study of the economics of higher education believes this, but a lot of self-serving and self-important faculty members are surely destined to say so. The point now is not whether more jobs will become available but what sort of jobs they will be. A job that doesn't pay a living wage is a form of slavery.

The academic McJob boom of the new millennium could end higher education as we know it, decisively proletarianizing the professoriate.[2] In ten years a substantial majority of college teachers will be part-timers, academic professionals, or clinical faculty. The titles are multiplying, but the bottom line is the same: no security, no benefits, no time for research or reflection, no academic freedom, no prestige, no institutional power. Think of college teaching as a low-level service job. The job boom may be sounding from a cannon aimed at our heads. For full-time tenure-track faculty may cease to be major providers of instruction. In many places, of course, they are already no longer the primary providers, but the trend may be radically accelerated when we face the *crisis* of new employment opportunities.

Yet it is no longer possible to hope we can address the job crisis for new Ph.D.'s on its own. The multiple crises of higher education now present an interlocking and often interchangeable set of signifiers. Conversation about the lack of full-time jobs for Ph.D.'s turns inevitably to the excessive and abusive use of part-time faculty or the exploitation of graduate student employees, which in turn suggests the replacement of tenured with contract faculty, which slides naturally into anxiety about distance learning, which leads to concern about shared governance in a world where administrators have all the power, which in turn invokes the wholesale proletarianization of the professoriate.

When Richard Chait, therefore, in an introduction to the New Pathways project, remarks, reasonably enough, that "technology threatens the virtual monopoly higher education has enjoyed as the purveyor of post-secondary degrees," we can and must recognize the implications along all the other cultural and institutional fronts his warning effects.

But our own programmatic responses and strategies, adopted under pressure, can easily make things worse. Thus whatever external assaults on humanities research, tenure, sabbaticals, teaching loads, and other elements of university life are mounted will be underwritten by disastrous compromises made in good faith by departments themselves.

English departments, for example, are compelled financially and structurally to hire non-Ph.D.'s at a time when Ph.D.'s cannot get jobs. Doctoral institutions also hire postdocs at teaching assistant wages—often out of the altogether decent aim of giving them additional years to get traditional jobs—and in the process undermine the status of the profession and the future job market by proving that Ph.D.'s can be hired at half or less the typical current rate for new assistant professors. And the department that hires a new Ph.D. for $3,000 a course is placing itself dangerously close to the salary scale adopted by the schools hiring Ph.D.'s for half that or less. Meanwhile, those with instrumental visions of higher education have no patience with the critical distance humanities faculty would like to maintain from their own culture. Their goal is to strip higher education of all its intellectual independence, its powers of cultural critique and political resistance.

From a national perspective, the struggle seems nearly over, incomprehensible as that may be to those on campuses where full-time tenured faculty with significant independence are still a major force. Viewed as a totality, the nation's faculty have already been displaced by marginal employees. As William Plater, a senior administrator at Indiana University/Purdue University in Indianapolis puts it, "The faculty no longer exists. It has been subsumed in an academic workforce of which tenured professors, tenured associate professors, and probationary assistant professors are only a small part, perhaps less than a third" (680).

Can this process, continuing but not yet complete, be reversed or resisted? Not entirely. But we are not impotent. Despite the paeans to powerlessness sung by virtually every president of every academic disciplinary organization, we are not powerless. That's the obvious lesson from the UPS strike: the workers did not roll over and play dead. Now since most tenured faculty take pride in rolling over and playing dead, we do have a personnel problem. But if we can find the troops, we can enter the battle. Here we are hopeful. For in the summer of 1997—here and there across the country—graduate student union activists were heading toward their local UPS facility to join picket lines and offer other forms of support. It remains to be seen whether the negative forms of academic

proletarianization—low salaries and abusive working conditions—can be more widely accompanied with a positive proletarianization: solidarity or identification with the working classes.

Campus union activism and solidarity with other workers on and off campus is one critical component of the defense and renewal of higher education. We need more radical workplace democracy, more militancy, and new alliances from below. We keep waiting for an administrator who welcomes such developments, but evidently neither he nor she is slouching toward Bethlehem to be born. Change will come from below, from the jobless, the exploited, the underpaid, the overworked. Perhaps their time will come again.

Throughout the country full-time cafeteria workers' positions with health coverage and retirement benefits are being outsourced to companies that replace them with minimum wage jobs with little or no benefits. And teaching assistants are watching their salaries succumb to inflation and their class sizes increase while the full-time faculty jobs for which they are supposedly being trained are disappearing. Most teaching or research assistants who work full-time for the whole academic year, especially those in the humanities not supported by the research grants scientists often receive, do not even earn enough money to live through the summer. There's not a college administrator in America without a gambling problem who could say the same. The part-time university employee who gets seriously ill is basically thrown out on the street without an income. The teaching assistant who has to buy health insurance for her children will find herself without enough money to buy food and pay rent. And the cafeteria worker who puts in thirty years may end up with little or no retirement income. The top salaries in higher education have become too high, while the bottom salaries have become too low. We have lost sight of the humane values that were supposed to guide us.

Is this the kind of community we want to be? Are these the values higher education should promote? Do you want your classes taught by people who have no reason to feel anything other than resentment toward their employers? Higher education's unfair employment practices threaten our public image and our mission. It is time for a change.

On many campuses that change is being spearheaded by support staff and graduate employee unionization drives.[3] They are sending a message that democratic collective action is the key to revitalizing higher education. The only alternative, it seems, is to listen to the bad advice many senior faculty and administrators are giving us, especially senior faculty who have adopted uncritically the entrepreneurial disciplinarity of the

last few decades. Believing that their working conditions derive directly from their own accomplishments, not from any underlying social and political conditions, they typically urge us to wait until the system rights itself, as it surely must. They are so wonderful, the discipline has repeatedly told them, that they have come to believe it. They conceive their subject positions as eternal features of the culture. Surely, they think, the country will want more people just like them in years to come. So all is well. We are wonderful, some of you can be wonderful. That's all we know and all you need to know. Actually, those of us with security and disciplinary prestige, those of you with tenure-track jobs, may be among the last generations to be so lucky. Virtually no one outside the higher education community has any passionate commitment to keeping the research model of humanities disciplinarity intact.

Yet tenured faculty continue to disparage or regret activism. At the 1996 annual MLA, held in Washington D.C., at a forum devoted to the job crisis, Harvard's John Guillory challenged us to confront the crisis in its proper historical perspective. "Ask yourselves," he implicitly urged the audience, "how the ancient Greeks would have responded to such a crisis."[4] Not believing that history is much help in solving anachronistic riddles, we can only say now that perhaps the ancient Greeks would have gotten on their cell phones to talk it through. Guillory himself had a stern warning to extract from his parable: "The worst thing that could happen," he announced, pausing for appropriate dramatic effect while we trembled in the plastic amphitheater of ancient Washington, "would be to let this passing crisis deflect us from our proper focus on transcendent verities toward a concern with the contingent and the political." In published comments he has suggested that the politicization of graduate students was a kind of manifestation of psychological pathology. Now he went further. The job crisis, he offered in a dark prophecy, just might politicize the profession as a whole. Well, so far he has little to worry about. Business as usual continues apace.

Yet the job crisis may have produced a new critical theory. Call it "addled eco-feminism." We refer to the talk by Adalaide Morris, currently chair of the University of Iowa's English Department, which was presented on the same program. Morris spent twenty minutes offering a series of biological tropes for a profession in crisis. "The roots and branches are severed, cut off from each other and torn out of the ground. The webs are broken, the connections lost. The liquids that once flowed peacefully from branch to branch now drip on the ground and decompose." Morris never got beyond these images or offered any proposals,

though it seemed plausible to suggest that a dehumidifier might solve our problems.

An obscure segment of the American Left has also chimed in with a benighted program for radical change: quote Lenin. This compact suggestion—our own redaction of their voluminous writings—comes from a pseudo-Marxist cult headquartered at Syracuse University. They have no plan, no specific suggestions to make, but instead issue endless denunciations of other leftists in their house organs, *Mock Orange* and *Red Sphincter,* usually flourishing quotes from Lenin as if these passages settle all questions of contemporary practice.[5] Led by Professors Mas'ud Zavarzedeh and Donald Morton, the group has declared itself the only reincarnation of the spirit of revolution. No reform of higher education is acceptable to them, because every such move is an accommodation to capitalism, making the system run more smoothly and curtailing the inequities that might lead people to rise up in revolt. From their tenured roosts, these sirens of Syracuse inform us that the agony of lower-paid workers should be intensified to press them toward revolution. They have not suggested their own salaries be cut to make them more revolutionary still. We suspect, moreover, that underpaid teaching assistants are unlikely to overthrow capitalism no matter how badly they are exploited. A better formula for radical change, we believe, is a collective effort within a series of individual industries exhibiting comparable forms of exploitation.

Our general cynicism about the willingness of tenured faculty to join such collective activity is obviously in tension with our support for the principle of tenure. But ending tenure will not resolve the tension in a helpful way. The problem here is not with tenure but with the way recent generations of faculty have been trained and socialized. They have assumed that their interests lay with their careers and their disciplinary identities; everything else, from finances to academic freedom, could take care of itself. Now we know they were wrong. The solution is to get tenure-track jobs for a new generation of graduate student union activists. We obviously have no intention of letting tenured faculty off the hook or of failing to tell them what we believe their responsibilities are; we just don't want anyone to count on them.

Yet without a major collective effort, higher education as we know it will be over within a decade or two. This is not the polymorphous play of interpretations. It's a struggle with material consequences for an institution to which many of us have given our lives, with material consequences for all of us who work within this industry. We think it is time for a revolution in how we do business.

As part of that revolution we need to undertake several major projects:

1. Recover our own repressed institutional history, including the full human cost of the exploitive, unreflective graduate programs we have run for three decades.
2. Restore fairness to the campus wage and benefit system, making sure that all employees earn a living wage and have the same health care benefits. Recognize the right for employees to have a voice in their own working conditions and to opt for collective bargaining if they choose. Although alliances and a sense of community are critical in higher education, graduate students and part-timers must also organize to represent their interests with greater clarity and force.
3. Devote substantial energy to multiple forms of public outreach, from lobbying legislators to explaining our work to general audiences. Professional organizations should train faculty members as lobbyists at their national meetings.
4. Initiate stringent campus-based budget reviews, reducing or eliminating outdated, unnecessary, or ineffective programs. Faculty must take a primary role in evaluating programs and allocating resources.
5. Promote campus-wide democratic debates about the aims, practices, and future of higher education.
6. Resist on multiple fronts the corporatization of the university.

Each of these points has numerous components. Each component will confront vigorously resistant constituencies. And if we do everything well, the quality of public higher education will nonetheless decline in many states, especially at second-tier institutions. No matter what we do, a decade from now many states will no longer have either a public or a private research university that merits the name. But we believe we can preserve a viable system of education that supports at least the minimum freedom necessary to advance and adapt cultural knowledge to changing conditions.

For that project we will need Ph.D.'s who have the time and resources to devote to continuing research. Alternative careers in industry or high school or community college teaching—none of these alternatives let research faculty in the humanities do the critical cultural work for which they have been trained. Imagine where we would be now if the research of the last thirty years had remained undone—in the narrow world of the restricted racist and sexist canon, still ignoring the work of women and minority writers.

Yet many more of our future colleagues are going to have jobs that many of us would find utterly unacceptable, jobs with no time for the life of the mind, jobs that make a mockery of the very notion of the university. We can work to make things better, losing some battles and winning others, or we can passively let things get worse. We can take up the struggle to make campuses moral workplaces or abandon them to the ravages of late capitalism. The path we are on now will leave us victims of forces we could have influenced.

CN

ACADEMIC KEYWORDS

The Dictionary

A

Academic Departments (ˌakəˈdemik dəˈpärtməntz) The good news—for students, parents, legislators, donors, administrators, and faculty—is that academic departments are very efficient mechanisms for delivering instruction. They assign courses, schedule them, hire teachers, obtain rooms, and do so with remarkably low administrative overhead. It's a complex task, balancing student needs, interests, and requirements with staff expertise and the limits of time and the physical plant. But the job gets done all over the country, and departments are efficient units to handle it. With reasonable diversity of expertise on the faculty, a department can deliver a full curriculum fairly easily. Often you can simply let each instructor do what he or she wants, and the results give you sufficient coverage and variety. Small departments have to negotiate more intricately, but careful hiring will still insure an adequate and successful curriculum. A department that functions well is thus sort of like a railroad; it schedules trains and dispatches them.

Yet these are about the limits of the enterprise. Academic departments are not for the most part centers of collective intellectual life. A faculty member's natural interest group tends to be the people around the country in other departments in similar specializations and subfields. You may be the only medieval historian in the history department, and in the end you'd rather talk with other medieval historians than with the expert on World War II down the hall. The medieval historians in the German and English departments may be better suited to work together than any two people in their own departments. Faculty members on a campus may well form voluntary associations within or across departments that are immensely fruitful, but departments in their entirety are rarely intellectually productive units.

Many faculty members nevertheless persist in imagining that a department somewhere—in the next state, down the road, over the hill—will be a vital center of intellectual collaboration and interaction, but mostly such

places do not exist. Some of the people who devote themselves to departmental life—rather than to their own teaching and research—do so because they are desperately unhappy and looking for institutional salvation. They make careers out of petty power struggles and are generally not reservoirs of psychic health. Successful and happy departments are often places that simply leave faculty members alone to do their own work.

Departments also often reproduce in miniature the intellectual tensions and disputes in a discipline, and from that real misery can follow. For debates that are stimulating when carried out in journals and at conferences can become disabling when reenacted in departments as personal struggles. Philosophy as a discipline has long been divided between those who work in Anglo-American analytic philosophy and those who work in continental philosophy. Geography is divided between physical and human geography. For decades English was split between those who identified with the theory revolution and those traditionalists who rejected it; the theory folks have mostly won and the traditionalists are thoroughly embittered. Sociology is very nearly an armed camp, with quantitative sociologists finding little or no common ground with qualitative or interpretive sociologists. History is now pulled as a discipline in two directions—toward the traditional large-scale narratives of the political, military, and diplomatic history of nation-states and toward the more recent project of describing the daily lives of ordinary people. Foreign language departments now encompass two very different faculties—those who make language learning pedagogy their exclusive focus and those who study a country's literature and culture. The biological sciences are divided between those who study whole organisms and their systems or tissues and those who believe all the important work is done at the molecular level. Speech communication is divided between those who fancy themselves social scientists because they stare at actual fragments of business conversation and those who see themselves as rhetoricians with a humanistic tradition dating back to Aristotle.

In biology this has sometimes led to departments splitting in two. In philosophy or sociology, on the other hand, often a department specializes in one or the other tradition while hiring a few alienated and mistreated representatives of the other school. On occasion these differences erupt into open hostility, and then departments can go collectively crazy, with faculty members cursing at one another in the hallways and doing everything possible to sabotage one another's careers when serving on university committees and review boards. At that point, the operative definition of academic departments might be something like "fratricidal congeries of

learned persons." In extreme cases departments become unable to perform key functions. They cannot agree on who should be head or who should be hired. Warring camps try to demolish every one of each other's tenure cases. Fluctuating enemies lists shape basic decisions like teaching schedules and travel awards. At some point, as Charlotte Allen reports, receivership may be the only option: someone from another department has to come in and run things. The department may have to be virtually mothballed until retirements make it possible to rebuild.

Departments can also deteriorate for other reasons. A distinguished Ivy League university's English department, notoriously out of date for nearly three decades, was finally rebuilt with outside help in the 1990s. Amazingly enough, it continued to be ranked highly for all that time, in the academic equivalent of respect for a decayed but once proud monarchy. For years its department members resisted hiring intelligent new faculty, partly to eliminate potential competition and partly because the existing members hated the way the discipline had developed since 1970.

It was in the mid-1980s, however, in the final days of the ancien régime, that this Brahmin English department heard revolutionary tidings and decided to make one belated effort to save their kingdom. They offered a job to a young modern poetry specialist with a decidedly theoretical dissertation about to become a book. We interviewed her at Illinois that same year, and by then she'd been told she was the more elite university's likely choice. "If I don't go there," she told us in our more modest hotel suite, "I'll spend the rest of my life wondering what things would have been like if I had." What she soon found out, alas, was exactly what things *were* like there.

At a formal department dinner at the faculty club her first semester, the most distinguished English professor in attendance had obviously begun celebrating the occasion before setting out for the evening's festivities. He made a series of orotund pronouncements and then passed out face forward into the first course. While the prospect of watching him drown at the dinner table was not altogether without appeal to his colleagues, they were uneasy about potential wider recriminations if they failed to come to his aid. So they lifted him up, wiped him off, and propped him up as best as they could. It was business as usual at their boy's club. Indeed, our assistant professor was the only female faculty member in attendance. The others were either unwilling to come or uninvited. Soon she was in the job market again.

Just a few years later, by the early 1990s, a midwestern Slavic department had completed a similar downhill slide.[1] Its faculty, either delu-

sional or embittered, included two accomplished scholars, but the more influential of the two was apoplectic about the humanities' move toward "theory" and thus unsuited to make cutting-edge junior faculty appointments. He persisted in conflating academic Marxist theorists with members of the international communist conspiracy. Feminism earned a contemptuous sneer. The third person in the department's pecking order was unfortunately in the habit of publishing his books on a basement printing press in his house. Meanwhile the department's reputation made it nearly impossible to attract qualified graduate students. The admissions committee, staffed by faculty members, performed a service that might as well have been handled by trained chimpanzees: offering admission to 100 percent of the undergraduates who applied to the Ph.D. program. Those poor souls who did make their way to the rural campus soon abandoned all hope, for the department exploited its graduate students remorselessly, paying those who taught about *one-third* what the English department did. I suggested that Slavic be renamed the Gulag department, preparatory to closing it down. In the end the campus decided to try delayed rebuilding because it had such strong Slavic studies resources in other units. The fact that the faculty in Slavic did not care for one another seemed the least of their problems.

Yet when departments become the terrain of open warfare, it is not merely because civility and collegiality have evaporated but also because the veneer of academic civilization is pretty thin these days anyway. Departments that mirror fractured disciplines essentially get along by agreeing to ignore their intellectual differences. That means among other things giving up any serious effort to define a common mission. A sociology department evenly split between quantitative and qualitative methods has little grounds for compromise and no basis for a unified vision of the field. So if people get along they do so in part by ignoring one another.

What's left is entrepreneurial disciplinarity—every man and woman seeking personal achievement, advantage, recognition, and reward. If a crisis comes, there's no real common bond—except the abstract commitment to excellence—to hold people together. Since intellectually divided disciplines encompass partly incompatible intellectual paradigms, there may even be no local departmental history of negotiation over a coherent curriculum. In a fractured discipline, curriculum planning frequently amounts to a turf war. Indeed many departments maintain relative peace only by avoiding large-scale curricular planning. People agree not to trespass on one another's territory and thereby maintain departmental peace.

The Bloods and Crips have nothing on these departments when it comes to the animosity required to reign supreme in one's "hood."

These disciplinary tensions have been exacerbated by increasing personal problems among department faculty. Put simply, many departments have been overtaken by the midlife crises of their faculty. The long hiring drought of the 1970s and 1980s, when many departments did little faculty hiring and some did none at all, has left a number of departments overburdened with faculty whose career ambitions have collapsed. Departments that begin hiring after a decade or more of abstinence often end up with generational splits, rather than with a continuum of people of different ages at different stages of their careers.

New assistant professors can easily indulge in dreams of fame and influence. Faculty members in their fifties and sixties have to begin to face reality. Those who cannot sustain themselves internally too often look to their departments to tell them they have not failed, that they are really wonderful and successful people after all. The departments have a hard time delivering this message, an even harder time delivering the financial rewards people want as proof. Those who have the least fun are probably department heads who have to serve as psychotherapists as a result, a position for which they are largely untrained. Decreased junior faculty hiring tends to intensify this problem, as does the much more limited faculty mobility we have seen in recent decades. The senior faculty member who sends long memos or e-mails to his colleagues regularly is often looking for something he will not find. When an academic department is dominated by people frustrated in their careers, it is not a pleasant place to work.

Over the last two decades a third source of trouble has been added to these intellectual and personal conflicts: the increasing inequities of academic employment. A department that sustains high salaries for tenured and tenure-track faculty by ruthlessly exploiting adjunct faculty with Ph.D.'s is hardly well situated to be honest about any of its other differences. Often enough in the arts and humanities, moreover, it is not astronomical salaries versus substandard wages that divide a department but rather bare middle-class incomes for one group (the full-time faculty) versus migrant labor wages for the part-timers. Then no one has anything they can afford to give up, and short-term personal interests dominate every negotiation.

There are certain conclusions to draw from all of this. In many departments faculty should look to their teaching, their research, and their close professional relationships for their career satisfaction. It is a bad

idea to depend on collective department life to sustain your identity. A mix of professional relationships at your home campus and elsewhere in the country is generally better than exclusively local ones. But the absence of some common departmental conversation is increasingly untenable. The imperative issues to address, however, are not disciplinary but economic. Departments are first of all workplaces, not intellectual structures or alliances. It is the conditions of academic labor we must first confront. From that conversation, perhaps, we can learn the basis of common purposes and common goals. Whether that can lead to disciplinary coherence remains to be seen. But it is a place to start.

CN

Academic Freedom (ˌakəˌdemik ˈfrēdəm) Academic freedom is the glue that holds the university together, the principle that protects its educational mission. It is the principle that guarantees faculty members the right to speak and write as they please without interference from the university, the state, or the public. It is the principle that gives both students and faculty in the classroom the right to say whatever they believe is pertinent to the subject at hand. It is the principle that affirms there are no limits to what subjects and issues educational institutions may study, investigate, debate, and discuss. As Louis Menand writes in *The Future of Academic Freedom*, it "is not simply a kind of bonus enjoyed by workers within the system, a philosophical luxury universities could function just as effectively without. It is the key legitimating concept of the entire enterprise" (5).

From the outset academic freedom was vested simultaneously in individuals and in institutions. It was designed at once to protect the independence of disciplinary inquiry and to protect individuals from the exercise of political and economic power, including the power of those who pay professors' salaries. The first American efforts to define academic freedom at the turn of the century, as in John Dewey's 1902 essay "Academic Freedom," came at a time when academics had no job security. They were hired on yearly contracts and could be fired at will, as indeed they were. Job security, it became clear, was the only way to protect the speech of individual academics. The American Association of University Professors linked job security with tenure when the organization was founded in 1915. At the same time, business interests were already arguing against it.

As Hofstadter and Metzger note in their classic study, the first

22

American academic professional organizations were founded in the 1880s, and it was these organizations and the disciplines they represented that were to lend authority to individual academics' claims of expertise. But academics were to be protected not only for speech directed internally, at the university community and the discipline, but also for speech directed toward the world of politics and public policy, at least when events in that larger world pertained to their expertise. Indeed, the struggles over faculty termination that led to the formation of the AAUP and the definition of academic freedom were most often struggles over faculty members' public statements, either about national policy or university governance, not their scholarship or their classroom speech.

Academic freedom is also, for better or worse, an ideal, not a fact of nature. It must be put into practice for it to have any meaningful effects, and the quality and nature of its observance vary within departments, across institutions, and between countries. The protections it offers differ for different classes of academic workers, with the highest degree of protection enjoyed by tenured faculty. That tenured faculty have the most secure and protected form of intellectual freedom is not inherent in the concept of academic freedom; it is a function of how academic freedom is deployed and given material reality in various social practices.

Even tenured faculty, however, cannot assume their academic freedom will withstand all forms of assault and all historical conditions. All faculty members lose their academic freedom in a dictatorship, as faculty members did in Nazi Germany. The guarantees academic freedom offered were also widely abandoned in the United States during the 1950s, in the long postwar inquisition that culminated in the McCarthy period. As Ellen Schrecker demonstrates in *No Ivory Tower*, many progressive faculty members lost their jobs during this period and none were able to speak freely without fear of punishment. Academic freedom must thus be relearned and defended continually.

The widespread betrayal of academic freedom in the 1950s—not just in higher education but also in high schools—did not do away with the ideal but rather proved its value. The existence of the concept of academic freedom helped faculty understand what they had lost, what they must guard more carefully in the future. As Joan Scott has written, "it was precisely in its loss that the abstract principle acquired concrete reality" (164).

Although tenure could not guarantee academic freedom in the 1950s, it has served academic freedom well in the decades since then. Its relationship to academic freedom is less philosophical than practical. Tenured faculty have legal protections against arbitrary dismissal; they can thus

speak and write freely without fear of the ultimate professional penalty, the loss of employment. They can take intellectual positions as they wish and defend them with conviction. They can embark on unpopular research projects without fear of retribution. When the British parliament defined tenure, as the *Chronicle of Higher Education* reported in August 1988, it called it "the freedom of academic employees to question and test received wisdom and to put forward new ideas and controversial opinions without jeopardizing their jobs or privileges." Tenured faculty have the job security that enables them to take issue with how their universities are administered as well. They can also often safely refuse assignments they believe are not in their own best intellectual and professional interests. As tenured faculty exercise these rights without sanction, they establish the conduct appropriate within the institution as a whole and set an example that some less well protected individuals are able to follow.

Some critics of tenure can be rather snide about its role in guaranteeing academic freedom. They point out that academic freedom really does not exist for *untenured* teachers—graduate students, part-timers, and adjunct faculty. Their control over course content is more limited, sometimes nonexistent, and their ability to speak freely is constrained by their disposability. This argument has real merit, especially for adjunct and part-time faculty, who can often be fired at an administrator's whim. In urban centers there is frequently a large pool of underemployed teachers waiting to take their jobs. Graduate students are not replaceable quite so quickly, since their applications have to be written and assembled, accompanied by letters of recommendation, then reviewed and processed by faculty committees. That usually only happens once a year. Replacement graduate employees are thus generally available only on a cyclic basis. There is now typically a pool of *underemployed* graduate students in other departments on campus, but even they may be unavailable once the semester is under way. But part-timers are very much like day workers. In some locations you really can hire replacements overnight. But any department can survive terminating an individual graduate employee or part-timer; for part-timers there is often no mechanism for appeal.

Under these circumstances academic freedom can be seriously imperiled. Many such vulnerable teachers are intellectually oppressed, especially in institutions that have a mission or intellectual profile that faculty are supposed either to support or at least never contradict. Proprietary schools or religious schools are the most frequent offenders here, but untenured teachers who address controversial issues in the classroom can

find themselves at risk in other schools as well. In such cases, nonrenewal is an almost invisible way to silence inconvenient speech.

The people who should be the local guarantors of academic freedom are the tenured faculty. Their tenure should protect not only their own free speech rights but also the rights of more vulnerable employees. Individual tenured faculty should be ready to step in and defend graduate employees and part-timers aggressively. On some campuses a recognized union, a local AAUP chapter, or a faculty senate can offer organized support for academic freedom when it cannot be successfully defended at the departmental level. But the first line of defense needs to be vigilant tenured faculty.

Some tenured faculty regularly play this role for graduate students, especially once a graduate student signs on to work directly with a faculty member. Others are willing to act on principle even for students they do not know well. Some tenured faculty will never take a risk for anyone else, but then they do not fully understand the responsibilities of tenure. The situation for part-timers and adjuncts is usually quite different. Tenured faculty may never even meet them and thus have no idea who they are. It is easier not to feel guilty about exploiting part-timers if they remain invisible to you. Then the academic freedom of part-timers can be seriously undermined. They can be dismissed by managers without due cause or kept so frightened they avoid exercising their free speech rights. This suggests that academic freedom cannot be dependably sustained in departments where a whole class of teachers is structurally isolated from tenured faculty.

On the other hand, if academic freedom is grounded in steadfast and committed tenured faculty who are responsible for all staff members, then it is reasonable to expect the line administrative officers—from the department head to the dean to the university chancellor or president— to be staunch defenders of academic freedom as well. If there is no substantial core of tenured faculty with a high degree of job security behind them, administrators may prove far less courageous. The president who oversees a vulnerable faculty of part-timers is often alone in trying to preserve the school's intellectual independence and integrity. Such an administrator may consider the job impossible, especially when outside forces weigh in on an issue. CEO-dominated boards of trustees, legislators, parents, and legislators often have little commitment to academic freedom when controversy is involved.

There is little ambiguity about what the key sites of controversy are: sex, politics, public policy, and religion. Imagine an academic institution

where all or most of these topics are either out of bounds or sharply curtailed. Add to the list the increasingly vexed area of working conditions at the school itself. If the college has major corporate sponsors, donors, or partners, their activities may be off-limits to criticism as well. As the areas of enforced silence pile up, it becomes more and more difficult to think of the resulting institution as one where adequate intellectual debate and inquiry can take place. Restrictions that apply to faculty may even be more severe for the student newspaper. Soon we really aren't talking about "higher" education at all; at best we're talking about job training, at worst we're talking about virtual indoctrination.

The restriction of academic freedom in the growing sector of proprietary education presents real problems for academic oversight. Certainly publicizing the matter can help, but such publicity will not automatically reach the proprietary schools' potential clients. More scrupulous oversight by accrediting agencies is another strategy, and it is being urged more regularly.

Equally difficult is the much longer running issue of academic freedom at religious institutions. When Arthur Lovejoy published his famous definition of academic freedom in 1930, he explicitly argued for the right of a scholar "to express his conclusions, whether through publications or in the instruction of students, without interference from political or ecclesiastical authority" (84). Lovejoy had in mind not only his contemporary scene but also the long history of heresy in societies dominated by religious authority. Through much of the 1970s it appeared that this problem was gradually solving itself. It seemed that many religiously affiliated colleges and universities were effectively becoming more secular, or at least more tolerant of intellectual diversity and dissent. Then in the 1980s the trend began to reverse itself, partly in concert with the rise of the New Right as a potent political force in the country at large.

We started seeing increasing restriction of academic freedom at religious schools, especially at schools affiliated with Evangelical or fundamentalist groups. In some cases restrictions were not only widespread but inconsistent or irrational. Expectations of faculty conformity in narrow doctrinal areas widened to include social and political positions. Thus some religious schools made it clear that issues like birth control or abortion rights could not be addressed freely in the classroom, certainly not so freely that faculty could admit pro-choice beliefs. At some schools academic freedom on such matters might vary from department to department, depending on whether secular or religious faculty were in charge and on

how closely subject matter impinged on doctrine. A department of sociology might be less restrictive than a department of theology. On the other hand, few conservative religious institutions would tolerate a sympathetic course on gay rights or Queer theory; such "illnesses," they are likely to feel, should be treated in the counseling center, not in the classroom. The conservative wing of the Southern Baptists gained control of some institutions and insisted that faculty affirm that the Bible was literally true.

At some religiously affiliated schools the faculty have a high degree of intellectual freedom while the students have virtually none. Often religious preferences intervene in hiring and promotion decisions. Faculty members at Marquette University told me they felt promotion requirements were sometimes relaxed for Catholic faculty members. One highly respected Baptist university in the Southwest proudly confirms that all its faculty are Christians; they go on to demand that 50 percent of them be Baptists. Your department may be told it has fallen below the 50 percent minimum and will be required to hire Baptists for the next several slots. A group of faculty at that school questioned that practice in a 1997 memo: "Some of us have heard that some departments are being told that any faculty hires that they make this year must be Baptists. If this is true how is it in keeping with the stated policy on hiring new faculty? Also, are we not being dishonest to advertise a position for which only Baptist candidates are viable candidates without making that limitation known to all involved from the very beginning?"

The memo's existence, on the other hand, highlights the conflicted nature of religious institutions. They often have campus cultures where traditions of deference to ecclesiastical authority translate into deference to administrators. Yet at the same time they can be places where arguments based on ethics or morality have more weight. Ethical arguments won't necessarily carry the day, but they may remain on the table and continue to have some impact while an issue runs its course. At many secular campuses, people wait out a moral argument while knowing that power and money trump everything else.

At religious institutions where religious and administrative authority are combined and wield nearly absolute power, unfortunately, such delicate maneuvering may never take place. As the AAUP's Committee A reported, at Brigham Young University, for example, doctrinal impact on academic freedom and tenure is unpredictable and surreal. Here is an excerpt from the AAUP's summary of BYU's handling of a 1996 tenure case in which a faculty member was fired for "heresy":

In the letter of June 5, 1996, notifying Professor Houston of denial of continuing status and promotion, the central charge in the case made against her was that she had "engaged in a pattern of publicly contradicting fundamental Church doctrine and deliberately attacking the Church." . . . From the panel presentation taped at the 1994 Sunstone symposium, at which she spoke informally for about six minutes, they [university administrators] cited offending comments:

> In one of my recent meditations—*which are prayer for me*—I visualized once again, as I have many times in the past, sitting on my Father-in-Heaven's lap and laying my head on his shoulders for comfort, and I saw myself being held in my Heavenly Mother's arms, and holding her hand tightly for strength. . . .

> While the Mormon hymn "O My Father" and other texts refer frequently to a Mother in Heaven and parents in heaven, the BYU administration concluded that Professor Houston's comments constituted "public affirmations of the practice of praying to Heavenly Mother that contradict fundamental Church doctrine that we should pray only to Heavenly Father."[1]

The uneasiness one may well feel about the status of academic freedom at religiously affiliated institutions has a long history. It was an issue at the turn of the century when the principles of academic freedom were first being fully formulated here. The AAUP has an exceptions clause for religious institutions in its statement on academic freedom and tenure. The reasons for the existence of the clause, which requires notice at the time of appointment of "limitations of academic freedom because of religious or other aims of the institution," perhaps including specific doctrinal areas where conformity is demanded of the staff, are partly strategic. If religious institutions were simply cast out of the conversation, officially stigmatized as betraying the basic notion of academic freedom, then faculty members at those schools would have no external protection. Yet some AAUP members see the clause merely as an opportunity for religious schools to announce when they are not honoring academic freedom, not as giving them greater latitude in defining it.

As it is, a significant number of religiously affiliated schools still want to be seen as being in the mainstream of American higher education, as being places where independent intellectual work can and does take place. It is also in many ways in our interest to draw them into the mainstream, to show them, as Martin Marty put it recently, that "their pursuits of heretics in their academic folds usually turn out to be self-defeating or

counter-productive" (64). So a difficult and delicate balancing act occurs continually, as scholars at secular institutions try in practice to define a line beyond which religiously affiliated schools cannot go. Defining the line in the abstract is quite difficult, so the focus is on evaluating practice and conduct. There was agreement in the AAUP's Committee A on academic freedom and tenure that Brigham Young University had stepped substantially over that line. Their report cites a number of cases where academic freedom was seriously abridged, but there were still more. The publication of the report informs faculty across the country about the school's conduct and sends a message to other schools about what sort of behavior will not be tolerated.

The conservative drift of many religiously affiliated schools has not been the only trend threatening academic freedom. A key element of the continuing debate about academic freedom reconstructs another controversy that has continued throughout the century—the question of whether speech outside disciplinary expertise is protected. The issue is not whether faculty speech is protected from criticism; it is not. Heated debate is fundamental to the continuing conversation of most academic disciplines. Academics entering the public arena are clearly subject as well to all varieties of public discourse. The issue, therefore, is whether professors can be punished academically for political speech exercised in the public arena.

As Thomas Haskell points out, academic freedom "came into being as a defense of the disciplinary community (or, more exactly, the university conceived as an ensemble of such communities)" (54). Joan Scott argues that "academic freedom protects those whose thinking challenges orthodoxy; at the same time the legitimacy of the challenge—the proof that the critic is not a madman or a crank—is secured by membership in a disciplinary community based upon shared commitment to certain methods, standards, and beliefs" (166). Disciplines through their members judge and mediate individual speech all the time, mostly by reviewing manuscripts for journals and presses and deciding whether or not they should be published. The protections for this sort of disciplinary speech are partly, as Richard Rorty notes, a matter of tradition and custom; thus they require continual reassertion and professional monitoring.

From the turn of the century on, however, nondisciplinary faculty speech has been a matter of contention. The case that partly led to the founding of the AAUP, the dismissal of economist Edward Ross at Stanford, clearly mixes not only intramural and extramural speech but also disciplinary and non-disciplinary speech.[2] In 1896 Ross endorsed the

idea of free silver in a pamphlet and spoke in public on behalf of William Jennings Bryan's presidential candidacy. Leland Stanford, the university's founder, had died and left control of the institution to his widow, Jane. She was offended at Ross's break with Republican orthodoxy and demanded that he be fired. The university president managed to secure a delay and a sabbatical for Ross to provide a cooling-off period.

On his return in 1900, however, Ross extended his public persona to include a condemnation of Chinese immigration that mixed labor issues with issues of race. Jane Lothrop Stanford was outraged, not because of Ross's racism but because the Stanford fortune had been built on Chinese labor. Now he was out of a job. Professional economists and some of the future founders of the AAUP came to Ross's defense, despite the fact that while the 1896 comments were partly within his area of expertise, at least insofar as an economist was qualified to comment on the gold standard, the 1900 remarks were clearly not, since they went beyond commenting on Chinese labor to include a plea for Anglo-Saxon racial purity. Of course the 1896 statements included not only economic analysis but also a political endorsement. Finally, one would like to think that at least some of Ross's defenders found his racism objectionable but defended his right to speak nonetheless.

And so it has gone for a hundred years. From then until now there have been numerous recommendations that faculty should confine public statements to their area of disciplinary authority, but few have suggested dismissal should follow for those who venture out of their fields. In the meantime, once colleges and universities began to sign on to the AAUP's 1940 statement on academic freedom and tenure, academic freedom could acquire some legal force and precedent as well. In recent decades academic freedom has also, as Haskell points out, become entangled with First Amendment guarantees of free speech. In 1967 Justice William Brennan spoke for the majority in *Keyishian v. Board of Regents* when he wrote that academic freedom "is of transcendent value to all of us and not merely to the teachers concerned. That freedom is therefore a special concern of the First Amendment, which does not tolerate laws that cast a pall of orthodoxy over the classroom."[3]

The combined effects of precedent, contractual commitment to the AAUP statement, and First Amendment guarantees would seem decisively to protect faculty speech in a uniquely comprehensive way. Certainly faculty cannot be effective citizens if they can be fired for participation in the political process or for criticism of university policy. Yet First Amendment protections alone do not protect employees who dissent

from corporate policy. It is the complex relationship among the several forms of protection for faculty speech that shapes the full meaning of academic freedom.

Michael Bérubé has recently argued in an essay in *Academic Questions* that academic freedom applies only to areas of a faculty member's "expertise," but that seems at once incorrect on the legal and historical grounds outlined above and misguided as a matter of policy. It raises the possibility of termination for political speech, which seriously undercuts the role faculty can play in a democracy. What's more, "expertise" is no more secure a category than disciplinary identification. Faculty members in the course of a career regularly take up new interests and sometimes abandon old ones. In today's climate of increasingly permeable disciplinary boundaries, these interests may bear little relationship to the faculty member's official discipline.

Bérubé's own work provides an excellent example of such cross-disciplinary permeability. When he began to write about human genetics and public policy for disabled persons, he was no longer working in literary studies, his primary field. He had no professionally certified expertise in genetics or public policy, nor did publishing in nonacademic venues like *Harper's* or with publishers like Pantheon confer academic credentials. Being reviewed in academic journals might partially confer them retroactively, but that is hardly a timely or reliable arrangement. If the awarding of the Ph.D. marks disciplinary or subdisciplinary certification, no such decisive temporal event credentials scholars who branch out into new areas. Thus an admission that "expertise" changes and expands over time will not begin to cover the gradual and unpredictable intellectual life of a contemporary academic.

Few academics, for that matter, are credentialed experts in higher education, but they have a vested interest in commenting on higher education policy, not only within the university but also in the public arena. I have published several books on the Spanish Civil War and several books on higher education policy, two research interests that I acquired fifteen years after receiving my Ph.D. Although the publications effectively grant me recognized expertise, I would argue I possessed some earlier on the basis of my reading and research. Yet no one stopped by my office to test me on either subject. There is thus no way to adjudicate and certify expertise. Limiting academic freedom to areas of either disciplinary or extradisciplinary expertise is unworkable and counterproductive.

These examples also demonstrate some of the reasons why academic freedom must be possessed not only by institutions but also by individuals.

31

During the McCarthy period, some who sought to fire left-wing faculty argued that academic freedom applied only to the discipline's collective right to pursue its ongoing research. But that is an empty safeguard if individuals are continually at risk. The very health of the discipline, so some conservatives argued, required purging "subversive" faculty. The result, of course, would be cautious or cowardly disciplines and intellectually tepid research.

This argument has now resurfaced in arguments put forward by the National Association of Scholars, many of whose members, as we point out in the separate entry on the NAS, argue that higher education must be purged of intellectually suspect faculty. The NAS has lost faith in the ability of the traditional disciplines to police themselves, because they have become intellectually corrupt, or so they claim. Not surprisingly, the NAS joins another of tenure's critics in taking this line. In "The Future of Tenure" Harvard Professor of Higher Education Richard Chait argues that "with respect to matters of 'political correctness,' many trustees, legislators, and citizens believe academic freedom actually *enables* faculty to offer unsubstantiated conclusions and pernicious perspectives with utter impunity." "Were it not for academic freedom," Chait continues, "professors would have to be *more* intellectually rigorous and *more* intellectually responsible" (3). We would like to think few academics would welcome legislators and citizens deciding what counted as intellectual responsibility and promptly beheading any professor deemed to have failed its demands.

In the fall 1997 issue of the NAS journal *Academic Questions*, James Tuttleton rails against "the politically correct imperatives of multiculturalism, feminism, gay studies, black studies, and so on," while Barry Smith simply collapses them all into creeping "tommy-rot" in higher education. Things are getting so bad, he bellows, "that entire disciplines might become in this fashion shorn from all external controls, their members habituating each successive generation of new students to ever wilder forms of tommy-rot. . . . The departments of Tommy-rot Studies in the affected universities would then be in the position of evaluating each other's work, awarding prizes and honors to each other's members." Inundated with students of tommy-rot, staffed with professors of tommy-rot, the university will be "filled to the brim with tommy-rot."

Elsewhere in the issue NAS members step forward to wail that they have but the power of reason to fight the forces of "tommy-rot." Yes indeed, reason and a grant of million dollars a year from the Olin Foundation. It's a bit like hearing reason extolled on an Alzheimer's ward. Well, we too are admirers of reason, even passionately deployed reason,

but this isn't it. Apparently this sort of jeremiad makes the NAS feel good, but one too many stiff drinks of this sort and your brain doesn't function very well anymore. One may only pray that Smith is not the designated driver for the *Academic Questions* editorial board.

It may be that the only place "tommy-rot" really exists is in Toontown State University, the cartoon institution of higher education NAS members have established rhetorically so they can bewail its excesses, though Dinesh D'Souza and Charles Sykes believe they have found it at Dartmouth, Duke, and Michigan. Meanwhile, the NAS steadily attacks the national organization that seeks to protect academic freedom, the AAUP. As Thomas Haskell points out, whatever you think of feminism or multiculturalism, it is difficult to see how they fall outside the protections of academic freedom. The NAS effort to refashion academic freedom as a weapon to use against people they disagree with is clearly really an effort to do away with academic freedom, not reform it.

Much the same is true of the effort to decouple academic freedom from tenure while explicitly eliminating tenure itself. Yearly or term contracts with very narrow and vulnerable definitions of academic freedom are one certainty. The Pew Charitable Trust has recently given Richard Chait a grant of over a million dollars to develop alternatives to tenure, long one of Chait's interests. "One size no longer fits all," he cheerfully announces in a *Harvard Magazine* article about the granting of tenure; "the byword of the next century should be 'choice' for individuals and institutions." In what is a remarkably disingenuous scenario he suggests that "faculty so inclined should be able to forego tenure in return for higher salaries, more frequent sabbaticals, more desirable workloads, or some other valued trade-off." But of course exactly the reverse is the case. We will forego tenure in exchange for lower salaries, no sabbaticals, and heavier workloads.

Most prospective faculty members will have less, not more, "choice" in Chait's brave new world. But "choice" is not the only slogan he cynically adopts; elimination of tenure and academic freedom, he suggests, will also help promote "diversity" in work arrangements. Other foundations linked to corporations, including the Mellon Foundation, are also mounting or supporting assaults on tenure. Some have suggested we measure the strength or weakness of current tenure policy by the level of public trust it elicits! Chait, on the other hand, has urged we decouple tenure from academic freedom and devise contractual guarantees for the latter. The proposals so far have been chilling at best.

The American Association for Higher Education has been a leader in

seeking ways to restrict the intellectual freedom and independence of the professoriate. As part of their "New Pathways: Faculty Careers and Employment in the 21st Century" project, they have distributed Chait's work and that of others in a series of occasional papers that should be required reading for everyone interested in the future we face. In a 1997 AAHE working paper, J. Peter Byrne's "Academic Freedom Without Tenure," prospective contractual guarantees of and limitations to academic freedom are expressed this way (the emphasis is ours):

> Faculty members have the right to teach without the imposition or threat of institutional penalty for the political, religious, or ideological tendencies of their work, *subject to their duties to satisfy reasonable educational objectives and to respect the dignity of their students.*

> Faculty members may exercise the rights of citizens to speak on matters of public concern and to organize with others for political ends without the imposition or threat of institutional penalty, *subject to their academic duty to clarify the distinction between advocacy and scholarship.*

> Faculty members have the right to express views on educational policies and institutional priorities of their schools without the imposition or threat of institutional penalty, *subject to duties to respect colleagues and to protect the school from external misunderstandings.*

It is the last requirement—to protect the school from external misunderstandings—that would have particularly amusing consequences in the corporate university. Imagine what caution these "guarantees" of academic freedom would instill in a faculty *none of whom had tenure* but any and all of whom could be fired summarily. Moreover, once dismissed, faculty would bear the burden of filing suit and seeking to overturn an improper firing. In the present system the burden of proof in dismissing tenured faculty is on the institution, which must supply that proof in lengthy proceedings.

Imagine trying to defend your "reasonable educational objectives" in a court committed to upholding the institution's right to be protected from "external misunderstandings." Astonishingly, Byrne's proposal underwrites dismissal for any disagreement that produces public controversy, even for debates about institutional policies and goals. And his demand that we "respect colleagues" would obviously justify dismissal for a sharp disagreement with an administrator; certainly anything as aggressive as a campaign to oust a dean or a president would warrant immediate removal of a faculty member. Chait promises a revised set of contractual guaran-

tees for academic "freedom" soon, but we do not anticipate deriving much comfort from them.

Such assaults on academic freedom combine old arguments and new ones. They also grow out of new cultural and technological developments. Many universities automatically save all copies of faculty electronic mail, and administrators sometimes consider it their right to read it all in search of evidence of wrongdoing, purportedly inappropriate personal communication, or unwanted political activity. If academic freedom is the major principle underpinning higher education's whole enterprise, it is also surprisingly fragile.

In summary, then, how is academic freedom being threatened today? Here are a number of the major ways; some of them are discussed in this entry, others elsewhere in the book:

1. By the ongoing shift from full-time tenure-track to part-time faculty

2. By attempts to decouple academic freedom from tenure

3. By attempts to redefine and restrict academic freedom conceptually

4. By politically motivated attacks on how faculty members use their academic freedom

5. By efforts to limit and narrow academic freedom contractually and legally

6. By the resurgence of restrictions on academic freedom at religious institutions

7. By surveillance of faculty communication by electronic mail

8. By the corporatization of institutions of higher education

9. By efforts to enact speech codes on campus that restrict or punish speech deemed unacceptable

10. By efforts to police or criminalize consensual personal relationships on campus

11. By occasional political surveillance of classrooms

12. By attacks on the major national organization that defines academic freedom and investigates abuses of it, the American Association of University Professors.

The combined effect of all these forces does a good deal more than threaten the privileges of tenured faculty; it puts at risk the very core educational and cultural missions of the university. For the academic freedom of the tenured faculty anchors everything else the university does. It spreads outward to protect the free speech of students and the

development of the disciplines. It underwrites the difference education can make in training the young and evaluating social policy. It preserves the possibility of a reflective historical memory and of a critical difference from contemporary opinion. Academic freedom *is* the university as we know it. Anything we put in its place would have to go by another name.

CN

See ***American Association of University Professors, electronic mail, National Association of Scholars, tenure.***

Accountability (ə¹kaůntə¹biləd·e)

No one raises the issue of faculty accountability because they are happy with the status quo. At the University of Washington a 1997 moral panic among legislators, reporters, and a conservative populace took as its starting point the scandalous revelation that a faculty member was seen mowing her lawn at ten o'clock on a weekday morning. Why wasn't she in her office? Perhaps they heard that administrators at the Shreveport, Louisiana, campus of Southern University recently tried to mandate that faculty be in their offices from 9 to 5. Were library or restroom passes available? Obviously something needs be done to make faculty members accountable to the people of the state of Washington! Telling angry constituents that the same faculty member might well be found working at her computer at midnight or all day Saturday may have little effect. For what fuels this public rage is a misguided class resentment about the uniquely flexible schedules faculty members enjoy and about the intellectual freedom they flaunt when they take progressive stands on matters of public policy.

People only talk about faculty accountability for one of three reasons: they believe faculty should not be accountable to themselves; they want power over faculty accountability; or they believe faculty are now unaccountable and worry whether the things faculty do are of no account. So it is time for an accounting. Let the accountants take over. No faculty member can give a satisfactory account of himself or herself. From its poisoned root of quantification and enumeration, accountability's parallel terms spread out metonymically to overshadow the campus. In characteristically demagogic rhetoric, Thomas Sowell in *Forbes* defined "faculty prima donnas" as "people able to make decisions without being held accountable for the consequences." It is no wonder that those faculty near retirement merely hope to bail out before the bean counters take over their lives.

Of course we might have done a better job of giving a public account of ourselves over the last several decades. But it is not too late to start now. Campuses should produce booklets in which faculty members describe their teaching philosophies and techniques. In their own words, in short essays of 500 words or so, faculty members could share their passion about teaching and their numerous pedagogical innovations with interested legislators and members of the public. So too with their research projects. The point is to provide these accounts and prove our accountability before this watchword for bureaucratic power gives higher education's enemies the opportunity to strip college teaching of all its dignity and intellectual independence.

Does this mean we should be irresponsible no-accounts, accountable to no one at the university? Hardly. But we do need to be clear that the concept of *accountability* does not embody a timeless Platonic form. It is a strategic term deployed in specific social and political contexts; its use serves particular needs and interests. While one might rather abandon the word, its widespread use necessitates a struggle over its meaning. We should hold ourselves accountable to those principles, like academic freedom, that we value. As members of a community, we should be accountable to one another, more accountable, to be sure, than we are now. And we should broadcast widely the nature and meaning of our central responsibilities. Make no mistake about it: invocations of accountability herald a battle over the future of higher education.

External forms of accountability can finally monitor only quantification, not quality. External accountability can regulate the number of students we serve, the hours we spend in classrooms and offices, the new programs that win approval, and the allocation of the budget, but its impact on the *quality* of instruction and research can be only neutral or negative. That is not to say that universities cannot benefit from both internal and external challenges. This book offers a few internal ones. And external challenges over the last decade have pushed universities to eliminate waste when they were reluctant to do so. Bill Clinton's Secretary of Education has called accountability "the watchword of the decade." But an intricate system of intellectually disabling controls—which is what accountability offers at its worst—will only make higher education less effective. In 1992 the Kentucky Legislature adopted a Higher Education Accountability Model that requires public colleges and universities to report faculty work hours in detail. Other schools have preemptively opted for various forms of "voluntary accountability" in which they offer to track work hours themselves. But all such forms of

bureaucratized accountability amount to attacks on faculty autonomy. The accountability that can assure that we challenge our students intellectually is the sort we wield ourselves. We hold ourselves accountable to our educational mission; it is in the public's best interest not to prevent us from doing so.

See *academic freedom, the corporate university, distance learning.*

Activity Fees (ak'tivəd·ē 'fēz) Virtually every college and university in the country requires students, undergraduate and graduate students alike, to pay activity fees when they register for classes. Activity fees are one of those expenses that, although less than tuition payments, when combined with others costs like health service payments and technology fees (charged for use of campus computer facilities) can run into a considerable amount of money. For graduate students on fellowship or other forms of financial support, many of these are classified as "non-remissible" fees: i.e., expenses not covered by an aid package.

While the paying of activity fees often provides an occasion for grumbling, especially from graduate students whose research and teaching, not their social lives, tend to dominate their time, most students pull out their checkbooks without giving it so much as a second thought. And those who consider the payment more carefully often assent to its validity, even necessity. After all, lecture and film series, concerts, intramural sports, and other similar campus activities are supported by these fees; such pursuits are significant to college life and, without sufficient funds, they would not exist—or certainly not flourish. All students' lives would be impoverished without the at times costly cultural and social events scheduled on campus during the academic year; thus, activity fees are one of those things in life that qualify as necessary evils. Better to pay them without too much questioning.

In *College Sports Inc.: The Athletic Department vs The University* (1990), however, in part an investigation of the various money trails on campus—where the dollars come from and where they go—Murray Sperber paints a different, at times disturbing, picture of the financial goings-on at some colleges and universities. Now a decade old, his data may even have been superseded by more recent, more shocking figures about major athletic coaches' salaries, the wealth of athletic associations, and the ways money from general campus funds gets siphoned off by athletic departments. On some campuses, according to Sperber, student activity fees constitute one of those troughs at which thirsty football programs in particular drink.

He quotes an NCAA study in the late 1980s as calculating that each Division I football program in the country received, on average, $1,196,000 from student activity fees. At smaller schools where football has difficulty paying for itself, the numbers are much larger. Sperber identifies Virginia Commonwealth's football team, for example, hardly a perennial contender for the national championship, as receiving $1.9 of its $2.2 million budget during 1986–87 from student fees. At The College of William and Mary the following year, according to a report in the student newspaper, each student paid "more than $500" to the university's intercollegiate athletics program (Sperber 82–83). If one thinks about that number too long, it makes the cost of those football tickets for homecoming weekend just a little exorbitant. School spirit ain't cheap.

Sperber, correctly we think, argues that the distribution of such monies on many campuses is hidden from students, that they don't often know what exactly they're paying for, and that they would be reluctant to fork over the money so readily if they did. We agree. Activity fees, when used this way, constitute a steady source of income for athletic departments regardless of the success of the football team. Stated in another way and to use a trope that runs throughout this book, the corporate university can be ruthless and dishonest not only to its workers but also to its consumers. Both need to hold its financial management more accountable; both need to demand a more exact mapping of where the money goes and who profits by it. Too often the answer is an overpaid managerial class and the football program.

One rejoinder to this allegation of hidden payments and mystified accounting would be that since Title IX, the cost of women's athletic programs has skyrocketed (not to mention that of other non-revenue-producing sports); athletic departments are thus compelled to receive funds from student activity fees, among other sources of revenue. Such a rationalization cannot explain the examples Sperber gives. And as the women's basketball programs at Tennessee, Stanford, and Connecticut have shown—as well as the women's volleyball teams on many campuses—Title IX has not only enhanced the variety of intercollegiate athletics but also enlarged the pool of revenue-producing teams. Let student-consumers decide which is more important to their college experience, lecture series or football. Some might decide that they'd rather support women's lacrosse or a foreign film series than the football team.

Administrative Perks (əd¹minə₁strā | d·iv ¹pərkz) Perhaps the
most strategically pertinent way to frame this entry is simply to say this:
if you do not know what they are, you ought to find out.

Yes, we know your university president gets a free house during his or
her time in office. Servants? Such as they are these days, a president gets
those too. Of course there's that famous yacht at Stanford, the one that
nearly sunk the university all the while it stayed afloat. And there's a cer-
tain Lear jet on a field in Kansas. Administrative salaries, especially when
administrators' qualifications are compared with those of the faculty, are
no small benefit. Certainly the faculty member who is judged unfit for
tenure and then becomes an associate dean with a generous salary
increase merits your attention. But that was not quite what we had in
mind. You might examine the limited oversight and scrutiny involved in
appointing more administrators, surely an opportunity for patronage if
not a perk, and compare it with the review mechanisms for faculty
appointments. You might look into the lifetime retirement benefits for
being an administrator for a few years, but even those are on the up-and-
up. Or at least they're up-front about them. We had a different sort of
perk in mind.

One notable administrative perk is the ability to hire other administra-
tors. As Carol Frances points out, the total number of nonfaculty profes-
sionals on campuses across the country rose 123 percent from 1976 to
1989, while the number of faculty rose only 30 percent. As Arthur Levine
writes, "More admissions officers were hired to attract more students.
More development staff was hired to raise more money. More student-
affairs professionals were hired to reduce attrition. And more finance
staff was hired to control spending" (4). Over the next decade the num-
ber of administrators declined slightly, while more faculty continued to
be hired, but of course most of those faculty hires were part-timers, not
full-time staff.

This is not to say we urge you to scapegoat or demonize administrators
as a class. It's not an easy or pleasant job these days. Being a department
head can be particularly trying, since you have to deal with every base
faculty impulse and need on a daily basis. The department neurotics, the
sexual harassers, the devotees of blind ambition, the perennially resentful
and unloved, they all arrive in your office wanting salary raises or absolu-
tion. Deans mostly never encounter the sources of these less appetizing
bodily fluids. At the top of the administrative hierarchy, encounters with
politicians and wealthy parents curtail some of the day's pleasures.

Nevertheless, we do wish administrators as a group welcomed initia-

tives from below, whether faculty evidence of programmatic inventiveness or lower-paid-employee efforts to unionize. The jobs do instill a conviction that father knows best. An ersatz program imposed from above always looks better to an administrator than a proposal growing organically from a constituency below. And power does corrupt.

Case in point: how many able-bodied administrators on your campus are quietly handed a handicapped-parking sticker to place on their car? Just to make life a little easier for them. We wouldn't be writing this if we didn't know it happens.

Affirmative Action (əˈfərməd·iv ˈakshən) The chancellor of the University of California at Berkeley, Robert Berdahl, tells a story from his early career, when he was a history professor at the University of Oregon in 1967–68.[1] The department was down to its last few finalists for an assistant professorship in American history. One of them was a woman, and the twenty-six department members, all men, were trying to decide whether to offer her the job. One major concern was the large lecture course, American Civilization. The current faculty members were tired of teaching it and wanted to turn it over to the new hire. "But can a *woman* carry a large lecture course?" one tenured professor asked. There was some discussion, but consensus was soon reached: no, a woman could not handle a large lecture course. She did not get the offer. Berdahl likes to note that affirmative action has not only outlawed such a conversation; it has made it an absurdity. Women now teach every sort of history class. That conversation can no longer take place.

In a number of fields, the percentage of women receiving Ph.D.'s has reached the point where a gender-blind hiring process, were such a thing possible, would result in half the new faculty positions going to women. Certainly over time a gender-blind selection of finalists would produce a balanced mix of men and women to be interviewed. Some departments, however, still require monitoring, especially those that have historically resisted hiring women faculty and still have few or none on their staffs.

We know one philosophy department at a midwestern school that resisted hiring women for years. They would periodically offer a job to one of the two or three most-famous women philosophers in the world, typically a senior tenured faculty member at Harvard, Oxford, or someplace equally distinguished. Are you interested in coming to Kansas, Illinois, Ohio? You may fill in the name. The answer was always negative.

41

When it came to hiring an assistant professor, where women *were* willing to come to the Midwest, they just never seemed to make the short list. After years of pressure from the affirmative action office, the philosophy department eventually hired two women in the 1980s.

In the same decade a new assistant professor at a small southern school was asked to go through the hundreds of job applications and make up the list of people to be interviewed for a new English department job. The department head gave him only one admonition: "No feminists and no blacks!" He called one of us to ask advice. We still do not quite know what we should have said. Had he phoned a federal agency to complain, he would in time have lost his own job. Our advice was to hire the most progressive people possible and wait fifteen years for those in power to die, retire, or change their minds. Or, we advised, get another job. The law is rarely a definitive shield for whistle-blowers.

There are also offenses on the other side. Now and again a coalition of faculty members in a department with a good gender balance will decide to block any male candidate for a given job. At least at the assistant professor level it is still easy enough to make a first-rate appointment, but senior appointments are far more difficult, and a rigid gender bias either way can mean no appointment at all. Many departments with appointments to be made in African American studies will only offer them to African American candidates, a foolish and unfair restriction in our view. Since there are so few black Ph.D.'s, it can take years to fill the position; meanwhile, African American history or literature may simply go untaught. At the same time, some schools are still terrified of hiring black faculty, so they wait nervously until the interviews to find a white faculty member for a job in African American studies.

Neither race nor gender biases of this kind can be easily addressed legally, however, since a group of like-minded faculty can always meet to make a private pact, though California's Proposition 209, which makes racial preferences in both admissions and employment illegal, could well test the situation in African American studies. In any case, the problems summarized in the last two paragraphs are not failures of affirmative action so much as they are failures of faculty judgment, professionalism, or good sense. Of course it is illegal to advertise a racially exclusive job, so no one admits such hidden restrictions, but they are in practice all over the country.

Overall, however, affirmative action has worked well in faculty hiring. It has forced departments to advertise jobs, rather than keep them secret and fill them through the old-boy network, a common practice until the

1970s. It has introduced sunlight and accountability into the hiring process. Not every department behaves well, but we now have a much more diverse faculty than we had thirty years ago, one more vital intellectually and more able to educate a diverse student body effectively. Conservative faculty critics of affirmative action see this as an empty goal. Thus Lawrence C. Becker, summarizing the "no-need" extreme, argues that for such faculty there is "no advantage to an institution of higher education in having any particular distribution, because matters of sex, age, race, nationality, or ethnic origins of its faculty members are wholly irrelevant to its teaching and research mission" (96). But, of course, affirmative action faculty hiring has never been a matter of quotas; it has rather been a matter of equal opportunity to compete and a matter of achieving a diverse teaching staff. Anyone who believes it is unimportant whether students ever see a woman or a minority member lecturing in front of a class has a very rarified view of human life indeed.

This more diverse faculty has also challenged many traditional disciplines and, in our view, helped both enliven and transform them. Yet not everyone is happy about the expansion and reshaping of many disciplines. As we point out in our entry on the Modern Language Association, changes in humanities departments in particular have been lightning rods for right-wing critiques of higher education. What seems too often overlooked, however, is the way conservative attacks on intellectual developments in the humanities are almost always accompanied by indictments of affirmative action. From Charles J. Sykes's *The Hollow Men* (1990) and Dinesh D'Souza's *Illiberal Education* (1991) to John M. Ellis's *Literature Lost: Social Agendas and the Corruption of the Humanities* (1997), affirmative action and revised curricula are indicted as coconspirators in the "corruption" of higher education. For Sykes, the 1980s "campaign for 'diversity' became a form of official ideology" (57) on campus. Nowhere was this more evident, he rails, than at Dartmouth (D'Souza prefers Duke, among others, to make his accusations). So, in his long excursus on the "deconstruction of Dartmouth," Sykes links affirmative action to the "disemboweling" of the liberal arts and the "propagating" of "totalitarian dogma" (309). In this revolution from above, higher administration and faculty at Dartmouth have intensified their "affirmative action programs for both faculty and the student body" at the same time as they have abandoned the sacred Western tradition.

Are the two phenomena coeval, or is one the cause or effect of the other? While the drive to expand the canon has been helped by affirmative action, it has not been at its core an affirmative action project, but

rather a project of recovering the rich part of our literary heritage that had been repressed or forgotten. We are enriched as a culture now that the canon of American literature includes Zora Neale Hurston, Charlotte Perkins Gilman, Amiri Baraka, Toni Morrison, Luis Valdez, and others. This is a project in which scholars of every race and gender have participated. After bemoaning the influence of "feminists and multiculturalists"—and reducing the complexities of curricula to the question of whether students should be required to study Shakespeare, even though Shakespeare courses are heavily enrolled all across the country—Ellis concludes *Literature Lost* by telling us how to "reverse or at least halt the deterioration" of the humanities: "[T]he most obvious step that could be taken is to stop the mechanism that continues to make the situation worse day by day: affirmative action" (226). Why? Because "race-gender perspectives" tend to "rob" minorities and women "of historical context and instead channel their energies into resentment. Many of the most able move into the bureaucracy of affirmative-action enforcement, where their further intellectual development is *permanently arrested*" (226, our emphasis). This astonishing slander of those committed to campus diversity speaks for itself, but we might add only this: a "race-gender perspective" can hardly be accused of ahistoricism, for it is designed specifically to remind us of our history. It is Ellis and company who endorse the notion of a timeless, ahistorical, and immutable Western tradition.

We believe the benefits of affirmative action in faculty hiring vastly outweigh its occasional injustices. And the injustices of the old system vastly outnumber those we face today. Higher education has, for the most part, found ways to increase faculty diversity on its own. Faculty employment is not so charged a public issue as undergraduate admissions. Parents and politicians alike mostly stay clear of the matter, so solutions are worked out on individual campuses. Of course, meaningful affirmative action for black faculty is largely moot; there are hardly any in existence. Jonathan Kozol's *Savage Inequalities* explained the reasons years ago. Until and unless inner-city kindergarten, elementary, and high schools are improved to the point where African American high school students become committed to higher education in greater numbers and decide later to pursue Ph.D.'s, there will not be enough black faculty available to hire. Indeed, according to a National Research Council study in 1989, African Americans received fewer than 3.5 percent of doctoral degrees awarded to U.S. citizens in the late '80s, down from over 4 percent a decade earlier (Cahn, 108).

It's at that point, long after undergraduate admissions, that affirmative

action in education and faculty hiring intersect. The huge disparity in the support for and quality of K–12 education, fueled by the scandalous and brutally undemocratic funding of public education by property taxes, eviscerates the project of establishing racially diverse faculties. It also puts the lie to merit-based undergraduate admissions programs that rely primarily on test scores and grade point averages. American students who attend substandard schools are not on a level playing field with the children of wealthy suburbanites. The shattered school rooms in inner-city Oakland are not to be found in most neighborhoods in Palo Alto. The virtually bombed out schools in south and west Chicago do not resemble the computerized schools on the north shore. Without equal opportunity there, you're not finally going to have it elsewhere. So differential opportunities for education are already derived from race and class, years before people apply to college.

The effects of unequal opportunities on college admissions became obvious in the spring of 1998, when the University of California campuses announced admissions results for the fall 1998 entering class of freshmen, the year after Proposition 209 prohibited California from using race as a criterion for admissions. The number of African American students accepted at Berkeley declined by 66 percent and at UCLA by 43 percent. Latino admissions dropped 53 percent at Berkeley and 33 percent at UCLA. That means Berkeley admitted 582 black students in 1997 and only 191 in 1998.

Many of the African American students Berkeley or UCLA would have admitted had perfect 4.0 grade point averages. Why wasn't perfection good enough? Unfortunately, newspapers in California failed to tell the whole story, and less detailed accounts in the national press told even less. The 1 April 1998 *Los Angeles Times* reported that entering UCLA students had a "weighted" GPA of 4.19. You might wonder what a "weighted" GPA is and how students on a 4-point scale could get such a GPA. As the senior admissions officer at UCLA we interviewed explained it to us, most of the successful admits have taken a series of advanced placement or honors courses, which earn *5 points,* not 4, for each earned grade of A. Most inner-city schools offer either very few advanced placement courses or none at all. The 1 April *New York Times* noted that Charles Jones, an African American student who was class president at Castlemont High School in east Oakland but was turned down at UCLA, had taken all three of the advanced placement courses his school offered. But the UCLA admissions officer informed us their freshmen have taken an average of *sixteen* such courses. So there is literally *no way* poor students can compete with

wealthy students from the suburbs. As our interviewee put it, "Admissions at UCLA is now like competing on the job market. Working in the admissions office is like living in your own private El Niño."

Add to that numerous other inequities. White students on average do slightly better on the Scholastic Aptitude Test, although the difference for top students admitted and rejected at Berkeley or UCLA is trivial. It can be explained by the fact that many wealthy schools offer special courses on test taking. Students take courses that train them not simply in math or reading but in how to do better at taking the tests. Again, those courses are often not available in poor districts.

But that's just the beginning of inequity. In the poor California city of Santa Ana in wealthy Orange County, some schools that cannot afford textbooks settle for photocopied texts, but these are too fragile to allow the students to take them home at night. So much for homework accompanied by the textbook. Meanwhile, as Hope Hamashige and Tina Nguyen reported, the one prestigious school established in Santa Ana, MacArthur Fundamental Intermediate School, has so many applicants that parents or relatives must camp out there to win a first-come, first-served slot for their child. "'It started with one night, then it became two,' said No. 52, Mariseia Gomez. 'Now it's almost a week.'"

Americans by and large want a level playing field, but they are incapable of the social and economic analysis that would help them understand why we do not now have one. The 1994 *Hopwood* decision by the fifth circuit court in Texas prohibits race-based admissions but leaves affirmative action hiring intact. It does not, however, bar aggressive recruitment of minority students or more intensified efforts to get admitted minority students actually to enroll. But its effects in professional programs like law that weight test results especially heavily have been decisive and disastrous. Meanwhile, *Hopwood* does not actually require merit-based admissions. It allows admission on the basis of nonracial preferences such as those given to athletes and alumni children. As former Texas President Berdahl points out, *Hopwood* allows the University of Texas to admit children of alumni but not children of parents who were denied admission when the school was segregated.

Madness rules in this wondrously contradictory ruling. Yet both current and past UT presidents (Larry Faulkner and Robert Berdahl) believe even affirmative action opponents in Texas are beginning to realize what the state has to lose in canceling affirmative action admissions. No rational observers in Texas want to see resegregation in the university system, returning the state to where it was nearly a half century ago in the land-

mark case *Sweatt v. Painter,* 339 U.S. 629 (1950). Yet the patchwork of backlash court decisions and ballot initiatives will relentlessly test these and other outcomes. Berdahl expects the University of California at Berkeley to become a majority Asian American campus, not perhaps at the 70 percent level predicted by some, and "Asian" in this case encompasses many different national origins and ethnicities, but it will certainly no longer include a Caucasian majority. The percentage of African American students at Berkeley will probably hold at about 6 percent, while the growing Hispanic population may not lead to Hispanic admissions above the current 13 percent. Meanwhile, no one really knows what "merit" means in admissions, despite national majority consensus that merit admissions are fair and despite the tendency of the press to reduce merit to test scores. At some point the Supreme Court will no doubt have to set national standards for affirmative action and, in doing so, tackle the problem of defining "merit."

Both those for and those against affirmative action bring deeply felt philosophical positions to the debate. And the philosophical positions tend to be underwritten by people's understanding of their own experiences, with those who haven't experienced discrimination confident in individualism and those who have concerned with group rights. Those against affirmative action are often anguished at the idea that race consciousness is being used to combat the effects of race consciousness. Those for affirmative action believe we will never get beyond race until we confront it and deal with it. But the battle is not being fought in the realm of philosophy; it is a political issue being fought out in the political realm, and there and in the courts are where its solutions and prohibitions will be devised. In this as in so many other areas, however, the courts tilt to the public political winds. And the political climate in some states may make it impossible to maintain or reinstate affirmative action admissions even if the Supreme Court confirms its constitutionality.

Race is America's longest-running and most difficult social problem, and all the affirmative action measures and countermeasures are redolent with centuries-old passions. Our fragile strategies can easily be swept aside by such forces. So we argue, plausibly, we believe, for the need for diversity on campus. We know the American population is becoming more racially and ethnically plural, and we know the globalized economy requires multicultural contacts and communication, so we argue for "diversity," not race, in undergraduate admissions. Diversity means the opportunity to *meet* diverse populations in school, not just read about them. But we do not actually make full intellectual and educational use

of the diversity we do achieve, and a diverse education alone, as the University of Illinois's affirmative action officer William Trent points out in campus discussions, might not require large numbers of minority admissions. We might test and interview to find those folks who could best help *educate* for diversity. You could achieve diversity of some sort without solving the problem of unequal opportunity. You could declare Berkeley diverse without increasing black or Hispanic admissions. In the end, large-scale affirmative action programs require a commitment to social justice, an admission that social justice can be one of higher education's aims. "Diversity that rules out social justice," William Trent argues, "is a moral failure."

That takes us back to acknowledging that equal opportunity does not exist for all races, and to the paradox of eliminating racism by foregrounding race. At the same time, we are gradually learning that race is a social and cultural construction, not a biological fact. Yet skin color has real social effects in America even if race is a biological chimera. We cannot help but be haunted by these paradoxes and contradictions. Some high school students gain preferential admission by racial self-declaration. Some affirmative action scholarships go to children of families who can afford to pay, while poor families have no chance of social mobility.

Meanwhile, following upon the civil rights movement, race-based affirmative action has done quite a bit more than make campuses more diverse, though few who have taught both all-white and racially mixed classes would want to return to the former. We might recall here what nearly half a century of struggle for affirmative action for both women and minorities *has* brought us. The project is literally fifty years in the making, from the first use of the term "affirmative action" in a 1950 bill presented to the House of Representatives (Burstein 30), through Lyndon Johnson's Executive Order 11246, which required that federal contractors "take affirmative action to ensure the hiring of qualified blacks, women and other minorities in their work forces" (Greene 15), to Title VII of the Civil Rights Act of 1964. Insofar as higher education is concerned, affirmative action has been refined—reconsidered, reshaped, made more complicated—by *Sweatt v. Painter* (1950), *McLaurin v. Oklahoma Board of Regents* (1950), *Regents of the University of California v. Bakke* (1978), and others. The compensatory valence of early discourse on affirmative action has given way to what some call a "broader redistributive view" (Greene 79)—a shift away from compensating for specific past inequities toward establishing better social conditions in the present and future—and that redirection has never met with unanimous support.

Nevertheless, most Americans today support the notion of equal pay for equal work and almost all welcome the opening of the professoriate to large numbers of talented women.

Affirmative action has enabled higher education to serve more segments of society, though many of the poor are still shut out of opportunity. Affirmative action has also helped create a sizable black middle class. As Trent pointed out, people attack the competency of affirmative action's beneficiaries, but they attacked the competency of black Americans long before affirmative action. By moving some blacks into positions of authority, affirmative action has helped maintain the stability of our political institutions and enabled them to fulfill their public roles. These are not trivial accomplishments.

Affirmative action *has* succeeded for women. From women's sports in college to women's admission to medical schools, affirmative action is a success and may eventually be obsolete. There are still, to be sure, glass ceilings; medical school admissions equality is not reflected in academic medical leadership, which remains largely male. There remain too few women in some fields and too few women with full professorships, but affirmative action has instilled considerable inertial force in corrective trends. Women are winning a place on a level playing field.

Affirmative action successes with gender mean that we should begin selectively to dismantle preferential treatment practices in particular fields and departments. Neither feminism nor affirmative action is meant to be reducible to a lifetime entitlement program for individual women. Neither feminism nor affirmative action is meant to place women above peer review or the normal give-and-take of professional dialogue. A general sense of justice and equality cannot survive permanently institutionalized differential treatment systems based in identity politics. A proper affirmative action program is designed to make itself obsolete by virtue of its success.

The lessons learned from affirmative action over gender now need to be applied to race. If it is true that equal opportunity is both reinforced and undermined by racial preferences, then one logic is to pursue race-based affirmative action in such a way as to make it unnecessary. That means making it succeed, which in turn means addressing opportunity *throughout* the educational system. Race remains our deepest social problem. The country's foundational history is profoundly contradictory: it runs from genocide and slavery to a belief in freedom and equality. We are still haunted by that history. Yet it is not a question of righting those wrongs but of dealing with their continuing consequences. It could be

done in two generations if we shifted sufficient national resources to the problem.

Welfare may not lift people up out of poverty but education does. We need intellectually stimulating day care programs, high-quality K–12 education in poor districts, after-school and summer educational programs, and individual counseling and mentoring on a national scale. We need massive funding shifted from defense spending and entitlement programs for the wealthy and then devoted to education. Those of us who have worked with children in the inner city know that education can make the critical difference. It is time to take affirmative action seriously.

CN

Alternative Careers (ȯl'tərnəd·iv kə'ri(ə)rz) As the news about the brutal job market in academia began to move from the ivy tower to the newsroom in the 1990s, academics began to talk once again about the alternative career model for the Ph.D., a plan almost every tenured faculty member thinks is the greatest thing since sliced bread. Advocacy for alternative careers outside academia, which the MLA is ready to embrace with giddy abandon, is without question the most cynical and self-interested solution anyone has offered to the job crisis. When one of us visited the University of Arkansas a few years ago to talk about the job market, a senior colleague rose to say he had little sympathy for people who viewed their failure to get an academic job as a disaster: "There are lots of things a Ph.D. can do. You could go into the army." This was appropriately greeted with groans and protest from the graduate students in attendance, and we doubt if even an MLA president would have enough of a tin ear to call for that solution.

MLA presidents will no doubt instead pick glamorous, high-salary career alternatives with some creative component. Screenwriting is one obvious fantasy they hope might bedazzle jobless Ph.D.'s. This is the MLA's version of what Alan Golding described to me as "the Michael Jordan effect." In other words, bring in high achievers outside academia with Ph.D.'s to inspire ghettoized part-timers and grad students. You too can be a star. Why teach? Direct blockbuster Hollywood movies. Run for the U.S. Senate. But no one needs a Ph.D. to become a film director or a screenwriter. We know *X-Files* star David Duchovny used to be one of "the blessed of the earth," but he quit before joining the priesthood. An Illinois graduate student left for Hollywood some years ago and became

reasonably successful, but he bailed out long before writing his dissertation. Meanwhile, dangling T. S. Eliot's bank job before a new Ph.D.— dissertation and Routledge book contract in hand—is not likely to win any gratitude for the MLA. Graduate students who complete their dissertations have typically *already* spent years as teachers and scholars. That is the life they have chosen and trained for, the life they are already embedded in by the time they test the job market.

The MLA doesn't seem to realize that most of these folks have already chosen *not* to be Horatio Alger. The organization's leaders might counter that Elaine Showalter, 1998 MLA president, earns just about as much writing journalism for *Vanity Fair* or *People* magazine as she does teaching for Princeton. Good for her, but has she quit her academic job? Journalists' paychecks are not quite so secure. Could Showalter have launched herself into high-profile journalism on the way out of graduate school? We've met more than a few Ph.D.'s who failed to get academic jobs and are now employed at the other end of journalism's income spectrum and are not too happy about the time spent in graduate school.

Faculty members like the alternative career model *for other people* for several reasons: It holds the promise of sustaining large graduate programs, along with their faculty perks; it gets complaining graduate students out of their hair; it allows faculty to combine their contempt for commercial employment with a hidden conviction that Ph.D.'s who don't get academic jobs are not as good as those who do. But no graduate student who loves reading literature and being in the classroom wants to be told cheerfully that insurance companies are hiring.

There is good reason to design terminal M.A. programs with alternative careers in mind, since the skills we teach *do* have wide applicability. Furthermore, M.A.'s have generally not yet fully internalized the classroom professor identity, so the likelihood of psychic damage is much less. Such programs should include courses and work experience linked to the alternative career, an option easier to realize at metropolitan campuses. We'll have to design appropriate curricula and hire appropriate faculty. But offering an alternative career to a talented Ph.D. is, as often as not, a cynically self-interested move. Furthermore, it offers no programmatic answers for the profession. There have always been jobs outside academia where the Ph.D. is a valued credential—including jobs at foundations and government agencies—but there aren't enough of them to justify maintaining doctoral programs. Nor are we likely to convince anyone, especially state boards of higher education, that literature or history or

anthropology departments are the best places to train film directors or advertising magnates. In short, we're not going to win formal public consent to turn humanities Ph.D. programs into alternative career mills.

The American Association of University Professors (thə ə¹merə-kən ə₁sōsē¹āshən ₋əv ₁yünə¹vərsəd·ē prə¹fesə(r)z) Founded in 1915 about thirty years after national disciplinary organizations came into being, the AAUP sought immediately to set universal standards and principles for faculty appointments and independent research. The most common faculty appointment at the time was a one-year contract with no guaranteed renewal. This was essentially at-will employment, and faculty members were casually dismissed whenever a trustee, a politician, a newspaper editorial writer, or a major donor took issue with a research project or a public position. It was no way to guarantee intellectual freedom, either in the classroom or in the private study.

The AAUP initially recommended tenure after ten years of service. In 1940 it reduced the recommended probationary period to seven years, with a promotion review and final decision the year before. It is a remarkable achievement to have made that basic model nearly universal for full-time faculty, especially given the wide variety of academic institutions in the United States. The AAUP also worked to make commitment to principles of academic freedom universal, and in that it has succeeded surprisingly well also. Thus when institutions violate these principles, they know they are doing so. When they deny their students or faculty academic freedom or offer some contractual alternative to tenure, they are entirely aware that they are breaking with the AAUP's published statements.

These standards require constant monitoring, however, and the AAUP has also made itself academia's major national watchdog, guardian, and negotiator over all the issues pertaining to faculty status. It issued its first "Report on Academic Freedom and Tenure" in 1915, and its Committee A continues to do so today. These reports grow out of campus visits and interviews and are widely known for their thoroughness and care. No other national organization arrives on campus to investigate violations of principle and practice in academic administration; it is thus the major force behind establishing and maintaining consensus about employment and working conditions in academia.

The national office in Washington handles over a thousand individual

faculty complaints each year. Almost all are resolved through negotiation, and that is the association's preference, for resolving a complaint means that a faculty member has been treated fairly and that once again precedent about academic freedom and tenure has been reaffirmed. A very few cases each year or two reach the point where resolution is impossible, among them the widely reported termination of faculty at Bennington College. In the 1990s Bennington fired a group of faculty with "presumptive tenure" (Bennington's term) without cause, and Brigham Young University denied several faculty members tenure on grounds that clearly violated academic freedom. After extensive negotiations failed, detailed reports were published in the association's magazine *Academe* and members voted to censure the institutions at the annual meeting. Far from dry administrative documents, these "reports" can be riveting reading for anyone interested in academic life.

As should be clear even from this brief account, the AAUP's national office supervises a well-informed and activist group of committees. The national staff is typically on top of every case and every issue receiving press attention. The same cannot be said of every local AAUP chapter, many of which are equally effective but a few of which have grown sleepy in the groves of academe. Some campuses feel they do not need an aggressive AAUP chapter; all seems well in their neighborhood. Other local chapters represent a narrower view of the profession; the national AAUP's Collective Bargaining Congress (CBC) endorsed Yale's graduate students' right to organize for collective bargaining, but many faculty in the New Haven chapter refused the Graduate Employee Student Organization (GESO) their support. Support for issues at the national level is not, therefore, necessarily interchangeable with the entire membership of local chapters. The national AAUP makes a critical difference in the profession whether or not the local chapter does.

The changing nature of the academic workplace has meant that the association has had continually to research new issues and publish reports about them. Increasing pressures to institute forms of post-tenure review in numerous states led an AAUP committee to produce the most thoughtful guidelines on the subject available in 1997. The following year the AAUP drafted a statement of principles on part-time faculty that numerous other academic organizations signed. In 1997 and 1998 it also published a thick packet of advice and background essays to help faculty defend tenure and a similar packet on part-time labor. Meanwhile, the national office kept up its intensive lobbying efforts on behalf of higher education on Capitol Hill.

In the early 1970s the AAUP made a major decision to support local AAUP chapters that wished to become the collective bargaining agents for their campus teaching and research staff. The national AAUP did not become a union, nor does it bargain for anyone, but through its CBC it does help chapters who vote to do so to organize and seek the right to represent the faculty. The AAUP's Collective Bargaining Congress does issue statements and resolutions on union and labor issues, but it does not speak for the association as a whole unless a document is approved by the association's National Council.[1] Furthermore, most AAUP work is done by individual committees and divisions that work separately while relying on the national office for coordination—but some traditional faculty felt collective bargaining was inappropriate in academia. Partly as a result the organization lost a significant number of members in the 1970s.

Total membership continued to decline through the next decade, though not so much because of the AAUP's new union role. From the 1970s until now a new factor began to affect recruiting. As older members retired or died, they were often not replaced by new members from the ranks of younger faculty. The issue hampering recruitment for nearly thirty years has been the changing nature and loyalties of the professoriate. Put simply, an increasingly career-oriented and entrepreneurial professoriate have assumed their major loyalties were to personal advancement and their academic discipline. New faculty members in the 1960s often thought joining the AAUP was one of the first things they should do when receiving their Ph.D. or arriving on campus. Now few think of it unless they are told.

So long as university life was relatively stable, people could safely ignore national adherence to academic freedom and tenure. Membership fell from just over 90,000 in 1971 to a low of 40,000 in 1990. Since then active recruiting has increased membership to 44,000, but that is far fewer members than the AAUP needs to deal with the eroding standards for academic freedom and tenure we face now and in the new millennium. The caseload for the national staff and for the appropriate committees could easily overwhelm the people and the funds available. Thus the association is compelled to do a painful triage on the complaints it receives and cannot resolve, picking only the more egregious and precedent-setting for the final recourse of legal action.

The AAUP, in sum, is the only source of progressive national positions on the major issues that affect faculty across the nation. In the late 1990s, for example, the organization produced the single most thoughtful analysis of post-tenure review, along with action packets on part-time faculty

organizing, defending tenure, and recommended lobbying techniques. As part-timers replace tenured faculty, as corporate-style administrations try to dilute academic freedom, the AAUP's presence is more and more vital. Years ago research universities could assume their graduate students would find jobs at schools with similar values. No more. Our networks of friends, colleagues, and former students link us with faculty everywhere. The decline of intellectual freedom on one campus threatens education everywhere. The only insurance policy a young faculty member can obtain for academic freedom, the one simple and painless action he or she can take on behalf of everyone else, is to join the AAUP.

See *academic freedom, lobbying, tenure.*

America's Fast-Food Discipline (əˈmerəkəz ˈfast ˈfüd ˈdisəplən)

The discipline we have in mind for this renaming is our own, English. We want to argue that English more than any other discipline has helped pave the way for the alternative academic workplace and the full proletarianization of the professoriate. If higher education's future is one of part-time work dominated by corporate managers, English has had a key role in making that future more likely. Confident for decades that literary studies opens Heaven's Gate, the discipline is about to learn it been praying in a corporate lobby. English has been an unwitting corporate partner in a project to defund, defang, and deform higher education as we know it.

We will thus show why English as a discipline bears a special responsibility for making the precipitous decline of higher education more likely in the coming decades. That is partly because English departments have made the college teacher what standard economic theory calls an *elastic commodity,* one for which there are any number of substitutes. English has been the discipline to rely most heavily on those substitutes.

We refer to the discipline's employment practices. For English departments above all have demonstrated that *neither* full-time faculty *nor* Ph.D.'s are essential to lower-level undergraduate education. What's more, we've shown that people teaching lower-division courses need not be paid a living wage. We can no longer claim that such courses have to be taught by people with years of specialized training. Like many departments, mine puts people in front of a composition class the semester after they earn their B.A. So the educational requirement to teach rhetoric is apparently a B.A., a summer vacation, and a week's training. A couple of years of graduate study, having completed M.A. course work and a pros-

eminar in teaching, and they are then assigned "Introduction to Fiction" or other beginning courses.

Any research university that wanted to would be educationally justified in hiring such folks full-time at $3,000 per course. In the English department at Illinois two-thirds of the undergraduate teaching is already done by graduate student employees without Ph.D.'s. We can hardly justify hiring full-time faculty with Ph.D.'s by arguing no one else is capable of teaching the courses, since we have already "proven" otherwise. Indeed, after an ethical decision to reduce the size of our graduate program, Illinois was forced to turn to graduate students *in other fields* to teach its composition courses. Illinois now hires more than a score of law students to teach introductory rhetoric. These "apprentices" are not even enrolled in the department's degree programs.

There is now some statistical support for these claims. Data from the 1993 National Study of Postsecondary Faculty, based on fall 1992 hiring figures, are now available as a CD-ROM. More-up-to-date figures will not be available for another couple of years, but they will hardly be heartening. Ernst Benjamin of the national office of the American Association of University Professors has assembled the raw 1992 data into charts and written an accompanying analysis. English departments nationwide had the largest percentage (8.2 percent) of the part-time faculty workforce. Four other fields with much smaller workforces overall (law, communications, computer sciences, and psychology) used a higher percentage of part-time faculty—English used 52.9 percent, whereas law used 65.3 percent and communications and computer sciences each used about 55 percent—but most of those other disciplines were employing moonlighting professionals who were supplementing full-time jobs for prestige or pleasure. Thus colleges of law regularly hire community lawyers part-time; notably, 99 percent of part-time law faculty in four-year colleges and 79.8 percent of them in two-year institutions have the appropriate professional degree. Communications programs often hire local journalists part-time. A number of other disciplines, like business and nursing, do the same with full-time practitioners in their fields. Taken together, English and foreign languages—the MLA's constituency—accounted for 11 percent of the part-time faculty in 1992. And they amount to a block of people working at slave wages—people who depend on their instructional income for their living expenses—that dwarfs other small fields like philosophy, which accounts for but 1.3 percent of part-time hires.

Finally, a number of these fields, like law, employ their part-time faculty to train students in professional schools, not for basic undergraduate instruction. It is above all English and foreign language departments that have proven that full-time Ph.D.'s are superfluous for at least the courses they offer for the first two years of the undergraduate degree. If we then considered what graduate students having completed all doctoral course work might teach—and what salaries we could hire them at—the picture becomes still more troubling.

Here and there across the country that picture is already being filled out. At Illinois, the large lecture courses once categorically (and self-righteously) reserved for faculty are now sometimes taught instead by advanced graduate students. The geography, history, and sociology departments, to name but three, sometimes have a graduate student give all the lectures in the 600-student Geography of Developing Countries or the 750-student Survey of American History or the 300-student Introduction to Sociology. Still other grad students teach the discussion sections. No faculty members are involved. It's a great opportunity for the graduate student lecturers, who may well deliver a fine course, often replacing faculty who are far less eager for the task, but it also further undermines the need to employ Ph.D.'s. In some departments grad students have replaced retired faculty who once taught the large lecture courses. As long as new graduate students are kept on line to take over from those who leave campus, the retired faculty never have to be replaced.

Yet it is still English departments that have pioneered the mass employment of college teachers at subminimum wages. English department employment practices have demonstrated that most—or even all—of the undergraduate degree can be handled by severely exploited labor. Indeed, many courses are taught *at a profit*. The gap between the tuition paid by the students in an introductory course and the salary paid to a part-time faculty member to teach it (from $1,000 to $3,500 per course) can be considerable. Moreover, do you really need a library, a gymnasium, a chapel, an auditorium, a student union, or an elaborate physical plant to teach such a course? Proprietary schools like the University of Phoenix, profiled by James Traub, have shown that we do not. As these forces come together in a moment of recognition, the corporate takeover of the profitable portion of the undergraduate curriculum becomes a possibility. As Arthur Levine writes in "How the Academic Profession Is Changing," "high-technology and entertainment companies are viewing noncampus-based education as an opportunity"; we can look for "the growth of

private-sector competitors." English has led the way in turning college teaching into a low-level service job; we are corporate America's fast-food discipline.

It is worth calculating just what the hourly rate is for Ph.D.'s paid $1,000–$1,500 per course, common salary levels at community colleges and proprietary schools. Assuming 30 to 45 classroom hours, depending on the length of the term, assuming a rock-bottom minimum of two hours' preparation time for each hour of classroom teaching, two hours a week of office hours, and a minimum of 75–100 hours of paper and exam grading per term, the hourly pay rate comes to *under* $4 per hour. But this calculation makes two assumptions—that preparation involves reviewing familiar materials, not reading and researching new topics, and that paper grading includes no extensive comments by the instructor. Getting involved in either of these traditional forms of teaching, let alone more extensive tutoring during office hours, can cut the rate of compensation to $3 per hour or less.

Some part-timers calculate their average pay at *under* $1 per hour. Others, struggling to find some dignity in their labor, prefer to put the best possible light on their working conditions. "Sure, in weeks when I'm grading papers," said one part-timer when we interviewed him in Cincinnati, "I earn less than $2 an hour, but in other weeks it's not that bad." Ask yourself how many $1,000–$1,500 courses a person has to teach to assemble a reasonable livelihood? How much attention can students receive from someone teaching a dozen or more of such courses a year? Are subminimum wages for Ph.D.'s to become the norm? Already in many places in the United States college teaching is the lowest-paying job in the community. In any other legal industry these wages would land an employer in court. Full-time college teaching in a research institution may be, as Stanley Aronowitz argues, the last good job in America, but part-time teachers have the worst salaries of any employment category in the country. English, we would argue, is the discipline most responsible for laying the groundwork for the corporate university.

Apprentices (əˈprentəsez)

> Gleefully Jerome and Léveillé set to work, aided by the journeymen. Armed with broom handles, bars of the press, and other tools of their trade, they went after every cat they could find, beginning with *la grise* [the grey cat favored by their master's wife]. Léveillé smashed its spine

with an iron bar and Jerome finished it off. . . . They dumped sackloads of half-dead cats in the courtyard. Then the entire workshop gathered round and staged a mock trial, complete with guards, a confessor, and a public executioner. After pronouncing the animals guilty and administering last rites, they strung them up. . . .

—Robert Darnton, *The Great Cat Massacre*

The grotesquely comic insurrection in the printing shop of Monsieur Jacques Vincent in the 1730s, as Robert Darnton explains, serves as more than an instance of the underclass running amok or a cautionary tale about a ruling class that values its pets more than its subordinates. It is not, in other words, an event originating solely in the working conditions imposed by Monsieur Vincent or in his wife's infatuation with cats. Rather, Darnton locates the apprentices' ritualized felinicide within the collapse of the guild system at this moment in the history of the French printing trade. Beyond its value as an historical amusement, then, its parodies of juridical and sacramental rituals with its mock trials and administrations of last rites, the "great cat massacre" retains significance in part because it was enacted not only by shopboys, apprentices in the printing trade, but also by journeymen as well. "During the second half of the seventeenth century," Darnton observes, "the large printing houses, backed by the government, eliminated most of the smaller shops, and an oligarchy of masters seized control of the industry." The result was an erosion of what might be termed the possibility of individual advancement or "upward mobility." For the demise of the smaller printing shops made it "virtually impossible for journeymen to rise into the ranks of the masters. About the only way for a worker to get ahead in the craft was to marry a master's widow . . ." (79). By the 1730s, in short, a system of learning and *then practicing* a skilled trade had collapsed with the result that both novice and experienced printers, defeated and demoralized, revolted.

Each group, it seems, had different and serious grievances to redress. While the journeymen's revolt was presumably instigated by the shattering of their ambitions, the apprentices were motivated by much more immediate material factors. Darnton explains: the two apprentices Jerome and Léveillé "slept in a filthy, freezing room, rose before dawn, ran errands all day while dodging insults from the journeymen and abuse from the master, and received nothing but slops to eat" (75). Madame's beloved pets, by contrast, were housed more comfortably and enjoyed superior food. Hardworking and forever occupied with the minutiae of the shop, the apprentices labored in the most abject conditions. Their

revolt thus aimed at striking an extravagant blow against their deprivations, while their older mentors responded to the destruction of a trade that once promised a meaningful career.

It is, of course, always precarious to transport analogies across centuries and cultures, but reading Darnton's account one is struck not merely by its ironic, almost Beckettian quality, but also by its familiar economic resonances: an affluent master able to pamper his pets and indulge his spouse's every whim; a middle class of skilled workers, totally disillusioned by the disappearance of the smaller businesses they once aspired to run (the corner drugstore wiped out by the pharmacy counters at Kmart or other franchise stores in the 1970s?); and a malnourished, badly housed underclass working hard for table scraps domestic animals refuse to eat. There once existed a time in which such an apprenticeship system of training flourished and its participants prospered, but for printers in the 1730s that time had long since passed. Conditions had changed, even though some clung to traditional ways of schematizing labor in the face of changes totally antipathetic to such schemas. Much the same desperate clinging to tradition—with much the same economic and professional ramifications (save for, perhaps, any imminent assault on the nation's domestic animals)—obtains in today's shops of higher education, especially in humanities departments at major public and private research institutions.

Yet many commentators both within and outside the academy persist in maintaining the mythology that nothing much *has* changed: that the old ways of doing things—and the models traditionally employed to represent the larger system of academic labor—are still viable and worth defending. Such is the case with the notion of apprenticeship: the idea that graduate-student teachers work as apprentices in the guild we call academe and someday will take their rightful place beside their journeymen-mentors as professors in academic departments. Implicit in this now spurious narrative, we feel, is the misconception that the professoriate will remain fully professionalized: that is, that college teaching will remain an occupation that at base provides minimal job security, "reasonably interesting work," and the semblance of both adequate compensation and the prospect of advancement for a job well done.[1] Like the journeymen and apprentices turned cat murderers in Darnton's account, however, today's graduate students *and* faculty can no longer be assured of any of these components of professional employment.

But even if this weren't the case, even if most or all holders of Ph.D.'s in the humanities *and* many disciplines within the hard sciences could find meaningful professional employment, could the conditions under which

most graduate students teach qualify them as apprentices?[2] Insofar as many graduate student employees, much like Darnton's shopboys, are laboring in a state of poverty, the answer is "yes." The increasing levels of debt many graduate students are carrying—and the rising number of students who find it necessary to borrow to complete their graduate degrees—are, by now, widely known (see *debt* in this volume). Suffice it to say that the GESO (Graduate Employee Student Organization) "grade strike" at Yale University in the winter of 1995–96 brought this issue into stark relief, as the university acknowledged that it never intended for teaching assistant stipends to come close to covering even the most *basic* expenses of a graduate education and subsistence living in New Haven. Indeed, Yale estimates that teaching assistant stipends fall short by some $3,000–$4,000 annually (*New York Times,* 17 January 1996, B6). It is thus not surprising that paramount among GESO's demands during the strike was a $2,000 raise (which would bring the salaries of most TAs in the humanities to between $11,500 and $12,000), affordable health insurance, and tuition waivers for all TAs, along with such other matters as smaller section sizes, more formal teacher training, a more diverse university, and so on.

After reading this list and talking to graduate students at Yale, Indiana, Iowa, Florida, UCLA, Tennessee, and other campuses, we realized what by now must be obvious to most people: whatever local differences obtain, graduate employees across the country are concerned about both their economic survival and their physical and psychical well-being (and, in some cases, that of their children).[3] And contrary to the allegations of GESO critics, such concerns are *precisely about class,* for while the average full professor at Yale earns some $90,000 a year (*New York Times,* 17 January 1996), many graduate students are struggling to make ends meet and accruing unprecedented levels of debt in the process. Given the uncertainty of the job market, hence the ability to repay the loans they are taking, most graduate employees want to earn enough to pay the bills and to purchase adequate medical coverage. Period. That Yale TAs teach less than many of their peers at other institutions is as true as it is irrelevant, as many of them are borrowing upwards of $20,000 to complete their degrees (the national average of debt carried by those graduate students who borrow now exceeds $30,000).

All of this would appear to have been news to many faculty and administrators at Yale during the strike—and months after as well. Writing to the membership of the Modern Language Association in January 1996 in an attempt to persuade it *not* to endorse the organization's proposed

censure of Yale for its treatment of striking graduate students, Margaret Homans argued that many striking TAs, "in training, after all, to occupy professional positions," acted in a manner that is not only "unprofessional" but "unethical" and "dishonest" as well.[4] Whatever else might be said about these allegations, one thing is clear: Homans presumes "professional positions" exist and that Yale graduate students will soon occupy them. Yet, as Cynthia Young, who participated in the strike and was singled out for severe disciplinary sanctions, complains, "in the 1994–95 academic year, the combined placement record of ten Yale humanities departments was only 27 percent" (184). Homans's rather smug assertion about graduate student employees being in training "after all" to occupy "professional positions" needs to be read in the light of the harsh market realities Young describes.

And then there is Peter Brooks, chair of the Yale Comparative Literature Department, whose infamous designation of Yale graduate students as "among the blessed of the earth" graced the pages of both the *New York Times* and the April 1996 issue of *Lingua Franca,* among other places. Although he eventually abandoned such intemperate language, at least in print, less than a year after the GESO "grade strike" began he and Thomas Appelquist, dean of the Yale University Graduate School, were still insisting upon the validity of analogies between graduate-student teachers and "apprentices." In an article in the April 1997 issue of the *Chronicle of Higher Education,* to which we shall return in our conclusion, Appelquist reiterated the Yale party line on employment: "Learning to teach is an integral part of graduate education. . . . More-experienced students may learn how to teach a class on their own, with appropriate supervision. Yet in doing these things, they remain primarily students" (B6). Somewhat differently, Brooks contended that "graduate learning" is an "apprenticeship" and advocated radical, in some cases, commendable, changes in the ways graduate education is conducted: revise and even dismantle the present seminar and qualifying examination system that exists in most programs, enroll fewer students, support them in "better" ways, and so on. Yet, at the same time, he offered in the name of apprenticeship several remarkable, even absurd suggestions: "keeping" students in graduate programs "longer," for example, in programs replicating "an older model of more leisurely apprenticeship to the profession." In such programs, somehow, students would develop the capacity to produce an "'original contribution to scholarship'" by working on "collaborative projects with faculty members" (A52). Since the median time to completion

of the Ph.D. degree in Brooks's own department in 1995 exceeded *eight* years—and, at present, exceeds ten and even eleven years in other major departments of comparative literature—one can only assume that a more "leisurely" paced program of the kind he proposes might take ten, even fifteen years to complete.[5] Then, he argues, after serving such an extended apprenticeship, students could move more confidently into the "profession they are entering and the place that they may be able to make for themselves in it."

If the potency of such a fantasy of professional advancement can lead the chairman of the country's leading Comparative Literature Department into such inchoate recommendations, it is hardly surprising that the same fantasy can induce graduate students to go into debt for what Anabel Patterson in her 1996 letter to the MLA terms the "privilege" of teaching at Yale. The grade strike at Yale and Brooks's "creative" suggestions therefore illuminate not only many faculty's inability to respond to this crisis but also the complete inadequacy or, perhaps, chicanery of institutional representations of graduate student labor. In this instance, the distinction between public and private institutions is more or less moot, as university administrators, eager to find terms other than "employee" to apply to TAs, attempt to essentialize through their metaphors the "as if" plural identities of graduate students.[6] Depending upon the institutional context in which they are positioned—and essentialized—graduate students are expected to perform "as if" they were students, "as if" they were faculty, "as if" they were professionals.

Worse, the indifference of many faculty to this condition helps perpetrate an institutional reality which, like the social reality Slavoj Žižek theorizes, is "in the last resort an ethical construction" composed of largely inadequate *as if* depictions of graduate teachers (Appelquist) and students (Brooks) as apprentices, trainees, and so on (Žižek 36). Administrators, of course, want to view graduate students as if they were apprentices to justify the meager wages they are paid; and many faculty *need* to regard TAs as apprentices to avoid acknowledging their own complicity in the exploitive calculus of graduate student employment. Until faculty can agree about this inadequacy of representation, very little is likely to change and the economic status of graduate employees will continue to resemble that of migrant workers, budding "freeway faculty" engaged in the seasonal labors of higher education. And if this is so, if this analogy holds, what does this suggest about the universities in which we labor? Before any intervention in this economy can be effected, we must gain

a clearer purchase of the language used to describe it, not allowing ourselves to be co-opted by terminologies contrived for the benefit of corporate managers, not of faculty or graduate students.

Apprenticeship, a favorite of Yale's faculty and of its president, Richard Levin, is one such term, one of several invidious "metaphors we live by" and were better rid of.[7] Like most metaphors, "apprenticeship" provides a "systematicity that allows us to comprehend one aspect of a concept in terms of another," in this case inviting us to perceive graduate students either as "professionals in training," something like beginning workers in today's skilled trades, or the "prentyses" trained by masters in medieval guilds (Lakoff and Johnson 10). But will either comparison hold up? And at what conceptual cost?

If administrators really thought through the concept of apprenticeship, of the turbulent history Darnton and others have recorded, they would rush to disclaim it. Yet just the opposite is typically the case. In a January 1996 letter to "Friends and Graduates of Yale," for example, after outlining the "immediate challenges" of negotiating with clerical and technical employees—the GESO grade strike effectively quashed, graduate employment presumably was rendered "less immediate"—Yale's President Levin turns to the matter of graduate funding:

> Although our financial support for graduate students is generous, graduate student life could be improved. . . . But we remain convinced that collective bargaining would fundamentally alter the teacher-student relationship, during the course of which a graduate student develops into a professional colleague. We believe that graduate students are apprentice teachers and scholars, and the teaching they perform is part of their training.

Levin's counterparts at other institutions make similar assertions, but typically fail to delineate precisely what "part" teaching plays in a doctoral student's training. *The Ohio State University Graduate School 1995–1996 Handbook* unintentionally advances at least one possible answer:

> A graduate student's principal objective is to earn a graduate degree. Appointment as a GA [Graduate Associate] contributes to that objective by providing an apprenticeship. This apprenticeship complements formal instruction and gives the student practical, personal experience that can be gained only by performing instructional, research, or administrative activities.[8]

In this formulation, teaching merely supplements a graduate student's formal course of study; it is something added to it to bring it to perfection or completion. This concept itself is fairly new, for only in the past two or three decades have beginning faculty been expected to bring a diverse repertoire of teaching experiences or, for that matter, completed doctoral degrees to their first jobs. In fine, and regardless of the quality of mentoring and pedagogical instruction a graduate student receives, the Ohio State *Handbook* clarifies the secondary role teaching plays in the graduate curriculum, begging the question of exactly how long a TA profits by the experience. When does teaching simply become a job?

Since the early Middle Ages, *apprenticeship* has meant various things, but an engagement in activities secondary or subordinate to another enterprise is not one of them. This history is by no means irrelevant, as it is frequently invoked in discussions of the labors of faculty and graduate students in the contemporary university. In her detailed account both of the GESO grade strike and of previous labor actions at Yale, for example, Cynthia Young alleges that faculty and administrators maintain the "fallacy of an antiquated guild system" to defend the idea that "graduate students function as apprentices whose primary compensation is the onsite teacher training they receive" (180). Apprenticeship, though, clearly posits—or, rather, once posited—"eventual full-time employment with better working conditions as its delayed compensation" (Bérubé and Nelson 20). In addition, apprenticeship also assumed the existence of a beneficent guild that "stood like a loving mother, providing and . : . car[ing] for her children even after death" (Smith cxxxiii). Although many would bridle at this familial metaphor, which in Lucy Toulmin Smith's account was rendered obsolete by the middle of the fourteenth century, a guild of scholars seems preferable to businesses like the Yale Corporation, the phrase typically used when earnings on Yale's $6 billion endowment are announced.

But as Smith and, more recently, Paul Strohm have shown, such visions of a guild of scholars are largely utopian (in the most uncritical and nostalgic sense), for the "harmonious relations" enjoyed by early craft guilds in England had almost certainly dissipated by the plague year of 1348 when the "consequent depopulation" brought "the opposition between the interests of the working-class and the employers for the first time . . . to a crisis" (Smith cxlii). Much the same is true of the relationship between apprentices and "maisters," as readers of Chaucer's "The Cook's Tale" might recall when Perkyn Revelour, a "prentys" in the "craft of vitaillers," was given "his leve" when "he were ny out of his prentishood." Strohm

regards Perkyn's name as significant, as "the imagery of revelry carried a
heavy symbolic freight in the later fourteenth century." In his reading,
Strohm argues that by the 1381 peasant rising apprentices constituted a
"volatile grouping," one more subversive of authority than the "disport"
(singing and dancing) for which the Cook's Perkyn is famous: "Appren-
tices, together with journeymen and others," Strohm contends, "may be
assumed to have been on the Westminster chronicler's mind when he sug-
gested that the London officials were paralyzed" with the fear that they
might join rebels and, hence, the city "would be lost" (164, 166).

It is important to recognize that in this chapter in the chronicle of
apprenticeship, as in the later "great cat massacre," journeymen joined
their younger colleagues in revolt, presumably because they enjoyed more
interests in common with them than with their "masters" or "employers."
Such, quite obviously, was not the case between striking GESO members
and faculty at Yale, nor has it been in recent court rulings.[9] In *N.L.R.B. v.
Yeshiva University* (1980), for example, the Supreme Court denied a
National Labor Relations Board petition to enforce its order giving fac-
ulty the right to bargain collectively at Yeshiva. Justice Powell, speaking
for the 5–4 majority, argued that because faculty "exercised supervisory
and managerial functions," they were excluded from "the category of
employees" and thus not entitled to the benefits of collective bargaining.
Writing the dissenting opinion, Justice Brennan distinguished between
medieval and modern institutions:

> The Court's conclusion that the faculty's professional interests are indis-
> tinguishable from those of the administration is bottomed on an idealized
> model of collegial decisionmaking that is the vestige of the great medieval
> university. But the university of today bears little resemblance to the
> "community of scholars" of yesteryear. Education has become "big busi-
> ness," and the task of administering the university enterprise has been
> transferred from the faculty to an autonomous administration [*100
> Supreme Court Reporter*, 872–73].

This ruling defines faculty not as professional employees, a designation
made available by the National Labor Relations Act, and not as mentors
or journeymen, but as supervisors so "aligned with management" as to be
indistinguishable from it. This is hardly surprising given the terms of this
discussion: if universities are now corporations, not communities of
scholars, and if graduate students really aren't apprentices in any mean-
ingful sense save perhaps in their subversive "volatility," how do faculty
function as journeymen? This question would seem particularly difficult

for the growing ranks of part-time faculty and those assistant professors at schools like Yale with little or no expectation of tenure. Are these fully enfranchised members of the profession, or do they share more in common with graduate student "apprentices"? *N.L.R.B. v.Yeshiva* depicts a faculty qua manager that wields supervisory authority over students and all "academic matters" pertinent to them, and maybe this portrayal is closer to the everyday realities of the academy than many faculty might wish to acknowledge. It won't be for long.

Just as there is little comparison between the compensation academic "apprentices" and faculty earn, there is scarcely any similarity between the salaries of graduate student employees and those of apprentices in the skilled trades. As we have mentioned, in the mid-1990s the ratio at Yale between the average salaries of full professors and those of advanced graduate employees in the humanities approached 9:1 ($90,000 to $9,940); the ratio between graduate associates in English and full professors at Indiana University was around 7:1; and that of humanities faculty of all ranks at such schools as the University of Illinois was closer to 5:1.[10] Such disparities are rare in most unions; moreover, the carefully calibrated systems of raises in most apprenticeship programs confirm one premise absent from the payment schedules of many graduate employees: namely, that as one acquires more sophisticated skills, his or her salary rises sufficiently to distinguish experienced teachers from beginners. In the skilled trades, an apprentice's salary typically rises in the final year of training to between 90 and 100 percent of that of a journeyman, as is the case with both the Central Indiana Carpenters Joint Apprenticeship Training Committee in Indianapolis, which operates on behalf of several locals, and the apprentice program of UA Local #136 Plumbers and Pipefitters in Bloomington, Indiana.

Central Indiana Carpenters	**UA Local #136 Plumbers**
Year 1: 45% (of $19.70/hr=$8.86) 55% (after six months)	40% ($21.68/hour=$8.67)
Year 2: 65%	50%
Year 3: 75%	60%
Year 4: 85%	75%
Year 5: 100%	90%
Journeyman ($19.70/hr)	**Journeyman** ($21.68/hr)

In addition, the pension contributions and insurance coverages of participants in these programs closely parallel those of journeymen. As in most

unions, all members of UA #136 in 1997 paid monthly dues of $16 and a 3 percent work assessment (for first-year apprentices working the expected 2,000 hours, this comes to approximately $520.20). Many unions also deduct a nominal amount from an apprentice's paycheck to pay for the instructional program (22 cents/hour in the carpenters' program outlined above, for instance).[11]

By contrast, the salaries of most graduate student teachers increase very little during the years they spend as TAs, often less than $1,000 from first year to last, a disturbing trend which further corroborates the premise of the Ohio State Graduate *Handbook*: what graduate students learn as teachers only supplements their formal instruction. And clearly the learning curve diminishes as a graduate student teaches the same small cadre of courses for the fourth or fifth time. Yet, again, at many institutions very minimal increases in salary distinguish a TA on his or her first day in the classroom from one walking in as many as four or five *years* later. In 1997, at the University of Tennessee-Knoxville, for example, graduate students in several humanities departments received more or less the *same* salary regardless of teaching experience; the most advanced graduate students in English at Indiana earned about $900/year more than a beginner; and at the University of Florida, senior graduate employees in English received about $300/course more than their newest colleagues (this varies by department and is based on .50FTE). If students really learned their crafts incrementally over a period of time—as apprentices in the skilled trades do—then it would seem to follow that their salaries would increase *significantly* as they refined the skills necessary to teach independently. This generally isn't the case.

A more problematic analogy exists between graduate student employment and apprenticeship in terms of the period of time one occupies such a status. That is to say, apprenticeships in the trades are carefully defined, measured either in years or hours of paid "on the job training."[12] As Cynthia Young discusses, Yale attempted in 1989–90 to shorten the time needed to complete a Ph.D. by restructuring its financial support and sharply delimiting the period of funding. Things apparently didn't work out so well. Known locally as the Kagan-Pollitt plan, dissertation fellowships, in themselves desirable funding instruments, were made more widely available at the same time that a six-year rule was enforced, i.e., no support after the sixth year. In Young's view, the plan might have indeed sped up Ph.D. production, but it did not "facilitate doctoral work" because these fellowships came at the expense of the teaching budget and TAs lost their jobs (181).

This problem is not unique to New Haven, for as the National Research Council's *Research-Doctorate Programs in the United States: Continuity and Change* (1995) makes abundantly clear, virtually no program in the humanities graduates *even half* of its students in less than seven years. In English, only Princeton has a figure of less than seven years in the statistic "median years to degree": half of Princeton's Ph.D.'s graduate in less than 6.8 years, half take longer. Yale is 7.6 years, California-Berkeley 10.1 years, the University of Chicago 12.1 years, and so on. Graduate students in such fields as German and comparative literature generally take even longer.[13] This is not to suggest that students cannot graduate in, say, six years; of course, many do. But a huge number—nationally, far more than half—do not, which begs the larger question of what rate of production should obtain in the present job crisis.

Obviously, this topic becomes much more pressing when the supply of jobs is consistent, one reason why time to degree was so important to William G. Bowen and Neil L. Rudenstine's *In Pursuit of the Ph.D.* (1992), which begins with the assumption that colleges and universities will experience "severe staffing problems by the end the 1990s" (2). By "staffing problems," Bowen and Rudenstine clearly meant difficulties finding qualified doctoral holders in the humanities, business, and physical and social sciences to fill tenure-track positions vacated by an aging professoriate and necessitated by a larger body of incoming freshmen. But even starting from this wildly inaccurate prediction, Bowen and Rudenstine reject what they term the "British model" of a "term-limit" degree, which unrealistic funding programs implement in de facto fashion, as an unattractive alternative that should not be considered unless all "other efforts to improve outcomes" (that is, get students through doctoral programs more expeditiously) "fail" (288). Have such efforts failed? And have we reached a point where Brooks's idea of a more "leisurely apprenticeship" lasting, say, ten–fifteen years is the best solution to all of these problems?

To return to an earlier point, the job "market" and the ratio of journeymen to apprentices also wrench the metaphor completely out of the orbit of rationality. Given not just a disastrous job market but Yale's unremarkable placement rate as alluded to above, it is hardly surprising that high on the list of strikers' "demands" was more formalized "teacher training." (One should always approach placement statistics with caution, as too often the figures compiled tell only part of a story: How many job seekers participated fully in the process? Did students accept all the jobs they were offered? What jobs "counted" *as jobs* in the first place?). But assuming that graduate student demands for teacher training reflect, at

least in part, a sense that low placement rates are related to inadequate teaching experience and preparation, a curious irony emerges: while universities rationalize low wages by underscoring the vocational training graduate students receive, many of these same graduate students recognize that they really don't receive adequate preparation as future teachers. The quality of teacher training varies from school to school: in English departments, typically, this ranges from the one-week orientation/department picnic or cocktail hours held just before classes begin to semester-long "proseminars" in the teaching of writing or literature. Many programs employ experienced graduate students as consultants to advise their younger colleagues. By contrast, as I have indicated above, labor unions provide highly structured learning programs, something made possible by the comparatively large number of journeymen to apprentices. That is to say, on most union sites the number of journeymen far exceeds the number of apprentices, because a homeowner, for example, won't buy a house built, plumbed, or wired by beginners. By comparison to plumbing or electrical systems, college degrees are simpler contraptions.

In addition to all the reasons outlined above, the inherent inadequacy of the metaphor of apprenticeship typically emerges in the slippages in administrative discourse whenever the topic of graduate student teaching is concerned. So, in a 20 February 1996 letter to my colleague Milton Fisk, responding to protests over Yale's handling of the strike, Richard Levin remarks:

> We regard the withholding of grades, however motivated, as an inappropriate action *for a teacher.* When one person takes on the power to evaluate another person's work, he or she takes on the responsibility to judge the performance fairly, objectively, and in a timely manner, and not to let external considerations interfere with the evaluation process. *That one group of students chose to penalize another group of students in furtherance of its own aims lent additional inappropriateness to this action* [our emphasis].

Bracketing for the moment the ethical issue of some Yale faculty's referring to the strike in letters of recommendation—participating in a strike is somehow intrinsic to academic "performance" and thus part of a "fairly" and "objectively" delineated evaluation?—the strategy of this rejoinder seems clear: graduate students are teachers when the administration wants them to be and students when it is more convenient to regard them as such. Hence, the "penalizing" of undergraduates, in Levin's

rhetoric, was all the more egregious because it was administered by fellow "students."

Graduate student employees clearly are *not* apprentices. And when they teach independently for the umpteenth time, they are no longer acting as students either, regardless of what President Levin and Dean Appelquist continue to argue. For as flawed as the metaphor of apprenticeship is—and as potent as the mythology of professional advancement in the academy remains—the notion of "appropriate supervision" of veteran graduate student teachers, one of several linchpins in Appelquist's thesis that "graduate students are not employees," is equally fallacious. Anyone who has ever taught for several years at a university *knows* what sort of supervision experienced graduate student teachers receive: little from a director of freshman composition or none at all. Indeed, such experienced classroom teachers generally *provide* supervision themselves to new teaching assistants.

Most obvious in comparison with the apprenticeship programs in the skilled trades, universities do not compensate graduate students as if they were indeed involved in an ongoing training *necessary* for independent teaching, and in some cases they do not even encourage students to regard teaching as sufficiently valuable to constitute the focus of their endeavors. So what are they? And what are the institutions at which they labor, literally and metaphorically, remembering that we "live by" the latter as much as we inhabit or live in the former? As higher education moves into the next century and a more precarious future, as families borrow more to educate their sons and daughters who, increasingly, are being taught by "apprentices" and adjunct or "non-tenure-eligible faculty," thoughtful answers to both of these questions will become increasingly imperative.

SW

Attrition Rates (ə·trishən ˈrātz) Undergraduates' rates of early departure and reasons for finishing school without completing their degrees are studied fairly aggressively. As might be expected, these rates have gone up since the dramatic postwar expansion of higher education and the shift from a minority to a majority of high school graduates going on to college. Administrators are even hired to focus exclusively on undergraduate attrition. The same emphasis has not been placed on graduate student departure from doctoral programs.

There are a number of reasons for this. First of all, it's much less of a

public relations problem. The number of students in graduate programs is usually much smaller. Parents are no longer so directly and emotionally involved. Legislators are less interested. It's also less of a campus-wide issue; undergraduates take courses from multiple departments and programs. It is always possible that campus-wide actions could affect the patterns of attrition. Campus policies on minority advising, for example, could have an impact on many departments. Graduate students, conversely, take all or most of their courses from one department. The culture of the department defines the world of graduate study. Problems and solutions, therefore, are more likely to be departmental.

Surprisingly enough, the percentage of graduate students leaving without completing their Ph.D.'s has remained fairly stable for many years. That percentage is also rather high, about 50 percent. Although that alone should have been cause for concern, it has generally not been. The most common assumption is that graduate students leave because they cannot make the grade; it's their fault. We now have enough research results to know that is probably not the case.

A soldier who stepped out onto the blood-soaked land between enemy trenches in World War I had a good chance of being killed or wounded. Survival rates in some graduate programs are not much better. That's the crux of the issue: it's not the national attrition rates that tell us what we need to know, it's the departure rates in individual departments. A national average is made up of figures from many different departments in many different schools. Graduate colleges sometimes keep overall figures for their institutions. Departments often do not. What is astonishing is how differently departments succeed at keeping their students until they complete their degrees. That 50 percent national average is actually made up of departments that routinely lose 35 percent of their students, year after year, and departments that routinely lose 75 percent, year after year.

Some departments waste students casually, employing practices or creating working environments that lead most students to abandon their graduate studies. Other departments do things that lead their students to want to stay and complete their degrees. In departments with competitive admissions, those who admit fewer than a third of all applicants, retention has little to do with the students themselves, all of whom seem well qualified. It is the departments and the supportive or destructive environments they create that make the difference.

Among the practices that help students become integrated into the life of the department and increase the probability of success, Barbara Lovitts has found, are these: providing detailed orientation sessions covering

degree requirements and program aims and structures; giving all graduate students office space, thereby maximizing their access to informal informational networks; giving students experience as teachers or research assistants.[1] Some graduate students benefited from prior socialization to the graduate student experience while they were still undergrads. On the other hand, undergraduate involvement with faculty members' professional lives sometimes led to early departure from indifferent graduate schools that offered no comparable experiences. Graduate students who leave often report a poor understanding of the structure and process of graduate education and a lack of interest and involvement from their faculty advisors.

Perhaps surprisingly, Lovitts found that students receiving full fellowships with no built-in responsibilities or socializing commitments had a *higher* rate of departure than those receiving research or teaching assignments. This suggests that fellowship students might well be required to teach one course a year; it draws them into department life and its informal learning networks. Her findings do not, of course, justify the excessive teaching graduate students in some departments must do if they are to have money to live on, but they do demonstrate the benefits from limited teaching. The comparable sense of belonging to a professional community created in science labs also helps explain why those departments often have low attrition rates.

As part of her dissertation research, Lovitts studied two universities in detail, one a large and prestigious private urban university, the other a distinguished rural public one. She promised confidentiality to gain detailed information about student enrollment and departure, including the name and history of each student enrolling over a period of time. She picked a cohort of students entering doctoral programs from 1982 to 1984, thereby maximizing the possible degree completion rates and allowing analysis of long-term effects of departure from graduate school. The attrition rates in the same fields for these two representative schools reveal the astonishing differences in their success rates:

Univ.	Total	Math	Chem	Bio	Econ	Soc	Psyc	Hist	Engl	Music
Rural	33	32	19	39	22	28	41	30	34	44
Urban	68	47	42	65	82	72	23	61	76	65

A few caveats about these figures are appropriate. First, Lovitts attempted to eliminate international students from her study, since their reasons for leaving or staying are sometimes quite different and follow-up

interviews would have been difficult to conduct. Second, these represent a specific cohort, students entering in 1982–84; some of these departments may have reformed themselves since, though our follow-up interviews suggest others have not done so. Third, although all these students entered their respective programs hoping to complete a Ph.D., some were forced out by various hurdles placed in their paths, such as qualifying exams or departmental review boards. These procedures often test for conformity rather than quality. A feminist student at urban university who receives one low grade from an antifeminist professor may be thrown out of the program. With these warnings in mind, the figures can give an accurate general picture of the problems and variations in graduate attrition.

The overall attrition rate for the urban university is twice the attrition rate for the rural one. Lovitts's survey results, encompassing data from 816 students who returned her questionnaire, and her follow-up interviews with a sample of people who did and did not complete their degrees at these schools, give us an unusually sound basis for deciding why students do or do not succeed in doctoral programs. Her survey confirms that the urban university has an overall climate that does not value graduate students highly and makes little effort to socialize them and integrate them into the department community. Yet a department like psychology is able to reverse the school's dominant culture; the urban university's retention rate in psychology is much better than the rural one's.

At the top of the heap for creating brutal, alienating social and intellectual environments are the departments of economics, English, and sociology at the urban school, which dispose, respectively, of 82 percent, 76 percent, and 72 percent of their students. Known as some of the top departments in the country, they continue to attract students despite the fact that few of them ever graduate with Ph.D.'s. Needless to say, these programs do not publish their attrition rates. If they did, many undergraduate advisors would tell their students to go elsewhere. We do not believe anyone could in good conscience recommend that a student enroll in a program in which 82 percent of the students fail to complete the degree. The urban university's tuition is not low and some of its graduate students take on quite considerable debt. Many of them do so for no long-term benefits whatsoever. Obviously professional organizations should not only recommend but also do everything to compel departments to publish their attrition rates. That is information people applying for admission very much need to have.

Departments with high attrition rates typically adopt a sink-or-swim

mentality, leaving graduate students to their own devices. The students may drift through an incoherent sequence of courses with no real idea how they relate to one another or lead to a basic knowledge of the field. The limited social life in such departments tends to isolate students from one another and from the faculty. There may be little sense of community. Just as nothing integrates graduate students into an intellectual subculture, so nothing facilitates social integration. From regular colloquia to brown bag lunch discussions to departmental parties, scheduled opportunities for interaction are wanting.

This sort of dysfunctional departmental culture does little to lead a graduate student to internalize the values and norms of the discipline. Disconnected, disengaged, and often heavily in debt, graduate students in such an indifferent environment may depart in large numbers. If, as with Lovitts's urban university, the school is prestigious, the faculty and administration may neither know nor care. Most graduate students depart silently, never communicating their reasons. Meanwhile, the admissions process is already geared up to replace them.

Faculty arrogance about the elite status of the program may reinforce a tendency to ignore graduate students or do little to help them. The more highly a greedy department thinks of itself, moreover, the easier it is to extract uncompensated or undercompensated labor from graduate students. Exaggerated notions of the program's benefits to students—and misconceptions of how lucky and privileged the students are to be there—will also enhance the program's cruelty. With pride in "excellence" comes inhumanity. Who needs to help "the blessed of the earth," to invoke Peter Brooks's now infamous characterization of Yale graduate students? We're so good, they're so good, that they need nothing from us.

Both anecdotal evidence from other faculty and our experience in our own departments suggest that the mid-1990s brought with them higher attrition rates among students early on in graduate study. We now see more people bailing out before finishing their master's degrees, more people completing an M.A. or M.S. and then quitting the program, and more people hanging around for a semester or a year after the master's degree and then calling it quits. The news about the disastrous academic job market is clearly penetrating graduate student culture and leading people to reevaluate their plans. This new pattern of departure may give faculty members yet one more reason to ignore the long-term and still powerfully causative reasons for attrition. The job crisis is a good external enemy on which to blame unacceptable levels of graduate student attrition, but the primary responsibility is ours.

The combined effect of the collapse of career prospects in higher education and the punishing cultural atmosphere of some graduate departments may push the overall national attrition rate to over the 50 percent figure that Benkin, Berelson, Bowen and Rudenstine, Tucker, and the National Research Council, among others, cite. Even without that increase, the news about the academic job crisis puts programs that receive greater public scrutiny in danger. Our continuing state of denial about why graduate students fail to finish their doctoral degrees leaves us wholly unprepared to understand the problem, let alone try to deal with it.

We have tended to blame the victim, assuming that the least-qualified students leave and the better students stay. There's no evidence that has ever been the case. In response to a false explanation of the problem, we then tinker with the admissions process, looking for better ways to predict success. Of course many departments make no effort to compile attrition statistics; indeed, graduate students who leave after course work is completed and their work with a doctoral committee flounders are often able to leave almost invisibly. For too long, academic departments have failed to look at themselves, at how they treat their graduate students, at the practices they do or do not put in place to encourage degree completion.

CN

C

Cafeterias (ˌkafəˈtirēəz) "What?" you ask. "What's to know about cafeterias?" Well, for one thing that food court in the student union building didn't use to be there. All those bright lights reflected in fresh grease stamped "McDonald's" or "Pizza Hut" were put up only a few years ago. Those minimum-wage workers behind the counter who come and go only came on the scene a few years ago, too.

There used to be a kitchen in its place, and workers who were hired by the university, not by independent contractors or multinational corporations. They spent their working lives in the cafeteria. Their salaries gradually increased, they had health care coverage, and they earned retirement benefits. Some of them bought cars, even small houses; they raised families. If you hung around campus long enough yourself, you might have come to recognize their faces, and now and again some of you may have greeted a familiar face behind the cafeteria line. Or maybe you were that familiar face.

These nearly forgotten university employees have been replaced through outsourcing; their jobs have been redefined and are now filled by minimum-wage employees hired by a firm under contract to the university. There's a cheerful magazine called *Business Manager* that shares these ideas for outsourcing. There are no copies of *Business Manager* in the lounge of the classics department, but it might be instructive if there were. Outsourcing saves money; real jobs are eliminated and full-time, permanent workers replaced with interchangeable, underpaid, often part-time temporary employees.

That cafeteria once had a person called a "chef" and a "dietician" who actually planned meals and may even have taken some pride in their work. At Indiana University one such employee, now gone, regularly brought in flowers from her garden and put them on all the tables. These people were in a very real sense part of the university community. Not so

the disposable corporate employee in the food court. Yes, we know one booth offers "healthy vegetarian wraps," but you didn't have to fire twenty cafeteria workers to produce that culinary and linguistic miracle.

Yale University, never loath to break bitter ground in labor relations, prefers more direct means of saving money in its food lines. Their innovations have been many, including cafeteria downsizing by job retitling. A chef becomes a cook, a cook becomes a food handler, and so forth. Responsibilities and the capacity for independent action are reduced at the same time as salaries are reduced. Yale closed one of its cafeterias so that, say, sixty workers were competing for perhaps forty remaining jobs. As if that were not enough to break morale, Yale in the 1990s tried to take away cafeteria workers' rights to alternative summer employment on campus, thereby turning cafeteria work into seasonal employment without benefits. The full story of Yale's multiyear project of crushing its cafeteria workers would require a separate entry, though one gets the impression they must have an administrator on the job full-time.

Now you may say that this does not have much to do with you. Yet when your university proudly announces *it* employs no minimum-wage workers, it is lying in your name. You cannot right all wrongs; you always brown-bag your lunch anyway. Hold your breath. Soon enough you'll pass a student on the way into the English building. "On your way to class?" you offer casually. "No," she replies, "I'm going to the Disney booth to pick up my composition paper." The annual prize for the best student essay is a trip to you know where. No, that's a cheap shot. Forget we said it.

It all started in the food court. Think of the cafeteria as the Stonehenge relic for the university of the new millennium. Welcome to the corporate university.

By the way, the Disney booth is manned by an English Ph.D. who earns $5.15 an hour.

See *the corporate university, outsourcing.*

Company Towns (ˈkəmp(ə)nē ˈtaŭnz) In an earlier essay in this
volume, we questioned the aptness of "apprenticeship" as a characterization of the training graduate students receive while teaching for the universities at which they are pursuing their degrees. Quite obviously, life is lived not only by way of such dilapidated metaphors as apprenticeship but also in the apartments, dormitories, and houses of college towns and big cities. And while universities in Boston, New York, and other major metropolitan areas might seem ill described by the metaphor of company

towns, we wondered while talking to graduate students across the country how persuasive the analogy might be in describing the corporate university. And we're not talking about the postmodern version of a company town, a "gated monocultural enclave" behind gates and guards like the Disney Company's settlement in Celebration, Florida, with its estate homes, architectural uniformity, and street names coming not from history or nature (Elm, Maple) but from Disney's creative "imagineering": a mythology that aids in ensuring design consistency for the houses lining Teal Avenue and Veranda Place (Rymer 69–70). Given the economic realities of graduate employees at the corporate university (see *debt*), "company town" retains both more traditional and insidious connotations.

In the law, in such cases as the *Illinois Migrant Council v. Campbell Soup Company* (1977), a "company town" is defined as a "community organized on private property by a private enterprise and so used that it becomes the functional equivalent of a municipality"; thus, "when a 'company town' exists, infringement of First Amendment Rights by those who administer town functions constitutes 'state action'" (438 *Federal Supplement,* 1977: 222). In this particular case, agents and employees of the Illinois Migrant Council, a nonprofit corporation funded in part by the federal government and devoted largely to adult education, especially English language instruction, and health services, were denied access to a community owned by the Campbell's Soup Company and filed a petition for relief. Universities aren't all privately owned, of course, nor do they necessarily form the "functional equivalent" of municipalities. But like company towns, today's agricultural ones and yesterday's coal mining communities, they provide workers not merely with employment but with many of the necessities of everyday life. Mushroom pickers at Campbell's Prince Crossing Farm near West Chicago are provided with "houses in which to live, a store from which they purchase company products, a cafeteria [that serves three meals a day if desired], and a recreational area within a multi-use building" (*Federal Supplement* 226). Most universities provide these amenities as well, to undergraduate students and graduate student employees. Yet unlike other kinds of employment, that in company towns—and many universities—brings everyday or private life squarely within the ambit of the employer; unlike most other kinds of employment, that in company towns—and universities— entails both compensation for labor performed and *repayment* to the employer for services provided.

For our purposes here, the quality of services employers like Campbell's Soup Company and American universities afford their employees is

not at issue; the amount of repayment required of student employees—
and coal miners and field workers—is. For what has changed since I
began graduate school in the early 1970s is that universities, like the one-
company mining towns and the produce industry that often exploit their
labor force, *knowingly* compensate graduate employees at a level inade-
quate for many to live on without slipping into debt. For this reason, the
metaphor of the company town and its infamous "company store" as
described by John Mellor in his study of Cape Breton coal miners earlier
in the century might be more accurate than comparisons of graduate
employees and apprentices. Consider the similarity of economies:

> At the end of every week, [miners] received their pitifully small wages
> along with an account known as a "Bob-tailed Sheet," which showed the
> total amount of deductions for rent, coal, light, water, doctor, hospital,
> church, blasting powder, and company store purchases of food and dry
> goods. More often than not, they were left with little or no wages after
> deductions, especially when employed on short time with only two or
> three days' work each week [15].

Central to this economy and the miners' lives was the company store,
which, while often providing quality goods and open lines of credit, led
miners into debt that effectively bound them to the company, at times for
life. As Mellor explains, miners who organized to protest these condi-
tions were fired and, at times, blacklisted to ensure that they would never
cause trouble again. This generation of graduate students understands
these economic and institutional realities all too well; they know what a
"Bob-tailed sheet" looks like.

Because the salaries of graduate employees have not kept pace with
inflation, it is now almost impossible for many student-employees to
begin graduate school the way I did in the early 1970s. To anyone familiar
with the recent congressional debates over raising the minimum wage
from $4.25 to $5.15/hour, my hypothesis will be totally unsurprising:
before the raising of the minimum wage, the yearly salary of $8,500/
year, a figure comparable to what many graduate students earn, was at a
forty-year low when adjusted for inflation. In 1973, a minimum-wage-
earner's salary of under $2/hour was worth almost $6 when adjusted for
inflation, or nearly 50 percent more than workers in the early and mid-
nineties made.[1] Hence, the tuition scholarship and $278 I brought home
each month for teaching two courses a semester, too much teaching for a
brand new M.A. student, paid for all of my living expenses—such as
they were. Lacking both a car and any semblance of cooking skills, I

needed to live on campus, so I moved into a single, cinder-blocked, ten-by-fourteen-foot dormitory room with all meals provided at a nearby cafeteria. In those days, needless to say, personal computers didn't exist (an old manual typewriter and a gallon of liquid paper were the requisite technology), I didn't own a television, and new graduate students felt no pressure to invest money in attending conferences halfway across the country (which I did in later years). A room, shower down the hall, television lounge, and cafeteria—these were all I needed, and $278 easily paid for them. This stipend left enough to buy books or the occasional pair of jeans, to go to the theatre and cinema, and to phone home on Sundays (calling collect most of the time). The salaries teaching assistants made then might not have afforded them a lavish lifestyle, but neither in most cases did it necessitate their borrowing much money.

Most students during the 1995–96 academic year (and today) could not lead this "life of Riley"—living in a tiny dorm room, eating at the cafeteria, and riding their bicycles whenever they needed transportation—without borrowing or bringing money with them into graduate school. Graduate students in English at Indiana in 1995–96, for example, earned approximately $875/month (ten-month contract), netting $750 after federal and state taxes are deducted. To live in a single dormitory room like the one I occupied, students paid between $3,005 and $3,481 for the school year and between $1,728 and $2,344 for meals (depending on type of plan). Taking figures for the cheapest room and best meal package (nineteen meals/week), my choices in the 1970s, a student's expense for the 1995–96 academic year was $5,349, leaving about $2,100 from the stipend for expenses. And these began right at registration. A graduate student employee at .50 FTE receives a tuition scholarship worth thirty hours/year, but must pay $18.66 in fees for each hour taken. If a student took full advantage of the tuition scholarship, then, carrying twelve hours per semester and six research hours or additional coursework in the summer, the cost would be $559.80. In 1996, that left a graduate student employee around $1,500 for the rest of the year. Then there were and still are technology fees, student activity fees, student health fees, and so on, not to mention transportation, telephone, books, clothing, computer costs, and the enormous cost of merely looking for a job for those who survive this process. And this list doesn't even include the big-ticket item on many graduate employees' budgets: health insurance. All of these expenses leave many of today's graduate student-employees at the end of the month in the same predicament as the hard-working miners Mellor chronicles in his history: in the hole and digging deeper (see **debt**).

Like the owners of company towns, universities already know before a graduate student signs on the dotted line that such stipends are inadequate. The Indiana University Office of Student Financial Assistance estimated that for 1995–96 a graduate student living on campus needed at least $9,052; off campus, the figure rises slightly to $9,292. Yet most stipends in the humanities fell short of both figures. As reported in the *New York Times* (17 January 1996), Yale administrators like Thomas Appelquist acknowledge that although the school provides "enormous amounts of financial aid . . . it should not be expected, and it was never promised, that we will cover all costs." In the same article, the shortfall between stipend and cost of living is calculated at some $3,000–$4,000, so the $2,000 raise requested by Yale's GESO members during the 1995–96 grade strike seems almost modest given the university's—or, rather, Yale Corporation's, as it is referred to in such articles—own analysis. Why would universities purposefully pay graduate student employees less than a living wage? For the same reason, perhaps, that, in her 1996 letter to the MLA protesting the proposed censure of the university, Yale professor Annabel Patterson objected to the term "living wage" in the first place: because the university/corporation provides significant fellowship support to its students, they really "perform no service" at such times and thus aren't working in the first place. Fellowships, though, aren't awarded out of the goodness of a university's corporate heart, and it is disingenuous in the extreme to suggest otherwise. Fellowships serve graduate programs as recruitment tools, pure and simple, as Patterson implies when acknowledging that not all students receive them because of the keen "competition for entrance." During the fifth year of many humanities programs, she notes, for those not on dissertation fellowships the "privilege" of teaching two courses during the year is "extended." No one could deny that Yale's fellowship support is impressive, yet the dean of the Graduate School does not deny that the funding is insufficient to live on. It is precisely for this reason that the GESO grade strike at Yale was so important, for it showed with unusual clarity the harsh economic realities of graduate students enrolled in one of the nation's best-supported, most prestigious institutions. Given more time than many graduate employees to conduct their research and pursue their intellectual projects, they are also afforded the "privilege" of substandard wages and taking additional loans, just like everyone else.

And then there's the matter of insurance which, according to Patterson costs students $696/year (Yale graduate students put the figure somewhat higher). As is the case at many universities, students at Yale foot

this bill for health insurance, and this includes the $1,800/year stipend a student with a dependent must pay. In the last half-dozen years or so, affordable, high-quality health insurance has been perhaps *the* most consistently sought goal of labor actions and graduate student organizations across the country. At UCLA, for example, graduate students have won an institutional payment of an approximately $159/quarter insurance premium as a result of a strike at California–Berkeley in 1989. At the University of Iowa, where graduate student employees organized as COGS (Committee to Organize Graduate Students) with the assistance of Local #896 United Electrical Workers, improved health and child care are among the top priorities.

And, of course, California, Iowa, and Yale are not exceptional cases in this regard; graduate student employees across the country want pretty much what a largely Chicana work force wanted in 1986 and 1987 during the Watsonville, California, produce workers' strike: to "know that they can take their children to the doctor when necessary" (*San Francisco Examiner,* 7 June 1987; quoted in Castillo 56). We don't offer this analogy frivolously, and indeed are not the first to compare graduate student employees or part-timers with workers in America's fruit and vegetable fields. Before 1980, graduate research and teaching assistants in the state of Florida, along with federal/state fruit and vegetable inspectors, were specifically exempted from the definition of "public employee" (section 447.203, Florida Statutes). In June of 1980, graduate student employees gained the status of bargaining unit represented by the UFF (United Faculty of Florida). Even so, in 1996 a single student in the humanities paid a premium of $507/year for health insurance; a graduate employee with a dependent paid $1,242/year, all of this on a stipend of between $8,800 and $10,000. And one might say that collective bargaining in Florida still has a ways to go, as graduate students in English routinely earn their salaries by teaching three courses during the academic year and one during a six-week summer term.

But for now, anyway, and however imperfect, collective bargaining and graduate student insistence upon the term "employee," not apprentice, seem far better than silence or passive endurance. In October of 1994, graduate student employees at the University of Kansas with the assistance of the Kansas Association of Public Employees won the title "public employee," and perhaps with it the possibility of securing something better than a benefits package that at that time contained no health insurance of any kind (although at the time this book went to press the struggles for graduate student employees in Kansas continued). Graduate student

employees at the University of Tennessee similarly receive no health insurance coverage, even though many of them teach the same teaching load as faculty. In April of 1996, nearly 1,000 teaching assistants at the University of Michigan participated in a two-day boycott of classes, and subsequently the university announced it would raise TA salaries over the next three years by the same percentage as the average faculty salary raise in the College of Arts and Sciences. From any perspective, these are modest gains. But in today's company towns or, rather, corporations of higher learning, modest gains like the ability to take children to the doctor when they are ill—or the possibility of having a little something left of a salary after the Bob-tailed Sheet is presented at the end of the month—are worth fighting for.

<div align="right">

SW

</div>

See *the corporate university.*

The Corporate University (thə ˈkȯrp(ə)rət ˌyünəˈvərsəd·e) The
current fear that universities are coming to resemble corporations has roots that go back several decades. Hand in hand with the dramatic postwar expansion of higher education—not only in the number of colleges founded but also in the size of many public universities—went a significant rise in paperwork, administrative oversight, and bureaucratic impersonality. The organizational intimacy of a small college gave way to the administrative complexity of managing 30,000 or 50,000 students and thousands of faculty and staff. Universities began to feel like government agencies. There were some compensatory moves, to be sure, including decentralization in major areas of department life, but the flow of reports, requests, and directives still saturated academic life with bureaucratic effects.

Research universities were also becoming steadily more entangled with and dependent on the federal government. The cold war inflated Defense Department budgets, and Defense Department planners turned to faculty members to carry out an expanding program of research. Contracts were signed with the Pentagon, various units of the armed services, and with the Central Intelligence Agency. There might be a demonic bottom line, but often it was at some remove. Notoriously, the Navy reportedly funded research in dolphin intelligence and communication in part because it wanted eventually to see if these bright mammals could deliver an explosive charge to an enemy ship. The CIA funded research on AIDS epidemic modeling in Africa, in part to see if governments might be destabilized and if opportunities for intervention would arise.

Yet often enough a faculty member could ignore an agency's darker purposes. Government-sponsored research was a model of how to purchase faculty time and energy in a package designed to take advantage of faculty skill at rationalization. One of us can still vividly remember a Defense Department–funded political scientist in the mid-1980s gushing about what an open-minded, even visionary sponsor the Pentagon was. "They're not just financing weapons development. They're interested in long-term basic research. These are imaginative people." Indeed, and nothing like swarms of research assistants, rooms full of equipment, and a full one-third annual salary supplement to instill belief in military idealism.

There were moments of resistance—such as the heroic and successful effort spear-headed by physicists to discredit "star wars" research—but mostly the trends went the other way. Although many government agencies sponsored excellent independent research, the military-industrial complex that Eisenhower warned us about in the late 1950s within a few years encompassed part of higher education as well. Not long after that, campuses erupted in protests against the Vietnam War. By the late 1960s university participation in the research and development of the modern war machine lost all consensual grounds for rationalization. An unjust, undeclared, and pointlessly deadly war made campus military research and academic involvement with the defense industry morally abhorrent. When the makers of Napalm arrived on campus to recruit new graduates, the red carpets were occupied with protestors. Yet when the war finally ended, many government/corporate/campus links were still in place.

The 1970s saw further increases in government grants and in the federal regulation of higher education. Accounting for federal funds and justifying indirect costs meant more campus surveillance of budgets, more reporting to administrators. But in the next decade the funding balance would begin to shift to industry. Corporations in the Reagan years began to purchase faculty research time, and Reagan-era legislation facilitated corporate/university partnerships. It was often cheaper for a corporation to buy faculty time than to hire staff and operate a lab on its own. What's more, university research added an air of prestige and objectivity to corporate projects. By the early 1980s reporters were starting to write stories about the buying and selling of higher education in corporate boardrooms.

As early as 1982, historian David Noble could write in the *Nation* that "the control over science by scientists—the hallmark of the postwar pattern—is increasingly becoming the control over science by the science-based corporations that scientists serve and sometimes own or direct" (3). Six years later, in *The New Politics of Science,* David Dickson noted a

still more fundamental ideological shift, arguing a new understanding of scientists' fundamental social responsibility: "the need to help private corporations achieve their economic and political objectives" (104). As Cheryl B. Leggon argues, "since the mid-1980s pressure has increased in Congress to shift national attention away from basic science and toward science with technological applications able to bolster declining American economic competitiveness" (223).

These may seem like exaggerated claims to some, particularly to scientists who prefer their prestige untarnished, especially since serious resistance to corporate ideology is still widespread in higher education. Numerous small colleges remain devoted to traditional liberal arts disciplines more concerned with knowledge and understanding than profit. Thousands of research scientists continue to investigate basic principles of life, matter, and energy with no easily imaginable short-term payoff. And even though the occasional administrator or engineering professor in a competitive research university may think the philosophy department is expendable, few institutions are ready to eliminate central humanities disciplines on behalf of instrumental instruction.

Yet this attenuated optimism neglects the combined effects of all the trends we have noted. Further, if the actual coordinated corporate purchase of whole institutions remains extremely rare, the effective purchase of individual labs or even entire departments' research functions has become common. Some labs as a result have become simple extensions of corporations. In other cases, whole departments have much of their research agenda set by one or more corporations. When the profit available from contract research becomes a department's main priority, then prestige and rewards flow to the department members bringing in the money. As institutions become more broadly addicted to the corporate profit pipeline, their whole raison d'être begins to shift. Profit-making departments become the first priority for institutional resources, and the profit-making function within those departments begins to dominate their other activities, from student recruitment to faculty hiring to curriculum design. "Excellence," that ambiguous, hyperbolic concept aptly analyzed by Bill Readings, gradually becomes conflated with profitability.

Most faculty in disciplines outside the corporate university loop have no idea what such relationships actually entail, let alone how thoroughly degraded a corporate-owned university program can become. The risks need to be stated with unvarnished clarity, for corporatization at its worst really is the devil's bargain for academia. *Those departments that reach the nadir of corporatization abandon all their intellectual functions.*

A corporatized department can become the academic equivalent of a truck weighing station on an interstate highway. If that seems impossible, let me give the standard pattern. The devil's bargain is struck for many programs when they abandon their program of original research in favor of a corporate-directed plan. Some departments then begin shifting their time and energy away from research entirely. Toward teaching? Toward community outreach? Hardly. They become *product-testing labs*. The most thoroughly degraded corporatized university program is one that no longer does any original thinking; it simply tests products developed elsewhere by the corporation.

There are now entire programs in higher education devoted to product testing. We have difficulty thinking of them as academic units at all, but they have offices, staffs, budgets, resources, and even tenured faculty. Some are called departments. We have some difficulty, for example, thinking of the Psychiatry Department at the University of Cincinnati as an academic unit. Its "research" is primarily drug testing for pharmaceutical companies. Cincinnati does not develop, invent, or discover the drugs. The drug companies do that. The Psychiatry Department just tests them. Yale's Psychiatry Department has now decided it shouldn't miss a good thing; it opened a clinical trials unit in partnership with Scirex late in 1997. Elsewhere across the country there are agriculture programs that concentrate on testing pesticides designed by chemical companies. And so forth. Every faculty member on such campuses should be concerned about the consequences.

When faculty are criticized for doing contract drug testing, they have a stock response: would you rather have the drug companies or universities testing their products? The question is aimed at a self-evident, common-sense answer, based on an assumption about faculty independence, prestige, and integrity. Unfortunately, university researchers are as corruptible as any other human beings. When they are being well paid by the companies whose products they are testing, bias, temptation, or self-deception are endemic. If actual fraud is very rare indeed, shading interpretable results in favor of an employer (and in one's own financial interests) is relatively common, especially in nonmedical research. The companies meanwhile do their best to co-opt these saints of the laboratory, offering stock options, bonuses, and future contracts.

As federal funding for research—with its system of peer reviewing and greater independence—is replaced with corporate funding, the pressure for scholars to turn themselves into company public relations personnel increases. Indeed, it is not just income but job security and advancement

that are at stake. A faculty member's record at obtaining grants or contracts can be a decisive component in a tenure or promotion decision. Keeping Sears or Goodyear or R.J. Reynolds or Smith, Kline, and French happy can make or break your career.

It can also break your budget. At the University of Illinois National Center for Supercomputing Applications, managers seek corporate partners who gain a degree of exclusivity in a particular research area once a joint contract is signed. The corporations have limited horizons and often want to initiate and complete a project in a year or two. The university's horizon is usually much wider; it wants to develop a research area over time by hiring faculty, admitting graduate students, and making a long-term commitment. But the corporations want rapid results. The university wants to keep its business partners happy, so it tries to achieve profitable outcomes quickly. That frequently means hiring new graduate assistants or shifting personnel from elsewhere to respond to changing needs for a rapidly developing project. There never seems to be time to renegotiate the contracts fast enough to have the corporation pick up the new unanticipated expenses. So the university puts its own money into the corporation's research. Of course the university is already paying accountants, managers, secretaries, and contact negotiators out of its own pocket. As it plans new faculty lines, the campus inevitably looks to areas where corporations are interested in funding joint ventures. So when business contacts showed interest in electronic commerce, NCSA approached the College of Commerce to see about hiring new faculty in that area. The university as a result gets to expand its enterprise in certain areas, but not without paying a price. The corporation gets more than it pays for, and the university pays for more than it gets. Sometimes courses in art, music, philosophy, or literature are cannibalized to get money to pay for corporate research.

Yet institutional inducements to take on genuinely profitable contract assignments can be still more powerful, for the amounts of money involved are staggering. That's why Duke University has built a 166,000-square-foot building dedicated to international clinical trials. University medical centers have become increasingly dependent on drug and medical device testing income to run their operations. Columbia University and the New York and Presbyterian Hospital earned over $25 million in 1998 conducting trials. The University of Rochester will probably have topped $20 million; as Blumenstyk and Wheeler report, they aim to please:

> Rochester keeps the priorities of drug companies in mind . . . viewing
> these companies as its own customers. . . . It offers the services of a new,

$140,000 drug-packaging and labeling plant. . . . And, more controversially, it pays an outside, for-profit institutional review board to approve scientists' plans for research . . . the company convenes panels of scientists, ministers, and laymen and pays them a stipend. The panels meet once a day, instead of the once-a-month schedule that is the norm at universities.[1]

As Harvard University's David Blumenthal notes in the same article, "what we're watching is the industrialization of clinical research." The experience of contracting out its services makes it easier for a university to contract *for* its service needs. The focus on profit-making enterprises makes university culture accustomed to keeping its costs as low as possible. Many corporations over the last decade and longer have devoted themselves to paying employees as little as possible. Increasingly, universities follow the same practice in many job categories, including most of their instructional workforce. As Christopher Newfield writes, "financial control tends to view labor as a cost, as a site of potential savings," rather than as a resource to be valued and nurtured. In contract research units that do no original research the emphasis in faculty hiring can shift from seeking people who will make intellectual contributions to looking for people who will serve the product-testing machine. When faculty members from more traditional units review these people for tenure, they are compelled to honor the hiring unit's debased business values. Administrators making campus-wide budget decisions may be tempted to give a high priority to their profitable units. Their "faculty" will receive salary rewards, while those who simply "cost money" may not.

We are faced, then, with several overlapping meanings for the notion of "the corporate university":

1. Universities that perform contract services for corporations

2. Universities that form financial partnerships with corporations

3. Universities that design curricula and degree programs to serve corporate hiring needs

4. Universities that condone corporate influence over curriculum and program development by accepting corporate-funded programs, fellowships, and faculty lines

5. Universities that adopt profit-oriented corporate values

6. Universities that adopt corporate-style management and accounting techniques

7. Universities that effectively sell portions of their enterprise to corporations

8. Universities that sell faculty or staff time to corporations

9. Universities whose faculty members are co-opted by corporations that hire them as high-paid consultants and fund their research

10. Universities that engage corporations to market the products of faculty/staff labor

11. Universities that instill corporate culture in their students and staff

12. Universities whose top level of governance—boards of regents or trustees—is dominated by executive officers of corporations.

The project of both conceptualizing and confronting the corporate university requires addressing all these forms of corporatization. Their penetration of university culture has, of course, been immensely enhanced and intensified by the higher education budget crisis of the last three decades. Although the effects of the crisis have been differential, that is, selective, unequal, and ideologically targeted, the crisis has also transformed university culture as a whole. As Newfield writes, the prolonged crisis has meant that "budgeting becomes *the* fundamental governing principle of the university as a whole . . . finance controls the discussion, decides who is asking for too much, who is unreasonable, and when the discussion is over. . . . Budget crisis becomes budget governance" (49). "From this perspective," he argues, "better means cheaper, growth means restriction, productivity means discipline, knowledge means regulation" (48). Gary Rhoades and Sheila Slaughter describe the consequences: "the discourse of executive administrators in higher education has been marked by a corporate 'language of alterations.' Colleges and universities are (pick your phrase) streamlining, downsizing, repositioning, reengineering, and restructuring. Academic programs are being merged, reduced, and reorganized. Faculty are, depending on one's rhetorical sensibilities, being retrenched, laid off, riffed, or reallocated" (17).

What many faculty do not realize, however, is that the "crisis" has been partly manufactured and certainly magnified by administrative determination to redistribute and reinvest university funds. At the University of Illinois, a vast twenty-year building program for grant- or profit-oriented disciplines has been only partially funded by private donations and capital investment by the state. An additional $10 million has come from selectively decommissioning faculty lines or restricting salary increases. Nor do we mean "building" metaphorically. We have been in the construction business for two decades and have eviscerated the humanities and the arts to fund the start-up and operating costs for new buildings. Aggressive capital initiatives on campus have thus been funded out of the salaries of

less profitable disciplines and by the exploitation of lower-grade workers.

Many other campuses have seen comparable building programs become a priority. And they come with a whole interconnected web of increased costs. When an industrial "partnership" produces a new campus building, or an industrial park springs up nearby—with patent, royalty, and research costs shared and negotiated between the university and industry—consequences ripple through the institution. New categories of administrators and managers emerge to oversee the arrangements. New staff are hired to do the work. And the supposedly consensual basis of the university's mission makes a basic shift without full faculty consultation.

The corporatization of the university has been facilitated by a fundamental shift of power on campus—away from faculty and toward managers and administrators. At the same time as faculty have lost authority over the institution's goals, they have also come to have less and less knowledge of what the institution is actually *doing*. Faculty knowledge of budget issues has always been limited, but an institution devoted primarily to instruction and basic research has a fairly clear shared mission whose budgetary implications are relatively transparent. A corporate university acquires complex financial entanglements about which most faculty know absolutely nothing. As the managers come to know more, they assume they also know what's best.

The institutional "cost" of cutting faculty out of the budgetary loop will only grow. The more financially ignorant faculty are, the less they can intervene intelligently and the more managers will want to keep them uninformed. Through the 1970s faculty ignorance about finances was considered a privilege. Administrators would order the paper clips, and faculty would be protected from the petty distraction of budgeting and accounting. But now finances are reshaping the university's mission, and whole new classes of expenditures have arisen. Financial secrecy in the corporate university eviscerates any notion of shared governance. Meanwhile, the relentless outsourcing, casualizing, temping, and segmenting of campus labor makes the traditional fiction of benign administrative "protection" ludicrously inapplicable. Exploited labor is not protected by its ignorance.

As a first step in shifting the balance of knowledge, faculty at all institutions should insist on making salaries a matter of public record. Most public institutions are required to do so, though summer salaries may remain unpublished. But private universities often maintain almost complete secrecy about compensation. That practice should end. Faculty needs to know not only the salaries paid to faculty and administrators in all

departments, but also the wages paid graduate employees, part-timers, and cafeteria workers. Otherwise they are not only kept blind to the financial consequences of disciplinarity and to the injustice of increasing salary polarization but also kept ignorant of the labor exploitation carried out in their names. The second step would be to introduce open budgeting throughout the institution. It would have to be accompanied by major efforts to educate faculty, but it is the only way to bring meaningful consultation and consensus to corporatization.

Merely asking for open budgeting will not, of course, produce it. In the corporate university it is especially important that faculty develop their own independent sources of knowledge and structures for influence. A faculty senate too often has input without impact. Unions traditionally hire someone to do their "corporate research," to gather information about corporate finances, investments, budgets, and decision making. Whether unionized or not, faculty and graduate students need someone doing their corporate research as well. Faculty at public institutions should also hire their own lobbyist to represent their interests to the legislature and coordinate faculty/legislative interactions. A lobbyist at the state capitol often has several clients, so the cost is not prohibitive. Even faculties without collective bargaining can form organizations to research institutional finances and lobby.

The results of open budgeting can be surprising. Indeed, the knowledge and insight obtained that way is the one great benefit of the spread of the accounting mentality. Perhaps the greatest revelation is that the purportedly profit-making units may not be turning a profit at all. RCM, or responsibility-centered management, for example, is an accounting and budgeting method with both risks and benefits. It redefines *income* to encompass both grants and tuition income raised by the number of students enrolled in courses. At Illinois, as a report presented to the Faculty Senate demonstrated, a large humanities department like English turns out to run a large profit overall, whereas units like the Colleges of Engineering and Agriculture run at a loss.

Agriculture especially brings in significant grant money but has relatively few students, so it generates little tuition income. Its grant receipts and tuition revenue are not enough to cover faculty/staff salaries. At the University of Illinois, then, the College of Agriculture consequently has to be heavily supported by state appropriations and by tuition income produced by departments like English. Putting both tuition and grants on the table together gives the lie to the prestige of profit. In fact, setting aside costs for building construction and maintenance, as well as contract

services paid for directly by outside businesses, it turns out that less than 5 percent of the cost of teaching and research at the university's College of Liberal Arts and Sciences is supported by state funds, whereas two-thirds of Agriculture's funding comes from the state.

There is a dark side to the profit equation in undergraduate instruction. My own teaching, like that of other senior faculty, loses rather than earns money, because my salary exceeds the revenue generated by the students paying tuition in my classes. Assistant professors turn a slight profit, a few thousand dollars per class, but the big profit margin comes from graduate student and part-time teachers. Subtracting graduate employee wages from tuition revenue, my department earns a profit for the university of about $8,000 for each freshman composition class taught (enrollment: twenty-two students each class) and about $15,000 for each introductory literature or film class taught by a graduate employee (enrollment: thirty-six students for each class). We offer about 150 sections of freshman rhetoric a year and about 100 sections of other introductory courses. So the yearly profit on freshman rhetoric is about $1,200,000, and the profit on introductory courses is about $1,500,000.

Illinois pays English Department graduate student teachers about $3,000 per course. Institutions that pay their graduate teachers less, as many do, or that rely on lower-paid part-timers (often with Ph.D.'s) earn still more. The University of Cincinnati pays its part-time composition teachers roughly $1,400 per course, enrolling twenty-six students in a composition class and forty-five or more students in other introductory courses. The profit is about $15,000 for a composition class and $27,000 for each larger class. There is obviously tremendous institutional incentive to maintain reliance on lower-paid teachers. To be sure, it is not just the finances of individual departments but rather the finances of the whole university and finally the entire higher education system that are grounded in labor exploitation.

Factoring in overhead does reduce the profit margins but does not eliminate them. The accounting mentality embodied in the corporate university does, however, produce some Kafkaesque moments. The surveiling budgetary gaze seeks to quantify *everything*. So the equation factors in space requirements. My department worries whether our generously wide nineteenth-century hallways will do us in. And debiting departments for space usage adds an incentive to proletarianize adjunct faculty further by crowding them into common offices. How much space does a professor really need? I took an ancient unremodeled office with linoleum scraps on the floor and rusted metal shelves, rather than a spiffy new

office, because the old one gives me more space for my books and papers, but the RCM formula doesn't deduct for shabby decorating and upkeep. So I am an expensive space consumer. There it is. I am reminded of this from time to time.

Meanwhile, across my own College of Liberal Arts and Sciences are numerous departments generating substantial tuition revenue, among them English, History, Math, and Spanish. Some science departments bring in grants while serving numerous students. As a whole, LAS earns money while Agriculture loses money; we pay for ourselves, while Agriculture has to be subsidized. On the other hand, putting *all* forms of income squarely on the table does put some small units in jeopardy. The Classics Department has no comfortable way of generating anything much in the income column, or so it thinks. Its one effort at drawing students—a large course in Greek myths where the instructor came in wearing a toga every week and went into a trance to predict college football scores—became something of a scandal. So small units that don't feed the money machine start looking vulnerable. The accountants are also looking for a way to quantify quality. Page counts of total faculty publications? Word counts? We await the next memo.

For corporatization is here to stay. It cannot be stopped, but it can be shaped and, where appropriate, resisted. At its worst, corporatization strips the faculty of its intellectual independence, impoverishes the teaching staff and diminishes its dignity and academic freedom, and deprives students of appropriate intellectual challenges. "No curriculum," writes San Diego State University faculty member James Wood, "should be dictated by corporations."

Wood voices thereby an anxiety that would have been incomprehensible but a generation ago. Then came corporate donors who put their names on buildings and faculty positions. Such corporate professorships include the Boeing Company Chair in Aeronautics at the California Institute of Technology, the Coca-Cola Professors of Marketing at both the University of Arizona and the University of Georgia, the La Quinta Motor Inns Professor of Business at the University of Texas, the Taco Bell Distinguished Professor of Hotel and Restaurant Administration at Washington State University, the Kmart Professor of Marketing at Wayne State University, the McLamore/Burger King Chair at the University of Miami, the Lego Professor of Learning Research and the Chevron Professor of Chemical Engineering at MIT, the Federal Express Chair of Information-Management Systems at the University of Memphis, the General Mills Chair of Cereal Chemistry and Technology at the University of Minnesota, the

Coral Petroleum Industries Chair in Renewable-Energy Resources at the University of Hawaii at Manoa, the LaRoche Industries Chair in Chemical Engineering at the Georgia Institute of Technology, the Ralston-Purina endowed professorship in small-animal nutrition at the University of Missouri at Columbia, the Merck Company Chair in Biochemistry and Molecular Biology at the University of Pennsylvania, the Sears Roebuck Chair in Retail Marketing at Marquette University, and several corporate-funded chairs at UCLA: the Allstate Chair in Finance and Insurance, the Nippon Sheet Glass Company Chair in Materials Science, the Hughes Aircraft Company Chair in Manufacturing Engineering, and the Rockwell International Chair of Engineering. As Julianne Basinger reports, MIT has an astonishing sixty-nine corporate-funded chairs, while Stanford so far has but twenty-two. We may add to these about a hundred "free enterprise"–chaired professorships across the country, sometimes named after a company, sometimes named after a businessman donor, sometimes named after a conservative business-funded foundation. We have the Gerken Professor of Enterprise and Society at the University of California at Irvine, the Goodyear Professorship of Free Enterprise at Kent State, the Scott L. Probasco Professor of Free Enterprise at Tennessee, and the Mastercard International Distinguished Chair in Entrepreneurial Leadership at the University of Virginia. The right-wing Olin Foundation has endowed professorships at a dozen universities.

Some of these corporations are no longer satisfied with their logo on a professor's forehead. In an interview with Basinger, J. Patrick Kelly, the holder of the Kmart Chair, spoke proudly of saving the company money with his research and summarized its view of its investment in higher education: "Kmart's attitude has always been 'What did we get from you this year?'" United Parcel Service carried on negotiations with the University of Washington not only to endow a professorship but also to name the chair's holder. Their choice just happened to be one Stanley Bigos, whose research suggested that "psychosocial factors" like "life distress" outweighed working conditions as causes of back injury claims. Good news for UPS, whose package-lifting employees claim back injuries with some regularity. In the end, as Robert Cwiklik reported in the *Wall Street Journal,* negotiations collapsed, but not because the university resisted UPS's demand to name the chair holder. In 1998 the California State University system faced a potential corporate partnership that might have led to much broader pressures about course offerings and faculty hiring until protests forced its cancellation.

Corporate funding can turn a purported faculty researcher into a

shameless corporate flack. As Lawrence Soley reports in *Leasing the Ivory Tower,* more than half the country's business professors receive extra income from corporate consulting. Consulting income of several hundred thousand dollars a year is not uncommon. Soley tells numerous stories of faculty members tailoring both research and court testimony to business interests, among them University of Pennsylvania, University of Michigan, Ohio State University, and Florida State University business professors who happily testified for tobacco companies in the 1980s and 1990s, asserting that cigarette advertising did not entice people to smoke. They went on to publish pro-tobacco articles or op-ed pieces without mentioning their substantial tobacco company income.

Even apparently more innocent forms of corporate sponsorship can be compromising. Thus another harbinger of ethical compromise at the corporate university in the 1990s, one that has sparked student activism on such campuses as the Universities of Arizona and North Carolina at Chapel Hill, is the contracts athletic associations at over three dozen schools have signed with Nike, Reebok, and other manufacturers of athletic shoes and apparel. North Carolina, a longtime powerhouse in college basketball that has recently developed a highly successful Division I football program as well, signed a five-year, $7.1 million contract with Nike. While seven million dollars is comparative peanuts to what Michael Jordan and Tiger Woods will earn from their contracts with Nike, university administrators nonetheless found it irresistible. Interviewed by ESPN for its investigation "Made in Vietnam: The American Sneaker Controversy," Michael Hooker, chancellor of the University of North Carolina, said he couldn't discern any difference between the university's contract with Nike and that with any other vendor.

Hooker was responding to questions about Nike's employment—and that of other companies like Reebok—of some 500,000 workers in Indonesia, China, and Vietnam at wages as low as 23 cents an hour. Vietnamese workers, some 80 to 90 percent of whom are young women between the ages of sixteen and twenty-eight, earn little more than the minimum wage of $40/month, work at times with hazardous glues and solvents, and sometimes suffer physical abuse from their supervisors. The impact on the shoe company's profits? Exploited labor limits the direct cost of a pair of $68 shoes to only $1.60. Further, while employees in China are provided with meals and what passes for housing (twelve workers sleeping in one room) as part of their compensation package, workers in Vietnam, in the best tradition of company towns, must pay the company back for meals and accommodations on-site (Saporito 52). What

does it say about the ethos of the corporate university that administrators see no particular problem with entering into long-term contractual relations with such companies? Does it matter that the name of the university appears right next to the Nike swoosh on the chests of varsity athletes? Should the athletic program be a billboard for big business?

To gauge how deeply the ravages of the corporate university can penetrate higher education, we should look to proprietary schools run narrowly and explicitly for profit. These schools now command only 2 percent of the education dollar, but they could easily control 20 percent in a generation, which would be a massive shift in the culture of higher education. They are sure to go after some of the more profitable higher education sectors. "For-Profit Higher Education Sees Booming Enrollments and Revenues" reads a 1998 headline in the *Chronicle of Higher Education*. The subhead adds: "Companies find that they can raise millions on Wall Street to finance ambitious expansions."

The most obvious place for investment is in distance learning. In Canada an industrial consortium embracing Bell Canada, GTE subsidiary MPR Teltech, IBM, Kodak, McGraw-Hill, Microsoft, Nortel, Novasys, Prentice Hall, Rogers Cablesystems, and Unitel is collaborating to develop a virtual university software platform. UCLA's Home Education Network, a university-sponsored for-profit corporation formed in conjunction with private businesses like the Times Mirror Company, is devoted to selling Internet-based distance learning. Until several corporations withdrew in response to campus protests and the initiative was abandoned, the embattled California Educational Initiative, or CETI, sought a ten-year partnership between all campuses of the California State University system and Fujitsu, GTE, Hughes Electronics, and Microsoft to do the same. With these and other initiatives under way, how could college administrators *not* start thinking of faculty expertise as commodified and marketable? How could they *not* think of courses primarily as *products,* research results not as discoveries but as *patentable* commodities? As David Noble writes in "Digital Diploma Mills," "the major change to befall the universities over the last two decades has been the identification of the campus as a significant site of capital accumulation, a change in social perception which has resulted in the systemic conversion of intellectual property into intellectual capital and, hence, intellectual property."

But corporations are insinuating themselves elsewhere in higher education as well. One place corporatization is now firmly entrenched is in university foundations, which regularly set fund-raising priorities without consulting faculty and without announcing them thereafter. Business

departments have thereby amassed huge endowments that are not visible to the campus as a whole. Corporate-supported programs thus get richer and richer, and everyone else loses relative support. All fund raising should have built-in mechanisms for sharing income with other units. A ruthlessly capitalist accumulation of wealth should be unacceptable in campus culture.

Although it is bizarre to have to make the argument, it must be said: faculty must try once again to occupy the center of their institutions; they must stand up for independent work everywhere on campus. To do so, faculty must be full-time and tenured. Governance and countergovernance cannot be exercised without job security and real power. Corporate university managers without actual experience in teaching and research have little understanding of the value full-time faculty add to an institution. Part-timers are more malleable, more inclined to take orders without questioning them. The accounting mentality that likes to segment labor and quantify all tasks, then hire people as cheaply as possible to perform them, is uneasy with the deeper institutional commitment full-time faculty are able to make.

As Noble reports again in "Digital Diploma Mills," the massive academic/corporate consortium Educom, representing 600 universities and 100 private corporations, has recently established the Learning Infrastructure Initiative, "which includes the detailed study of what professors do, breaking the faculty job down in classic Tayloristic fashion into discrete tasks, and determining what parts can be automated or outsourced. Educom believes that course design, lectures, and even evaluation can all be standardized, mechanized, and consigned to outside commercial vendors." The corporate university clearly needs informed dissent; it needs it from all staff members, and only a principled core of tenured faculty can protect the free speech of all involved. At many institutions that principled core must include distinguished researchers, who are sometimes the only people with enough cultural capital to be able to stand up to the administration. Without full university citizenship for its faculty, higher education will put at risk the very competitive edge it already has in global markets. For part of that edge is grounded in unquantifiable quality, in the search for knowledge without regard to its financial benefits.

CN

See *Between Meltdown and Community: Crisis and Opportunity in Higher Education, America's fast-food discipline, cafeterias, distance learning, downsizing, outsourcing, responsibility-centered management.*

D

Debt (ˈdet)

> The typical person who receives a Ph.D. in English spends eight years in graduate school, accumulates $10,000 worth of debt, and is unable to find a job.
> —Louis Menand

Louis Menand made this observation in the fall of 1996 in a much-discussed essay in the *New York Times Magazine*, situating it in the context of a declining job market for young scholar-teachers, a "market" in which "the supply curve has completely lost sight of the demand curve in American academic life" ("How to Make a Ph.D. Matter" 78). The term job "market," in part because it connotes increasingly scarce opportunities to "sell" or exchange services, may not be the right term here, but his larger point is nevertheless well taken. And Menand's emphasis on the lives of doctoral students *before* they receive their degrees is equally salutary. Yet there is also reason to believe that the precarious economics of graduate study, especially insofar as debt is concerned, are far worse than he implies. Moreover, if recent trends in student borrowing continue, the indebtedness of graduate and professional students will rise to more dangerous levels just in the months between the time we wrote this book and the time you read it (undergraduates are also borrowing more than ever before, but their predicaments will not constitute the focus of this essay). In many cases, this debt will seriously undermine these students' financial stability; and in about 10 percent of the cases—about the percentage of graduate and professional students who default on their loans—it will effectively ruin their credit ratings for a decade or more, thus impairing their ability to buy homes, start families, and so on.

The level of debt of Menand's "typical" Ph.D. in English—that is, a student who borrows about $10,000 to complete his or her degree—*was* indeed typical in the early 1990s as the accompanying graph, which

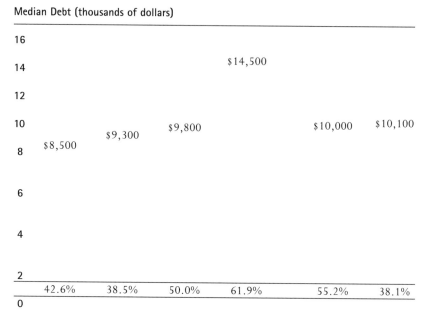

Median Debt (thousands of dollars)

16						
14			$14,500			
12						
10		$9,800			$10,000	$10,100
	$9,300					
8	$8,500					
6						
4						
2	42.6%	38.5%	50.0%	61.9%	55.2%	38.1%
0						
	Phy Sc	**Engineer**	**Life Sc**	**Social Sc**	**Humanities**	**Ed.**

MEDIAN LEVEL OF EDUCATIONAL DEBT AND PERCENTAGE
OF Ph.D.'S WITH DEBT, 1993[1]

appeared in the National Research Council's *Summary Report 1993: Doctorate Recipients from United States Universities* (1995), suggests. Other data corroborate Menand's designation of 8 years as the MYD (median years to degree) of the average Ph.D. recipient; in fact, very few of even the most generously supported doctoral programs in English, Comparative Literature, and other humanities departments have an MYD of under 7 years.[2] Between 1982 and 1992 Yale University's top-ranked Department of Comparative Literature, for example, had an MYD of 8.6 years: that is to say, as many doctoral students took longer than 8 years to conclude their studies as those who graduated in less time. The data in modern language study and English tell similar stories with rather analogous casts of characters: increasingly, thirtysomething students, many of whom will have been forced to borrow large sums of money to complete their doctoral work.

Equally serious, recent statistics regarding job placement are clearly as grim as many commentators have reported. According to the "Final Report" of the Modern Language Association's Committee on Profes-

sional Employment, for example, which released its findings in December 1997, *"fewer than half the seven or eight thousand graduate students likely to earn PhDs in English and foreign languages between 1996 and 2000 can expect to obtain full-time tenure-track positions within a year of receiving their degrees"* (their emphasis, 7). In their study *The Production and Utilization of Science and Engineering Doctorates in the United States* (1995), William F. Massy and Charles A. Goldman observe that the supply and demand ratios for Ph.D. recipients in such fields as mechanical and electrical engineering, mathematics, and geoscience may be only slightly better than those for doctoral recipients in many humanistic disciplines.[3] As dismal as the job prospects are for young mathematicians and geoscientists, however, they are better than those for Ph.D.'s in history. In a 1998 issue of *Academe*, Todd Pfannestiel, a graduate student at William and Mary, assembles two telling statistics: first, according to the American Historical Association, 767 new Ph.D.'s in history were conferred during the 1995–96 academic year; and, second, according to the College and University Personnel Association, only 262 tenure-eligible hires in history were made in 1996 (Pfannestiel 46). Even if *all* of these 262 positions were filled by newly minted Ph.D.'s—that is, even if none of these jobs went to candidates who had been out of school and looking for work for a year or more, clearly an impossible circumstance—the placement rate would still be only slightly better than 34 percent. In reality, it's probably closer to 25 percent or less.

These statistics tell only part of the story of the lives of many students and the ways in which the huge levels of debt they are shouldering will affect them. As we mentioned above, indicators confirm that the situation has become far graver than the NRC documented in 1995. And as will become clear, many of today's graduate students will be hit hard by a kind of "double whammy": not only a difficult time finding a job in the profession to which they have sacrificed close to a decade of their lives but also a decade of repayment that will extend the penury of their student years long into their middle age.

To begin, it is worth noting that debt as a category or statistic was only added to the NRC's annual survey of graduate students in 1987 (*Summary Report 1990*, 25). Before the late '80s graduate student borrowing, it seems, was either so insignificant as to be unworthy of study or simply too materialistic a concern to elicit much attention from an ivy-covered academy. This new category in the survey asked students to estimate the total level of debt they incurred pursuing both undergraduate and graduate degrees. Based on the evidence of 33,113 respondents, the 1990

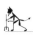

Summary Report identifies 12 percent of those surveyed as borrowing between $5,001 and $10,000 and 22 percent as borrowing $10,001 or more. But it became clear to many that such borrowing was increasing dramatically during the early and mid-'90s. In November 1994, the American Council on Education (ACE) released *Student Borrowing: How Much Is Too Much?,* which, among its other sobering statistics, revealed that in 1993 and 1994 the total volume of Federal Family Education program loans jumped by 47 percent and that other loan programs had experienced similar, if not quite so precipitous, increases. The ACE's mantra in this study, that undergraduate, graduate, and professional students (and their families) are "borrowing a lot more money than ever before to finance their higher education," was being echoed in the mid-1990s by various organizations, the NAGPS (National Association of Graduate and Professional Students), for instance.

The American Medical Association and National Center for Public Interest Law (NAPIL) recognized these alarming trends as well. Speaking for the NAPIL, Hector Vargas described a significant rise in the borrowing patterns of law students, some 29 percent of whom in 1990 borrowed between $40,000 and $79,000 to complete their studies. By 1992, the percentage of law students who borrowed this amount had nearly doubled, to 52.4 percent. To put such numbers in perspective, the National Association of Law Placement estimated that mean starting salaries for the graduating classes of 1992 and 1993 were $36,000, *down* from 1991's mean salary of $40,000. In 1994, mean starting salaries in the private sector were around $50,000, in the public sector, $28,000 ("Heavy Debt" 17). One need not be an analyst for Smith Barney or an addicted viewer of *Wall Street Week* to recognize the economic ramifications of these numbers for young lawyers in the 1990s (even though the better law programs continue to place some 90 percent-plus of their graduates). As disturbing as these ramifications are, the cost to society may even be greater. For even the most committed and progressive young attorneys will find it more difficult to resist the monetary inducements of private practice over the less remunerative public positions so vital to the country and its promise of justice for all, including the nation's poorest citizens. The financial futures of many of these lawyers may depend on how cold-bloodedly they can abandon their social ideals, find work in private practice, and never look back.

The Association of American Medical Colleges shared these concerns in the early 1990s. Contributors to *Academic Medicine* in 1992, for example, worried that "mounting educational debt" was "driving students toward

the more remunerative fields and thwarting efforts to overcome the country's shortage of primary-care physicians"; and they argued, much like those who have studied the increased borrowing of graduate and law students, that in the 1990s medical students were burdened by "substantially higher indebtedness" than their predecessors in the 1980s (Kassebaum and Szenas 700). Between 1981 and 1991, for example, the median student debt rose from $20,500 to $68,000 at private schools and from $18,000 to $45,000 at public schools. Over 20 percent of all medical students graduated in 1992 with over $75,000 in debt. The rise has continued through the middle 1990s as well.

Of course, some doctors take jobs with hospitals or medical groups that, as a recruitment inducement, agree to pay off their student loans as part of the total compensation package. Other young physicians are able to pass off the burden of loan payments to their patients in the form of higher fees. Chaucer specialists and classicists, however, are never wooed by schools eager to assume their student loans, which, for many doctoral students in the humanities and sciences, are clearly spiraling upward and out of control.

The 1995–96 National Postsecondary Student Aid Study (NPSAS), a survey conducted every three years that gathers data from students, institutions, and families about the financing of undergraduate, graduate, and professional students, provides an even clearer picture of a relatively recent "sea-change in the way that students are paying for graduate education" (Syverson 10). "Sea-change" in this context might be defined against the data from 1993 indicating that the median level of debt of those doctoral candidates who took loans was, for many disciplines, about $10,000: life sciences, $9,800; humanities, $10,000; education, $10,100; and so on. The NPSAS data for 1995–96 collected from the responses of 7,000 graduate and professional students across the country are sobering indeed: 40 percent of doctoral students borrowed an average of $21,350, and *80 percent* of professional students borrowed an average of $53,662. In the case of graduate students, while the number taking federal loans dropped slightly from 1992–93, the average amount borrowed increased sharply; for professional students, both the number taking loans and the level of debt incurred rose "substantially" (Syverson 10). One analyst of these figures, Peter D. Syverson, concludes that "the use of loans by master's and doctoral students is *growing rapidly* and is a real cause for concern for the graduate community" (8), and he recommends that the graduate community pay particular notice to the next NPSAS, due to be published in 2000.

To illustrate just how dramatic these data might be, we want to refer to some startling statistics provided us by the Graduate School at Indiana University–Bloomington.[4] Even after studying the data from 1993 and 1995–96 and thus presumably prepared for just about anything, we were shocked by them and suspect you might be as well by the accompanying abbreviated chart. Suffice it to say that more and more graduate students in almost all the forty-seven academic departments listed in Indiana's Graduate Program Data Bank for the College of Arts and Sciences, too many to be reported here, were borrowing significantly larger sums of money to finance their studies during the 1996–97 academic year than they were earlier in the decade. A few fields, physics and philosophy, for example, were somehow able to contain the borrowing of their graduate students, but the vast majority clearly were not, with some departments witnessing a 400 percent increase (or more) in borrowing since the decade began. Some of the more extreme examples appear in the following table.

| Dept | 1991–92 | | 1993–94 | | 1995–96 | | 1996–97 | |
	No. of Students Borrowing	Total$	No.	Total	No.	Total	No.	Total
Anth	17	$106,684	33	$289,651	31	$360,954	49	$554,331
Biol	1	$ 4,913	1	$ 7,744	12	$ 99,898	10	$ 86,363
Chem	13	$ 57,916	16	$117,047	36	$319,187	42	$373,232
Comp Lit	13	$104,041	25	$264,430	33	$373,531	36	$415,096
Engl	71	$490,076	78	$745,746	87	$871,834	84	$786,000
Art Hist	27	$166,192	36	$298,983	79	$907,070	42	$481,685
Folk	26	$164,407	34	$345,527	35	$477,076	54	$679,344
Fren-Ital	16	$ 98,107	26	$250,612	34	$347,119	32	$330,511
Geol	4	$ 22,364	6	$ 38,645	9	$ 80,690	17	$153,107
Hist	60	$434,804	78	$771,995	87	$899,489	86	$920,532
Psyc	17	$ 73,416	28	$232,529	29	$260,176	24	$249,556
Spe Comm	11	$ 63,036	24	$217,025	21	$189,553	21	$225,269
Spe Hear	26	$173,286	53	$522,544	64	$890,641	65	$891,534

Annual Borrowing Patterns: A Selected Survey, 1991–96

A number of figures on this chart merit further scrutiny, and there is no reason to believe that they represent a dilemma unique to graduate education at Indiana or at midwestern research institutions more generally. Indeed, it isn't hard to see why debt has exploded in the 1990s and, unless strong steps are taken, why it might continue to skyrocket in the

next millennium. To take just one example mentioned earlier in this book in the discussion of *apprentices,* during the winter 1995–96 GESO grade strike at Yale, Graduate School Dean Thomas Appelquist observed (as quoted in the *New York Times*) that stipends for TAs were never intended to cover all of the basic costs of living in New Haven. Rather, Yale estimated that TAs would require an additional $3,000–$4,000 to pay for basic living expenses. Because the majority of doctoral students in most humanities departments at Yale take seven or more years to complete their degrees, this means that those students with limited personal funds will need to borrow upwards of $30,000. And this at one of the best-supported, most prestigious institutions in the country.

To return briefly to the above chart, the *enormous* increases in borrowing by graduate students in anthropology, comparative literature, fine arts (art history), folklore, and French and Italian must be noted, as must the irony of the exceptionally bleak professional prospects for students in these fields. The corporate university is hardly clamoring for more folklorists or specialists in Hungarian literature. (Even worse, a substantial percentage of these borrowers will not even complete their degrees, as the attrition rate of many of today's graduate programs exceeds 50 percent.) If the job "market" remains the same disaster it has been for the past two decades, more than half of those who persevere and graduate will be hit with that "double whammy" we have already alluded to: no job in their field and 120 months of significant loan repayment (most student loans are structured over ten years). For the few "lucky" ones, the single whammy won't be insignificant either: as we approach the end of the decade and century, those few Ph.D.'s in the humanities with tenure-track jobs (save for those on either coast) will be starting at a salary from the midthirties to the low forties. And how will adjunct faculty earning $12,000 or $13,000 a year even begin to repay these loans?

If it is representative, and we believe it largely is, the accompanying chart suggests that many students who finally obtain the Ph.D. degree will do the one thing that makes most loan officers shudder: namely, carry a debt that exceeds their starting salary. Many of the numbers for Indiana students borrowing in 1996–97 confirm this: the eighty-six students in history who took out loans totaling $920,532 (or $10,700/person), for example; or the thirty-six students in comparative literature who accrued loans of $415,096 ($11,530/person); or the fifty-four students in folklore who borrowed $679,344 (or $12,580/person). Compare these numbers to the figures in the NRC's *Summary Report 1993* in which the median debt of graduate students was $10,000 for

their entire programs—or the *Summary Report 1990* in which only 34 percent of the respondents reported borrowing more than $5,000 for their entire terms as doctoral students. The number of student-debtors in folklore and comparative literature at Indiana exceeds 50 percent of the population on campus, and the amounts borrowed, again, are for only a single year of their degree programs.

A number of factors might be cited as responsible for this alarming increase in graduate student borrowing, and there exists a slight possibility this trend will reverse in the future if academic departments continue to downsize their programs (which is not to endorse downsizing, a hugely embattled strategy, as any kind of radical panacea). That is to say, some student-borrowers in the middle and late 1990s were part of the comparatively large incoming classes too many departments admitted in the late '80s and early '90s in response, at least partially, to studies that predicted a shortage of Ph.D.'s in the middle and later '90s.[5] And, of course, tuition and other costs for basic necessities have risen far more sharply than fellowship or teaching assistantship stipends, thus necessitating further loans. In response to this need, the ceilings on many student loans were raised in 1992, thus enabling students to borrow more.

But perhaps most responsible for this dangerous trend are a myopic yet pervasive ideology of scholarly commitment in many departments and the failure of institutions to provide the financial support necessary for most students to adopt this ideology without paying dearly for it later. We refer here, particularly for graduate students in the humanities, to the ideology of progress and professional success that informs many programs. It works something like this. Competent graduate advisors reiterate to their students the need to move through the program in a timely manner; if you take too long to complete your degree, the logic runs, you will appear slow to a future employer, and slowness to finish signals potential troubles at tenure time. Yet to finish a high-quality dissertation in an impressively efficient manner, students in the humanities, typically not supported by grants in the summer as many of their peers in the sciences are, must take out additional loans (they take them out during the regular school year as well to avoid the alternative of a part-time job). To survive without going further into debt would mean summer teaching or other work, and dissertations don't get written this way. So ambitious students, the ones who take seriously the advice of their faculty mentors and commit themselves to their scholarly work, are the ones most likely to incur further debt. In this way, heeding the best "professional" advice

comes at the expense of future loan payments and may lead to a lower quality of life for years after graduation.

These statistics on the debt of a growing number of graduate and professional students—coupled with the reality that in order to work in their fields, many scholar-debtors will be forced to cobble together a career from low-paying adjunct appointments—do not augur well for the future of higher education. How could the quality of higher education be improved by—or maintained despite—the poverty of many college and university faculty?

SW

See *apprentices, company towns.*

Disciplinary Organizations (ˈdisəplənerē ˈȯ(r)g(ə)nəzāshənz)

There is a national or international organization devoted to almost every significant disciplinary grouping, from the American Psychological Association to the International Communication Association and the American Historical Association. In a very real sense, however, we do not have any organizations devoted to the political, social, economic, and ethical health of these disciplines. Ever since higher education's expansionist 1960s, academic disciplinary organizations have concentrated on helping people add lines to their vitas or, less bluntly, on offering professional opportunities to their members. Disciplinary organizations advertise new academic jobs, hold conventions, publish books and journals, form commissions to discuss scholarly matters, and serve as clearinghouses for news about additional professional opportunities. They rarely interrogate their own institutional practices, preferring self-promotion to self-criticism, and they are reluctant to venture into political and cultural conflict even when their own interests are imperiled.

Most academics are dimly aware that certain fundamental matters like academic freedom and tenure apply to all disciplines, not merely to their own. It has made a good deal of sense, then, to leave those larger concerns to the one organization that represents all disciplines, the American Association of University Professors. But the last two decades have seen two discipline-specific developments that the AAUP could not fully address: namely, the rise of public cultural and political attacks on particular disciplines and the growth of unethical, discipline-specific hiring practices and job systems. Where political engagement and ethical self-scrutiny should have been, a void has been in place instead.

We have also seen the size of many department faculties shrink gradually while the number of undergraduate students served has remained roughly the same. More recently, political support for higher education has declined in the wake of the cold war's conclusion. And a long-term job crisis that leaves many new Ph.D.'s either unemployed or marginally employed in part-time jobs has become permanent. Tenure is not so much under assault as it is being whittled away by a slow but inexorable shift to part-time employees. Academic freedom is beginning to be undermined as fewer and fewer faculty members have any meaningful job security.

In this environment disciplinary organizations should be lobbying far more widely and aggressively on behalf of higher education. In the persons of their officers, they should be a public policy presence at both state and national levels. They should take an active role in limiting the size of Ph.D. programs. They should encourage more enlightened faculty retirement programs. They should study the human costs of doctoral training far more thoroughly and deeply. They should be monitoring how changes in technology and the slow collapse of the academic book market will affect requirements for tenure. They should be setting ethical standards for graduate study, the job market, and the probationary period for new faculty in times of economic crisis. As the Modern Language Association's Graduate Student Caucus, the only organized source of new ideas in the association, has urged, they should collect and publish both full-time and part-time academic salaries. They should organize and encourage discussion, debate, and research among their members on all these issues and communicate the results widely.

The officers of disciplinary associations should be highly visible, readily identifiable spokespersons on the national scene. This is not, I should emphasize, a matter of taking positions on Vietnam or Bosnia. It is a matter of assisting and, where necessary, confronting politicians, journalists, faculty members and administrators, as well as members of the general public, where issues of the funding or interpretation of higher education, research, and teaching are at stake. In these crucial projects, the presidencies of disciplinary organizations have been notable failures.

So consistent has been the failure of recent heads of disciplinary organizations to provide effective, galvanizing leadership in a time of crisis that we must look beyond the people elected to the offices themselves for an explanation. It is almost as if academic organizations were *designed* to be politically ineffective or invisible, dismissible or irrelevant players in the public sphere. These organizations sometimes seem like factory assembly lines serviced (but uninfluenced) by their staff and elected offi-

cials. Two points seem obvious in the light of the experience of recent years. First, faculty members typically elect a disciplinary president on the basis of a bibliography and a sound bite. The statements of purpose are usually so brief as to be little more than empty generalities. So members try to predict a candidate's conduct in office on the basis of *his or her* scholarly work. But there is no necessary connection between one's scholarly commitments and how one responds, say, to the job crisis. Second, members have shown a tendency to elect scholars doing progressive work, but progressive scholarship unfortunately guarantees nothing about a person's views on other professional issues and nothing about a person's administrative ability.

The presidency of a disciplinary organization has largely been an honorary office, the chief curriculum vitae enhancement the organization offers. A person can accept the job without fear that his or her research will be seriously interrupted. One recent MLA president reportedly spent part of the term of office in a Paris apartment. So long as the profession was in relative boom times, little damage was done. But we now face an era when politicians and corporate executives will be proposing unimaginative and often destructive solutions to our fiscal problems. We can do better ourselves, especially if we work together. But for that we need disciplinary organizations that are seriously devoted to working on these problems and leaders who are willing to broaden their expertise to include issues of basic policy.

People running for offices in disciplinary organizations should have to produce platform statements of perhaps a thousand words that include specific proposals for action. Like-minded members might well run as slates committed to a common program. The MLA's Graduate Student Caucus is now making just such an effort. For disciplinary associations need to be far more involved in a whole range of issues affecting our future. Many departments have neither the resources nor the expertise to come up with creative solutions to this multileveled crisis. They need the pooled resources and imagination of the profession as a whole. Each academic discipline's national organization should be at the forefront of that effort.

At the top of the list of professional concerns, however, should not be our public image or our struggle for resources. The first thing disciplinary organizations need to confront is the employment practices of their member departments. Fiddling while Rome burned, disciplinary organizations for years have promoted individual faculty careers while their participating departments became increasingly exploitive places to work. Should it

matter to a national organization that its member departments deny many of their teachers—especially graduate student employees and part-timers—a living wage and basic benefits? We believe it should.

One could look through all the publications of the Modern Language Association of the last twenty years, for example, without finding any acknowledgment that English, rhetoric, and the foreign languages are the most aggressively exploitive employers of all academic disciplines. Far from recognizing how uniquely dirty its hands were, the organization representing these disciplines typically denied the existence of a permanent crisis and urged patience while awaiting better times.

In January of 1998, the MLA's Committee on Professional Employment (CPE) did mail a major report on the job crisis to over 30,000 members. The report gives us a reasonable—if economically and contextually impoverished—account of the recent history of the academic job market in the humanities. Its opening subheading, as one reader pointed out, introduces a passage in the text that refers to "the best of times at large contrasted eerily with the worst of times in academia." Of course the millions of underemployed or unemployed Americans, all those working at poverty- or near-poverty-level wages, are not living in the best of times. We are not alone, and as long as our disciplinary understanding of the national and global economy foregrounds us as exceptional victims, the chances for meaningful solidarity, meaningful alliances, and significant change remain slim.

But at least the single largest disciplinary organization is now symbolically committed to recognizing that its own house is in disrepair. Having argued for a time that jobless Ph.D.'s were primarily ungrateful, the CPE report's principal author now more or less announces: "I feel your pain." The proposals for action put forward in the final section of the report are less generous. The report generally settles for stating vague principles rather than taking actions. And it fails to view the crisis in higher education broadly enough. Both its narrow view of the forces acting on higher education and its recommendations for change have already been overtaken by events. The astonished gaze its collective author casts on recent history suggests the windswept visage of a profession no longer in control of its fate. Eyes bulging, the figure is nearly swept away by forces it cannot comprehend. In stark terror at their oncoming fury, it dares not turn to glimpse their destination. Yet after more than a quarter century of denial, with this report English and the other literature and language professions have now condescended to admit that there is a problem.

One relatively minor but telling example of an area where the report

avoids tough action is in its response to efforts to create *new* Ph.D. programs. Although many faculty members find it difficult to believe that institutions would attempt to establish new doctoral programs in the midst of the current oversupply of Ph.D.'s—because creating new programs is much like throwing gasoline on an uncontrolled fire—there are always several such efforts under way. Often the pressure comes from above, from administrators who want to move up the hierarchy of rankings by institutional type, sometimes because that produces more state support. A number of doctoral programs were forced on faculty members on campuses in the Michigan State University system for that reason in the last decade. Sometimes departmental faculty resist these efforts but are overwhelmed by coldly unscrupulous administrators.

A university president in Texas in 1997 urged his large humanities departments to start Ph.D. programs for the first time: "The job crisis is over, and we have got to position ourselves to take advantage of the new job boom. We cannot miss this opportunity for prestige, impact, and visibility."[1] Departments who do not want to initiate new Ph.D. programs, he warned, would face penalties when next year's faculty salaries were assigned. When the history department courageously voted against starting a doctoral program anyway, one was imposed on them. Professional organizations like the MLA should be leading the way to block new doctoral programs, and they should be doing so simultaneously on multiple fronts. Working on the supply of new Ph.D.'s this way will not solve all our problems, but it is one necessary component of a comprehensive approach to the job crisis and can somewhat increase the employment prospects of the many underemployed Ph.D.'s now seeking meaningful careers.

One succinct way of highlighting the other problems in the organization's response to the job crisis is to point out a basic contradiction in the CPE members' recommendations. Put bluntly, they cannot recognize the tension between their realism and their elitism. The report repeatedly urges us to prepare graduate students to teach in the real world, to prepare them for the jobs and responsibilities that will exist in the new millennium. "An offer from a two-year institution or a high school should not," the report remonstrates, "elicit the response (as it recently did from a prominent academic), 'Oh, well, it'll put food on the table while you're looking for a job.'" Indeed, "the primary goal of graduate education should not be to replicate graduate faculty." Departments "will have to reimagine the size and shape of the graduate programs they offer and the directions in which those programs ought to evolve, given the range of educational needs our profession will have to meet in the twenty-first century."

Part of the accompanying rhetoric is simply uninformed, as when they quote George Levine warning that "graduate programs will have to find ways to incorporate into their training 'the sorts of material that would serve students finding jobs at heavy teaching colleges'" (25). Here in River City, as in many other rural spots, we already do that; we've been doing it for decades. Our graduate students teach not only a whole range of lower-level composition, literature, and film courses; they also teach remedial rhetoric and composition for disadvantaged students, and they train at intensively tutoring remedial students. Short of practicing community college groundskeeping or high school lunch room monitoring, it's not immediately clear what more our students should do to prepare themselves for the service jobs of the future. Certainly not all of them have set their dreams on the research track; some end up sick of their dissertations and hope never to see another major research project. Those who invest themselves in remedial tutoring seem to do it with great dedication; they believe the work matters and they are skilled at it. Whether any community colleges will be willing to pay for this kind of individual attention is the real issue, not whether our graduate students are qualified and interested in doing the work.

Where the real contradiction in the CPE report arises, however, is between its purportedly bracing dose of realism about jobs in the new millennium and its recommendation about graduate student teaching loads. The committee goes on to urge that graduate student employees teach only one course per semester. What the stern warning about preparing for the jobs that will exist means, quite simply, is hurry and set up what far too many faculty at elite institutions secretly think of as "the rhet/comp droid assembly lines." These dedicated "droids," so many literature faculty imagine, will fix comma splices, not spaceship wiring. But why give rhet/comp droids extra leisure time? What are they going to do with time off? They beep and whir and grade, that's all. They're not training for research.

The University of Illinois department offers teaching at two courses per semester, and virtually every graduate student signs up for it. They need the money for living expenses. For years we have urged our departments to reduce the teaching load but retain the full salary. We want our students to have more time for their intellectual lives. But the jobs of the future so confidently touted by the MLA will not have a major intellectual component, not *any* substantial intellectual component, let alone research time. That's not because they will be comp jobs, however, but rather because the instructors will be so underpaid and so overworked

that they will have little time for reflection. So there's no reason to provide graduate students facing that sort of future with anything but job training and little reason not to extract the maximum labor from them while they're at it. Extracting the maximum labor at the lowest cost has been the aim of graduate training in English for decades.

Because we have the research-oriented Ph.D. in mind, our own politicking to lower the teaching loads of graduate employees has the aim of providing increased time first for seminar projects and then for dissertation research and writing. But do the droids need to write dissertations? It's hard to see why many traditional faculty would think so. Of course a number of people have been doing serious and intellectually ambitious work on rhetoric and technical writing for years, including political analyses of corporate writing, but the current premium on rhet/comp Ph.D.'s, as opposed to M.A.'s, in some corners of the job system is partly a product of mystification. In the assembly line comp course model, a Ph.D. has only limited pedagogical warrant. Demand for rhet/comp Ph.D.'s now generally exceeds supply, but the profession will surely remain true to form and eventually generate an oversupply. We doubt if we are more than a decade away from that point.

Despite its weaknesses, the report can serve as a foundation for action if the association is willing to act. And there is no comparable report we know of from any other disciplinary organization. For this reason, the MLA has perhaps been *the single most activist* large disciplinary organization. Most of the others are even more frightened of the public sphere, more unwilling to undermine faculty privileges and departmental autonomy. Thus the MLA has been one of few such groups to defend NEH funding on Capitol Hill consistently and aggressively. One would think all humanities fields would have been in that battle for years, but such is not the case. The MLA also cosponsored an important conference on part-time labor initiated by the American Historical Association in 1997, working closely with the American Association of University Professors. The AAUP drafted the conference's detailed statement of principles and recommendations.

Like other professional associations, the MLA needs more input and participation from those at the bottom of the academic pecking order, especially those graduate students, adjuncts, and part-timers who have been active in disciplinary subgroups or union organizing. Those activists at the bottom of the profession have a better understanding of higher education's future than do the high-achieving faculty members at prestige institutions who have long led our disciplinary organizations.

In this time of radical change disciplinary organizations need to help faculty members think through the challenges we face. They need to coordinate and spearhead our responses. And above all they need to take responsibility for securing fair wages for all their exploited members.

See *the Modern Language Association.*

Distance Learning (ˈdistən(t)s ˈlərniŋ)

It was the day after the U.S. president's 1998 state of the union address, and he had just mounted the podium at the University of Illinois. A few hours later *Air Force One* would sink into midwestern mud at the local airport, but now the audience of 10,000 students and faculty would instead be mired in cyberspace. The university president introduced William Jefferson Clinton by heralding the future of education. He looked forward to the day, he said, when distance learning would be the norm, not the exception.

This apparently cheerful prediction met with no ovation. It did not dawn on the university president, an engineer, that the faculty and students at a residential college might not welcome this prospect. He had earlier giddily written to the faculty to announce that the Internet and computer-based learning would take us "beyond the boundaries of space and time." The gossip from the president's office was less utopian: the university had to act fast, lest individual faculty members videotape their classes or go on-line on their own and copyright the teaching materials they had developed. The university wanted to secure any income to be derived from marketable courses. Besides, we could hardly let Duke, Iowa, or Kansas beat us to the punch.

Meanwhile, a thousand miles away secretaries at a General Electric plant were unloading boxes mailed from the local university, with which GE had contracted to offer master's degrees in engineering on-site. The original plan was for factory employees at the plant to gather in a room when an appropriate course was meeting on campus. The lectures would be transmitted directly to the plant by satellite, and the "students" at GE could ask questions by satellite hookup when the lecture was over. It seemed technically feasible and educationally sound. Unfortunately, the satellite connection proved too expensive; the university was losing money on the deal. So it was decided instead to videotape the course lectures; the minor detail of dialogue with a faculty member was abandoned, so too any participation in class discussion.

The videotapes came out of the boxes. Inside as well were the machine-gradable exams that would test what GE's employees had learned. They

would get their degrees without ever being questioned or challenged, without ever appearing on campus, without ever experiencing the give-and-take of social learning. It was an education of sorts, but it would not be so likely to teach anyone to think critically. They would receive their degrees and no doubt be more useful employees, but anyone who thought this the equivalent of a campus education would be misled.

Distance learning has been in place at some schools for years and has served students well. At the Open University in London, course materials for external students are assembled by faculty teams who aim for the highest possible standards. Great effort is put into devising detailed examples, illustrations, exercises in critical thinking, and questions that compensate for the loss of face-to-face contact with students and faculty. The courses are designed to challenge students and make them think. Videotapes are professionally produced. Textbooks are often the very best written on their subject. And correspondence or e-mail provides for some real interaction between faculty and students.

Distance learning serves social functions at the Open University as well. People with full-time jobs gain access to higher education they otherwise could not have. But the courses are tremendously time-consuming and expensive to prepare. The aim is education, not profit or mere convenience. It is difficult to be confident that similar concerns with quality and intellectual challenge will shape the American market, certainly not if corporations dominate the field or if universities simply package their lectures for sale. Distance learning constitutes a different educational environment that requires new learning techniques and strategies. It has potential for real social benefit, but many of those benefits will not come cheaply, especially during the course development phase.

There are, of course, obvious bases for savings in distance learning. The need for a physical plant is severely reduced, as is the need for full-time faculty in residence. Stanford University, known to its critics as the Silicon Valley Training Institute, began offering an exclusively on-line master's degree in Electrical Engineering in 1998. Duke University now offers an M.B.A. degree primarily on-line. The nineteen-month program requires attendance at several two-week seminars available at a number of sites around the world. The university earns income from its software and from student tuition; if it decides to increase enrollment and income from this highly targeted program, all it really has to do is hire more part-time faculty at bargain rates. Duke may neither want nor need more services from those faculty. Distance learning is thus not merely likely but certain to increase the trend toward more part-time and underpaid

faculty, in part because students not in residence do not need many of the services faculty ordinarily provide. The earlier model for distance learning was correspondences courses, also often taught by part-timers, but even they required more individual attention. There are also no practical limits on enrollment for Internet courses. With no space requirements, Duke could presumably offer its virtual M.B.A. to thousands of students. All they have to do is hire more part-timers to service the computers. Meanwhile, Duke, whose on-line business degree is supported by over a hundred corporate donors, is not exactly marketing this product to the tired and the poor; total cost for tuition and fees per student in 1999: $85,800. The salary for faculty responsible for electronic courses: the University of Chicago paid virtual teachers $965 per course in 1997.

Distance learning also offers students the chance to take some of their courses from other universities. A student enrolled in a University of Pennsylvania degree program might choose to take an Internet art history course from Harvard. Other students have the opportunity to take infrequently taught languages on-line. Sorting out all the credits and payments for multi-institutional programs may require hiring a few more administrators, but that would hardly overturn recent hiring patterns. Increased choice and availability would give students opportunities to take courses and degree programs not available anywhere near their homes.

The downside of that will be the temptation for schools to reduce the size of or entirely eliminate departments that are well represented with nationally available courses. Updating courses will hardly require hiring full-time faculty; once again, part-timers will do. But the priority to service on-line courses may go to the top of the instructional budget. Partnerships with corporations to market on-line courses then increase the possibility that profit-oriented firms may gain an important role in campus staffing decisions. Overall, once large numbers of courses are available on-line, they are certain to have a significant impact on faculty hiring and the nature of the professoriate. As historian David Noble writes in his essay "Digital Diploma Mills," widely circulated on the Internet early in 1998,

> once the faculty converts its courses to courseware, their services are in the long run no longer required. They become redundant, and when they leave their work remains behind. In Kurt Vonnegut's classic novel *Player Piano* the ace machinist Rudy Hertz is flattered by the automation engineers who tell him his genius will be immortalized. They buy him a beer. They capture his skills on tape. Then they fire him. Today faculty are

falling for the same tired line, that their brilliance will be broadcast on-line to millions. Perhaps, but without their further participation. Some skeptical faculty insist that what they do cannot possibly be automated, and they are right. But it will be automated anyway, whatever the loss in educational quality. Because education, again, is not what all this is about; it's about making money. In short, the new technology of education, like the automation of other industries, robs faculty of their knowledge and skills, their control over their working lives, the product of their labor, and, ultimately, their means of livelihood.

That future is already partly here. As Noble continues, "at York University, untenured faculty have been required to put their courses on video, CD-ROM or the Internet or lose their job. They have then been hired to teach their own now automated course at a fraction of their former compensation. The New School in New York now routinely hires outside contractors from around the country, mostly unemployed Ph.D.'s, to design on-line courses. The designers are not hired as employees but are simply paid a modest flat fee and are required to surrender to the university all rights to their course. The New School then offers the course without having to employ anyone."

Actual geographical distance is now irrelevant for both faculty and students. Western Governors University, based in Salt Lake City, grants cyber-degrees using on-line courses drawn from seventeen states (plus Guam), though it is particularly concerned with separating skills certification programs from full-scale degrees. Many industries, Western Governors realizes, will prefer skills training to a broader education. Universities have begun marketing on-line degree programs abroad, and the foreign market is likely to grow rapidly. Eliminating the need for physical access or proximity also makes name brand universities available to students everywhere. Why take a degree from the community college down the road if you can earn one from Harvard on your home computer? Some less prestigious institutions will surely suffer when they have to compete with gold-plated schools for students. Rapid growth in distance learning will force some programs and perhaps some entire institutions to close. A 1998 flier for the new magazine *Distance Learning,* which brags about keeping you up to date "in only thirty minutes of reading a month," quotes one Eli Naom from *Edcom Review* somewhat hyperbolically claiming that "many of the physical mega universities . . . are not sustainable, at least not in their present duplicative variations. . . . Ten years from now, a significant share of conventional mass education will be offered commercially and electronically."

Some degree programs, to be sure, are so far unsuitable for distance learning, including many graduate programs. A virtual science lab is still not a science lab—though Indiana University/Purdue University's Indianapolis campus (IUPUI) does offer a miniature take-home lab to accompany its Internet-based Chemistry 101 course—but other areas would be vulnerable to forced conversion. Faculty could be offered the option of replacing a residential degree with an Internet equivalent or watch their program be closed down. We have no clear models for governing how resultant disputes would be arbitrated. The only decisive action so far is the 1997 faculty strike at York University in Toronto, which made faculty control over distance learning and all other technologized instruction a major issue. The faculty contract now gives them, not administrators, full control over digitized and videotaped instruction.

Administrators, Noble argues, see distance learning "as a way of giving their institutions a fashionably forward-looking image. More importantly, they view computer-based instruction as a means of reducing their direct labor and plant maintenance costs—fewer teachers and classrooms— while at the same time undermining the autonomy and independence of faculty." Unfortunately, some of the foundation support distance learning is receiving is also motivated by downsizing. At a 1998 meeting to review regional web-based instruction, a Mellon Foundation officer kept turning the discussion away from intellectual issues toward cost-saving. One of York University's more unnerving moves was to offer private corporations the right to place their logo permanently on any on-line course in exchange for a $10,000 donation. Since faculty would be signing away all rights to the course, it would then be easy for administrators to eliminate components critical of specific corporations, of the logic of globalized capital, or of anything else that bothered a donor. As Noble points out still more darkly, "once faculty and courses go online, administrators gain much greater direct control over faculty performance and course content than ever before and the potential for administrative scrutiny, supervision, regimentation, discipline, and even censorship increase dramatically. . . . The technology also allows for much more careful administrative monitoring of faculty availability, activities, and responsiveness."

The distance learning universe is expanding at an accelerating rate. The Global Network Academy in Texas lists 10,000 on-line courses on its web site. And local initiatives keep swelling the numbers. Florida's new tenureless Gulf Coast University expects 25 percent of its courses to be offered exclusively on-line. The California Virtual University already lists nearly 1,000 courses. The Southern Regional Electronic Campus began operating

in January 1998 with a more modest 3-figure catalogue; a year later it had 1,000 on-line courses. By then the Community College Distance Learning Network was up and running with 500 video or web-based offerings. Caliber Learning Network, a private business venture cofounded by Sylvan Learning Systems of Baltimore and communication multinational MCI, is planning to market courses from Berkeley, MIT, Johns Hopkins, and the Wharton School of Business at local shopping malls.

One key element to watch is production costs. The University of Missouri has found it can assemble an entire low-tech video lecture course for captive audiences for only $10,000 beyond the faculty member's salary. The Michigan Virtual Automotive College, a University of Michigan/Michigan State project formed in cooperation with automakers and the United Auto Workers to offer auto industry training, rachets course production costs up to $10,000 *per hour*. But Ted Marchese reports that some entrepreneurs recommend a development budget of *$80,000 per hour* for on-line graphics intensive courses with high national and international marketability. No university can fund such a course. So industry will pay for them and control their intellectual content. Perhaps that is why Bill Gates has invested so heavily in the electronic rights to paintings and photographs. For a glimpse of the future, sign up for publisher Ziff-Davis's on-line HTML course and chat group for $29.95.

Despite all this, it is clearly reactionary to reject every plan for distance learning. Humanities and social science Ph.D. programs thus must help make their graduates adept at using these new technologies. Distance learning offers among other things some remedies for class-based and economic inequities. But to embrace its more shallow incarnations uncritically is equally counterproductive. Students who do not get to interact with one another and with their instructors lose a great deal; they lose the opportunity to be inspired and corrected by their peers; they lose some of the inspiration of the presence and example of learned intellectuals. Corporations will certainly package intellectually unchallenging courses and market them for a profit. Academic freedom is significantly threatened by distance learning in several ways. All this requires careful discrimination and hard thinking. In a manifesto that grew out of his experience as an "e-worker" on an Internet project at the University of Illinois's Chicago campus, Ken McAllister makes a number of principled pledges administrators are unlikely to come up with on their own: "We shall establish as the foundation of all our electronic educational initiatives a set of humane, rather than technological or institutional, ideals. We conceive of our purpose as being community and culture

development within an educational context; our scope is greater than the dissemination of information" (281). The distance learning bandwagon is not guaranteed to take us anywhere we want to go.

<div align="right">

CN

</div>

See *the corporate university, teaching.*

Doctoral Dissertations (ˈdäkt(ə)rəl ˌdisə(r)ˈtāshənz) We cannot

begin to defend the country's investment in graduate training without a better understanding of the role of the doctoral dissertation. What is at stake in writing a dissertation is not just preparation for future research. That is the general, very narrow, and, in our opinion, spiritually and culturally impoverished view that prevails. You write a dissertation to train yourself to do more such projects. If you are not going to do them, why write one? That seems as well to be Louis Menand's perspective on dissertation writing. In "How to Make a Ph.D. Matter" Menand argues for a three-year Ph.D. with no dissertation or with only a moderately expanded seminar paper. He sees dissertation writing not only as unnecessary but as culturally counterproductive, since it leads to inflated books that are little more than "articles on steroids."

But there is also a pedagogical reason for undertaking elaborate doctoral research. A person who writes a dissertation, one hopes, leaves graduate training with an understanding of the discipline based on deep, extended, even obsessional intellectual commitment. A person who writes a dissertation has ever thereafter a certain model of intellectual devotion, of in-depth study and reflection, as the only entirely appropriate and fulfilling way of coming to know anything well. It is that experience of thorough intellectual devotion that grants you the right to profess before a class. And every more casual intellectual encounter thereafter— every one of the hundreds of thousands of such casual encounters one promotes and requires as a teacher—is undertaken with knowledge of its inherent lack and limitation. You never thereafter believe the student who merely does his or her homework, whether carefully or perfunctorily, or who spends but a week on a seminar paper, has exhausted his or her potential or really traveled to the end of any intellectual journey. And as much as possible you try to embed echoes of more thorough devotion into the transitory work that actually occupies American classrooms. Writing a dissertation is thus part of the appropriate training in how to represent and transmit disciplinary knowledge. It also provides a model of intellectually committed writing, writing as a serious and extended

<div align="center">

120

</div>

undertaking, that can inform the perspective of any composition teacher. Do we really want our writing teachers never to have written anything longer than a seminar paper? That is what pedagogy loses when we stop hiring Ph.D.'s or grant the degree without a dissertation. And that is the bright new world some faculty are unknowingly offering to us with such pride in realism.

Proposals to dumb down the humanities Ph.D. would have other negative consequences as well. Since no one is suggesting that physics or chemistry professors do not need to do dissertation research to get a Ph.D., the possibility of a two-tier credentialing and prestige system arises, with humanities faculty even lower in the professorial pecking order than they are now. Watering down the humanities Ph.D. would help maximize the salary spread between disciplines, make it still easier to hire people without Ph.D.'s to teach humanities courses, make humanities departments less competitive in the battle for campus resources, and turn us into less effective advocates in Congress and elsewhere.

Downsizing (ˈdaủnˈsīziŋ) At this advanced point in the degradation and causalization of academic labor, a point at which ruthless corporate tactics are becoming all too apparent on campus, *downsizing* would hardly seem in need of a definition. As a managerial strategy, it is the epitome of perhaps the most pessimistic connotation of that other desideratum of human resource management, flexibility. That is to say, while from one perspective downsizing provides strategic adaptability, the capacity to adjust continuously to change, from another view it means just what Emily Martin describes: the "school system [or industry] flexibly contracts or expands; the powerless employee flexibly complies" (145). For as Martin explains, "small and nimble," not big or even stable, are privileged values these days, so privileged in fact that almost any means necessary to achieve so spritely an end can be rationalized by a business or university. Flexible credit cards, flexible payment plans, even the gastroenterologist's best friend or, rather, instrument of choice, the flexible sigmoidoscope—these are all good (in the case of this last innovation, one must concede, very good indeed).

Downsizing is one of those things that potentially can serve a greater good than that adaptability gained by an institution or corporation—or it can cause a greater harm. Certainly the authors of this book, as ought to be clear from such entries as **part-time faculty, outsourcing,** and

cafeterias, deplore the downsizing of the nation's tenured professoriate (and of the workforce more generally) and the erosion of academic freedom that has inevitably been one of its results. From only the most cynical perspectives of the professoriate and of higher education as serving largely a credentialing function for undergraduates could the downsizing of tenured faculty be viewed as serving a greater good. The exploitation of teachers and deterioration of education in America are far too heavy prices to pay for such administrative flexibility.

Yet at various times each of us has supported, even advocated, *solely as a temporary strategy,* the downsizing of both moribund academic units and overenrolled doctoral programs, especially those that continue to produce far more Ph.D.'s than any "market" will ever employ or demand. Such advocacy constitutes what we regard as a principled response to the material conditions of today's graduate students and the bleak prospects many face. So long as significant numbers of new Ph.D.'s in English, history, sociology, mathematics, and other fields need to borrow large amounts of money to complete degrees (see *debt*), drop out before completing their degree programs (see *attrition rates*), *and* find it extremely difficult to find gainful employment, we shall continue to take this position. When the huge pool of surplus Ph.D.'s dries up, making it no longer possible for schools to hire part-time faculty at $850, $1,000 or $1,500/ course, then of course such advocacy would seem misguided. Until then, we will hold to this position and, much like the MLA's Committee on Professional Employment, ask schools producing more than their share of doctoral holders to reconsider the size of their programs.

So, for example, when four English departments (out of over 127 that grant doctoral degrees in the United States) like the University of California–Berkeley, Columbia, CUNY's Graduate Center, and New York University produce by themselves nearly 11 percent of the total degrees granted between 1993 and 1995—188 Ph.D.'s in just two years—downsizing might not seem like such a bad idea ("Modern Language Job Market" A7).[1] To be sure, these are all fine departments, but one graduate student we know found out recently what the market—or, rather, "job system"—in New York is like for Ph.D.'s in English as a consequence of this overproduction. He applied for an assistant professorship at a metropolitan area community college that was advertised in only one Sunday edition of the *New York Times.* He later learned from the department chair that such an advertising strategy was becoming commonplace at the college. And why not? That single notice attracted over 300 applicants, the job seeker was informed, a potential labor pool more than large enough

to contain many talented teacher-scholars. Taken together, as the MLA's data show, Columbia, CUNY, and NYU, three of the top four schools in America in terms of the numbers of Ph.D.'s they produced between 1993 and 1995, bear considerable responsibility for this condition.

What condition, you might ask? Joseph Berger pretty much summed it up in the title of his 8 March 1998 article in the *New York Times*: "Life as a Ph.D. Trapped in a Pool of Cheap Labor." One of the adjuncts whose "professional" life he describes is Wendy Scribner, a Ph.D. from NYU who teaches at CUNY, among other institutions. CUNY, by Berger's account, employs some 7,500 adjuncts, 60 percent of the total faculty. An adjunct for seventeen years, Scribner only recently qualified for health insurance benefits from the school; prior to that, she saw doctors at the public clinic at Bellevue Hospital. Her perennially low salary, however, has allowed her to buy a small co-op for $6,000 and, from time to time, to fill the gas tank of her 1978 Chevy van. She does a good bit of walking, though, moving from one institution to another around the city and carrying much of her work with her. Such labor is necessary, because Scribner has been afforded by New York City Technical College in Brooklyn the storage space of only one drawer in a standard-sized file cabinet and the use of one of five desks some thirty teachers share. Throughout this book, we have related similar kinds of stories, but in the context of an entry on downsizing, we thought it appropriate to describe this part of the job system in New York: CUNY, NYU, and Columbia produce a huge surplus of academic workers with Ph.D.'s, whom they can later hire at salaries, as Berger notes, that amount to less than that of an elementary school teacher with a baccalaureate degree.

Downsizing, of course, is no panacea. Who ever said it was? It isn't especially radical either. Neither of us has ever claimed that it was. Yet a number of commentators continue to vilify anyone even suggesting downsizing as a possible response to the crisis in higher education, or continue to insist that it will do more harm than good, or persist in their denials of problems that downsizing might remedy. Such assertions run a wide ideological gamut, which the following shortlist is intended to demonstrate, from the solipsistic to the "political," from the self-centered to the selfless, from the statistical to the accusatory:

1. Cutting back on graduate admissions, if indeed it happens, will be a draconian remedy to the current crisis, punishing both those who want to study literature beyond the undergraduate level and those eager to teach them (Showalter, "Diary" 25).

2. Indeed, according to Stephen Watt, reductions in admission to the English Ph.D. program at Indiana have already resulted in a graduate student population increasingly drawn from elite private and major public schools. Essentially, the Bérubé-Nelson proposal [from the introduction to *Higher Education Under Fire*] would solidify this prestige game and increase class inequity (Neilson and Meyerson 246).

3. Having fewer students, graduate or undergraduate, means that fewer teachers will be needed. There is also the issue of critical mass. Downsizing will undoubtedly affect the quality of work produced by the graduate students and teachers who remain in the programs that survive (Pfannestiel 46).

4. Nelson's suggestion . . . accepts as a "necessity" the other corporate demand that critique-al humanities be "downsized" (according to the *Chronicle,* "marginal" doctoral programs should be closed). . . . To be more precise, Nelson's suggestion is little more than a Reaganesque trickle-down arrangement that effectively institutionalizes cheap labor so as to increase the "profit" in the knowledge industry: it introduces all-too-familiar corporate "privatizing" measures into higher education (Zavarzadeh 57).

Most arguments against *any* kind of downsizing, to any group at any time, resemble these just cited and need to be considered. Let's also say that each of them, to a greater or lesser degree, raises objections well worth such consideration.

"Lesser degree" describes Elaine Showalter's comment in her "Diary" of experiences at the 1994 annual convention of the MLA. That she ascended to the presidency of the association just a few years later and that in 1997 the MLA initiated more formal ruminations about jobs and the academy are ironies of the highest order. For at this point in her deliberations on the matter, the only intervention Showalter seemed capable of making was the insight (quoted elsewhere in this volume) that humanists might "promote graduate study, like travel, as broadening." Something like the grand tour of Europe aristocratic Americans used to take, only vastly more expensive both economically *and* psychically for those least able to foot the bill. Given the implications of this trope and its connotations of privilege, it is hardly surprising that she finds faculty "eager" to teach graduate students as the victims of downsizing. Downsizing graduate programs thus punishes these faculty unfairly, poor darlings, as if someone speaking *ex cathedra* from the offices of the MLA at 10 Astor Place or the national headquarters of the AHA declared it the divine right of profes-

sors to lead acolytes into the sweetness and light of literary or historical study. That some talented undergraduates might be deprived of the experience is, quite obviously, a regrettable consequence. And that Showalter didn't actually know that many programs by 1995 had already begun to reduce admissions—"Cutting back on graduate programs, if indeed it happens"—is equally unsurprising. The presidents elected by many professional associations seldom trouble themselves with such details.[2]

The middle passages above, in effect, are sincere if also, particularly in the case of Neilson and Meyerson's projection of their own worries onto one of the authors of this book, uncompelling criticisms of the downsizing of graduate programs. But each of their objections is serious. To address their particular concern about the downsizing of graduate programs leading to elitism, I should mention that not long after my own department began to reduce its graduate enrollments in 1990, I recognized an incoming class as coming, to a disturbing degree, from a highly privileged background: expensive Ivy League and other private schools, undergraduate years abroad, and other signs of affluence (and I mentioned this observation to Jim Neilson). An admissions committee sensitive to the issue of elitism will make sure reductions in class size do not lead, as Neilson and Meyerson feared in an earlier essay, to a privileged homogeneity: a "younger, whiter, wealthier graduate student population" ("Public Access Limited" 270). In fact, something of the opposite appears to be the case in recent classes at Indiana: slightly older students, for example, with rich work and diverse academic experiences, and a more heterogeneous population in general. Like Showalter, Neilson and Meyerson are quite right to bemoan the reduction of educational opportunity for aspiring young academics, which is why both of us hope such reductions at the graduate level will not be necessary in the near future. But educational opportunities at the undergraduate and graduate levels are indeed far different matters: everyone doesn't need a doctorate to succeed in this world.

Todd Pfannestiel's difficulties with downsizing seem, for the most part, understandable but not particularly insoluble. No one wants to see the "critical mass" of a department's graduate student population erode to the extent that a basic curriculum is undermined. Further, since graduate student classes, especially seminars, in most disciplines are fairly small, a reduction in graduate student population should not lead to a huge loss of faculty lines, as he fears. And the quality of work in many disciplines should improve, not deteriorate, as graduate faculty are afforded more time to mentor more effectively the students they do have. Pfannestiel is

quite properly concerned with state legislatures—he mentions Ohio's—eliminating graduate programs at "all but a handful of public institutions in the state" (46). Clearly, legislators are not in the best position to know how best to manage graduate education. But his observation does beg one question: are there more than a "handful" of history departments at public universities in Ohio—more than four or five such departments, that is—that *should* be producing doctoral holders when, by Pfannestiel's own calculations, fewer than one-third of last year's new Ph.D.'s in history found full-time jobs?

Mas'ud Zavarzadeh's critique of downsizing is far more complex and, finally, far more personal. To begin, he is certainly right to insist that downsizing should not be thought of as replacing or rendering unnecessary "more serious and thorough solutions to the crisis of labor relations in the academy" (57). Of course. And, to be sure, "spontaneism" in the form of trade unionism has not always proven itself to be an effective substitute for both a "global theoretical understanding" of the labor crisis and, in one of his several obeisances to Lenin, a "revolutionary 'class' struggle" (58). But, on the off chance that part-time instructors of English, Spanish, and mathematics are not finally able to catalyze a revolutionary class struggle, what would be the next best alternative? That's a tough question for Zavarzadeh, for whom such "practical" considerations are always already "ideological constructs"; the "practical" is always practical, he maintains, "for the status quo" (57). Radical transformations are not wrought from practical considerations. And nothing less than "radical" transformations will satisfy him and his compatriots at the *Alternative Orange*.

But what about this scenario? What happens when a pool of unemployed Ph.D.'s or ABDs dries up in a university community? If a large doctoral program has downsized its student population, who will teach those introductory courses colleges and universities need to get taught? What does an institution do in such a time of crisis after rumbling about increasing class size and other tactics which, when revealed, contradict its advertising campaigns and claims of providing consumers (aka students) with a quality undergraduate education? This is, to be sure, plain old supply and demand economics: elementary, unsophisticated, not "radical" in the least. It is, to some degree, even Reaganite supply-side thinking or, worse in Zavarzadeh's characterization, a banal form of "pragmatic localism" (58).

Quite right. But until the class struggle comes or postindustrial Americans all achieve a transformative Leninist epiphany, real, even practical, decisions await us. Can every university, no matter how large, still afford this course in Hungarian literature, that course in Old Norse? Can faculty

in highly specialized areas—Czechoslovakian literature or Creole studies—expect to earn a full salary while teaching four or five students a year? Is there something inherently wrong with requiring such faculty to contribute some of their time teaching a few larger courses within the realm of their professional competence? "Local pragmatism" isn't nearly so important as "global theoretical understanding," no question about it. And when that understanding can so ameliorate the reasons for downsizing marginal graduate programs—let's say, for example, the doctoral program in the seventh-best history department in a public university in Ohio—we'll all be much relieved.

<div align="right">

SW

</div>

E

Electronic Mail (ə¦lek¦tränik ¦māl) It's not likely you could find any campus where people do not wonder whether e-mail is more bane or boon. It makes staying in touch with people much easier, but it also may dramatically increase the number of messages you receive. Some departments treat e-mail access to faculty as an inalienable right for students. Some faculty who sponsor e-mail discussion groups for their classes invest them with similar moral imperatives: any comment posted by a student must receive faculty feedback. Few thought the computer would literally become the temple of the academic workplace, but perhaps these new religious practices will lose some of their appeal once they become routine.

In one area e-mail offers us something we have not had before—a way for geographically scattered people in a political movement to maintain a collective dialogue quite easily. While it will not replace the face-to-face contact often necessary for recruitment to a cause, it is a new way for an organization's members to debate an issue, interact with one another, and maintain a form of participatory democracy.

Yet e-mail also presents other sorts of opportunities, especially opportunities for surveillance. Many of those who use e-mail accounts based at a corporation or a university assume roughly the same sort of privacy they have in sending first-class mail. Yet that is not always the case. Most e-mail accounts like this are backed up, or archived, on a mainframe computer. A business may consider its e-mail business property; a university may view its e-mail as the equivalent of official business. If reason arises, either a corporation or a university may call up the entire archive of a staff member's e-mail and read it. A corporation may regard monitoring e-mail as a routine matter, to make certain an employee is not wasting time at work.

The very ease of "auditing" e-mail is generating increasingly officious memos from administrators and anxiety from staff about what is or is not appropriate in "official" communications. Everyone who uses e-mail

includes personal asides even when doing official business. You acknowledge receipt of a paper and mention you hope the children are doing well. At the University of Washington, state guidelines permit such a human interaction *so long as its duration is minimal and the personal portion is contained within an official business communication.* Cheerfully hoping to guide the ship of state past such treacherous shoals, an official state agency, the Executive Ethics Board, offers the following example in its guidelines:

> An employee uses her agency computer to send electronic mail to another employee regarding the agenda for an agency meeting that both will attend. She also wishes the other employee a happy birthday. This is not an ethical violation. Although there is personal communication in the message, the message was sent for an official business purpose. The personal message is de minimis and improves organizational effectiveness by allowing informal communication among employees.

In case faculty were feeling pretty good about their freedoms after reading this item, the Washington state guidelines go on to define e-mail more broadly:

> Electronic mail is not analogous to telephone use. Electronic mail is not private; its source is clearly identifiable; and, it is subject to public disclosure requirements. Consequently, electronic mail communications may remain part of the state's records long after the employee "deletes" the communication. If a state officer or employee represents an opinion or viewpoint that does not reflect the official position of the agency, such communications should carry an appropriate disclaimer.

Punitive campus surveillance of e-mail is on the rise. At Yale a young faculty member accused of sexual harassment found his e-mail had been read by administrators for supporting evidence. Administrators at Appalachian State University did the same. Staff members at the University of Washington who file lawsuits or grievances not uncommonly find their e-mail being audited to see if they are using it improperly; a vague state law prohibiting private use of government resources lets administrators intimidate staff who send "personal" messages by e-mail. Some faculty members at the Open University in London now routinely place a disclaimer on their e-mail messages: "This in no way represents the views of the university." At other campuses threats have been made to audit e-mail to find if people are using it to do union organizing.

Some public institutions are taking advantage of the availability of

e-mail to a supervisor to pose still more restrictive and intimidating questions: what topics is an "officer of the state" (read faculty member) permitted to address in official correspondence? To the corporate mentality such oversight seems natural, even inevitable. Many faculty on the other hand feel strangers reading their e-mail would be no different from someone opening and xeroxing their first-class letters before they were sent. At least the FBI requires a court order before opening mail, not so the dean before he reads your e-mail. At one state university a faculty member routinely places an aside to the dean in his e-mail: "Are you listening, Jack?" "Was that sentence 'professional' enough for you, Jack?"

At Wayne State University in 1997 outgoing president David Adamany issued an "executive order" limiting computer and e-mail use strictly to official business, meanwhile asserting full administrative rights to monitor e-mail to ensure compliance and promising punishment for offenders:

> The University advises users that the University is entitled to access and monitor its information technology resources without prior notice, knowledge or permission, for bona fide University purposes including, but not limited to, resolving an urgent circumstance, obtaining valuable University-related information, complying with a court order, warrant, subpoena or other legal discovery request for information, assessing compliance with University policies or any applicable law, preserving property or information that may be lost or destroyed, attending to maintenance concerns or addressing safety or security concerns. Therefore, the University advises users that they have no privacy interest or expectation of privacy in information stored on or transmitted over the University's information technology resources, and that access and monitoring is [sic] a reasonable means of advancing University purposes.

Adamany added that "users should take care not to display or broadcast in shared computing facilities images, sounds or messages that could create an atmosphere of discomfort, harassment or intimidation for others, and refrain from transmitting such images, sounds or messages to others." Since he issued this policy without faculty or student input, he managed to choose the most confrontational way of announcing it. He effectively put the university on record as responsible for the content of all e-mail messages, including those from students, and thereby raised serious liability consequences. All this, combined with Adamany's departure, combined to help local faculty put a stop to the plan. But less dramatic surveillance is under way elsewhere.

One obvious if partial solution to this problem is not to archive e-mail, to keep no copies on campus or anywhere else, or perhaps to archive it

for only two to three days. Faculty members should begin insisting that permanent backup systems be dismantled. That would also solve another problem—that e-mail backups could otherwise be subpoenaed in a court case. In legal terms, e-mail is discoverable. Campus e-mail has already been monitored by federal law enforcement agencies. The privacy of e-mail in the corporate world has become a public issue and may be addressed legislatively. Yet the situation in academia, where First Amendment rights also intersect with traditions of academic freedom, is not identical. Faculty have a special basis to insist on their right to unsupervised communication. Otherwise we will soon be referring to the Orwellian world of e-mail. Our electronic utopia will prove a dystopia after all.

<div align="right">

CN

</div>

F

Faculty (ˌfakəltē)

> At the community college where I now [1997] work part time . . . the criteria [for reappointment] are rather low. The English department has fifteen full-time faculty and about sixty part-timers—the dependence on part-timers is clearly enormous. Every semester, the department head has to scrounge enough qualified people willing to teach a class for between $1,100 and $1,300.
>
> —James Sullivan

In what must be regarded as an irony every bit as cruel as T. S. Eliot's April, as more adjunct faculty like James Sullivan labored in the freshman classroom for a salary that frequently fell below the minimum wage, critics of higher education continued their assaults throughout the 1980s and '90s on an "overpaid, grotesquely underworked" professoriate living the good life at the tuition payer's expense. Such critics, however, often echoing the list of "indictments" with which Charles J. Sykes introduces *Profscam* (1988) as we just have, typically haven't bothered to look very hard at higher education in America and the status of the people actually teaching introductory mathematics, English, or Spanish. Or, for that matter, bothered to credit the industry of the vast majority of tenured faculty on today's college campuses. The numbers don't lie: in 1993, 47 percent of the teachers at the nation's colleges and universities were part-time or "non-tenure-eligible" faculty working for little pay and often less job security (see Table 1);[1] another 18 percent were graduate students who, increasingly, borrow more and more money to supplement the meager stipends they earn teaching. Nor have critics like Sykes actually made any effort to discover what life is like for a growing number of Ph.D.'s in English, history, sociology, and French, earning a salary just above the minimum wage *if* they can successfully cobble together a career teaching two classes here, two or three there, a town or two away down the highway. Our later entry on **part-time faculty** attempts to provide a glimpse

of their lives. In this essay, however, we hope to extrapolate from such sobering statistics a definition of what the term *faculty* might mean in the new millennium.

Table 1

Change in Faculty Distribution by Type of Appointment, 1975 and 1993

	1975	1993	%Change
Full-Time Faculty:	435,000	545,706	**25%**
(% of all)	**56%**	**49%**	
Tenured	228,000	279,424	**23%**
(% of full-time)	52%	51%	
(% of all)	**29%**	**25%**	
Probationary	126,000	114,278	**−9%**
(% of full-time)	29%	21%	
(% of all)	**16%**	**10%**	
Non-Tenure-Track	81,000	152,004	**88%**
(% of full-time)	19%	28%	
(% of all)	**10%**	**14%**	
Part-Time Faculty:	188,000	369,768	**97%**
(% of all)	**24%**	**33%**	
Graduate Assistants:	160,000	202,819	**27%**
(% of all)	**20%**	**18%**	
All:	783,000	1,118,293	**43%**

Note: These data on faculty are derived from "Fall Staff in Postsecondary Institutions, 1993," NCES, 1996; and "Digest of Educational Statistics, 1995," NCES. Graduate assistant data are based on statistics from EB/AAUP, June 1997.

At one time, of course, the word *faculty* wasn't difficult to define. In the mid-Victorian era, for example, John Henry Cardinal Newman's conception of a faculty, despite its obvious gender and class valences, had an attractive metaphysical solidity and emphasis on academic community:

> An assemblage of learned men, zealous for their own sciences, and rivals of each other, are brought, by familiar intercourse and for the sake of intellectual peace, to adjust together the claims and relations of their respective subjects of investigation. They learn to respect, to consult, to

aid each other. Thus is created a pure and clear atmosphere of thought, which the student also breathes [76].

If faculty are more easily definable in Newman's *Idea of a University* (1852), so too is the mission of a university in which the "liberal education" that marks a gentleman takes precedence over merely "useful knowledge"; philosophical "habits of mind" and the cultivation of critical taste reign supreme over more mundane and instrumentalized pursuits. Certainly many college and university teachers would find Newman's institution a more congenial habitus than their own. But on many campuses today, what does the term *faculty* actually mean, and is there any real possibility of creating a learned community there? More important, what sort of intellectual "atmosphere" do the students breathe at a school in which part-time faculty dominate their tenured colleagues by a ratio of 2:1 or more? Because *faculty* too often means part-time academic laborer and *student* at the corporate university too often connotes "consumer,"[2] Newman's "pure" intellectual air at many institutions is deteriorating into a meretricious climate in which, in the worst instances, some student-consumers treat faculty with the same indifference or outright disrespect they often show other lowly paid service workers. Some of the most egregious instances of this behavior are reported below.

In addition to denigrating the integrity of college faculty, such critics of the professoriate as Sykes, both in *Profscam* and his sequel *The Hollow Men* (1990), and Dinesh D'Souza, in *Illiberal Education* (1992), have serious ideological axes to grind. For it is one thing to indict tenured or tenure-track faculty for abandoning the classroom in favor of their research, an indictment worth examining given its presumptions that this abdication actually exists and was freely chosen by most faculty; it is another to accuse them of creating "dour and brittle new orthodoxies" to impose on "both scholarship and academic life" so as to "prescribe draconian limits on both free speech and the exchange of ideas" (*Hollow Men* 16). At the heart of such paranoid discourse—and its proponents' multifoliate rhetorical strategies to paint a distorted picture of higher education—is a twisted logic that in the new millennium may become obsolete: Sykes's idea of tenure not as "the guarantor of the academy's freedom of thought" but as the "ultimate control mechanism" (*Hollow Men* 21). As the tenured professoriate at many institutions reaches retirement and are replaced either by "non-tenure-eligible" faculty or, better from the managerial standpoint, by heavier teaching loads and larger classes for

their colleagues who remain on the job, Sykes will have less reason to lose sleep at night over the politics of tenure reviews.

Sometimes this criticism of college and university faculty comes from, well, less formidable sources. Such was the case in the South Carolina legislature in 1995 when a retired agricultural extension agent from Clemson and a retired professor of physical education from Erskine College supported a bill (GJK 21346SD) that would have amended a 1976 code permitting faculty to receive tenure at state institutions. Their argument, one grounded on their many years of experience at the farm co-op and in the equipment room at the gym, consisted of two points: tenured faculty tend to "slack off in their teaching" and "perhaps just as bad, they often lose themselves in frivolous research" ("Tenure Is Essential" C1). The frivolity of this research was never quite specified, at least not in the way Sykes and D'Souza disparage specific courses and research projects they don't like at places like Duke and Dartmouth, and it is to the great credit of faculty in South Carolina that many responded forcefully to these aspersions on their characters and intellectual projects. The bill failed.

Such accusations of frivolity or ideological narrowness give way, at times, to delusions of material privilege, fantasies of an easy life enjoyed on campuses more like country clubs than institutions of learning. Such is the case in *The Cliff Walk* (1997), Don J. Snyder's chronicle of being fired by Colgate University before a tenure decision was rendered, a part of which was excerpted in the *New York Times Magazine* (2 March 1997). But even for those who missed the *Times* that Sunday or haven't yet cracked the entire dream narrative Snyder weaves, his reminiscences of faculty life at "Camp Colgate" bear an uncanny resemblance to similar myths promulgated by critics like Sykes and certain elderly South Carolinians. Like Sykes and D'Souza's work, for example, Snyder's early chapters contain brief salvos aimed at developments in the humanities that offend his notions of transcendent aesthetic beauty and reverence for the imperiled Western tradition. So, in relating his life of privilege at "Camp Colgate," Snyder celebrates the "majesty of literature" when it isn't "waterlogged by scholars' literary theory" (29). "Dream," by the way, is not my characterization but Snyder's; neither is "Camp Colgate," which is the invention of his former students. Faculty life there seemed, to young Professor Snyder, "charmed": the university ski slopes temptingly visible from his office window, "the squash courts and beautiful indoor tennis courts, or the award winning eighteen-hole golf course and the trap-shooting range"

a mere "bike ride from campus" (12). Working, by his computation, less than half a year and residing in a comfortable six-bedroom house near the school, Snyder and his family lived "like royalty" (13).

Perhaps Snyder's ill-conceived ideas about the work successful faculty must do—planning and teaching courses, meeting with students, reading undergraduate theses and graduate dissertations, serving on committees at a variety of professional and institutional levels, *and* producing high-level scholarly or creative work—had something to do with his abrupt career change. The fact is, in the fifty years-plus the authors of this book have worked in higher education, very few faculty indulge themselves in the ways Snyder implies. The vast majority of faculty work hard, typically well over forty or fifty hours per week, and typically for far less money than professionals in other lines of work. That small minority who don't, who abuse their job security, need to be identified and sent packing. And Sykes and those like him who promote such destructive fantasies of faculty privilege need to study the matter more diligently and honestly—or find other lines of work, as Snyder has.

A far more serious characterization of faculty—and a more trenchant critique of the value of the research in which many scholars in the humanities are engaged—is offered by David Damrosch as part of his larger aim to change the "culture" of the contemporary university. There is, to be sure, little arguing with his assertions that the sense of community at many universities and within many academic departments has been sundered by their inherent structures of academic specialization, even isolation; and that there is a fundamental contradiction at work in many institutions. Like Snyder's account of a sumptuous life at Colgate, Damrosch's observations seem all too familiar: his meditation on the contradiction between, on the one hand, a "monolithic status system in American higher education" based largely on "research" and on the "national reputation" it and large graduate programs can bring, and, on the other, the urgent need to teach undergraduates whose education may not be enhanced much by the arcane intellectual pursuits of their teachers (39). Worse, the most successful of these faculty, the most ambitious and narcissistic, preach asceticism to their graduate students while they enjoy a "jet-setting" lifestyle ("jet-setting" serving as Damrosch's adjective of choice throughout his invective against the "professorial entrepreneur"). A "rarified and exotic sort" who flit from one conference to the next, these "jet-setting academic stars" constitute the most conspicuous evidence of what for Damrosch is the modern university's major problem: the "pressure toward homogeneity" (43). Because "smaller schools," even those

136

with "no graduate programs of their own," now require "all the trappings of specialized research in their faculty" (39), all that remains of the "individual character" of a college are the "few diehard senior faculty whose hearts are in undergraduate teaching" (43).

That the postmodern institution pushes faculty toward homogeneity hardly seems a startling insight; many commentators on postmodernity would surely expect such a condition. Nor is it any great shock to learn that Columbia, where Damrosch teaches, harbors a "few" diehard teachers who would just as soon not publish anything or have much truck with graduate students. That those faculty who flourish in such conditions would be impugned as unconscionable careerists or yuppie "jet-setters," however, while perhaps not surprising is nonetheless disturbing. So, while Snyder describes indolent faculty too preoccupied with their tennis games to work a full week, Damrosch castigates a faculty too busy writing to teach or invest their time in cultivating a collegial atmosphere. Either way, the critique seems clear. Faculty aren't doing what they should: they're prospering from what in one case is lethargy and what in another is professional hyperactivity.

The life James Sullivan leads as a part-time faculty member in the English Department at Illinois Central College bears no resemblance to that of Snyder's happy campers or Damrosch's careerists: no ski slopes or six-bedroom houses, no squash courts, not a scintilla of jet-setting prerogative. Not even the leisure of expressing a wistful nostalgia for the more congenial days gone by, the days before productive junior faculty— "these young publishing scoundrels (to borrow a Jamesian phrase)"— were "treated by administrators with greater privilege than that accorded to senior faculty whose stature has been achieved in more complete ways" (Miller 9). Life as an adjunct faculty member at this community college in Peoria, Illinois, is obviously more austere. And it is also far more representative of the present and, unless recent hiring trends and university managerial philosophies can be successfully countered, future status of faculty in higher education than Snyder's reveries of the idle, solipsistic lives of the gentleman-scholar or Damrosch's unflattering portrait of a small bevy of academic superstars.[3]

At community colleges in many states, the ratio between full-time and part-time faculty that Sullivan identifies, roughly 4:1 or 80 percent part-time faculty, has become commonplace. Writing for the American Federation of Teachers in 1996, Perry Robinson identifies the states in which reliance on part-time instructors is the most profound: Vermont (100 percent), Nevada (80.5 percent), Colorado (74.1 percent), Illinois

(73.6 percent), and so on (Robinson 9). In the names of such innocent-sounding corporate goals as "flexibility" and "efficiency"—keywords in the Board of Regents of the University of Minnesota's attack on tenure in 1995—full-time and tenure-track positions, at community colleges and research institutions alike, are on the decline.[4] Even excluding the huge amount of teaching graduate students do at research institutions, as we have mentioned above, over 40 percent of the nation's faculty of higher education in 1997 were part-timers, with all this implies about inadequate salaries, poor benefits (if any), and so on. (We discuss the "flip side of the part-timer coin," as Vincent Tirelli puts it, the "expansion of the administrative apparatus," elsewhere in this volume.) That this "casualization" or degradation of the academic labor force diminishes the quality of undergraduate education would appear obvious: how could part-timers be expected to invest fully in "maintaining program continuity and integrity?" (Tirelli 79). How much enthusiasm could they be expected to muster year after year for syllabi they might be handed only days before the beginning of class? How much time could they devote to meeting students outside the classroom in the mad dash many part-timers make from one school to the next, one parking lot to another? How could the quality of education, in short, not be affected adversely no matter how skilled and dedicated the part-time faculty member?

As important as these questions are—and as obvious and negative as the answers are—we want to turn instead to the subject of this chapter: faculty. What are they now, and what are they likely to become if universities continue to corporatize? The stories below are intended to provide suggestions of possible answers, all of which are unsettling and about as far away from both Cardinal Newman's community of intellectuals and Snyder's fantasy of faculty privilege as one could imagine.

Adjuncts, Gypsy Cash Cows, and *Maquiladoras*

> As in most U.S.-Mexican border foreign-owned factories, called maquiladoras, the majority of workers are women. . . . Most of the women make base wages of 52 cents an hour.
> —"Jobs to Juárez," *Bloomington Herald-Times*, 26 January 1998.

In a session on "Part-Time Faculty, 'Others,' and the Profession" at the 1996 annual meeting of the Midwest Modern Language Association, Katherine Kolb described a "gypsy sense of tribe: [part-time faculty] are a

dispersed proletariat lacking a redeeming—and politically energizing—solidarity with our peers" (37). Vincent Tirelli agrees, regarding the problem Kolb identifies as part of an odious pattern of employment which will almost certainly become more prominent in the future: "The fragmentation of work roles in the post-Fordist era places obstacles in the path of successful mobilization of workers and raises the question of what, if any, strategies and tactics might help to alleviate exploitative conditions" (75). Karen Thompson, an adjunct faculty member at Rutgers for many years, offers what we regard as the first principle in effecting any amelioration of these conditions: solidarity among both part-time and full-time faculty, student organizations, and staff unions, all of whom have much to gain from this alliance. Such mutual cooperation, Thompson asserts, was perhaps the "most important" lesson she and other faculty learned as they attempted to organize and negotiate with Rutgers: "part-timers can't make gains by themselves" (283).

But it isn't just the atomization of "faculty" in the corporate university that makes the project of amelioration so difficult. Nor is it the lingering ethos of gentility, as pronounced as it is in organizations like the MLA and the AHA, that often prevents an enervated professoriate from recognizing its common interests with adjuncts and staff—or the same ethos that prevents many tenured faculty from regarding themselves as employees in the first place. As significant as these factors are, they only contribute to the plain economic facts of part-time employment as sketched by Sullivan and others: part-time instructors are among the fattest—or leanest, depending upon your perspective—cash cows in the postmodern university. Here are Sullivan's calculations based on his salary of $1,140/course in the fall of 1997 at Illinois Central:

Tuition		$42	per student/credit hour
State Subsidy		$26	per student/credit hour
Typical Class (hours)	X	3	credit hours
		$204	gross income/student
Minimum Enrollment	X	7	
		$1,428	"break-even" point
Instructor's Salary		($1,140)	
Overhead (clerical, etc.)		($288)	
	X	0-	

Since Sullivan taught forty-two students in two courses of freshman composition in the fall 1997 semester, he netted approximately $5,712 for the institution (4). If the other forty-four part-timers in his department taught similar class loads and numbers of students—and, of course, most

part-timers teach far more than this—they earned over a quarter-million dollars for their institution. In so doing, they served as cash cows for their departments, ones necessary if full-time faculty are to enjoy something resembling a profession.

This essential role part-time faculty play in the economy of the corporate university parallels that of cheap labor throughout the world in the age of transnationalism. And universities, in this regard, are coming to look a little more like *maquiladoras* every day.

Maquiladora is the name given to foreign-owned plants that, since the 1980s and especially since the passage of NAFTA, have started or expanded operations south of the American border in cities like Juárez, where nearly 200,000 workers produce parts for and assemble consumer electronic products, particularly televisions. Over the past several years, firms like Thomson Consumer Electronics (TCE, makers of RCA products)—with factories in Indianapolis, Scranton, and elsewhere—have relocated many of their operations to Mexico so as to reduce labor costs involved in manufacturing. More specifically, labor now accounts for only 5 percent of the cost of producing a $200 portable color television set which, when assembled in the United States, retailed at $270. It isn't difficult to determine how such a savings is made possible: with food coupons, free meals, and transportation allowances, a worker's salary of 52 cents at Juárez's TTM plant (Thomson Televisones de México) amounts to only $1.54/hour in total benefits; by contrast, a line worker in Bloomington, Indiana, where TCE closed its fifty-seven year-old factory at the end of March 1998, earned $10.29–$10.60/hour, which, with health and retirement benefits added, amounted to nearly $19/hour in total compensation.

Before discountenancing this analogy between academic laborers and Mexican factory workers, one needs to consider the demographic data that accompany such a degradation of the workforce. The nearly 1,100 employees who worked at the TCE final assembly plant in Bloomington before it closed were, on average, forty-nine years old and had been on the job for twenty-six years; the average age of the 4,200 workers at TTM is twenty-six, and they have worked at their jobs less than two years. Aided by both the Teamsters and the United Electrical Workers, the Authentic Labor Front established an office in Juárez in 1996, but the cause of *Sindicalismo sin Fronteras* faces enormous obstacles. Like the gendering of today's part-time faculty, the majority of Juárez's workers are young women—"They are more patient," one manager explained. "The girls accommodate better to this kind of work" (Hinnefeld A5). (By

painful contrast, many of the lifelong workers at Bloomington's plant were single women in their late forties or fifties, too young to retire but too old, many feared, to start a new career.) They are also every bit as "atomized" as America's part-time faulty and as "nomadic," to return to Kolb's metaphor: in some areas it is not uncommon to have a 10 percent turnover of the work force *per month*. The size of TTM's workforce in Juárez, for example, has decreased significantly in the past eighteen months, largely because countries like China and Indonesia offer TCE, SONY, Samsung, Zenith, and other companies with plants in Mexico a less costly labor force. With a little luck, that $200 nineteen-inch color television might be even cheaper in a few years. And the color might be just as crisp if companies like TCE can successfully train a Pacific rim workforce that will almost surely include children.

Fortunately, eleven-year-old children cannot teach freshman composition or introductory calculus; and, of course, part-time faculty typically earn more than 52 cents/hour. But how much more? Could Jim Sullivan, teaching forty-two students in his two freshman composition courses at Illinois Central, earn even the minimum wage of $5.15/hour? By the time he prepares for and meets his classes, holds several office hours during a week, and then grades—what, 250–300 essays a term?—could he earn even $4/hour? Then, there are "little things" like getting to and from work or dressing appropriately to look like a "faculty member," a concern workers from Juárez's *colonias* don't share because their employers provide them with smocks to cover their T-shirts and jeans. But the most striking comparison between the two kinds of workers transcends clothing, transportation, or even salary; it concerns an attitude, in Sullivan's more Althusserian analysis, an interpellation largely absent in the *maquiladoras*: the aspiration for a professional identity. Many adjuncts, Sullivan argues, and here we must also recognize the different motivations that drive part-time teachers, continue to teach in abject material conditions because, "interpellated" into a larger system in graduate school, they "began to think of themselves as academic professionals." To drop out or quit now would therefore invoke a "wrenching of our identities" as it also lowers a "sledge hammer" on "the cast of our ambitions" ("Not a Calling").

However psychically difficult to drop this hammer, though, longtime adjuncts like Linda Bergmann urge part-time faculty, especially women, to refuse to endure the enforced "poverty and obedience" of the postmodern monastery/corporation or, through their continued abjection, to implicitly valorize the ideology that to leave the academy is to "sell out to

the forces of evil" (49). (Her image here, by the way, is terrific: what is a high-paying corporation with all the perks for a privileged few acts as a kind of monastery for others, complete with poverty, self-chastisement, and an often numbing discipline.) Yet it is one thing for Bergmann to admonish adjuncts in this way; it is quite another for the tenured professoriate to presume to lecture to their part-time colleagues, even if some of us once taught as adjuncts ourselves. My own experience is that when tenured faculty offer this brand of "support," it is often delivered with implicit incriminations and without any sense of institutional critique: *you* need to refuse your further exploitation; *you* need to conduct a national search and be willing to move; and, far worse, *you* are the primary cause of your predicament.

So, while Bergmann's recommendation that part-time faculty conduct as large a job search as possible seems sensible *in theory*, we do not intend to echo her exhortation here except to say this: when in a recent essay John Guillory arrogated to himself the task of answering the question of "what graduate students want" with the simple answer—a job and gratification of all the desires that inhere in the notion of secure and meaningful employment—he did not consider fully the rather different kinds of jobs in teaching they might desire (Guillory 4–5). The fact is, as Bergmann and others realize, not all part-time faculty desire or are able to conduct a national job search; and not all adjuncts would jump at *any* tenure-track job they are offered. This is precisely why the solidarity and organization Karen Thompson endorses will be no easier to achieve than the *Sindicalismo sin Fronteras* sought by the Authentic Labor Front in Ciudad Juárez. Still, the term *faculty* denotes—and promises consumer-students—a *professional* teacher in the classroom; and, at base, as Guillory observes, of the "desires contingent on employment," the term *professional* gratifies the desire for at least some job security and the prospect of pursuing reasonably "interesting work" (4). Without such security and prospects, can part-timers or adjuncts, who are often not treated as professionals, be described as "faculty"? If not, then the majority of academic employees at many colleges and universities do not qualify as "faculty," and the institutions that employ them might very well qualify as *maquiladoras*.

Faculty and Wagging Dogs

> The issue here is not what I "feel." It is not my "feelings," but the feelings of women. And men. Your superiors, who've been polled, do you see? . . .

[They've found] That you are *negligent*. That you are *guilty,* that you are found *wanting,* and in *error*; and you are *not,* for the reasons so-told, to be given tenure.

—Carol to John in David Mamet's *Oleanna* (1992)

At about the same time the news media discovered the possibility that President Bill Clinton might be guilty of sexual indiscretions with former White House intern Monica Lewinsky, Barry Levinson's film *Wag the Dog,* cowritten by Hilary Henkin and playwright David Mamet, opened in theaters across America. Almost every major film reviewer in the country adduced parallels between Levinson's film and the realities of a Clinton administration besieged by one scandal after another. In *Wag the Dog* White House advisors contrive with a successful Hollywood producer to stage a fake war so as to divert attention from a sex scandal involving the president. And while the Clinton-Lewinsky relationship was dissected nightly on CNBC and CNN, America prepared to go to war with Sadam Hussein. Was art imitating life, following the mandate of Aristotelian aesthetics for mimesis, or in a sublime moment of fin de siècle decadence, was life imitating art as Oscar Wilde theorized a century ago in *The Decay of Lying?*

As eerie as this parallel seemed at the time, and without casting Mamet as either a prophet or a cynic, *Wag the Dog* is hardly his only prescient work, as the lines quoted above from *Oleanna* might suggest. Written months before and first produced just after yet another scandal of national proportion entered public consciousness—Anita Hill's bringing a charge of sexual harassment against Clarence Thomas at Thomas's confirmation hearings before Congress—Mamet's play sparked enormous controversy, angering feminist critics in particular. Perceived by many as a play that deftly manipulates the audience into cheering a professor's physical and verbal assault on a female student responsible for ruining his career, *Oleanna* is often regarded as a dramatic treatise against political correctness (a charge Mamet has denied). Whether or not such a reading does justice to *Oleanna* or Mamet is not my concern here; nor is the question of whether or not American campuses have become havens for a brittlely authoritarian political correctness, as commentators of Sykes's and D'Souza's political persuasions have charged.[5]

More interesting in the present context is the manner in which, in the speech cited above, a student stands in a position of powerful judgment of her teacher. She delivers the news; she explains the institutional rationale for denying a professor tenure. Moreover, she unquestionably believes in the justice of such a verdict, for John has not only made her feel "stupid"

but in her view has also lorded his power over her by awarding her a failing grade on a paper. She clarifies these feelings near the end of the play:

> You are going to say that you have a career and that you've worked for twenty years for this. Do you know what you've *worked* for? *Power*. For *power*. . . . Don't you see? You worked twenty years for the right to *insult* me. And you feel entitled to be paid for it [64–65].

Going to John's office in Act One seeking help in passing his class—and confused by such concepts as "term of art" and the word "index"—Carol by Act Three announces her acute awareness of John's exercise of a distasteful "paternal prerogative" in his teaching and of his misguided belief in a "protected hierarchy" in academe that cannot save him. She now represents a "group," a small number of similarly aggrieved students who, after two semesters, have decided not to tolerate John's pedagogy anymore. They report their dissatisfaction and vague accusations of sexual harassment to John's tenure committee. He is fired.

John's brutal actions in the play's final scene, his throwing Carol to the ground and castigation of her as a "little cunt," clearly cannot be supported; indeed, they confirm her worst accusations of him. But John's outrage in the closing moments of *Oleanna* should not induce us to overlook the play's final tableau. Horrified by his outburst, John returns to his desk and begins straightening papers as Carol tells him, "Yes. That's right . . . yes. That's right." What's right? The confirmation of his potential for violence or his chastened, embarrassed behavior? Could it be that the polarity of institutional power against which she has inveighed throughout the play has now been reversed? What's right is that she—and her group—now determine what's right, not faculty like John. They decide what books they will read and the campus bookstore will sell; they inform John that the terms of endearment he uses in conversation with his wife are offensive and will not be tolerated on campus.

Perhaps this reading of *Oleanna* is not *right*. But put in the context of recent cases similar to the one Mamet depicts, one thing seems certain: no faculty member should put his or her faith in anything vaguely resembling a "protective" academic "hierarchy." In the corporate university, the student-consumer may always be right, and customer power just might trump faculty power when the going gets rough.

Although such a redirecting in the valence of power on campus was not readily apparent in Don Snyder's dismissal from Colgate, his story does at one point bear a striking resemblance to John's in *Oleanna*: a student helps

him realize just how much professional power a faculty member really has. After the news of his imminent dismissal from Colgate spread through the campus, Snyder encountered a former student. "Man, not another baby boomer out of work," the student told Snyder. "Every time one of you guys loses his real job you take the crap jobs at Blockbuster and the mall so I can't even pick up summer work" (10). A short conversation with the dean convinced Snyder that the kid might be right; fifteen minutes later, he's out the door of the administrative offices heading home. And eighteen months later—after serving his final "grace" year at Colgate, running through much of his retirement savings, and unable to find an academic position—any kind of job was beginning to look pretty good.

The story is far worse in the tenure case of Adam Weisberger, former assistant professor of sociology at Colby College. Because we discuss this case at some length in the entry on sexual harassment, only a few details need be related here—and these all bear comparison to John's failed tenure case in *Oleanna*. Like Carol and her group in Mamet's play, one of Weisberger's students began talking with others about the assignments he gave them in his Sociology 215 class. Many of these were based on the students' ability to apply the insights of such intellectual heavyweights as Hegel, Marx, and Weber to their own familial experiences. Later, though, one student began to have misgivings about the nature of these assignments—this sociology class was "not the appropriate place for psychoanalysis," she felt—while another wondered about grading: "How do you grade something like that? No one can assess the value of my pain?" (Shalit 32). But besides launching such critiques of pedagogical propriety and assessment of performance, topics undergraduates hardly seem qualified to evaluate, other students felt moved as well to revisit their feelings while enrolled in the course. One student in particular who had written a quite glowing evaluation of Weisberger's class at the time discovered a year later that he made her feel "sick, tense, ill, scared, embarrassed." Like Carol's experience in *Oleanna*, hers got much more traumatic as time passed, even though the vast majority of her peers rated Weisberger's teaching as an unqualified success (three-quarters of the 116 letters received by Colby's tenure committee were enthusiastic, a handful were neutral, and some twenty were negative).

But just as Mamet's Carol felt "stupid" in John's class, a few students began to feel "uncomfortable" in Weisberger's—or, rather, some realized later that they had been uncomfortable in his class. And just as Carol had reported to the tenure committee that John had told her she looked "fetching" and professed to "like her," one of Weisberger's students—the

one just quoted above—alleged that well over a year earlier he had phoned her, told her she looked "lovely," and expressed strong affection for her (allegations Weisberger has flatly denied). On the contrary, he countered, she had made a suggestive remark to him; and, whatever the case, he asked administrators to investigate the charges fully as Colby's written policies require. They did not. The student's unproven allegations appeared in his tenure file against the wishes of faculty charged with formal review of his case; and the rest is, as they say, history. He was fired. In an article in *Lingua Franca*, Ruth Shalit reaches what we regard as one of several inferences that might be drawn from Weisberger's tenure case: Colby "appears to put a greater premium on pleasing students than on ensuring justice for a lumpenproletariat faculty." And she quotes a Colby professor, who holds an even more cynical view: "At bottom, it's the cash nexus driving all of this. . . . The model of the suburban mall has encroached on higher education" (Shalit 38). What was that Carol said in *Oleanna* about a "protective" hierarchy in the university?

At this well-heeled college, Cardinal Newman's liberal education would seem to have become inflected, if not contaminated, by market considerations that place a higher value on customer satisfaction than faculty rights. And there is little evidence in this case of the kind of collegial interaction among faculty Newman idealizes in his idea of a university. Yet one should not cast Professor Weisberger as a melodramatic victim any more than his discomfited complainants portray him as some sort of voyeur or villain (this latter role was clearly played by several craven administrators). Perhaps he should have recognized earlier the risks and sensitivities involved in asking that assignments for the course originate in a student's personal or familial experience. Sadly, Weisberger's case is hardly unique. Indeed, several years earlier, as he was unpacking his books to begin his stay at Colby, a young assistant professor of English in his first year of a tenure-track appointment at Millsaps College in Mississippi was packing his up to leave. He was fired after his first semester of teaching at the college after several students convinced the chairperson (in her first term as well and not the chair who had hired him) that they would never take courses from him again. His brash, somewhat aggressive New York demeanor made them feel "uncomfortable," and rather than work to acclimate him to his new department, the simpler course of action was to terminate his appointment. Never mind that a pink slip in the mailbox in January made it impossible to conduct a full national search that year, as I argued to his feckless department chair; never mind that it was his first academic appointment. Better not to risk alienating a

handful of undergraduate consumers—and better not to complain too loudly, the young academic understood, if he wanted positive letters of recommendation for his dossier.

Such administerial attitudes toward faculty poison the "atmosphere of thought" at a college or university; and, sadly, persuasive evidence exists that the learning environment in many classrooms at the corporate university has already been tainted by student incivility toward faculty. In fact, there is a growing body of literature on this phenomenon complete with methodologies of how faculty might cope with increasing incidents of "CIs": classroom incivilities. The American Council on Education (ACE) published a study in 1990, "Campus Life: In Search of Community," that attempted to address not only "broad social problems" (racism, sexism) among students but also incidents of what the council termed an "'alarming lack of civility and consideration' toward other students and toward faculty members" (Sorcinelli 365).[6] Like the ACE, Mary Deane Sorcinelli, who studies this phenomenon, attributes much of this behavior to an "erosion of the sense of community" on college campuses, and insofar as there are now more schools in America of over 10,000 students than ever before, her thesis may have some merit. Or, perhaps, as S. J. Bartlett more caustically argues, undergraduate "barbarians" enmeshed in a "web of laxity, indiscrimination, and materialism" bring with them to campus both a "fear and resentment of authority" and an "intellectual lassitude" that signal inevitable trouble at some point in their careers (308). Commentators like Bartlett often exaggerate the state of affairs on most campuses, and anyone who has actually taught a wide number of students must surely recognize the extent of his overstatement.

But if he overstates the case, Sorcinelli might well be understating it when she expresses concern over "student behavior that is, at the least, troublesome, and, at the most, disruptive" (365). At Indiana University during the fall 1997 term, Chana Kai Lee, an assistant professor of history who is African American and has taught at Indiana since 1992, experienced far more than disruptive behavior, although her complaints to the university's Dean of Students Office against two groups of male students began with incidents of classroom disruption: the passing of notes, talking, and leaving, then returning to class in the middle of lectures, and so on. These behaviors, according to Lee, accelerated into an obscene gesture, lewd remarks, and threatening telephone calls, one of which referred to her as a "fat nigger bitch."[7]

In her earliest complaints, eight male students were identified: one small group of black and white varsity football players and another group

of white male students. Attempting to control the students herself, she reprimanded them in early October with little success. In November, she reported this conduct to the Dean of Students Office and, in the case of the athletes, to Steve Downing, associate athletic director and African American himself. Downing, using a metaphor of choice in the IU athletic program, stated that he told "the kids" such behavior could not be tolerated and expressed his "irritation" at Professor Lee for engaging him in "heated" conversation over the incidents. In the spirit of gentlemanly rustication, several of the students, including all of the football players, were removed from the class but were permitted to complete it by studying separately and sitting for the final examination. Four students were allowed to remain in the class and, occasionally, continued their disruptive behavior. The campus police department conducted an investigation of the allegations, recommending several security measures be taken to assure Lee's personal safety.

Dissatisfied by the response of the athletic department, Lee filed a formal complaint against three football players and a fourth student with the student judicial board, which met in February 1998 to consider the charges. Accusing all four of disruptive behavior, Lee further alleged that one of the athletes engaged in "lewd and obscene conduct" toward her— specifically, grabbing his crotch and making an obscene gesture—when she had reprimanded the group the previous October. Although the university does not as a rule publish the results of student hearings, Lee voiced her opinion of the board's findings in the 27 March 1998 issue of the *Chronicle of Higher Education*: "four slaps on the wrist" for classroom disruption. And on the last charge, that involving lewd conduct, the judicial board decided that while the student was guilty of classroom disruption, he "had not grabbed his crotch or made an obscene gesture" (the *Herald-Times*, 10 February 1998, A1). The rationale for the finding is in some ways more disturbing than the decision itself, as an administrator from the Dean of Students Office explained: "If there is going to be an error made, it will generally be made in favor of the student because it is the student's hearing and his record" (the *Herald-Times*, 10 February 1998, A7). "Error," however, hardly describes the basis upon which this verdict was reached. The board in fact decided that compelling evidence to substantiate the charge did not exist, because the only evidence of wrongdoing was the testimony of the professor, which the student denied. The denial of such a "student" was sufficient to refute the professor's accusation. Case closed. In the *Chronicle* Richard McKaig, dean of students and apologist for the university, contended that "just because a

student is not suspended or expelled doesn't mean that a serious sanction wasn't given" (Schneider A13). Given the secretive nature of such deliberations, one can only guess at the severity of the "sanction."

There is little doubt that Lee's own analysis of this case is accurate: as an "untenured, black female professor" her status would not seem to warrant any further consideration of her complaint by the university. Conversely, who could imagine that a *varsity* football player and his buddies, after exhibiting such copious disrespect of a faculty member, would ever do anything even more inappropriate? Answer: no one in the corporate university *could* or would. So, who ends up actually leaving the campus? Not students who read newspapers during lectures, gab loudly across the lecture hall, or treat their teachers with such disrespect, but the professor whose classes were disrupted and whose life was terrorized (Professor Lee requested and was granted a leave of absence). As a result of this case, some thirty Indiana University faculty formed a Committee for a Respectful Learning Environment, a commendable action to take. But the response of the university's higher administration? At the time of the decision, the president of the university said he regarded the issue as a purely local one and declined comment (*Indiana Daily Student*, 18 February 1998); several days later, perhaps after reconsidering the matter or consulting with university spin doctors, he expressed his regret over the situation.

The lesson? The student's record must be kept clean, which is as much as saying that the word of the consumer-student is worth more to the university than that of a faculty member. This is precisely why Lee's analysis, which underscores her ill treatment because of her race and gender, while certainly accurate, constitutes only one horrific chapter in a much larger, equally dismal story. When placed in the larger context of the treatment of faculty at Colby, Colgate, and Millsaps, her case clarifies in the best Mamet-like fashion that at today's corporate university it isn't hard to determine who is the dog and who is the tail.

"Faculty" and Corporate Marketing

The spring before Chana Lee's course in American history was being routinely disrupted by a pack of "student-athletes," Myles Brand, the president of Indiana University, called a number of faculty together for one of his regular coffee chats. I was one of those invited to discuss this question: would an increase in the number of "non-tenure-eligible" faculty constitute the best institutional response to a general downsizing of graduate

programs on campus? Fresh from a meeting of other presidents of research institutions, he asked a group of some fifteen of us from across the university to consider the ramifications of replacing teaching assistants with a larger cadre of "non-tenure-eligible" faculty. If we don't have so many teaching assistants as we once had, he asked, who will teach the freshman and sophomore courses they taught? A good question, one answer to which involves a reformation of departments many of my colleagues would not rush to embrace; another might involve actually hiring faculty, paying them a living wage, and thus trying to provide the quality instruction universities claim in their advertisements to offer their students.

Significantly enough, the most shocking responses to the president's question came from both scientists (a successful biologist, in particular) and humanists alike (a well-known professor of Romance languages, in particular, whose salary exceeds $100,000/year), the latter of whom found nothing at all even slightly objectionable with the notion. Get more adjunct Ph.D.'s, he urged in the strongest possible terms; in this market, even the products of the most prestigious doctoral programs could be hired at significantly less than $20,000/year. If the buyer's "market" continues as it has, he concluded, we should certainly take advantage of it.

This advice was coupled, in the recommendation of the biologist-advocate, with a kind of new tactic concerning the constantly shifting nomenclature universities use to describe such "faculty": "visiting assistant professor," "adjunct," "part-time teacher," and so on. Let's call such teachers "clinical faculty," the biologist recommended. I'd heard this sort of thing before. Twenty years earlier, as an "instructor" at the University of Wyoming, I taught four classes of freshman composition/semester. Had I stayed on another year, I would have done the same teaching (at approximately $1,100/course, what Jim Sullivan makes today at Illinois Central) as a "lecturer," as all the instructors became. "Lecturer," after all, sounds a bit more like the similarly named faculty of prestigious British universities, loftier and more formal than "instructor." And as Sullivan reminds us, many institutions, including the comprehensive university at which he formerly taught during the 1990s, market these names to unsuspecting parents and freshmen. That is to say, at Bradley University where he once taught (which Sullivan doesn't name, but we will), student recruiters contrived the disingenuous marketing strategy of claiming that *all* incoming freshmen were taught by "faculty," not graduate students ("Scarlet L" 257). Besides the duplicity of the claim and obvious deprecation of the fine teaching of many graduate students, such strategies traffic in images, not realities. At the corporate university, what does the term *faculty* really mean?

To return to my colleague in the biology department's exuberant endorsement of increasing the number of non-tenure-eligible teachers, can such instructors be called "clinical" faculty? As most everyone is aware, law and medical schools, business schools, and other professional degree programs have for some time relied upon "clinical" faculty to supplement their course offerings. Such faculty, like a rheumatologist I know who is also a clinical associate professor at the Indiana University Medical School, typically have achieved—or still enjoy—significant success as doctors, lawyers, or CEOs. They already earn full incomes outside the university and, in most instances, return to teach a single, highly specialized course to advanced graduate or professional students. How can otherwise unemployed or underemployed academics be compared by title with the highly paid clinical faculty of medical and law schools? How does the teaching of a single course in one's specialty compare with the labor of teaching multiple sections of freshman composition or introductory calculus?

Tenured faculty, although on some campuses this may only amount to 25 percent (or less) of the teaching staff, must adapt what James Joyce once termed a "scrupulous meanness" in interrogating such managerial tactics or, to call them what they really are, misleading marketing schemes. For to remain silent when administrators concoct such fundamentally unethical means of further exploiting vulnerable faculty is, at the same time, to lend tacit approval to the deliberate misleading of one's potential students. Remaining silent about such enterprises—and it takes a good deal of energy to keep up with the schemes administrators are now dreaming up—in no way supports any idea of a university save that which confuses education with a diploma, a fuzzy toilet seat cover with an institutional logo, and a football team to cheer for on Saturday afternoons.

When part-time faculty must be hired—and we all are aware of the numerous legitimate (and, sadly, illegitimate) reasons why such faculty are hired—tenured faculty should never forget Guillory's second definition of professionalism: the freedom of an expert-practitioner to pursue intellectually "interesting work." Here, tenured faculty are not so much posed in *resistance* as committed to forging a *community*. Such a project entails at least two responsibilities: the willingness to share major courses with appropriately trained adjuncts, so as to help expand their repertory of teaching experiences and potential marketability; and a commitment to the notion that all faculty receive institutional support to develop professionally. This means, of course, that adjuncts at research universities should be eligible to apply for the same funds full-time faculty receive to travel to conferences (or to subvene other professional expenses); that

they become full partners in the intellectual life of the department; and that, finally, their teaching load (both the number and kinds of courses they teach) allows reasonable time for such development. This means, bottom line, that tenured faculty *demand* that adjuncts be given reasonable compensation for their labors and some time to become a part of an intellectual community. Without lending such support to their colleagues, tenured and tenure-track faculty in effect become the silent partners of the overpaid, button-downed MBAs who are, increasingly it seems, taking over the management of today's colleges and universities.

But in addition to resisting ethically dubious corporate managerial schemes, tenured faculty might also work to dismantle the gendered economy of adjunct teaching. For if by whatever name they are described part-time adjuncts can be regarded as full-time "wives," then their contributions and professionalism can always be underassessed. Most important, if the tenured faculty of an institution fail to remain cognizant of the strategies its own administration deploys in recruiting new students, then their status as "faculty" will inevitably be diminished more so than it already has been. The result will be nothing like Cardinal Newman's idea of a university, or nothing like that education for which families and students borrow money to attain, but more like the ideas that led to the University of Phoenix's credentialing mill.

SW

G

Graduate Student Unions (ˈgraj(ə)wə̇|t ˈst(y)üdᵊnt ˈyünyənz)
Graduate student employee unions have been functioning and bargaining
successfully in higher education for decades. The first was established at
the University of Wisconsin in 1969, where it has since negotiated for
salary and benefits, debated its form of organization, and handled griev-
ance cases. Graduate assistants at the Universities of Kansas, Michigan,
Oregon, and Wisconsin have affiliated themselves with the American
Federation of Teachers (AFT), whereas those at the University of Iowa
have chosen the United Electrical, Radio, and Machine Workers of Ameri-
ca (UE); those at Rutgers University are represented by the American
Association of University Professors (AAUP); and those at the University
of Massachusetts at Amherst have selected the United Auto Workers
(UAW). Graduate student unions on the campuses of the State University
of New York (SUNY) system are affiliated with the Communication
Workers of America (CWA). Graduate employees at the University of
California campuses, still seeking formal recognition, have signed up
with the UAW.

The disastrous job market, the failure of graduate employee wages to
keep up with inflation, and the general atmosphere of change and crisis
in higher education have made this a growing national movement in the
1990s. Graduate employee unionization drives are under way at Yale,
Minnesota, the University of Illinois, and elsewhere. A series of court
decisions, some still under appeal, have consistently confirmed that grad-
uate employees have a right to organize. Despite hyperbolic claims by
administrators that such unions will destroy collegiality on campus, all
the existing history suggests otherwise. Unions involve graduate students
in governance and alter the power relations on campus, but they have
produced no long-running confrontations; unions do lead to more fair-
ness in working conditions and to a more full and democratic dialogue
among all campus constituencies. They can also help initiate a desperately

needed campus-wide conversation about the purpose and future of higher education.

We are thus particularly lucky that the campus workplace revolution of the new millennium is being spearheaded by graduate student employee unions. We saw some labor unions harden into immobile bureaucracies in the 1950s and '60s. They lost touch with their members and with their larger social mission. As Vinny Tirelli put it at an April 1998 conference on part-time faculty labor, unions need to devote themselves not only to material benefits but also to "the ideals we hope to live by—democracy, community, dignity." At the same conference, Barbara Bowen of CUNY's Professional Staff Congress remarked that the struggle to create a union needs to be followed by "the struggle within the union."

But graduate unions cannot easily harden in place. They are like the Phoenix, but not the ersatz Phoenix of Arizona. For graduate employee unions foreground intellectual challenge, while they are reborn continually out of the ashes left by the fires of change. Their members relentlessly pass on into other lives. Their leaders must be replaced every year or two; three years is a very long term for a graduate student union president. One year is more typical. Even when unions hire full-time organizers they tend to move on after a few years, since members will often resist the power that comes with knowledge and experience. Yet the risk in wholesale turnover is huge. Such unions are repeatedly in danger of losing their collective memories.

Every year the new entering class of graduate students needs to be organized from the start. They will be the new holders of memories in what is partly an oral culture. New students need to be told the stories the union must remember, and they in turn must pass them on to the next generation. The posters, flyers, leaflets, manifestos, and other documents of past years certainly help transmit the union's culture to the next generation, but they are not sufficient, for in the heat of organizing much is never written down or recorded. A large part of the history and culture of the union will be passed on in conversation. Yet organizing a new class of graduate students means not just educating them but talking with them, incorporating their needs, their emerging agendas, into the union's plans. A graduate employee union that does not devote itself continually to organizing and integrating new members can drop to less than 50 percent membership in two years and risk dissolution thereafter. Administrators, always eager for union-busting opportunities, will take advantage of such weaknesses in the next contract negotiation. Indeed, administrators often complain that it takes so long to bring new graduate employee

negotiators up to speed, to inform them of past issues and contexts, but the fact is that administrators are often delighted to exploit lack of knowledge or loss of collective memory. Graduate employee unions are thus in a permanent crisis of identity, structurally and generationally committed to steadily finding new grounds for renewal. They must relentlessly question their aims and the reasons for their existence. They are the perfect campus mechanism for a participatory democracy constantly adjusting to new times.

The nature of the democracy they put in place is not given in advance; it has to be tested, worked out, evaluated, revised. Both on individual campuses and at regional or national meetings there is an ongoing debate about the nature of governance, about how democracy can be successfully practiced. The unions on the different campuses of the University of California system, all fighting their administrations for recognition, have developed different styles of decision making, and they inevitably debate these alternatives when they get together for system-wide meetings. The Graduate Employee Union at the University of Wisconsin calls regular meetings of the general membership and uses those meetings to decide issues both small and large. But low attendance is a constant risk. At the University of Michigan, on the other hand, stewards in every academic department constantly canvass the members they are responsible for and bring their views back to the steering committee. The Graduate Employees Organization at Yale aims for one organizer for every five members. The Yale and Michigan systems require a continual influx of new activist members ready to do the work of organizing and canvassing their departments. An intellectual vanguard can easily lose contact with the membership unless structures are established to sustain democratic participation. But an organizing union, one that constantly seeks new members, can help create an atmosphere that also maximizes attendance at meetings. Nothing can be taken for granted.

Discussions like these should now be taking place in every unit of every American campus. Faculty members would do well to attend graduate employee union meetings when they can. We have attended meetings several hours long on more than one occasion and found them consistently inspiring. At faculty meetings one often endures grandstanding, pontification, whining, and a general inability to listen to anyone else; the only people who seem to change their views are the ones who do not have any, preferring to wait on all matters until they know what way the wind is blowing. But graduate employee meetings often instead display the collective power of human reason. They are rational, people are attentive;

the aim is to contribute and facilitate, not perform. These groups can restore your faith in the university. We often tell these students they are living the collective intellectual life at its best and warn them to expect a falling off if they become a faculty member.

These unions offer young people leadership training and the experience of taking control over their own lives. That's one of the reasons young women often see graduate employee union drives as a form of feminist activism. From pay equity to leadership opportunities, women and men find fulfillment here in working together. Graduate employee unions also give us working models of multiethnic and multiracial collaboration, something potentially inspiring to both the campus and the community outside it. And often it is these union activists alone—not tenured faculty, nor administrators—on a campus who realize the nature of the education we can provide will depend on the nature of our workforce.[1]

CN

J

The Job System (thə ˈjäb ˈsistəm) Marc Bousquet, former head of the MLA's Graduate Student Caucus and now a faculty member at the University of Louisville, recently suggested to us that there really is no job market in English, and we agree. Bousquet and other members of the MLA's Graduate Student Caucus would argue that there is really a *job system* in higher education, not a job market. Certainly the standard model of supply and demand is inapplicable for several reasons:

1. Supply and demand in higher education are so thoroughly out of sync with each other that the product being marketed—the new Ph.D.—has become almost valueless.
2. The supply of new Ph.D.'s and the demand for full-time faculty in the higher education job system are not a function of need—or even dynamically interdependent—but are rather each independent variables shaped by quite different social and political forces.
3. The forces shaping supply and demand for new Ph.D.'s are not exclusively or even necessarily primarily economic but rather cultural and institutional.
4. The supply of candidates has been artificially increased and the demand for full-time employees artificially depressed. This is not a simple economic relationship, though new Ph.D.'s are suffering the classic economic consequences of dramatic oversupply.

Let's say, for example, that the country actually wanted to guarantee that all college students could read texts critically and write well. Many of us have some idea of how much close attention and tutoring we would need to achieve that standard. We'd need a hell of a lot more English professors than we have now. The same holds for math professors, science professors, and foreign language teachers. If we wanted undergraduates to be knowledgeable about art or music, well, once again, demand might

match supply. Yet if the need exists to hire large numbers of faculty, the cultural and political will to pay their salaries is nowhere to be found.

Ph.D.'s are produced in large numbers, not because of a massive demand for new faculty but because of an institutional demand for cheap graduate student and part-time labor and because of faculty desire to maintain the perks and pleasures of graduate education. It's basically a pyramid scheme, most dramatically not only at the Ph.D. level but also for the M.F.A. in fields like creative writing.

There is thus no independent market for full-time academic employees registering supply and demand. Rather, the job system we have is an interlocking structure of employment patterns, job definitions, salary constraints, hierarchized reward systems, training programs, institutional classifications, economic struggles, ideological mystifications, differential allotments of prestige, and social or political forces. Together, all these mechanisms produce an artificially restricted number of full-time jobs for Ph.D. holders. Graduate students or adjunct faculty employed to teach introductory courses at brutally exploitive wages are part of that job system; so are the dwindling percentage of tenure-track faculty. They are all part of one system that severely limits the number of decent jobs for new Ph.D.'s.

As a first step, then, we need to visualize new full-time tenure-track jobs as one slice of a single employment pie in higher education. Such a pie graph may help us realize that the system of employment is relational and interdependent. But the whole job system has many other components. The mystification of humanities teaching that makes it seem just and reasonable for English professors to teach four times as many courses as microbiology professors is part of the system. All the elements of the system work together to regulate and normalize it. New jobs are not independent functions of the number of students we need to teach or the courses we are expected to offer. If the market for full-time positions flowed directly from those needs, all our recent Ph.D.'s would have jobs. So the job offerings in each discipline are a highly manipulated and contingent phenomenon. They are a small overdetermined segment of the job system.

Economic or cultural investment or disinvestment in one part of the system affects other parts either immediately or over time. Both the responsibilities individuals have and the benefits they receive are functions of this system. Even rewards for unique achievement are made possible and justified by it. That means we are all responsible, that our

different status positions are interdependent. But many elements of this system are subject to change.

So it's not simply "the economy" that has given us a job crisis, as if the economy were our inexorable and monolithic fate; it's a host of social, political, and cultural forces, values, and constituencies that *can be acted upon,* that can be influenced and modified. And the faculty members who tell us otherwise—who spread disinformation out of their own naive ignorance and self-love—are culpable. So too are faculty members who believe they bear no responsibility for institutional practices. So too those faculty members who believe their sense of entitlement flows from nature, not from differential forms of exploitation. Failing to acknowledge individual responsibility or to credit the potential for collective agency are two major ways tenured faculty help to sustain the present deteriorating job system.

L

Lobbying (ˈläbēiŋ) Those faculty members who can do it well should. The rest of us should stay home. In the latter category are those who begin bellyaching the moment they meet a legislator. Complaining about your salary is bad enough. No one wants to hear about it, but most academics have a litany of regrets, complaints, and resentments on the tips of their tongues; best swallow hard before heading to the state capitol. Swallow even harder on the way to Washington.

That said, lobbying is actually very easy. You are a constituent. Your representative is accustomed to being courteous to that category of person. "Constituent" trumps "professor" every time. You have to make an appointment in advance, usually a few weeks, but thereafter a successful visit is not difficult if you keep a few things in mind. Linda Pratt writes usefully about her own experience lobbying as a faculty member. Ruth Flower gives good advice about lobbying campaigns.

First of all, lobbying in the state capitol often involves building a relationship. Every representative is accustomed to focused approaches when a relevant piece of legislation is up for a vote. If you haven't met your representative before, special pleading is often best done by mail. Otherwise, it may be a good idea simply to have lunch with a legislator and talk about how you spend your time and about what matters to you, thereby creating a better sense of what values inform daily life for a faculty member. Remember that for years all contact with state representatives was maintained by administrators, a class of people increasingly less familiar with either classroom or laboratory. Public higher education could benefit from a more informed human identification with those of us who teach and do research. You may do more good for your university by giving a legislator a powerful sense of what it means to be a faculty member than by making a request.

At the federal level, contact is a little more uncertain. A member of the House will readily meet with one constituent. A senator may require

a small group to capture. Be prepared to make one quick point if the visit has to be kept short; if a committee meeting has been scheduled since you made your appointment, you might have to wait outside a hearing room until a quick break can be arranged. Then you will only get a moment. Otherwise, a more leisurely meeting with a staff member is always possible.

The AAUP schedules a day on Capitol Hill as part of its annual meeting in Washington. Except for national officers and committee members, everyone else is supposed to spend the day talking with their congressional representatives. The AAUP hands out fact sheets about current legislation and gives general advice. An example of the latter is: always bring a camera, even a disposable one, and ask an aide to take a picture of you with the senator or representative. The hometown newspaper will often publish it, and everyone benefits as a result. Both the legislator and the university get free publicity, and their shared interests are imaged for public consumption.

A faculty union or AAUP chapter can help to coordinate legislative visits and help to train faculty to do a good job at them. Why should legislators support us if they have never met us and have no idea what we do?

M

Mentoring (ˈmen·tȯ(ə)riŋ) The concept of mentoring, as old as ancient Greece, has become fashionable once again in education. It refers to all the individual guidance faculty often have to give students to ensure their success, and it has special relevance to the support and guidance various disadvantaged populations have needed as they entered the academy in increasing numbers. Often neglected in all this is the mentoring that graduate students—with their highly individualized plans of study—must receive.

The twenty-eight years that I have taught at Illinois have also been years in which the nature of graduate student mentoring has changed substantially. When I was a Ph.D. candidate I met with my advisor twice—once to seek his approval for my topic and once to give him my completed dissertation. When it came time to apply for jobs, I prepared my materials on my own and never showed them to anyone on my committee; they had never asked to see them. Many members of my academic generation (I graduated in 1970) tell similar versions of that story; indeed, for both the 1950s and the 1960s dissertation directors were often rarely seen or heard.

Now all that has changed. The job market in the humanities collapsed in 1971 and has never fully recovered. Competition for jobs has thus increased dramatically, and it is essential that faculty members extract every ounce of competitiveness from their students. Sometimes that means a student on the market for several years must assemble a vita and list of accomplishments strong enough to earn tenure at a major university—and that simply to get a tenure-track job. Meanwhile, requirements for tenure have increased at many schools, while other universities are simply more consistently and rigorously enforcing standards long ignored. Both these tendencies have had the effect of intensifying and extending the mentoring process. Now mentoring begins early in graduate school, extends through a job search that may last several years after

the Ph.D. is awarded, and then continues until the new assistant professor completes his or her six-year probationary period. Mentoring not uncommonly lasts fifteen years. So much, one might say, for those outside academia who think graduate teaching is not really teaching! Fifteen years of advising an individual undergraduate is hardly typical, but it is increasingly typical for dissertation directors.

The rewards for this kind of long-term mentoring can be very great, especially when graduate students end up doing research that makes a substantial contribution to the field. Of course, that represents a somewhat narrow view of dissertation research, which is first of all an exercise in intellectual concentration and focus, the deepest long-term investment in individual research that many Ph.D.'s will ever make. Whether or not they publish their results, new Ph.D.'s will take with them an understanding of passionate and sometimes obsessional intellectual commitment that will shape their teaching and understanding of their field ever after. It gives them a model of intellectual dedication available in no other form.

Yet many of us are still not fully satisfied unless a doctoral dissertation produces either a series of articles or a book. That is the goal toward which most graduate faculty work with all their students, one many have either met or are near achieving. For the advisor in a humanities department, that first of all means reading and rereading many hundreds of pages of essays and dissertation drafts each semester. That is typical for a faculty mentor in a discipline grounded in extensive writing. Most of us try to go further in encouraging students to think of publication possibilities and opportunities for conference presentations. Especially at research universities, students are challenged from the outset to focus on contributing to and shaping the development of the field. That begins in graduate seminars, which are often organized not only around the texts or period to be taught but also around current research in the field and the opportunities it offers for dissertation projects. Graduate students from the first year must have in mind the eventual goal of producing important and innovative original research; they should not be pressed into trying to produce such research prematurely, but they should understand all their courses, exams, and seminar papers as pointing in that direction.

It is, however, terribly important not to impose a research agenda on a graduate student. The mentor's role rather is to help students to recognize and define their own interests; then, to draw the best work out of them, shaping it to assure that it is realistically achievable and that it will be

recognized as important and interesting by others. The job market makes that practical focus on professional reception essential, and most graduate students do not have sufficient experience to provide it for themselves. Yet there is a very delicate balance between neither overestimating nor underestimating what a particular student is capable of accomplishing. The first excess is disastrous, the second pernicious, and yet making an error in either direction is an incredibly easy thing to do. Effective mentoring thus requires continual reassessment of each student's progress and potential. Despite long professional experience, faculty members will be regularly surprised by students' accomplishments and failures.

Evaluating and advising individual graduate students also requires a subtle balancing act in relation to all the other explicit and implicit messages they receive from their department. Some departments are quite good at socializing new students and integrating them into the academic discipline. Others regard their graduate students as disposable and take a sink-or-swim approach. Graduate students who are drawn into department activities—from teaching to colloquia to social events—will receive some of their mentoring from their peers and from multiple contacts with faculty. But departments that have little or no integrative social and intellectual life often alienate graduate students and inhibit their progress. In such programs the chief faculty mentor must compensate.

There is another kind of compensation that faculty members must provide in even the very best departments; they must compensate for both encouraging and discouraging messages graduate students receive about the quality of their work. Most departments award fellowships and special teaching assignments very selectively, and the judgments on which these distinctive awards are based can be quite subjective or inaccurate. Over time, the results can offer circular confirmation. The students who consistently receive more fellowship support may indeed do better in the program; after all, they have more time to do their work and more consistent encouragement and recognition. Yet they can also become overconfident. I have seen such students dismiss the need to revise their dissertations or approach the job search with an irrational and counterproductive overconfidence. Hence, a department favorite can become overconfident enough to risk long-term professional failure. At the other end of the spectrum, a brilliant but quirky graduate student, less inclined to interact with faculty, will often be overlooked when fellowships are awarded; such a student may begin to lose confidence and be impeded in his or her progress toward the degree. Self-esteem can be so undermined

that a talented student drops out of the program. It is the faculty mentor who has to try to right this balance.

When the dissertation is near completion and the student is preparing for the job market, new responsibilities come into play. Mentors should visit advisees' classes, review their syllabi from several courses, discuss their teaching philosophy with them, and help them plan possible courses for the future, so that they can comment on both their teaching and research in a letter of recommendation. The major advisor must also review their dossiers thoroughly and, when necessary, talk with colleagues about how they can improve or clarify their letters of recommendation. A good letter of recommendation typically requires extensive thought and revision over a period of weeks; it must not only be very strong and detailed but also be substantially different from every other enthusiastic letter a faculty member has written. Each student must have a unique letter; nothing else will suffice.

The extended job search, often lasting years, also requires substantial personal and professional support from a dissertation director. Psychological counseling is often an essential component of mentoring at this point. Perennially unsuccessful candidates will feel they have been judged to be inadequate, even when you know them to be highly talented and accomplished. The mentor must continually direct the new Ph.D. away from self-doubt and toward self-improvement. As I mentioned above, often enough the successful job candidate must accumulate a dossier worthy of promotion and tenure just to get a tenure-track job; it is grossly unfair, but that is the reality the mentor must help the new Ph.D. confront.

Once a person has a job, the mentor from the Ph.D.-granting institution still has a role to play: to provide professional advice in an atmosphere of unqualified advocacy and support. Although I have successfully mentored a number of untenured faculty at Illinois, the relationship always includes an element of uneasiness, largely because I will eventually be judging the person for tenure and because absolute confidentiality in this context is impossible. I am not likely to announce a problem to the whole department, but I may well discuss it privately with the head. On the other hand, when advising one of my own Ph.D.'s at another school, my role is unambiguous; I can give advice in complete confidence, readily discussing problems about which the new faculty member may not want colleagues to be informed.

Eventually, mentoring blurs into collegial equality. The former student

often becomes a lifelong friend and sometimes a collaborator on research projects. Mentoring in this and other ways is both a personal service and a professional activity; it simultaneously helps individual people and defines the research the next generation of scholars will do.

It is increasingly clear, however, that individual mentoring alone cannot compensate for all the difficulties our students face in the current market. There needs to be a national conversation about the ethics of graduate study and employment, a conversation in which senior faculty play a far more active role than they have played to date.

CN

See *attrition rates, teaching.*

Merit Pay (ˈmerət pā) Merit-based pay is one of the most contested issues in the academy. Most administrators at research universities support the concept, however, not only because it enables them to reward "excellence," performance, and achievement but also because it provides more discretion and control in awarding money overall. Merit pay underwrites the whole system of disciplinary pay disparities and makes it easier to reward administrators and punish dissidents when salary decisions are made. President John Silber of Boston University regularly denied any merit pay increases to distinguished historian Howard Zinn because he rejected Zinn's progressive politics. Rutgers University administrators in contract negotiations in the mid-'90s argued that all salary increases be based on merit, presumably because it was a way to divide the faculty and undermine union solidarity. The administration lost the battle, but the tactic will no doubt reappear elsewhere.

Merit pay increases have also become meaningless at many schools that have hardly any salary raise money to distribute. Filling out detailed annual reports and appointing committees to award merit increases is disheartening work when a 1 percent merit pool is being distributed. We know committees that struggle over $25 or $50 merit increases. Competing for pennies does not ennoble the faculty or increase its dignity. The results at such schools typically take one of two routes: either almost everyone gets a pittance of merit or only a tiny few receive any merit at all. Neither practice makes people happy.

Several principles are worth reinforcing in considering fair and effective means of raising faculty salaries. Most importantly, everyone working for an institution should earn a living wage. "Merit" is a completely hypocritical concept in an institution that impoverishes lower-grade

employees. Second, everyone who is doing his or her job acceptably deserves a salary increase each year, certainly enough not only to keep up with inflation but also to make some progress in annual pay. Third, people with major achievements also deserve recognition when salary increases are given out. Promotion in rank should include a significant salary increase, not an insult. For if such signal events as promotion and tenure are *not* rewarded financially, salary compression and disillusionment almost surely follow. "The good news," a young colleague who has been subjected to a thorough tenure review is told, "is you got tenure. The bad news is our new assistant professor makes more than you do." Important scholarly achievements should be rewarded. Exceptional teaching should earn salary increases. Universities interested in fulfilling these principles ought to make the decisions necessary to do so, even if it means *not* building the colossal new athletics building. Making the decision about how to honor these principles *whether or not* more funds can be found is the key step.

It must also be acknowledged that not everyone does his job. Some fail to meet their responsibilities or behave in such a way that they must not be given salary increases. The failure to find the courage to punish faculty who are seriously derelict in their duties or who violate basic standards of behavior does not reinforce solidarity; it cheapens the meaning of the work everyone does and whatever rewards they receive. The troubled faculty member years ago who regularly urinated in his office did not deserve a salary increase. The sexual harasser who assaulted women did not deserve a salary increase. The poor soul who thought mythological figures materialized before him in the flesh probably should not have been first in line for merit.

Yet all sorts of absurdities creep into salary reward systems. Awarding salaries on a strict percentage basis simply makes the rich richer and the poor still worse off. Over time this produces severe inequities. Senior medical school faculty unsurprisingly seem to like percentage-based salary increases, as do faculty members in other highly paid disciplines. Making merit awards dependent on rank is inherently unfair; a given accomplishment should be worth more or less the same whether it is achieved by an assistant professor or a full professor. Systems need to be put in place to compensate people who, say, publish their award-winning book in a year when there are no salary increases. Some schools routinely look at three years' worth of accomplishments each year to balance uneven salary raise pools. Some senior faculty routinely resist rewarding junior faculty; a higher-level administrator should intervene in

such cases. I know one department whose full professors were convinced Western civilization would fall if their raises were not always the first priority.

Some faculty believe union representation and merit-based systems are incompatible, but that does not have to be the case. Unions will certainly try to protect some universal increases, but a faculty union is fully capable of ensuring merit as well. Indeed most union contracts for college faculty already include some provision for merit.

Those who resent merit raises awarded for published scholarship often decry the lack of similar rewards to teachers. The implication is that they would reap significant benefits from such a system. Yet my own department found an 85 percent correlation between the most productive scholars and the teachers most highly rated by their students. Funds were set aside to reward those few outstanding teachers not also publishing. The truth is that some of the remaining folks are not very adept in the classroom either.

One colleague constantly trumpets his "teaching" while receiving among the lowest student evaluations in the department. When confronted with the evidence undermining his claim, he announced that his real skill was not in the classroom but in private conferences. Ah well, would that he had fewer sexual harassment complaints from his office tutorials. People are also quite deceived if they think exceptional merit awards for teaching will not generate much the same resentment as salary raises for publishing. When I visited the University of South Florida, I heard numerous complaints about $5,000 teaching raises granted by administrators to political favorites among the faculty.

A key issue, therefore, is who actually awards merit pay. For many nonacademic college and university employees it is a supervisor or professional manager who decides relative merit or denies it entirely. That places considerable power in the hands of one person. Even more power flows from systems that depend heavily on one-time bonuses. That keeps workers docile and denies them the increased dignity, independence, and security that can accompany increases in base pay. Humane management entails rejecting one-time bonuses in principle. Faculty members may be accustomed to committees of their peers either deciding or at least having input into merit decisions, but other campus employees may not be. Yet committees can also become tyrannical vehicles for popular will. Thus there need to be checks and balances and multiple systems for winning financial recognition and reward.

Finally, if the huge and cynically achieved differences in *discipline-based salaries* for faculty were eliminated, then merit overall might be unnecessary. The notion that we must compete with IBM for a business professor is highly suspect, since people choose the university environment for its inherent rewards—the ability to pursue the fruits of knowledge rather than profit, the ability to exercise more control over your time and set your own intellectual goals, the continuing contact with young people in the classroom. Philosophy professors who choose not to become lawyers willingly pay a penalty in salary for those privileges; so would business professors who opt out of corporate life.

The time has come to explode the myth perpetrated at many schools of law and business across the country. The myth goes something like this: if an institution does not pay a new assistant professor of finance or business law more than it pays successful full professors in other disciplines—in some cases *considerably* more—the young J.D. or stock market whiz will decide to work on Wall Street or in a major law firm. Nonsense. A young associate at, say, Deloitte & Touche or Smith Barney isn't the same person with the same life goals as an assistant professor in finance or accounting. Faculty who can afford to have three months in the summer to pursue intellectual projects of their own design; meanwhile, their classmates are working eighty-hour weeks for six-figure salaries and a shot at a future partnership in the firm. The latter assume time is money; the former have already decided time is worth more than money.

Such salary inequities also exist outside professional schools. What makes an associate professor of sociology worth more than a full professor of English? What makes an English professor worth more than an art history professor? If we treated all disciplines equally, then all who teach in higher education could be fairly paid for their labor. We would welcome that day.

<div align="right">

CN

</div>

See **superstars.**

The Modern Language Association (thə ˈmädərn ˈlaŋgwij əˈsōsēˈāshən) The December 1997 "Final Report" of the Modern Language Association's Committee on Professional Employment (CPE) cites a very good question posed by its executive director, Phyllis Franklin: "And what are the obligations of an organization like the MLA both to its members and to the field?" (22). We would add an even more basic one:

what *is* an organization like the MLA? The CPE was hard at work for some eighteen months, longer than perhaps anyone had imagined they would be. Yet precisely because the CPE labored so earnestly at its task, anyone disappointed by the MLA's long indifference to the job crisis will probably remain disappointed by the report and its recommendations to improve the bleak professional prospects graduate students in the humanities face. This document represents, in short, the MLA's best efforts, which have everything to do with the question it begs: what is an organization like the MLA?

Unpacking this question will not only entail a critique of a key recommendation in the report but also demand some historical perspective. Indeed, the report itself regards today's job crisis, at least in part, as the historical product of "revised labor conditions for the professoriat" caused by cold war "federal funding initiatives" (19). The question motivating this essay, however, requires a slightly different history, one that returns us to 27 December 1883, when the MLA was founded as the dream of some forty "gentlemen-scholars" who convened that winter at Columbia University. In his 1965 address at the association's annual December convention, MLA president Howard Mumford Jones revisited that 1883 meeting, underscoring its regional connection to the "Atlantic seaboard": twelve scholars came from New England and twenty from the "Middle States and Maryland (which meant in fact Johns Hopkins)." Only two hailed from the "Middle West," as it turns out, only one from the South. "These men," Jones concluded, "created . . . an informal national club with a simple constitution and by-laws" (3). In the following year, 1884, the secretary of the newly formed association reviewed the most significant points the gentlemen had deliberated, one of which revealed a tension still felt today: namely, that while the group agreed on the need to centralize "the modern language forces in this country," it also recognized a competing need to weigh "sectional differences in any general scheme of improvement" (Jones 4). The matter of how these differences could even be perceived, given the nascent organization's regional and class inflections, will have to wait for another day. But Jones's characterization of the embryonic MLA as a gentlemen's "club" is particularly useful in coming to some understanding of the at times conflicted—and, in some quarters, controversial—nature of the MLA.

The MLA's rapidly expanding membership in the mid-1960s also concerned President Jones, as the title of his address, "The Pygmy and the Giant," implies. In 1939, before America entered World War II, the MLA

was composed of 4,374 members, a number that expanded modestly to 4,991 in 1946. Between 1946 and 1965, though, MLA membership soared past 20,000; and by the later 1990s it has held fairly steady: 31,794 in 1995 and 31,568 in 1996 (Franklin 451). In her 1997 report, Phyllis Franklin notes that graduate student membership has risen significantly, up 3.9 percent since 1995; further, graduate students accounted for one-third of the nearly 9,500 members who attended the 1996 meeting in Washington (Franklin 449) and are now a third of the MLA's overall membership. As Jones remarked over thirty years ago, the largely eastern "informal club" has indeed evolved into something much larger and more variegated. If not a "multitudinous army," his term of choice, then what? Equally important, the gentlemen's club in the 1960s was "called upon to do an infinitely greater variety of things than its founders ever dreamed of doing" (Jones 5). It still is. For the composition of its membership has changed dramatically and so have their needs and interests. How has it responded to such calls?

This history and the realities of the association's present membership base clarify at least one thing: the MLA is not now, nor has it ever been, a professional organization. Unlike the ABA (American Bar Association) and AALS (Association of American Law Schools), for example, which accredit schools of law, the MLA has no comparable professional clout. Unlike the AMA (American Medical Association), it does not investigate violations of professional ethics, conduct, or practice, and thus has neither been in a position nor shown much inclination to police its membership or administer sanctions for professional misconduct. Nor do the MLA, the AHA, and other academic organizations try to limit the number of people entering the profession, as the AMA does. This is hardly surprising. As the historical sketch above suggests, the MLA was not founded to be a professional organization, and in pursuing such matters as the CPE investigated it was responding to a growing pressure, albeit unacknowledged by the committee, to do something that both its founders and current leadership never, "ever dreamed of doing." This disjunction between the organization's history and the daunting challenges presented by the current crisis in higher education is perhaps the primary reason for the belatedness of this report: not the eighteen months it was in process, but the fact that the MLA only got around to conducting this study in 1996 long after debate over and analyses of the job crisis had begun. Indeed, the debate itself has been a feature of such MLA journals as *Profession* and the *ADE Bulletin*.

171

For the most part, the CPE report reveals neither the purported radicalism nor the much-lampooned "trendiness" of the MLA, seasonal charges leveled every January in critical dissections or parodies of the annual convention, but just the opposite: its history as a gentlemanly, not professional, organization. To be sure, the association *has* advanced significantly from the days when issues of *PMLA* included a "For Members Only" section which, among its announcements of various scholarly awards and bibliographical projects, included a section entitled "Scholars' Wives." Here, regular tributes to the wives—"Bless them, they write wonderful letters," gushed the February 1952 installment—merged with other "sociable" items of interest (v). But has this advancement led the MLA far enough away from its roots to act as a fully professional association?

Not when it comes to enforcing rules of ethico-professional conduct or responding to the increasingly grave condition of higher education and the erosion of full-time and tenure-track teaching positions. Indeed, for a period in the early and mid-1990s various MLA officials denied that any serious problem even existed. Reporting on the 1994 convention in *The London Review of Books,* for example, Elaine Showalter, president of the MLA in 1998, reviewed the important position the job crisis had assumed at the meeting. In her efforts to recommend possible futures for young scholars outside the academy by alluding to notable Ph.D.-holders who have achieved some measure of success there—Newt Gingrich, for example—she noted that in "bad times, the MLA has provided expert advice on non-academic employment. But the graduate programs themselves have continued to produce academics trained to speak and write for each other. . . ." (Why Professor Showalter believed that this particular bait would prove appealing to anyone reading her essay is hard to say.) She then proceeded to offer some of this "expert" advice herself: "It would be better to find ways to expand the usefulness of the degree, or to promote graduate study, like travel, as broadening" (25). The former recommendation is, of course, easy enough to make but far more difficult to implement, unless one is prepared to broaden the curricula of more traditional departments to include courses in professional writing—desktop publishing, graphics, grant writing, and so on—now offered by graduate programs in professional communication at such schools as Iowa State University, Purdue University, and the University of Tennessee. Showalter's latter suggestion is even more intriguing: graduate study as a version of the Grand Tour of Europe upon which young American gentlemen and gentlewomen used to embark. The problem is,

for many doctoral students today such an excursion would last over eight years and require loans that would take another ten years to repay. And with good help these days increasingly hard to find, it's difficult to feel confident that our weary travelers could find anyone to carry their bags throughout this journey.

What this gentlemanly history—and gentlewomanly advice—tells us, we think, is that one should not have expected too much from those parts of the CPE Report and recommendations that would require the MLA to act in the manner of a professional organization. (And we shall "bracket" here Lennard J. Davis's larger, more trenchant questioning of our collective reliance on organizations like the MLA in the first place. For Davis, professional organizations in general are "by and large" not only "traditional" and incredibly "conservative," but also complicit in the subtle businesses of aiding institutions in the domination and observation of their faculty.) What Davis calls "compulsory bureaucracies" like the MLA are incredibly resistant to change (199), so it should come as no surprise that a key recommendation to the Association, one that promises an organizational response to cases of unethical or unprofessional conduct, falls disappointingly short. One might well wonder why such a recommendation is necessary in the first place. Can it really be true that an appreciable number of humanities departments have forgotten their manners—and any semblance of "gentlemanly" and professional ethics?

The recommendation in question calls for the "collection and publication of information about hiring-procedure problems confronted by job-seekers" and is composed of two parts: "[W]e recommend that either through the current standing Committee on Academic Freedom and Professional Rights and Responsibilities (CAFPRR) or through another body, the MLA act as a clearinghouse for information about problems in hiring procedures confronted by job seekers, [and] that job seekers who encounter ethical problems report their difficulties to the CAFPRR or another appropriate MLA committee" (36). Although the committee's motives in making this recommendation are never thoroughly explained, the report states that "considerable evidence—much of it, to be sure, anecdotal—[suggests] that the tight job market has sometimes produced situations where job seekers feel abused by hiring committees and departmental administrators" (36). What these abuses might be are never made specific, but, all in all, whatever its inherent vagaries, the recommendation sounds good.

But that's the point: it's supposed to sound good. Equally obvious, a number of faculty and graduate students have been relating these

"anecdotes" (what else could they be until investigated, documented, and proven?) for some time now. In *On the Market: Surviving the Academic Job Market* (1997), Elisabeth Rose Gruner reiterates the "lowlights" of several sexist, unethical, and perhaps even illegally conducted interviews women have endured both at the convention and during on-campus recruitment trips. Gruner asks, "To whom might a candidate report such questions? A lawyer? The MLA?" More to the point, "what are the sanctions against illegal questions, and what can we do about them?" (97). To add a few more interrogatives to the list, what in the MLA's opinion constitutes an abuse in the first place? Departmental culpability in the incidents Gruner reports—inquiries about marital status, children, and so on during initial interviews—would seem more or less transparent, but other practices may be more open to debate. Requiring applicants to send writing samples by Federal Express or overnight mail? The practice, refined by the East Carolina University English Department in 1995, of posting a job notice that promised one lucky Victorianist the "opportunity" to "bypass the traditional MLA 'rite of passage' interviews" by accepting ECU's job offer in November, thereby forgoing any alternative employment possibility that might arise at the convention (Palumbo and Taylor, "Letter")? The posting of job notices when a committee already knows who it intends to hire—or that it is not interested in candidates of a certain gender or ethnicity? Let's not be naive about this last matter: it happens.

It was apparently happening at the 1997 convention in Toronto if two of the "anecdotes" floating through hotel lobbies there were true. We shall provide only the contours of these stories here, but if the MLA wants to investigate and, after sufficient corroboration, publish these stories (which of course it really doesn't), we can provide more details. The first begins with the phone call on December 29th that every job candidate, after interviewing earlier at the convention, wants to receive: we liked your answers yesterday, and we want to speak with you further. "Great," the candidate said, "I'd be very eager to visit your campus." "No, you misunderstand," the voice gently corrected, "we want to speak with you again tomorrow morning before the convention is over. I hope you can arrange your return flight accordingly." It doesn't take a labor negotiator or CPE member to infer the extortive nature of this phone call: if you want a job at our school—and the odds are now more in your favor of securing one, because you've made the "next cut"—you'll spend whatever it takes and reorganize your life for the opportunity to speak with us again. The second story concerns a prestigious West Coast institution that has lost a distinguished professor to another school and wants him/her back. So it

runs a national search for a junior position and winds up with a shortlist that, remarkably enough, just happens to include the senior professor's significant other, turning the longstanding spousal hire dilemma in a direction that effectively rips off every other candidate who paid to have dossiers and writing samples mailed to the department (not to mention the time and emotional investment involved, and the mockery of law and ethical conduct inscribed in the department's job announcement with its perfunctory statement about equal opportunity).

But even if mitigating circumstances existed to explain both instances—what these might be is, frankly, beyond us—can the MLA really operate as a "clearinghouse" to disseminate such information? That is to say, can it simply publish the name of any department (or individual) against which someone levels an accusation? Of course, such charges cannot be published without careful investigation—and published where?

The topics of abusive, or just plain thoughtless, recruitment practices and MLA waffling in responding to them are, admittedly, hobbyhorses of ours. In separate letters to the *MLA Newsletter* in 1995 and 1996, we protested the practice of departments' ordering expensive materials from candidates—dossiers and substantial writing samples—at the *beginning* of the recruitment process for an initial screening. If a committee wants to order these expensive documents after reading a letter, vitae, and dissertation abstract, fine. But we've counseled enough job applicants, from our own schools and many others while serving as job advisors at the MLA convention, to know that some will spend *hundreds* of dollars responding to these demanding initial applications. And if they happen to get an interview or two, hundreds of dollars quickly become a thousand or more. Before one of our letters could appear, however, it had to be revised several times and, at the behest of an MLA official, vetted by some anonymous legal staff. You see, one of us responded to a department chair who defended the practice of a committee's ordering everything "up front" (he also expressed his dismay that the MLA would dare tell him how to conduct a search.) Using the example of the several hundred applications both of us have received serving on recruitment committees for young faculty working in twentieth-century literature, we maintained that it was impossible for a committee *to read* this many writing samples with any degree of attention. This line had to be dropped. Because no evidence existed that the committee did not read all the essays it received, this supposition could not appear in the letter—at least not in any letter the *MLA Newsletter* and its legal counsel deemed safe to print.

This entire episode is reminiscent of lines from Harold Pinter's dystopic play *Party Time* (1991), in which one abusive aristocrat tries to induce another to join his club. The scene of the drama is a swank cocktail party; beautifully dressed members of the ruling class sip champagne and swap witticisms while a brutal crackdown on political dissidents takes place outside. Best of all, one member explains, no voices are "raised" at the club; people there don't do "vulgar" things.

Being a gentlemen's and gentlewomen's club, the MLA doesn't punish dissenters; it just makes certain they aren't appointed to committees like the CPE. Meanwhile, the CPE's gestures toward activism, like this specific recommendation, cannot possibly work as stated. *The MLA cannot serve as a "clearinghouse" by collecting and disseminating every accusation it hears, and it knows it.* It is obliged to investigate before it publishes anything, even a relatively innocuous letter protesting a department's recruitment practices. Still, such recommendations imply that the "gentlemen's club" will "boldly go" where no MLA official has taken it before: near the ambit of a professional organization. If this is true, then it also marks a sea change in the MLA's view both of itself and of its capacity to intervene in its members' conduct. After all, it wasn't that long ago when, after irritating a number of members with an ill-advised "President's Column" in the *MLA Newsletter,* Patricia Meyer Spacks claimed, "MLA action does not issue from a mysterious monolith, nor does the MLA possess the power to make administrators, department chairs, or individual faculty members do its will. (Guidelines are only guidelines; there are always many who will ignore them)" ("Voices" 3). We'll simply have to wait and see how "abuses" in the hiring process relate to violated "guidelines"—and see if the MLA can fulfill the promise of the CPE's strategically ambiguous recommendation by doing what it never "dreamed of doing" before.

Yet, to be fair, if the MLA is still too gentlemenly and gentlewomanly an organization—still too much a product of its East Coast pedigree and too far from being a thoroughly professional association—then it also scarcely resembles the bastion of faddishness its myriad of conservative detractors portray. This is especially true of the annual convention: a meat market of the worst order for job seekers, to be sure, but hardly the symptom of trendy irresponsibility the Charles Sykeses and Dinesh D'Souzas of the world depict. Like the association itself, the convention has grown tremendously in the past half century. At the 1964 convention, for example, some 213 papers were delivered in 106 sessions, compared with some 2,100 papers delivered in over 700 sessions at the 1997 Toronto conven-

tion. In her address at the 1963 convention, then president Marjorie Hope Nicolson feared that "real" standards in the "discipline" of English ("if, indeed, it is a discipline," she remarked [9]) were in peril because Latin was being dropped as a required language (6). Now, Jonathan Yardley accuses the "Lords and Ladies" of English departments of running "academic whorehouses" in which "popular culture, hetero- and homosexuality, and retrograde 1960s radical politics" predominate, while literature of "quality, importance, and universality" withers away untaught (1F).

Is it true that the MLA and English departments have abandoned "great" literature? Admittedly, the MLA hasn't released a tome on Shakespeare's penmanship since 1927, or one on sources and analogues of Chaucer's *Canterbury Tales* since 1958. But throughout the 1980s in a series on approaches to teaching literature, the association has published volumes on teaching *The Iliad* and *The Odyssey, Paradise Lost, Middlemarch,* and many other works of "universal" or historical importance. Contrary to Yardley's claims, Shakespeare remains one of the more popular courses in the curriculum. His works are still the center of discussion at any number of scholarly conferences, sessions at the MLA convention included. Indeed, the requirements of most departments with which we are familiar demand that students read canonical British and American literature, and academics still discuss this literature. But "canonical" does not mean unchanging. MLA conventions and English departments *do* change, just like other disciplines. Haven't departments of mathematics over the same period, or within an even shorter one, struggled with catastrophe theory, chaos theory, fractal geometry, and other issues? Is it just English that is supposed to remain fixed and unchanging? The world, the academy, and the MLA—this includes the convention—are much larger, much more diverse places, as we have tried to indicate in our thumbnail sketch of the association's history.

So the MLA is neither quite so professional as its CPE report implies, nor nearly so radical as its critics allege. It is still too self-protective and overly insulated from dissent, too self-congratulatory; like the gentlemen in 1883, it is still too unaware of professional practices out there on the frontier, although, through the CPE report, it claims to have a compelling interest in such matters.

Well, okay then. Here's a recruitment practice for the newly professionalized MLA to investigate. It's also an especially appropriate one, since, beyond the association's commitment to professionalism inherent in its recommendations to itself, the appendix to the CPE report reiterates the importance of instructing graduate students in the finer points of

professional "etiquette." Villanova University's English Department posts an advertisement in the October 1997 *Job Information List* for an assistant professor of contemporary American poetry/creative writing. Candidates are required to forward just about everything—letters of application, dossiers, samples of *both* creative and scholarly work—at the beginning of the process, and the department conducts interviews at the Toronto convention. Then, in early January, Villanova's recruitment chair invents a new professional genre: the form rejection e-mail memo. This hybrid form combines, electronically, the rejection letter with the traditional form letter by notifying several of the candidates interviewed that their applications were no longer in consideration. Because the chair either could not be bothered to use a LISTSERV or did not know how to create one, to accomplish this simultaneous and wonderfully efficient mass rejection, each recipient of the bad news was made aware of every other person receiving it, as all their names appeared at the top of the memo (and could be forwarded just about anywhere, to people like us for instance). No right of privacy for the rejected applicant and, from the hiring department's perspective, no need even for a book of 32-cent stamps and a half-dozen envelopes. Sure, these candidates mailed expensive materials to the school, and sure, they probably spent hours researching the English Department. And, yes, they did spend hundreds of dollars flying to Toronto and attending the convention. But apparently that doesn't mean they each deserve their own rejection letter.

The last word on the MLA, however, goes to Howard Mumford Jones who, writing about the crisis of gigantism over thirty years ago, put it like this: "Either we believe that the MLA means greatly and means well, or we do not" (6). Sadly, we do not. The gentlemen's club has a long way to go before it can pass for a professional association with ethics that would do its members proud.

SW

Moonlighting (ˈmünlīd·|iŋ)

Many faculty members routinely put in ten- or twelve-hour days six or seven days a week. Home and office are indistinguishable. But if you have a light teaching load of one or two courses a semester, perform no advising, direct no undergraduate theses or doctoral dissertations, supervise no laboratory, accept no administrative responsibilities, refuse to serve on committees or prove yourself so cantankerous or incompetent no one would appoint you to any, never

update your courses or read new material in your field, never design new courses, abandon all serious efforts at research, never make yourself available to your students outside class, do no peer reviewing for scholarly journals or book publishers, never write letters of recommendation, do no outside consulting to businesses or organizations that need your expertise, and give up all service to national and regional academic organizations, well then your job may not be exactly back-breaking. Of course, if you do many of these things, a forty-hour workweek will hardly suffice. But what about the occasional faculty member on a light teaching schedule, something many faculty will never have, who does nothing except meet his or her classes?

We had a fellow like that on campus some years ago, since retired; in fact, he took early retirement. Before then he had enough free time to work at a men's clothing store in the local mall. It wasn't then (nor is it now) permissible for a full-time faculty member to take extra work like that without permission. Now he'd have to lie on his annual "conflict of interest" form, an action that could get him quickly fired and perhaps prosecuted. But twenty years ago a gentlemanly honor prevailed. He just didn't possess it in sufficient quantity.

At first the story developed in fits and starts, haphazardly, repeatedly pushed below conscious thought. Over a period of months a number of people felt sure they had seen him at the local Redwood and Ross outlet, a rather preppie clothing store where you could pick up a tie decorated with your fraternity logo. It seemed as if he was helping *other people* try on sport coats and blazers, not trying them on himself. They shook their heads and dismissed their suspicions as misperceptions. Everyone noticed he had become an increasingly snappy and fastidious dresser; here was the explanation: addictive clothes shopping. But now and again someone caught a second glimpse of him patting a suit down on someone else's shoulders. Finally, a couple of people stopped by the department head's office to voice their concern, relieved to pass the uneasiness on to him. The head called in the faculty member in question to put the question directly—are you working at the mall?—meanwhile reminding him of university regulations. There was relief in the office when the tenured full professor denied the accusation with vehement incredulity.

Nonetheless, reports and rumors persisted. The department head, a thorough and determined man indeed, decided on an expedition to the mall, a site visit if you will. Opting for stealth rather than disguise, he peeked into the store, then ducked out of sight. Sure enough our

Haberdashery Professor was there, rearranging pants on a rack in a manner that suggested employment rather than a compulsive commitment to public order. It was time for a more thorough investigation.

The department head, equally orderly in his own way, divided the seven days of the week into an hourly grid that ran from the mall's morning opening to its late-night closing. He was planning to sleuth the mall every hour. Yet one problem remained. At night and on the weekends he could simply drive out, park his car, check out the mall, and return home. But what about the daytime hours when he was supposed to be at work? The faculty parking lot was some blocks away. What's more, he could hardly do his own proper work while he was driving to and from the mall twenty times a day. The suspected immorality of his colleague was driving him to an almost equivalent irresponsibility: failing to perform his own appointed duties. The only solution he could think of was nearby public transportation. So he then checked one final, critical detail, determining that it was possible to take the mall bus from campus, get out at the first stop at the mall's west end, run like hell to Redwood and Ross, look in, and immediately run to catch *the same bus* at its last stop all the way down at the Sears anchor store at the mall's eastern edge.

He divided up the week with the long-suffering associate head, and they took turns at this keystone cops surveillance scheme, returning to campus, at least in the version of the story that entered departmental lore, to put a red "x" in every slot where our well-clothed professor was in the store. The grid filled up with blood red evidence of his crimes. What with days, nights, and evenings there were quite a few hour slots available at the store. Our professor meanwhile had more than a few spare hours available for extracurricular activities. After seven days the red x's left no room for doubt: the man was mall-lighting forty hours a week!

I will not give full details of the plea bargaining session on campus, though I will say that a rather plausible claim of "midlife crisis" was offered among various extenuating circumstances. Meanwhile, one must say that the university would have been better off hiring a hit man than letting the legislature find out a full-time tenured faculty member had time for a little forty-hour add-on job. That gave our perpetrator at least a bit of leverage. The only demand was that he *stop*. He agreed, and all seemed well. Then in time he backslid and was out at the store again. Now and again I wondered if he'd be crazy enough to risk working at the campus branch, but so far as I know he kept a bus ride's distance between

his employers. Now a more aggressive departmental encounter ensued. Eventually, he quit his second job for good (or whatever), but soon after that he left the university as well. As I said, if you aren't doing many of the things faculty members do, at some schools you can carve a few spare hours out of the week.

CN

N

The National Association of Scholars (thə ˈnashən⁼l əˈsōsēˈāshən əv ˈskalə(r)z) The National Association of Scholars gathered again in December 1997 to reward the faithful, lick its proud new wounds in public, and excoriate "the enemy within." I was attending its annual conference by invitation as its token lefty for 1997. Reflecting on why I was there, I could well remember the advice one of my undergraduate teachers gave us years ago: "If you really want people to bond with one another at a party, be sure to invite one person they all hate." So I was wary at best, but I would in fact be treated with consistent courtesy over the weekend. It was the best way to write an entry about the association—by seeing what it was like on its home ground, gaining a better sense of its motivations, and learning what we have to expect from it in the future.

No longer able to get quite the press attention it received but a few years ago, the NAS is nonetheless still startlingly effective when its money can be articulated to public sentiment. It was members of NAS's California chapter, we must remember, who researched and wrote California's Proposition 209, and the national NAS is pursuing a sustained attack on academic freedom and contemplating one on tenure. How much of an independent hearing NAS can get for these initiatives remains to be seen, but it can certainly help to forge a conservative consensus on these issues. Above all, then, the organization and its members are symptomatic of the nongovernmental cultural right, especially that part of it still obsessed with higher education.

So I accept its invitation. As I arrive in New Orleans, an unusual cold front has swept over the brightly colored masks and T-shirts that surround these dour academics. About 300 of them have gathered in one continuous session that lurches back and forth between celebration and lament. There are a few blacks and women in the audience, but many of the NAS members in attendance are specimens of that vanishing but still aggressive species, the confrontational white male wearing a bow tie.

The theme of this year's annual conference is "multiculturalism." A conference on multiculturalism sponsored by the NAS is obviously not exactly a disinterested trying of the case. The guilty party is being brought out to be condemned and executed yet again. As always, NAS accounts of the enemy begin with epithets. The lions must be fed before the audience can act like Christians. "Multiculturalism," declares David Horowitz, "is the team banner of the hate America left." Horowitz, once on the left himself, is now a violent apostate. It is as if he must struggle to keep the progressive virus at bay within his own body; one systemic purge follows another, but there's no way ever to be really clean and healthy again. And so with his rhetoric. There's no way to get his warranted curses right, so he keeps trying. As he becomes flushed with anger, I am reminded of what a colleague said after meeting Alistair Cooke, long-time host of Public Television's *Masterpiece Theatre*: "It's not your set, folks. He really is that pink." "Multiculturalism is neo-fascist tribalism," Horowitz continues, but no one other than me is scribbling the phrase down for subsequent use. Perhaps something more elaborate will work. "Multiculturalism is the place where the left went to lick its wounds when the '60s was over so it could continue its malevolent agenda."

Ah yes, wounds again. It's the Stockholm Syndrome; America has been captured by communists and now the poor good-natured nation is misguidedly tolerant of them. Not Horowitz. His all-purpose curses could serve as well against affirmative action, feminism, Marxist theory, or a number of other causes or intellectual movements. Some NAS members will confess in private they find him a trifle unhinged, but that's part of the NAS strategy: put their most virulent rhetoricians on stage, then *privately* disavow them. But the crowd has clearly not yet risen to the occasion. In a final tactical move, Horowitz tries a more personal assault: "Cornel West is an empty suit. He's a charlatan, but he's black, so nobody can say it."

Later that weekend I would be asked repeatedly if West was really as bad as Horowitz said. The NAS is an organization that collects black villains and black heroes with equal fervor. It is proud of its courage in naming the former and thus desperate to honor the latter. Shelby Steele and Thomas Sowell would receive standing ovations in New Orleans. Steele is there to give a thoughtful keynote speech, Sowell to repeat some conservative platitudes and receive an award, but the crowd is not about to make subtle distinctions among their black chosen. Meanwhile, they are desperate for minority recruits, since the charge of racism always hangs over their heads. For the same reason they are very careful before

excoriating a black faculty member. I do my best to distinguish between the different sorts of writing West has done and explain why I admire him, but I can see their eyes glaze over at any kind of complication.

There are other reasons, however, why the NAS's black friends and black enemies lists have to be carefully vetted. The NAS was founded by a small group of academics a decade ago. They were mostly New Yorkers and, as it happened, mostly Jews. Most had supported the civil rights movement and condemned the Vietnam War, though they were not militant protestors. Their abiding heroes were those New York intellectuals who had once been Trotskyists and later not only became anticommunist but actually abandoned all ties to international socialism. By the 1980s these former fellow travelers of liberalism were voting for Ronald Reagan. Now the themes of their lives coalesced around one story: faith betrayed. It was faith in reason, faith in the academy, faith in America.

They had also been faithful to the cause of racial justice, and now Leonard Jeffries was calling them names. Presumably that explains another of Horowitz's splenetic definitions: "Multiculturalism is anti-Semitism." That claim conflates multiculturalism with some versions of afrocentrism, hardly a fair characterization, given that Henry Louis Gates and Angela Davis, among actual black advocates of versions of multiculturalism, have spoken out strongly against black anti-Semitism, but no matter. Some in the NAS see all evil condensed in the academic left.

But other NASers have different histories, including some who integrated the politics of the early 1960s into their professional lives. One founding member, a historian, had studied with legendary black scholar John Hope Franklin and himself become a specialist in black history. Now it was all over with; he had become an exile in his own heart. His wife, a modern literature specialist, leaned over to me conspiratorially to underline their group identity, borrowing a metaphor she might once have resisted taking out of context: "Some of our members have practically been *lynched!*"

Officially devoted to higher education's future, the NAS is really held together by shared resentment and regret. Its members tirelessly commiserate with one another in the hallways; their martyrs are victims of a colleague's insult. By and large resentment is not the ruling emotion in the lives of the young. But then the NAS is not an organization for the young.

Its founders, in late middle age a decade ago, have begun to die of natural causes. But as the annual meeting honors its dead with a series of awards in their names—Sowell receives the Sidney Hook Memorial Award, Mary Lefkowitz receives the Peter Shaw Memorial Award—the

circumstances of their deaths become blurred. The manner of presentation suggests battlefield heroes. Indeed these fallen heroes are casualties of the culture wars.

Meanwhile, the young turks of the organization are in their late fifties. A few faces in their forties are to be seen and one or two still younger, generally veterans of campus right-wing clubs who went on to graduate school and then failed to get academic jobs. They now run errands for conservative think tanks and get thrown spare change. Other than that, the group despairs of attracting young recruits. Of course, there are many vital people of all political persuasions in their seventies and eighties, but no organization can renew itself without recruiting younger members. There the NAS continues to fail.

That is no surprise. Founded by a small group of Jews, the group soon began to attract more than its fair share of university WASPS, typically failed academics buzzing about the decaying remains of their careers. The young still have hopes and ambitions, but the typical NASer now reserves his remaining energy for revenge. They are professionally and emotionally focused on resentment, and the NAS was founded to tell them it it's not their fault.

In the last thirty years intellectual fields have developed rapidly, and those who don't keep up find themselves confused in a few years and decisively alienated soon thereafter. In no time at all, it seems, their disciplines have become incomprehensible. The NAS wants them to know these mutagenic disciplines are worse than wrongheaded or superficial; they represent unreason.

In higher education today, so virtually every NAS member is convinced, illogic masquerades as theory, partisan politics pretends to be research, ruthless indoctrination has taken over teaching. The fault, dear members, is not in yourselves. Thus higher education can only redeem itself by excommunicating the enemy within.

The organization, now several thousand strong, rose to power on the coattails of the political correctness media panic, assisted by a million dollars a year from friends in the John M. Olin Foundation. But when its members banded together they had in mind not only the unseemly urgencies of tenured radicals but everything else higher education had become since the 1960s. "Political correctness" embraced the new sham scholarship, the scandal of affirmative action, the intrusively politicized campus, and the rude behavior of women and minority students and faculty alike. Above all, PC was what had unjustly cut them out of the action, what took them off the field prematurely.

The NAS's New York state chairman, British expatriate Barry Smith, specializes in contempt in cultured tones; all these developments are fair game. He has one word for the university of the 1990s: "tommy-rot!" The term covers feminism, afrocentrism, Marxism, cultural studies, deconstruction, postmodernism, multiculturalism, science studies, affirmative action, and anything similar on the horizon. No distinctions are drawn between these various movements or initiatives, and no opportunity is missed to hammer home the message.

Desperate themselves to be treated with all due deference and respect, NAS members caricature feminists, Marxists, and postmodernists so broadly they appear less discriminating than lemmings. By the light cast by *Academic Questions,* the NAS house journal, women, minorities, and homosexuals are never victims but rather always undeserving place holders on the lower end of the bell curve.

On stage at the conference, Smith also has his say in the fall 1997 issue of *Academic Questions.* There, as we said earlier, he joins my other favorite harumphateering NASer, James Tuttleton of New York University, both of whom are well on the way to refining unwitting self-parody as an art form. If I describe my intellectual and pedagogical aims to you and you begin bellowing "tommy-rot" at the top of your lungs, there's not much point in pretending we are having a conversation.

In New Orleans, Daniel Bonevac, chair of the Philosophy Department at Texas, characterizes all these developments as an "infection" and warns that in his own discipline "the field where the infection has spread most deeply" is continental philosophy. Smith meanwhile has his ad hominem slogan for the domain of theory: "Jacques Derrida is the anti-Christ of the modern world."

One speaker argues that "radical feminists take the same view of scholarship as communists or fascists." A member of the audience rises to second the point: "These women multiculturalists are not women or feminists, they're communists." "It's not clear how diverse we can be and still live together," warns Stanley Rothman. Another speaker inveighs against "the war against history that is being waged by multiculturalism" and gives his favorite example: "I watched the Ken Burns history of the west and Indian chants were in my head for weeks afterward. Hey Ho Hey Hey Ho Hey Hey Ho Hey."

Eugene Genovese tries to interject an element of rationality into the proceedings when he calls for an end to global condemnation of women's studies and black studies. He reminds the audience that the left got its programmatic opportunities because women and blacks were severely

mistreated in universities through the 1960s. The failure to counteract such mistreatment, he argues, had opened the door to the abuses we now decry. But the troops were having none of this. A faculty member in attendance rose to say, "It's untrue that women and blacks were mistreated. I went to a segregated school, but I still learned about George Washington Carver." In a spoof of multiculturalism that gets out of hand, James Caesar suggests that these folks would surely object to interracial marriage ("miscegenation") because it would compromise identity politics. This justifies his new term for those who fight political correctness: "abolitionists." "There should be no doubt about multiculturalism's conquest of the curriculum," announces Elizabeth Fox-Genovese, a tightly wound and obscurely embittered speaker. In moments of relaxation, Fox-Genovese clamps a long thin black cigar between her teeth, but this is not a moment of relaxation.

It is views like these that carry the day. On stage to chair a panel, Smith gives each speaker a faux multicultural introduction: "Our first speaker, Paul Cantor, comes to us from the former slave state of Virginia. He is followed by Walter McDougall, who comes to us as a result of the tragic *diaspora* of the McDougall clan. The only non-white male on our panel is a Marrano Jew who was able to declare himself a Hispanic on the U.S. census form." It is yet another reason why the NAS cannot draw young acolytes, for very few young faculty members share all these resentments.

What young Ph.D.'s particularly do not share is the global hostility to theory. Most young chemists could care less about the terms of humanities research. Even those few recent English or history Ph.D.'s who reject feminism or poststructuralism realize they are not all one thing and don't find them incomprehensible. As long as the NAS rejects all the theoretical work of recent decades, it can only appeal to disgruntled faculty in their waning years.

But the NAS is increasingly inclined to take a scorched-earth approach toward the contemporary university. Why not? Its own members are nearing retirement or already retired, and their compatriots among the young, so they all believe, are not getting university jobs. So there is little disinclination to save the university by destroying it.

Various items on the program and scattered remarks by speakers suggest what the emerging NAS consensus will be. The one element most are uneasy about is recommending the abolition of tenure, but several speakers test the waters. Alan Wolfe announces that "multiculturalists never met a form of tenure they didn't like" and calls tenure "the most

pervasive form of discrimination in American life" because it "freezes out people born after a certain date." Moreover, "it has permitted the left to remain in power." That is the key point, and if the membership can rally behind this claim, linked to all their longstanding resentments, then the organization will champion this new cause.

Sowell reinforces all of Wolfe's arguments: "people with our views are not getting hired in the first place . . . tenure just redistributes security and insecurity." Then he makes the connection between tenure and the purported abuse of academic freedom that has been churning in the NAS journal *Academic Questions.* Tenure, it seems, has turned academic freedom into a "blank check." Multiculturalism, feminism, cultural studies are all signatories to this blank check, anti-intellectual movements exhibiting none of the responsibility that is supposed to accompany freedom in the university. Bonevac argues that people in such politicized fields now acquire "sham credentials"; their dissertations, Ph.D.'s, and publications are all spurious. Steele points out that multiculturalism actually "suppresses our rich cultural diversity when it is not compatible with victimization" and warns that multiculturalism "masks a bid for pure atavistic power."

The mounting NAS case against tenure is at least a political curiosity. One might well argue that tenure is an inherently conservative force, one the NAS might therefore support. It installs people permanently in positions of some power and prestige. It can make them satisfied, turning them into agents of a system they might otherwise seek to change. On those grounds the left might well feel tenure is counterproductive. One certainly hears such complaints from unemployed Ph.D.'s. On the other hand, tenure also gives people enough job security to speak frankly if they choose. And frank critique does not belong to any political group over the long term.

Some in the NAS actually feel that tenure provides a cover for a *covert* politics. When Lino Graglia, a law professor from the University of Texas, rose from the audience to speak, he immediately received a standing ovation. The NAS's new heralded victim, he had created a 1997 firestorm when he announced that minority members do poorly in college because of their cultural background. Graglia now commented that the debate in Texas might have been clearer and more revealing if he himself had *not* had tenure. Then legislators and administrators alike would have had to display their real PC colors. As it was, so Graglia claimed, they could piously say he should be punished but tenure prevented their doing so. So tenure for Graglia is a problem because it provides cover for the

entrenched left's real agendas. But most in the NAS are more direct in their anger: too many tenured faculty members are feminists, Marxists, or multiculturalists. We have to lose a few good conservative comrades in order to clean house.

Cleaning house was the ultimate aim of another powerful NAS activist. To castigate the latest multicultural infamy, Candace de Russy rises to speak. A former literature professor and now Pataki appointee to the Board of Trustees of the entire State University of New York, de Russy is a veteran of the recent panic over a 1997 conference titled "Revolting Behavior: The Challenges of Women's Sexual Freedom," held on the New Paltz campus. She has been on the New York state radio talk show circuit and calls the conference on sex toys "multiculturalism at its sleaziest and its seamiest" and hurls a series of accusations that might well be comical were it not for the power she wields. The conference "propagandized for lesbian sex and culture"; it amounted to the "campus-based marketing of female masturbation." Her voice mounting, she pauses for the final insult; these people actually "denigrated heterosexuals."

"Where are the responsible faculty and administrators to draw the line?" she asks. One audience member has the temerity to ask whether academic freedom is at issue, but he is swept aside. Whatever else it may be, academic freedom is not a license to denigrate heterosexuals. Boards of trustees, legislators, and alumni must intervene. In a published piece a few months later de Russy announces that "academic freedom has become confused with simple freedom of expression—burning the flag and other, similar gestures"; it has been "reduced" to "a prerogative of obscene self-indulgence." This claim is in line with the presentation from Lynne Cheney's National Alumni Forum that has pride of place on the conference program. The NAS, it is clear, is disenchanted with both academic freedom and faculty self-governance. Public opinion and political force must be applied. It is time to save the university by destroying it.

Academic freedom must be redefined as a responsibility to eliminate intellectually irresponsible—read politically unacceptable—faculty members. Hence the McCarthyite references to the enemy within the university. Soon HUAC looks like a defender of academic freedom! And indeed it is the 1950s argument recycled. Feminists, Marxists, and multiculturalists aren't themselves really advocates of free speech, democracy, and the American way. If they were, they'd be on our side. They all aim to suppress real freedom, so the truly free must rid the body politic of these brainwashed theorists and multiculturalists.

What breaks through most decisively in de Russy's rant is an anger well

beyond the reach of reason. If wit is the NAS's best weapon, their Achilles heel is the realization that all their wit is displaced rage. It breaks through the veneer of civility at other moments over the weekend as well. Thus Abigail Thernstrom, flush from her first confrontation with Bill Clinton, cannot help blurting out in the midst of listing Shelby Steele's accomplishments the key fact about his ascension into the Hoover Institution: "He is no longer the member of a stifling department of English." And a faculty member from the University of Massachusetts, who gives a witty talk protesting the silly and offensive requirement that all faculty declare each year what they have done for multiculturalism, bursts out in anger in private conversation. And of course the memory of Horowitz's nearly homicidal rage hangs over all the proceedings.

I have occasion to talk with many of these people over the weekend, but Horowitz and de Russy are not among them. Yet there are even moments when I sense limited grounds for common cause with other NAS members. I cannot say that I feel much camaraderie during Stephen Balch's nauseating introduction of Glynn Custred and Thomas Woods— NAS activists who coauthored California's Proposition 209—as "the greatest Americans it is my privilege to have known," and the presence of Custred and Woods on stage reminds me that the NAS can still wield real political power when it funds a strategic cause, but I set my fear and loathing aside once they have received their awards and stepped down.

One of these fleeting moments of agreement arises while I am on stage during a discussion of the curriculum. The NAS has been pushing Great Books programs, and I point out not only that I am in favor of them but also that on my campus it's not the depraved humanists who stand in the way of such programs but rather the business professors and the engineers. An audience member lurches to the microphone to ask whether I would include the *Iliad* and the Greek tragedies in a Great Books program. I assure him I would, though I must confess I read them in college in translation.

Fox-Genovese is on stage with me at the time and is nodding her head in agreement, but then a grimace constricts her face. She smells a rat, or perhaps a Trojan horse, in my too easy capitulation; beware tenured radicals bearing gifts. She scribbles a note and passes it to me hurriedly: but not twentieth-century books, she points out, books have to be around for a long time before we know they are great. She's not about to let multiculturalism slip onto the shelf beside the Great Books. Of course, alliances mean compromise, but these folks want unconditional victory.

Anything less, and they'll take the Enola Gay out of mothballs and fly over center campus.

I imagine the response there's no point in making. First I might remind her we are about to gain a definitive form of distance from the entirety of our century. Then I think of explaining that we would be teaching the Great Books in twenty-first century America, not in a galaxy far, far away. I might feel differently were that the case, but here and now I want the Great Books program to prepare my students to confront the issues, like race, that shape the real world in which we live. I am thinking of W. E. B. DuBois, Franz Fanon, and Langston Hughes among my authors when an NAS foot soldier cries out: "Just remember that there's a difference between Aristotle and Franz Fanon." Fox-Genovese smiles, and I must quickly reassure myself this is ideology, not telepathy, at work.

I make one of my final efforts at communication at dinner on my second day in New Orleans. Smith, a cocky little man, a graying rooster in a business suit, is casting unhappy glances my way, but other NASers, eager for any convert, no matter how unlikely, are making efforts to reach out. In a long conversation with one of the organization's leaders, I quote two things Fox-Genovese said. "Instrumentalism," she remarked, thinking about the university as a model of the general culture, consistently "trumps integrity." Later she declared that "the economy almost always gets the curriculum it wants and deserves." I point out that, because the increasing corporatization of the university threatens both old and new humanistic values, this ought to be an area where we can agree. "These people," my dinner companion observes, "will never attack the corporate economy."

So that is it; in the end, at capitalism's altar the NAS will tolerate no apostasy. That is hardly surprising, given that NAS's primary benefactor, the Olin Foundation, has funded numerous endowed professorships for conservative faculty across the country and funds several Law and Economics programs at prestigious schools. These programs promote the notion that market forces rather than government regulations should govern many areas of social life. The Olin Foundation has been a significant force in promoting corporate values in the university. So has the NAS, though its role has been indirect. Its campaign against political correctness helped delegitimate higher education and thus justify reductions in financial support. When corporations moved in to fill the void, the necessary critique by progressive faculty had been preemptively smeared as "politically correct." So it is not hard to see why my proposal got nowhere.

My other conversations are equally cordial and equally fruitless. To Steele I argue that his faith in merit as the only sound basis of all recognition, including college admissions, would be more persuasive if inner-city schools were not scandalously underfunded. He agrees that the schools are terrible but doubts that improving them will do any good on its own. I will put it to a reporter from *U.S. News and World Report,* who is not an NAS member but a sympathetic fellow traveler, that the New Paltz events followed in a long and welcome tradition of pro-sex conferences that counter feminism's more puritanical side. He will have none of it: "There's no reason for universities to fund people's sexual activities. Besides, these lesbians have been trying to tweak public opinion for years." I approach a senior NAS insider who is outraged that New Paltz had sexually oriented performances at the conference. "A conference on Shakespeare might well have actors perform *Hamlet,*" I point out, "so at New Paltz they brought in a performance artist." He is immediately angry: "You're comparing Hamlet to a stripper?" Something indeed is rotten in the state of Denmark, but this time it may be the loyal opposition who present the greatest danger, and there may be better solutions than leaving everyone dead at the end of the play.

CN

O

Outsourcing (ˈaut ˌsō(ə)rs·iŋ) It begins as an apparently simple way to save money. Instead of hiring people to fill a role, you contract with an outside vendor to hire and supervise them. Whether in preparing to negotiate an outsourcing contract or as a result of living with one, you think less in terms of employees with mixed duties and significant loyalties to the business than of specific tasks to be performed by people who do exactly what they are paid for and no more. Then you find a company that specializes in performing those services. The company typically pays its workers a good deal less than you do; it may hire them part-time and thus avoid expenses for benefits like health care or retirement. The outside company may also save money from economies of scale; it cleans scores of buildings throughout the city every night, buys its supplies and equipment in bulk, and maintains everything on its own.

Outsourcing is but one of a series of cost-saving strategies a business can adopt. They are partly interchangeable. Hiring part-time and temporary workers, thereby casualizing what was previously a permanent workforce, is another. Once one strategy is adopted, once one group of full-time employees is replaced, the next strategy is easier to assimilate and the next employee category easier to terminate and casualize. Outsourcing of course can place a protective layer between you and a company that pays workers poorly, gives them no security, and sees them as interchangeable and replaceable. But once a university signs on to such a system, those values become its values as well.

Outsourcing is thus not only an economic issue. It is also a way of thinking about the workplace, an attitude toward employees, a view of community responsibility, and finally an ideology that helps define a corporation's or a university's whole vision of its aims and methods of operation. That is not to say every instance of outsourcing is unacceptable. In an area with a very low unemployment rate, some outsourcing can be

done without major community impact; that is, without serious loss of full-time jobs. But the decision about whether to outsource should not be made by looking only at the task and the budget. You must look inward at the institution as a whole and outward at the entire community. It is the wider internal and external effects that must be understood and evaluated. That's what responsible management entails.

As an industry, higher education also has special characteristics that must be kept in mind. Colleges and universities have traditionally asked much more of their employees than the completion of specified tasks. They ask and generally receive a level of commitment and dedication that often far surpasses what a casualized work force should offer. Yet in some areas, notably instruction, higher education has found it can temp or casualize its employees and still get their complete devotion. Make no mistake about why that is possible: these underpaid part-time teachers are first subjected to prolonged training and socialization in graduate programs. The tasks they perform without fair compensation are steeped in mystification. The subjects they study are sacralized and the methods of study ritualized. Selflessness, service, and corporate devotion are instilled as transcendent values. Only then is a part-time teacher willing to collaborate in his or her own exploitation.

The indoctrination young teachers receive of course far exceeds anything a university's other employees experience. And most part-time employees simply do not have as much time as full-timers to devote to the job. Indeed, in far too many areas of the university, outsourcing produces inferior work. Equally damaging, and certainly more insidious, is another pervasive effect of outsourcing: certain kinds of work are no longer done at all; they simply disappear.

Outsourcing, temping, and casualizing labor are also strategies for downsizing, or ways of compromising with a mandate to downsize. You substitute a part-time position for a full-time one and thereby reduce your annual budget. Or you hire less well qualified (and less expensive) people in roughly the same job category. You hire a student, rather than a trained professional, to catalogue books. You hire an M.A. rather than a Ph.D. to teach a class. You hire part-time rather than full-time secretaries. You replace two full-time secretaries with one full-time secretary and an undergraduate work/study student. *Deprofessionalizing* is the catchall term for these practices.

Many administrators, quite obviously, would be reluctant to accept our characterization of outsourcing as a tactic of deprofessionalization.

Rather, the rejoinder would go, it is a strategy designed for greater efficiency. But is it always so efficient?

A good example of the perils of outsourcing is the state of Hawaii's 1995 decision to outsource the book acquisition for state-operated libraries to a private firm, Baker & Taylor. The state signed a five-year, $11.2-million contract with the vendor, a decision heralded by state librarian Bart Kane as providing "the model for the 21st century." Less than two years later, after Baker & Taylor had ordered a substantial quantity of unwanted titles and, according to a report in the *Library Journal* (July 1997), was late in the delivery of ordered books to the state, the State Board of Education endorsed a recommendation to the state attorney to "decide on what basis to terminate the contract."

One could easily imagine reasons for terminating such services. What might happen if, for example, a university library hired a vendor to supply books for its special collection on, say, the Civil War or Abraham Lincoln. Would a flood of unwanted volumes on *Abe Lincoln's Log Cabin* or *Honest Abe in Springfield,* books addressed to a fourth- or fifth-grade readership, greatly enhance a research collection on nineteenth-century America?

Law librarians were similarly shocked in March 1995 when the entire library staff of ten at Baker & McKenzie's Chicago office was terminated without any advance warning or notice. In April, Baker & McKenzie, the world's largest law firm, turned to a temporary employment agency while it negotiated with two outside vendors. From the perspective of the *American Association of Law Libraries Newsletter* (June 1995), the reasons for outsourcing transcend or go beyond mere dollars and cents or the ruthlessness of a post-Fordist management philosophy that privileges output over the cultivation of a loyal workforce. At least part of the rationale for outsourcing, Donna Tuke Heroy contends in her essay in the AALL *Newsletter,* is that "research is so easy," librarians "just aren't needed anymore." Young attorneys can surf the web and other archives themselves, based on the vendors' apparently successful premise that "everything lawyers need is online and easy to find" (388).

Thus, in an age of outsourcing, the principal expertises of professional librarians—reference and research, on the one hand, and technical services (cataloguing and acquisition) on the other—have been challenged by the claims of outside vendors. Yet, as the problems with the state of Hawaii's contract shows, resituating the responsibility of acquisitions to a company that may reside thousands of miles away from a library and its

patrons is fraught with perils. So, too, is the notion that cataloguing largely from Library of Congress records will lead to the organization of logical, user-friendly collections. One might have to look for Cary Nelson's *Repression and Recovery,* on modern American poetry, in the self-help section, or head for the music library to fetch the recent *Joyce's Grand Operoar,* a book written for scholars of the work of James Joyce.

Perhaps more important than these obvious limitations or risks, the outsourcing of a professional librarian's work on college campuses—and that's sure to come, as the law librarians at Wright State University learned in the early 1990s—effectively denigrates the major contributions librarians make to an intellectual community. On those campuses in which librarians are tenured (and on many in which they hold professional staff positions as well), they can almost always be counted upon to stand up and speak when issues of censorship insinuate themselves into campus life. Yet, sadly, outside of food service workers, librarians may constitute a group on American campuses most threatened by the ideology of outsourcing.

When a university segments jobs, in short, outsourcing or temping the rationalized fragments that remain, it loses the faculty member who spends a day or a week helping one student with his writing; it loses the secretary who comes in on Sunday to push a grant proposal through, the electrician who remembers the layered history of a building's wiring, and the acquisitions librarian who knows the strengths and weaknesses of the book collection. It loses the faculty member who has time in the summer to read widely in her field to stay current, the faculty member who stays in touch with her students for years after they graduate, the faculty member who invites his class over to his house for dinner and discussion.

When much of the university is outsourced, temped, and part-timed, what's left is no longer education in any deep and powerful sense. It's the exchange of credits for tasks performed—a rationalized, segmented faculty teaching rationalized, segmented courses. Not to worry, though. A year or two after a college overtemps and wantonly outsources itself, no one is around to remember things were ever any better.

P

Part-Time Faculty (ˈpar|t ˌtīm ˈfakəltē) We had originally planned not to write a separate entry for part-time faculty. After all, as we argue throughout the book, part-timers and temporary teachers increasingly *are* the faculty. They teach about half the college and university courses in the country. Graduate student employees teach still more. Traditional tenure-track faculty now only do about a third of the teaching. But we wanted to set aside a special place to tell some of their stories in greater detail and to draw some conclusions from them. We'd like to start by letting one part-timer tell her story in her own words and then summarize our interviews with several others:

> I tried to live at a place in New York state—in the middle of nowhere, actually—about equidistant from the three colleges I teach at, but of course you never know from one semester to the next what you'll be doing anyway. I need to teach at least five classes to get by. The most I've ever earned is $2,200 for a course, but the junior college only pays about $1,400; too many of those courses and I'm in trouble. You try to put together a last-minute schedule, allowing for driving time and hoping you don't get a flat tire. I read about 120 papers a week. They're not only from my own students but also from student portfolios in other sections. Meanwhile I also try to teach similar topics simultaneously in all my composition courses, since otherwise it becomes really confusing, but the course plans at some schools make that impossible.

It may be useful to lay out exact income figures for this sort of life. In 1996, a beltway flyer in Washington, D.C., was piecing together a living of sorts teaching composition at four different institutions. At the bottom of the pay scale was Charles County Community College, twenty minutes from Washington, which paid him $940 to teach one course. Prince George's Community College was a little better at $1,150. Montgomery Community College, the best-paying two-year institution in the area, offered $1,500. And he was lucky to top off his service to higher educa-

tion with a prestige course: composition at Catholic University paid a full
$2,000. He could not obtain a second class at any of them, so his total
income for the semester was $5,590. None of the schools offered access
to health insurance, but he was young and healthy and decided to take his
chances. Suffice it to say that turned out to be a bad idea.

He could have headed north to New York, but there the New School for
Social Research paid its part-timers only $1,000 per course. By the
spring of 1999, the New School's rates will balloon to about $1,200. Far-
ther north still, of the more than 350 part-timers at the University of
Massachusetts at Boston, many with a decade's service, only 13 had health
coverage. If you would prefer to teach at a school where long-term loy-
alty is rewarded, try Carlow College in Pittsburgh, a four-year school
with a few M.A. programs. There part-timers get a raise after eight years
of service: $25 per course. If this does not seem like a definitive example
of academic piece work, you could jet across country to one of the
California junior colleges that pays *$30 for each hour you are in the class-
room*. Night classes may go five or ten minutes longer; the 1997–98 *Guide
for Adjunct Faculty* at Fresno City College, supplied to us by the college
administration, is reassuring on that point: "Your hours of pay will be
adjusted for the additional minutes." Miss a class because a family mem-
ber is ill, you get docked $30. You do accumulate sick leave yourself—in
one-hour units. You accumulate about three hours' sick leave each time
you teach a course. There is no compensation for hours invested outside
class and thus little incentive to meet students on the park bench you
declare as your office. There is equally little incentive to prepare classes
in advance, since you are only hired when enrollment figures are in—a
week or less before the semester begins.

The "Do's and Don'ts" section of the Fresno City College *Guide* makes
all this explicit:

> Often a dean has to get on the phone and hire a part-timer on the day
> before instruction begins. . . . It is possible that the assignment you pre-
> pared for will be modified or even eliminated. Reasons may be low class
> enrollment, district load limits, contract load requirements, or the like. If
> this does happen to you, you will be *compensated only for the hours you
> actually spent teaching*. You will *not* be paid for the hours you spent
> preparing for the assignment or the time spent completing the employ-
> ment process [1].

If you do get a course under these uncertain conditions, you will be given
a course outline: "All courses have identities, boundaries, expectations.

Those for the course you are teaching are spelled out in the official course outline, which your division dean will give you when you are hired. Read the course outline carefully and plan to use it as a basis for what, and perhaps even how, you will teach. . . . When the outline is specific, do what it says" (6–7). For many courses there is a college-assigned text, but you may be given the right to choose your own text. There is a procedure for that too, even if you have a Ph.D.: "To do this, show the text you want to use to your department chair and to one other full-time teacher in the department—to get their approval. As long as it looks and feels and smells appropriate, you won't have any trouble getting their approval or the approval of your division dean" (5). If you aren't yet feeling patronized, proceed to the section on teaching practices. Here you are given "The Three F's of the Successful Classroom": Friendly, Fair, and Firm. "The Three E's" that follow are a little less varied: encouragement, encouragement, and encouragement. They don't want you to pitch things too low. Your class shouldn't quite have "an overall, cozy, familiar, right-in-your-own-backyard course feel," but don't be "fanatic about grammar" and pause "now and then to point out pop, real-life applications" (28).

The problems all these people face thus go well beyond the key one of a complete lack of job security. Yet on that score at least now and again one of them decides to fight back, something that will never be widely successful until part-timers organize and act collectively. But sometimes individual passivity becomes intolerable. Part-timers at the University of Colorado Humanities Program were assured in the spring of 1996 that all was well. They should return the following fall to stand in front of the blackboards again. Their services would be needed. One young Ph.D. was teaching there part-time and supplementing his meager income with food stamps. Indeed, since he was supporting his family, he also qualified for a specific form of welfare: government surplus milk and cheese, which he picked up in town on a regular schedule.

As the part-timers filtered into the department head's office that fall they received the bad news: the university had closed out the part-time jobs. There was nothing for them. The department head had not bothered to call anyone to give them the news. Wasn't required. Six of last spring's instructors had so far been sent on their way, but the seventh was not inclined to be conciliatory. "It's September, so it's too late to get another job. You promised me employment. You didn't notify me differently. I've got a family. I need a job. I'll be back in two hours. You find me a job or I'll punch you out. Your choice." Surely the department head must have thought of calling the police. Perhaps he remembered he should feel

guilty. Perhaps he realized bad publicity wouldn't do him any good. In any case, when our young scholar returned, he had work for the semester. Two years later he was earning $29,000 as a tenure-track assistant professor at Midland College in Nebraska; for the first time he was more or less self-supporting.

Although most self-supporting part-timers are constantly short of funds and have no job security and little intellectual freedom, at least some of them get to live in one place. Except for the fellow supplementing his salary with surplus milk and cheese, they can all cling to some stable sense of work-related identity. As our beltway flyer was criss-crossing our capital city in the shadow of the Lincoln Memorial, he might have no idea what form his emancipation might take, but at least he could declare himself a college teacher to anyone who asked. Except for his fellow department ghosts, few would have any idea how little prestige and income that title entailed. But the identity kept him at the job.

Other part-timers, it seems, will do almost anything to sustain that identity. Consider one part-timer who began her career at Bradley University in Peoria, Illinois, in the 1985–86 academic year. Adjuncts got $600 a course and had an "office" symbolically sited in Hell—specifically in the campus boiler plant. The following year she was at Lansing Community College in Michigan, where things were somewhat better. She pulled in $10 an hour part-time at the campus writing lab. But itinerant labor must go where the work is, so 1988 found her at Harrisburg Community College in Pennsylvania. She was ecstatic. They paid $1,200 per course. Her "office" was now a desk shared with four other people, and someone else's mess was always getting mixed up with hers, but the steam tunnels and turbines were out of sight. She supplemented the courses at the community college by working for minimum wage in the writing lab at Penn State University's Harrisburg campus. That still wasn't enough to support her two children from a failed marriage, so she found further work on Sundays coordinating classes at the First Unitarian Church.

The arrangement lasted four years. Then she was on the road again, this time earning the highest salary then or since, $2,300 a course teaching night classes at Franklin and Marshall College. The following year found her down the pecking order again: Lebanon Valley College paid her $1,800 per course. She filled in doing substitute teaching at the high school, particularly during breaks at the college. And so it went, on to the University of Louisville, in 1988, where she pulled in $1,980 per course. A part-time job in the bookstore at the airport now makes it barely possible to get by. But when one of her students comes in to buy a magazine,

she is clearly shocked. The news spread through the class: what sort of professor works at the airport? What sort of professor indeed? She is not a Ph.D., but she has both an M.A. in English and an M.F.A. in creative writing. She has no retirement plan, no probable future but time itself. Should she get a Ph.D.? Forget guarantees. Was there any advice I could give her that comes with favorable odds?

The large uncertainties of part-time or temporary employment are supplemented by numerous smaller ones. Here is a 1998 memo from a temporary instructor at a midwestern university. She has published a book at a prestigious Ivy League university press and articles in distinguished literary journals. As requested, we have changed all names but left everything else the same:

Dear Bob: Because I know you're associated with the AAUP here on campus, I wanted to bring a matter to your attention that's of some concern to me; I'd also welcome some information about it, which I thought you might know. Earlier in the year I asked Mrs. Blaine if it would be possible to have my name listed on the Linley building directory this year, since I (for the space of this one year, anyway) have an office in the building. I was told that the directory listing was only for faculty who are here permanently, not for visiting faculty. I was puzzled since I had been listed during the span of my last year-long appointment, and because I thought that the directory was not a guide to the status of faculty, but rather a courtesy to those looking for faculty. (Sure enough, some students have been puzzled they can't find my office listed on the board.) I know that this sounds like a small matter, but it's what I see as a "dignity" issue for adjunct and visiting faculty. Kathy Joe Klinger told me that, prior to her tenure-track appointment, and even during the time she had three-year positions, she found it impossible to get her phone number listed in the faculty phone directory, and that students who called the information operator were told (even though she had worked here for years, and these were students currently in her classes who were asking) that there was no Kathy Joe Klinger who worked at U of R.

My concern is twofold: I do believe it's a matter of efficiency and courtesy to students and others to list office and phone numbers of visiting faculty, but I am also concerned with the discourtesy (even if unintentional, I am sure) of not acknowledging the existence of members of a community who have a marginal status.

It's a bit ironic that my book is on display in Linley lobby, but my name is a blank space on the directory board! Of course, it wouldn't matter whether I had a book or not; it seems only fair for people to be acknowledged for what they are—faculty members, even if for a brief space.

I bring this to your attention because I wanted to know if any regulations exist at U of R on such matters, and, if so, whether they can be changed at all if they do stipulate that visiting faculty not be listed in

building and phone directories. Would this matter have to go through Faculty Senate, perhaps? Pardon my ignorance, but—as my own sojourn here may be a brief one!—I had wanted, if I did leave U of R, to contribute something to the community before I left; as someone who has had to deal with this kind of marginality and who cares deeply about the position of adjunct and temporary faculty, I do feel it appropriate that I at least inquire into this before the year is up. Thanks for your time, and best wishes, Ellen.

"On some days when I go to that building," Ellen told me in an interview, "I look for the most obscure side entrance. I want to be invisible. But then, when I walk in the front door, I find no one looks at me anyway. I'm already wearing a cloak of invisibility."

Part-time and temporary faculty persist in their jobs partly in the hope that they will become tenure-track faculty, though with, say, the fifty-five-year-old woman I met earning $13,000 a year teaching composition courses, that is hardly likely. But for many the reasons run much deeper. Part-timers are psychologically and ideologically chained to their sweat-shop grading machines. They are held captive by iron links of loyalty, devotion, and altruism and, overall, by a focused and deeply embedded identity. That identity is forged in seven years of graduate study, study sustained by an equal number of years of teaching.

In the course of those years, young people are trained to see teaching as a higher calling, not some base material enterprise. Religiously affiliated schools sometimes make that connection specific, urging adjunct faculty to see their low salaries as a purifying form of Christian devotion. Occasionally faculty turn the tables, quoting scripture in defense of justice, rather than to institutionalize oppression, as faculty at Baylor University did in a 1997 letter:

> How does President Sloan justify not awarding cost of living or any other type of increased compensation for three consecutive years to a full-time lecturer who has been with the university for some time and consistently teaches courses requiring a minimum of 17 contact hours per semester for three courses? I feel that the quality of output of work eventually suffers as well as the self worth of the individual. For the scripture says: "You shall not muzzle the ox while he is threshing" and "The laborer is worthy of his wages" I Timothy 5:18.

But an implicit sacralizing message is universal in higher education. If teaching is mystified and student papers become eucharistic wafers in this campus kitsch theology, the students themselves are apparently all

immaculately conceived. Why else would the Yale University graduate employee grade strike have been such a violation of taboo. I'm sorry to have to break the news: in the history of secular religious inventions, the *mission* of grading semiliterate composition papers is one of our silliest inventions. It's not a calling. It's a goddamn job!

That's about as far as theological tropes will take us in clarifying this matter. For academic institutions themselves the temptations of exploitation wages seem decisively secular. Paying sweat-shop wages to teachers is like getting addicted to heroin: you don't kick the habit easily. Now whole campuses are hooked.

Two things are clear enough from this account. First, *paying faculty subminimum wages constitutes a genuine violation of professional ethics.* It must be characterized that way by everyone involved in higher education. Second, this kind of brutally exploitive salary structure represents the single greatest threat to quality higher education and the greatest temptation for corporations contemplating hostile takeovers of our enterprise. *It is not enough for organizations like the MLA to issue general statements urging fair compensation for adjuncts and part-timers.* The Modern Language Association recommends that departments and institutions do "self-study" to determine whether their enrollment and compensation practices are fair. That's all well and good, but East-West University in Chicago, a four-year institution, paid $1,000 per course to part-time faculty in 1997; asking them to look into the depths of their soul is really demanding they plumb the shallows.

The disciplinary organizations need to set minimum wages for part-timers and work to enforce them; there is no alternative. Full parity with full-time faculty is a necessary goal and a useful logic to deploy even if the goal remains distant. But the articulation of the principle alone will have little direct effect on the wages paid academia's exploited teachers. More direct and forceful action is needed from professional organizations.

Each discipline should publish an annual "Harvest of Shame" listing all departments and institutions paying less than $3,000 or $4,000 per semester course to instructors with Ph.D.'s. Salaries at schools on a quarter system could be set at $500 less.[1] It is also essential that abstract institutional responsibility for exploitive labor practices be shared by those staff members who benefit from that exploitation. Thus full-time faculty members and administrators from those schools should be barred from privileges like discounted convention room rates and barred from advertising in professional publications. That means publishers could not advertise the books of those faculty in professional journals. We would also

consider barring full-time faculty and administrators from such schools from publishing in journals published by professional associations and urging a ban on publishing in all university-sponsored venues. Other ways of highlighting faculty and administrative responsibility should be found for institutions not oriented toward research. Regional campaigns should condemn the institutions involved. And professional organizations, as Karen Thompson of Rutgers University suggested at the 1997 national conference on adjunct and part-time faculty, should also consider censuring institutions that treat part-timers unfairly by denying them all access to benefits like health care. Finally, a major national effort must be undertaken to brand schools paying less than $2,000 per course to any instructor as rogue institutions that threaten the quality and survival of our higher education system.

There will be tremendous resistance among full-time faculty members toward any suggestion that they should be personally penalized for their departmental or institutional policies. They will claim powerlessness, and however false that claim may be, they will believe it. Some will argue with good reason that they are fighting to change exploitive practices at their own schools. Others will have so deeply entrenched a sense of entitlement that they will be convinced underpaid teachers are underpaid because they are inferior. Despite all this, we believe penalties must promote recognition of individual responsibility and accountability. Even the personal challenge built into the *prospect* of individual penalties for institutional behavior would be productive.

The only other argument mounted against an organized assault on part-time hiring practices is a particularly confused and defeatist one. We refer to the regular protest that some people *want* to teach part-time. First of all, no one wants to be paid $1,250 per course for their teaching. *Underpaid labor is devalued labor.* We would have fewer complaints about part-time employment if all Ph.D.'s were paid at least $4,000 per course and had health and retirement benefits, increased job security, and proper grievance procedures. But the simple fact is that no power on our corner of the earth will enable us actually to eliminate part-time employment. The best we can hope for is to raise wages and benefits, stop the trend toward shifting still more full-time to part-time jobs, and perhaps alter the overall ratio of positions somewhat. But we are not going to be able to eliminate part-time employment in the academy. There will still be plenty of bad jobs out there. Voicing fantasmatic fears that the freedom to be exploited will disappear should not count as rational argument.

The only sound reason to hesitate taking any of these punitive actions is if the number of schools involved is too large and the threat of censure thereby becomes ineffective. On the basis of the national statement on part-time/adjunct faculty published in the January/February 1998 issue of *Academe,* on resolutions debated by the MLA's delegate assembly, and on the ongoing accrediting challenge to institutions with excessive reliance on part-timers, it seems the profession is beginning to counter this threat on several fronts. We must now intensify this effort. For if we do not resist this exploitation, we will eventually find corporate-managed proprietary schools dominating the education market. Then the quality of the education we can provide will substantially decline.

Here and there across the country a courageous administrator realizes the damages done go well beyond those done to the teachers themselves. One dean of the college of arts and sciences at a midwestern university said so with great clarity in a 1997 memo:

> • Less than half of our freshman/sophomore courses are taught by full-time faculty.
> • Only about two-thirds of our upper-division courses are taught by full-time faculty.
> • Almost 25% of our graduate courses are taught by part-time faculty.
> • Only about half of our undergraduate courses are taught by full-time faculty.

> To estimate the dependence of some of our large-enrollment courses on part-time faculty, I also gathered data about freshman/sophomore courses taught in the Departments of English and Mathematics. Those data are equally disappointing. For example,

> • More than 60% of our first-year and second-year Math courses are taught by part-time faculty.
> • Only about one-in-fifty of our first-year and second-year English courses is taught by full-time faculty.

> Perhaps this would be acceptable if these were small-enrollment programs that were relatively unimportant to our overall curriculum. But this is not the case; indeed, the enrollments in these courses exceed those of virtually all other departments (and some entire colleges) on campus. Moreover, these are courses that we require of all students. In some departments, our reliance on part-time faculty is so excessive that an undergraduate can get a degree and never take a class taught by a full-time faculty member.

Our overdependence on part-time faculty sends a variety of clear messages and has several equally clear consequences:

- Although we proclaim that there is a group of "core" courses on which all others depend (e.g., Composition to teach writing skills; Math to teach quantitative skills), we have subcontracted most of that entire program to temporary employees. No other group of courses has been so abandoned by full-time faculty.
- Although many part-time faculty do an excellent job, some do not. In large programs such as English and Math, it's almost impossible to find enough people qualified to teach the courses, regardless of their teaching skills. Not surprisingly, this makes it difficult for the department chairs and program directors to ensure the quality of those core courses.
- Few part-time faculty contribute significantly to their departments' advising programs, scholarly work, service, etc. Most show up to teach their classes and then leave. This, combined with the fact that most part-time faculty do not have offices, is why students have so much trouble finding their instructors outside of class. This, in turn, contributes significantly to poor performance and increased frustration, and ultimately to why almost three out of four students who enter [here] do not graduate.
- We charge students large amounts of money to attend [our institution]. Students arrive on campus ready to be taught by professors. Yet during their first two years, the students are most likely to be taught by part-time instructors having less training than many of their high school teachers. Rather than introduce students to our best faculty, we assign them to part-time instructors.

The narratives with which we began make it clear why part-timers cannot stay around to chat with their students. While we believe that most part-timers teach well, it is clear they have insufficient time to prepare new course lessons and advise students. Yet the truth is that part-timers work much, much harder than they should for what they are paid. They should calculate an appropriate hourly wage and then stop working when they reach it. They should unionize, perhaps forming unions covering a metropolitan or geographical area, as Tom Johnson suggested at professional meetings in the late '80s and again in *Against the Current* in 1992. There are many advantages to this area-wide hiring hall concept: it would make hiring scab labor more difficult, give part-timers their own physical space for interaction and organizing, and make it possible for people to organize at campuses other than their own, thereby minimizing the potential for retaliatory firings.

It is a bit daunting to set out organizing, say, the part-timers hired at forty to fifty New York area schools, but one might begin with a few schools and then seek help from a national foundation or union. A couple of salaried part-time organizers from among the local adjuncts would help a great deal. So would support from tenured faculty. But part-timers need both to be full voting union members and to have their own semi-independent union structure, as they have at Rutgers, if their needs are to be given any priority. Otherwise tenured faculty may well treat them very badly. At CUNY, the part-timers won medical coverage only after they mounted a union decertification drive. Had they joined the union (the Professional Staff Congress) in sufficient numbers, they could have made their salaries and benefits a priority. As Marcia Newfield writes, "WAKE UP ADJUNCTS! Only 600 of you out of 7,500 have joined so far. . . . The PSC is not going to 'do it for you' until you become the PSC." That is what part-timers at Lansing Community College in Michigan did when full-time faculty failed to pursue their interests; they took over the union.

That is not to say that part-timer gains from unionization will soon be revolutionary. At least not until there is wider campus solidarity and regional control over part-time hiring, but unions can ameliorate abusive working conditions. Health insurance is one of the benefits unions fairly consistently win for their members. Consider the 1996–98 part-time faculty contract between the American Federation of Teachers (AFT) and Vermont State Colleges. Part-timers there get about a 4 percent annual pay raise *in addition* to three step raises of about 11 percent after each three years of teaching. After a decade, then, a part-timer would be earning about 75 percent more than he or she earned at first. Appointments are handed out on the basis of seniority, and an effort is made to award them forty-five days before classes begin. There are grievance procedures and modest professional development funds for part-timers. When a part-timer has a death in the family, he or she gets five days' paid leave. Part-timers continue to be paid when they are called for jury duty. Part-timers who get sick after teaching 60 percent of a course get paid for the rest of the term. These are the sort of modest decencies colleges seem disinclined to offer on their own. Yet unions that do not win major increases in part-timer pay rates risk becoming part of the institution of wage slavery. A hopeful alternative is suggested by the Part-Time Faculty Committee's summer 1998 victory at the Boston campus of the University of Massachusetts. They won a per

course salary of $4,000, plus health benefits (including family coverage) and retirement plan participation.

It is also time that *all of us* realize the consequences of the wholesale outsourcing of higher education. They include not only the damage done to both exploited part-time teachers and underserved students but also increasing salary depression for the full-time faculty as well. People have warned about that possibility for some years; now it has come to pass.

Across the new South—in many of our former slave states—a whole lumpen professoriate is forming and hardening in place. What unifies many of them, despite differences in job security, is salary. You can get burned out at $20,000 per year, or you can be indentured for life at the same pay rate. Status and prestige differentials are on the decline throughout this group, which ranges from temporary to tenure-track faculty. A few runaway teaching slaves make it north to better-paying jobs, but they bring with them the news about southern hospitality. As word spreads, so does temptation. We can hire faculty at half the price we pay now. Why not? Why not, indeed? This is America.

You can be a tenure-track faculty member at Southwest Missouri State University for $20,000 and teach four courses a semester. Maybe you'd rather trade in your job security for $21,000 at Morehead State University in Kentucky. But then you'd have to teach 5/4 and Morehead is talking about 5/5 at the same salary. Why not? It's America. Land of opportunity. Wait a minute. At Morehead State you get a fixed, nonrenewable five-year contract. After that, you're out. No second chances. You get health care coverage during the academic year. Want summer health coverage? Pay $510. Sound bad? Try Alabama. At Alabama A & M University in Huntsville, founded in 1875, you get year-round health care and teach a mere 4/4 for $21,000 as a tenure-track assistant professor. But it's mostly composition, and they let the enrollment go up to thirty-five to forty students per section. Like grading papers? By the way, down the road at Calhoun Community College in Decatur they're planning to move to a 6/6 teaching load for full-time faculty.

The combination of part-timers with Ph.D.'s earning $10,000–$14,000 and tenure-track faculty pulling in roughly $20,000 is creating a growing majority of faculty earning less than many blue-collar workers. The proletarianization of these faculty involves not only their wages but also their working conditions, with increasing loads of undergraduate papers, growing class sizes, decreased intellectual freedom, and frenetic migrant travel between campuses the permanent lifestyle for many. As such people become the norm, can faculty any longer sustain their tradi-

tional class identification or carry any of the cultural capital they have had throughout living memory?

Already many part-timers see themselves as workers and view the prestige associated with the professoriate as a sham. Nor do we imagine that the full-time faculty at South Dakota's Mount Marty College, earning barely $20,000 a year, see themselves as among America's ruling class; when they attended a national conference in Chicago in 1997 they saved money by staying at the homeless persons' shelter. How these shifting class identifications will play themselves out is difficult to predict, but the status of faculty members is surely headed south. Once the word gets out about depressed faculty salaries in the arts and humanities, few students seeking class mobility will opt for an academic career. Undergraduates who want a salary they can use to help their parents or extended family will be well advised to give the clear-cut groves of academe a pass. That probably means fewer poor and minority students seeking humanities Ph.D.'s and thus a professoriate that again becomes as white, though not as male, as it was in the 1950s. Can anything be done?

Certainly increased numbers of part-timers and an increased reliance on underemployed part-timers holding doctorates have made organized resistance more feasible. But the struggle to win justice for these workers is now in its third decade. We have in our files a blue mimeographed document dated 8 May 1973; it's from Dennison University's AAUP chapter and it's called "Proposed Bill of Rights for Part-Time Faculty." The opening sentences are worth quoting:

> Although some of the insecurities of part-time employment are the inevitable result of fluctuating enrollments and financial uncertainties, others are brought about by institutional and individual insensitivities that may verge, at times, on exploitation. The part-time faculty are disenfranchised and taken for granted—but they constitute a professional labor pool which the college draws upon and depends upon in time of need. The students taught by these faculty members deserve and regularly get competent, professional instruction—and their teachers deserve recognition for their competence and professionalism.

The two-page, single-spaced memo notes that "women more than men constitute this reserve work force" and then goes on to list eight points in a proposed bill of rights for part-timers. They include adequate hiring procedures, justification of termination, notice of termination (with severance pay after four years), prohibition of unfair unilateral department hiring policies, individual salary reviews and merit pay raises,

participation in departmental decision making and university governance, prorated fringe benefits, and accrual of sabbatical credits.

That was 1973, a quarter century ago; most of these benefits are still unwon, and a few now seem almost utopian. No doubt some of those Ohio part-timers are now in their graves. At a small school in Rhode Island a full-time faculty member in the 1990s was given an office once packed with part-timers. On the wall, partly abraded, was a stenciled notice: "Part-Time Faculty Office." The college offered to paint it over, but the new faculty member refused, wanting some residue of the school's labor history to remain.

That history includes repeated efforts to forge consensus around national standards. The national AAUP condemned full-time, non-tenure-track appointments in 1978, calling them a threat to academic freedom, and two years later issued a statement of principles for part-time appointments. The Conference on College Composition and Communication reiterated those guidelines and added its own principles in what is now known as the Wyoming resolution, in 1989. In 1998 several disciplinary organizations joined with the AAUP to issue a still more detailed report and set of recommendations on part-time employment. Critical as these documents are, they will come to nothing without organized resistance.

Joe Hill's final words remain the only relevant advice: "Don't mourn. Organize." Twenty-five years ago a lonely effort to win rights for exploited academic workers took form here and there on campuses across the country. At the time it seemed a moral imperative to address it, and exploitation was the only counterargument to opportunism. Now a whole industry is imperiled by employment practices that have made college teaching the lowest-paid legal job in America.

Part-time appointments are the single worst problem higher education faces, and they are linked to every other crisis in the industry. If you start talking about the detenuring of the faculty, you end up talking about part-time employment. If you address threats to academic freedom, you must deal with the part-time scene, where they are worst. Take up the risks in distance learning and you arrive at the certainty of more part-time hires. Discuss the future of affirmative action hiring and you confront the way part-time employment will shape and undermine it. Talk about faculty authority on campus and you must talk about how part-time employment is destroying it. Talk about the place of humanities disciplines cannot occur without confronting their takeover by part-timers. University governance? Try addressing it without discussing part-timers' role in its

future. The quality of undergraduate education? The future of graduate study? Faculty teaching loads? Funding for higher education? The dignity of teaching? The massive shift to part-time employment is at the center of everything we do.

But for the first time a national movement is taking shape. Meanwhile, too many tenured faculty think the best way to address these issues and win benefits is to wait patiently outside the president's office hoping to press a wet nose into his palm as he heads to or from work. Administrators will grant nothing on their own initiative. You will win what you take.

CN

See *academic freedom, the corporate university, faculty.*

Peer Reviewing (ˈpi(ə)r rəˈvyü·iŋ) Peer reviewing is the system of evaluation that protects academic independence and assures a level of disciplinary consent about scholarly publication. It operates in several contexts. Scholarly journals send out essays submitted for publication to other faculty members for evaluation; the names of the evaluators are kept secret. Academic presses do the same with book manuscripts, and agencies like the National Science Foundation and the National Endowment for the Humanities follow the same procedure with grant applications. Universities use peer reviewing to assess candidates for promotion and tenure. Some journals withhold the names of authors from reviewers, though the names of book authors and promotion candidates are always revealed. Peer reviewing is not a perfect system, since it uses fallible human beings to choose reviewers and equally fallible human beings to make judgments about another faculty member's work, but it is the only system we have. Nonetheless, intellectual bias, prejudice, jealousy, ignorance, and sometimes outright malice can intervene to produce faulty evaluations. The system thus requires considerable oversight if its reliability is to be maximized. Negative reviews should always be carefully investigated for possible bias. Peer reviewing needs to be peer-reviewed.

But peer reviewing also needs to be properly conceptualized. Academics like to think of it as an *objective* process, and that it is surely not. It embodies and speaks for disciplinary consensus, which reflects the historical, social, and political limits of current thought, not transcendently objective truth. Groundbreaking work that challenges the taken-for-granted "truths" of the discipline is notoriously difficult, though not impossible, to

publish. Peer reviewing is not only a mechanism for evaluation but also a mechanism for control. It rewards certain forms of thought and discourages others. If it helps guard against fraudulent work and thus safeguards disciplinary integrity, it also encourages intellectual compliance and safeguards the prestige of dominant opinions and paradigms. As we point out in the entry on *promotion reviews,* it can be a weapon that unscrupulous academics in power can use to destroy people's careers.

The most important scholarly analysis of peer reviewing is surely the study published by Peters and Ceci in 1982. It is an essay every professor in every discipline should read and keep in mind throughout their careers. It is the result of a daring experiment whose results few would have predicted. The authors picked twelve distinguished psychology journals from a variety of subfields. Each journal followed the practice of leaving authors' names and institutions on essays when they were sent out for evaluation. From each journal Peters and Ceci selected one essay published in that journal over the last two or three years.

The investigators then *retyped* the twelve published essays, gave each a new title and new authors, using fake names of the same gender, and invented institutional names that would have no high status identification. So a published essay by a Harvard University faculty member would now be submitted from, say, "Tri-Valley Center for Human Potential." Peters and Ceci then resubmitted each retitled essay to the same journal that had already published it. Of the twelve essays, only three were recognized as resubmissions. Of the nine essays that were then peer-reviewed, *eight* were rejected by the very journals that had already published them. The editors and associate editors of the journals agreed with the reviewers' evaluations.

It is difficult not to conclude that institutional prestige has something to do with successful navigation of the peer reviewing system. The actual content of the essays themselves hardly seems to have been decisive. Indeed the most frequent ground for rejection was "serious methodological flaws," a criterion that certainly *sounds* objective. But these essays had already been found to be methodologically sound. None of the reviewers of the eight rejected essays said anything like "adds nothing to the existing literature," which might suggest the original publication had already entered the discipline's knowledge base. The Peters and Ceci experiment is published with a large number of comments from other scholars, many of which are interesting. But a few revealing notes creep in: of course psychologists are unscientific, but *my* discipline (physics, chemistry, whatever) is objective; or, why shouldn't essays from Harvard count for more

than essays from Kansas State? The sample used in this experiment is small, but the results are still suggestive.

They reinforce our own experience in the humanities, in which we find that acceptance or rejection of essays often depends on whether the approach and conclusions match the peer reviewer's assumptions. Peer reviewing of single-author book manuscripts, as opposed to anthologies, we find more consistently reliable, perhaps because reviewers reading a whole book manuscript are more likely to credit the author's aims and methods, rather than just imposing their own. When one of us several years ago submitted the manuscript of *Marxism and the Interpretation of Culture,* a large collection of essays from a groundbreaking conference, two readers from different theoretical perspectives accepted or rejected essays largely on the basis of their own theoretical commitments. Since one was a traditional Marxist and one a poststructuralist, they had almost no points of agreement, though both did want us to drop what would eventually become the most influential essay in the book. On the other hand, we have both had wonderfully helpful peer reviews on single-author books.

See ***promotion reviews, scholarly books.***

Ph.D. in the Side Pocket (ˈpē ˈāch ˈdē in thə sīd ˈpäkət) Active
researchers in departments of kinesiology or exercise physiology conduct sophisticated studies of respiration, muscle movement and mass, and so on. Such professors help fund their students through research grants and fellowships, and of course their departments support graduate students through teaching assistantships. What sorts of courses do these students teach? Bowling, canoeing, tennis, even billiards and Ping-Pong (table tennis, sorry). Professors thus need students with formidable backgrounds in science and statistical methods, while departments need instructors with a mean backhand, expertise as a kegler, or the ability to hustle fish out of their paychecks at the local pool hall. Sometimes these two competing needs lead to considerable discrepancies in the abilities of newly admitted graduate students.

It shouldn't come as a big surprise to anyone that many brilliant students in kinesiology wouldn't know a massé shot from a kayak paddle. So, when asked by an admissions committee to list all the sports and games they are competent to teach, many do the only thing they can if they hope for a career in the field: they lie a little. And they hope their impressive transcripts, high GRE scores, and "rave" letters of recommendation will

get them in. Then, if necessary, after sitting in seminars on biomechanics and conducting sophisticated research, they read the rules of nine-ball on the way to teach their pocket billiards course.

Promotion Reviews (prə'mōshən re'vyüz) This entry will take the form of a cautionary tale. Some years ago the Political Science Department here asked me to serve as an external (but voting) member of a panel evaluating a potential promotion case. The faculty member in question included feminist theory as one of her major areas of teaching and research, and the department felt it had no one qualified to judge feminist theory, so both I and a colleague from women's studies joined the promotion committee. We both felt the candidate merited promotion (she was up for a full professorship), as did one of the political scientists. Two other political scientists wanted to reserve final judgment until the outside letters came in, which was fine; indeed, there's no point in putting a case forward without strong outside letters. So we decided to move to the next stage—choosing potential referees from other universities.

This is always a difficult issue. When publishers consider a book for publication, they prefer to find someone sympathetic to the *kind* of work being done, to the intellectual traditions out of which a person is working, who then has the job of deciding whether the book is original, important, and well written. Publishers generally realize they're wasting time and money if they choose someone who dislikes the kind of work undertaken or the approach the author used. Then you most often get a knee-jerk negative evaluation. It tells you nothing. You don't send a book about how to do psychotherapy to someone who thinks Freud was a fraud, and so forth. Responsible promotion committees conduct themselves the same way; after all, you know what sort of work people do when you hire them. It is irrational to fire someone without a full and fair evaluation. Of course it doesn't always work that way. Unscrupulous faculty members in my own department managed to sabotage a faculty appointment in 1996 by assigning the case (another feminist) to external reviewers who hated feminism.

Different schools, however, conduct the process in different ways. Most schools give the candidate the opportunity to name some potential referees. When I came up for promotion for the third time in 1974, I was

allowed to pick all my outside referees. I had been warned to avoid selecting friends, so I simply chose the most distinguished people in my field who seemed likely to give my publications a fair hearing. Now, my university would not permit a candidate to choose all of his or her outside referees, and actually it's better that way. For one thing, a young faculty member may not know the politics of the field or the obsessions and personalities of nationally known figures well enough to pick appropriate names. I turned down a tenure candidate's nominees years later because I was certain they were dreadful choices, that they would all reject his scholarship out of hand. So some thoughtful system of checks and balances is essential. On the other hand I know a school that actually has a candidate *write for and receive the outside letters on her own.* If the candidate considers any of the letters unhelpful, he has the right not to pass them on to the department; there's no requirement even to tell the university how many letters were solicited and received. That is clearly not really a review process at all.

In the effort to "get tough on tenure" in the 1970s, some schools instituted procedures that increased the probability of capricious and unfair decisions. Northwestern University decided that even departments could not be trusted to solicit outside letters. Instead they assigned that task to an ad hoc review committee of faculty outside the department appointed separately by the dean's office for each tenure case. The department could recommend names of potential referees, but the committee was under no obligation to use them. Not knowing the nuances of the field, these committees were in danger of picking highly inappropriate reviewers, as they not infrequently did. The result was an increase in the number of those denied tenure, which the administration felt meant standards were being raised and the quality of the faculty being improved. There seemed an informal guideline at work aiming at tenuring no more than 50 percent of probationary faculty. Ethical practice demands that each case be considered on its own merit, not on the basis of a quota. Moreover, for a department focused on doing first-rate hiring, a quota or an arbitrary review system is immensely disheartening.

In order to enhance the power of these ad hoc committees at Northwestern, their members' names are kept secret and the letters they solicit are kept confidential. Not even the tenure candidate's department head is allowed to see them. So if negative letters are received and a case runs into trouble, the department has to rebut letters it cannot read. The department head gets to read the committee's anonymous report and may

thereby get hints of the content of the letters, but both their full text and the names of the people who wrote them are withheld.

In the mid-1990s this system was slightly modified. The department was also allowed to solicit a few letters for the file. But departments were simultaneously informed that the letters they obtained would carry less weight than those acquired by the ad hoc committee. As in many tenure review systems, at Northwestern the existence of one negative letter can be damning. There is a tendency to say, "Now we've finally heard the truth!" when a letter critical of a faculty member's work arrives. In a system like this, the odds of receiving one or two negative letters dramatically increase. There is no way, then, to assure young faculty of fair procedures or consistent standards for promotion. The chance of receiving negative letters also goes up when the sheer number of letters requested rises. Many schools obtain five letters from outside reviewers, but a few seek substantially more. Indiana University requires ten outside reviewers and does not trouble itself to compensate them for their time.

Some fields, moreover, have adversarial cultures that make it difficult to obtain balanced outside reviews. In the humanities, philosophers are among the more aggressive reviewers, sometimes considering it their ethical obligation to list every single minor disagreement with a candidate's published positions. But the worst discipline in this regard is law, where faculty members routinely behave like prosecutors setting out to demolish an opponent's case. A talented young law professor can end up with a promotion dossier full of briefs against his or her work, and the department then has to mount counterarguments that are difficult for university-level committees to believe. Of course the standards for tenure and promotion in law are also less than in many other fields. One rather long, well-researched essay is all that's required. Law schools claim this is the equivalent of a book, but the fact is that almost all probationary law faculty finish their "tenure piece" in two or three years at most and are routinely granted early promotion.

In the committee meeting for the political science promotion, however, I was about to be introduced to a practice entirely new to me. We each arrived one day with the names of prospective reviewers and proceeded to read them out loud. I was astonished at one department member's suggestions. "Have you read the candidate's work?" I asked. "Of course," came the answer. "But your list of evaluators is a list of all the scholars she attacks in her own work. In one case she says his so-called 'scholarship' is

nothing better than propaganda for the Nixon administration's foreign policy." There was a moment of silence, then a hypocritical defense: "These are all distinguished, honorable scholars. I'm sure none of them would allow her negative comments about their work to influence their evaluation of her promotion case." I countered that this was one of the most unethical suggestions I'd ever hear of, that if these names were not dropped, I'd go directly to the provost to complain. I got my way, and the outside letters ended up being positive. No matter, the department, which was awash with personal malice at the time, refused to forward her promotion anyway. She got another job and successfully sued Illinois for sex discrimination. Since much of the department's shenanigans ended up as part of the court record, I feel free to tell the story now.

But there is one more chapter to come, a chapter that takes us back to the issue of tenure reviews. One member of the Political Science Department sat mute through this committee debate, all the while staring at me with an eerily blank look beneath a furrowed brow. I could not decode the look or its accompanying silence. I thought about both, but they were unreadable. Years later, I got my answer.

I was having dinner with one of the department's former members, now a faculty member elsewhere, when I told my story. I was relating what I naively took to be a unique tale of corruption when my friend set me right. "Whenever the department wanted to fire someone coming up for tenure, the head routinely asked his assistant to go through the candidate's publications and make a list of the people whose scholarship the candidate criticized. We used those names as outside referees. It was standard procedure for us for years." My mind suddenly flashed back to the several left-wing scholars the department, heavily funded by the defense establishment, had fired over the years. Had this been done to them? The process was confidential, so the candidates would never have known. Of course, any tenured faculty member who read a candidate's work would have known, and presumably kept silent.

Promotion reviews require vigilance from tenured faculty who try their best to be fair and professional. Assistant professors coming up for tenure often benefit from a knowledgeable senior colleague serving as a mentor. The formal process requires multiple opportunities for appeal. Shoddy conduct is possible at all levels. If some cases are unethically sabotaged, others are hypocritically endorsed. Indeed, I have known faculty members to write glowing reviews of a candidate's work and then privately admit they think it of very poor quality.

There is tremendous variation between departments even within

individual institutions. Having reviewed roughly five hundred full promotion dossiers from almost every discipline in the American university, I can report that often enough departments with the best of intentions assemble a case incompetently. Outside letters occasionally come from close personal friends, even former lovers. They are sometimes solicited from businessmen who extol their company's product line and never evaluate the candidate. Despite all that, I have found the procedures here mostly thorough and fair, but it takes hard work and much thoughtful analysis to keep the process on track. No faculty member enjoys being reviewed for promotion, but there is no alternative to the only system we have that protects academic freedom by awarding tenure.

CN

R

Research (ˈrēˌsərch) Everyone thinks he or she understands the broad objectives of research in fields like science, engineering, and agriculture. Scientists work to cure cancer; engineers invent new building materials or design better bridges; faculty in agriculture improve crop yields or breed better pigs. More basic or theoretical research may make people uneasy, but the faith in material progress at least obliquely underwrites the entire scientific enterprise. The practical benefits gained from many research projects generally balance and compensate for whatever seems incomprehensibly abstract.

Of course when the cost is too high and the benefits difficult to foresee—as with expensive high-energy physics projects—public or political support is more frequently withheld. That is largely because science's other great protector, the cold war, has come to an end. Indeed, funding for scientific research is more difficult to obtain now that it is no longer underwritten by cold war paranoia, but a wholesale rejection of research in the sciences is still nowhere to be seen. Even science's demonic triumphs, like the development of nuclear weapons, or its demonizable triumphs, like cloning, are eventually widely forgiven. That is not to say that scientists sleep easy these days, but they do not quite worry about waking to find that the world they know is gone.

The situation in the arts and the humanities is altogether different. The public credits the humanities with transmitting eternal verities, with civilizing students, with disseminating culture, with promoting upscale leisure activities—and might even admit that the storehouse of cultural treasures increases its holdings over time. But none of this much calls for *research,* or so many outside academia would conclude. Except, perhaps, for agreeing that new works should get added to the cultural heritage, the public has little sense that the humanities oversee a developing tradition.

Unfortunately, many well-read members of the public would prefer that the humanities be devoted exclusively to transmitting a stable body

of texts and values. Such notions have been regularly reaffirmed at least since Cardinal Newman's *Idea of the University.* Cultural conservatives like Dinesh D'Souza now treat the rise of theory in the humanities and social sciences as the decline of commitment to the core messages the humanities can otherwise preserve. So research, if it alters or destabilizes this imaginary body of harmonious truths, is far from superfluous; it is a threat. Conservatives have thus succeeded in delegitimating not only recent theory but also the ongoing conflict of interpretations.

Without the humanities research of the last several decades, of course, we would still be transmitting the racist and sexist literary canon and historical narratives that dominated both the curriculum and scholarly conversation until well into the 1970s. America's single most distinguished African American poet and the premier poet of the American Left, Langston Hughes, would not be known at all or by only a handful of his least threatening poems; most of his work was out of print until 1994. Except for Virginia Woolf, Jane Austen, or the Bronte sisters, most women novelists would neither be read nor taught; they certainly were neither studied nor researched when I was a student in the 1960s. The table of contents of volume two of the *Norton Anthology of English Literature,* first published in 1962, had only Woolf and Katherine Mansfield in its first edition. History until recently emphasized diplomatic, military, and political history, passing over the lives of ordinary people in most periods. So humanities research is needed first to correct the massive omissions and blindnesses of the past.

But even if the humanities were devoted to an unchanging group of great works, it would still have to reinterpret them in the light of contemporary knowledge and experience. The precise words scholars and teachers said about Shakespeare a hundred years ago would not serve our students or our culture well. Nor are humanities disciplines as a whole immutable; they must adapt to the changing cultures of the nation and the world. This process of adaption takes place as a continuing conversation and debate. It produces new interpretations that alter our understanding of even classic texts. Such reinterpretations take place not only in scholarship but also in more public venues. Thus it is not the same to teach Greek drama after seeing Tyrone Guthrie's stage production of *Oedipus Rex* or Pier Paolo Pasolini's film version of the same play.

The passage of time and new historical events also lead us to revise our views of earlier works. It was hardly the same to teach black students after slavery was outlawed as it was before. It is not the same to teach

African American literature after the civil rights movement as it was before. It is not the same to talk about the solar system after the Apollo program. It is not the same to teach modern history after the fall of the Soviet Union. It is not the same to teach Jewish history after the Holocaust. It is not the same to teach American women's writing in the wake of the feminist movement or now that dozens of forgotten women writers have been rediscovered and brought back into print. It is not the same to teach about homosexuality in the wake of the AIDS epidemic or in the wake of the radical new scholarship on the social construction of gender. There is no point in nostalgia for a time when all this had not happened. Nor is there much sense in saying that teaching physics in the light of the theory of relativity makes a far more powerful difference than any or all of these other events and developments.

Research and writing together *produce* the contemporary intelligibility of the humanities. They would have far less purchase on our lives without it. While it is not necessary that every humanities scholar do this work, a sufficient number must be free to do so and be given the support they need.

CN

See *the corporate university.*

Responsibility Centered Management (rəspän(t)sə'biləd·ē 'sentə(r)d 'manijmənt)

> Internal competition as a substitute for formal rule- and committee-driven behavior permeates the excellent companies. It entails high costs of duplication—cannibalization, overlapping products, overlapping divisions. . . . Yet the benefits, though less measurable, are manifold, especially in terms of commitment, innovation, and a focus on the revenue line.

When Thomas J. Peters and Robert H. Waterman, Jr., advanced this argument in *In Search of Excellence: Lessons from America's Best-Run Companies* (1982), university administrators and businessmen and women on boards of trustees apparently took note. For the whole notion of a university was beginning to undergo profound change. Less and less did it connote community or a disinterested pursuit of knowledge. In the era of responsibility center management (RCM, known more often as responsibility

cent*er*ed management), the university is dissected into a series of self-interested academic units in a competitive struggle for survival.

That has always been partly the case, but RCM intensifies the competition. RCM is both an accounting and a budgeting program. It aims to translate every department function into either an expense or a source of income. Thus all department activities are quantified, and departments can be held accountable for the results.

The one form of "revenue" implicitly available to every department is the tuition dollars paid by the students it teaches. So staff salaries, equipment costs, and space utilization are placed in the expense column, while the tuition dollars and grant money the department earns are placed in the income column. It then becomes clear which departments are effectively earning money for the institution and which departments are financial burdens. The classics or linguistics departments can suddenly look like expensive luxuries.

Because its decentralizing trajectory lays both the costs of teaching and—more important—the tuition revenues for students taught squarely in the doorways of academic units, RCM can produce an aggressive internal competition for students. This often leads to precisely the kinds of duplication and cannibalization Peters and Waterman describe. And for many in higher education, the bottom-line thinking of such internal competition has destroyed the idea of the university.

In a working paper written in 1996, University of Michigan economist John G. Cross traces the central ideas of RCM to the 1950s and a series of articles in the *Journal of Business* that, in addition to outlining the complexities of the issues involved, discussed the "possibility that sub-units of large corporations might be managed as semi-autonomous businesses" (13). The advantages to academic departments of such a management scheme? Flexibility and autonomy, of course, not to mention "excellence" as Peters and Waterman suggest, hardly unfamiliar terms at the corporate university. The liabilities? Cross discusses one of the most deplorable: "It is its one-dimensional linkage between credit hours and revenues that generates the fear that VCM ["Value-centered management," Michigan's more attractive sounding version of RCM] will stimulate units to attract student credit hours through offering courses that are compromised in academic quality" (4). Because education is perhaps the only commodity that many consumers actually desire to be of lesser quality rather than greater—how many times does the announcement of a canceled class or a relaxed requirement meet with a cheer from students?—such compromising of academic quality is an almost inevitable result without the vig-

222

ilant centralized governance RCM was intended to replace. When deans feel compelled to warn departments *not* to advertise courses waiving such requirements as final examinations or, more common still, guaranteeing that no substantial essays will need to be written, something has indeed contaminated the idea of the university.

More common, and more damaging finally, is the manner in which RCM has led schools within the university to duplicate introductory courses once taught across campus and, in effect, bring their own chickens (and tuition dollars) back home to roost. That is to say, as Cross explains in considering the liabilities of RCM, academic units that "provide large numbers of 'service course' credit hours to students in other units will lose credit hours (and hence revenue) as these latter units seek to retain the instructional credit hours for themselves by offering their own courses as substitutes" (5). So, not surprisingly, the School of Business at Indiana offers a course in professional writing that strongly parallels an analogous course taught in the English Department. To be fair, such was the case before the implementation of RCM. What's changed, however, is that now more business students stay home, as it were, and that more of these courses (though not all) are taught by English Department graduate students working for the School of Business. (That's the Kelley School of Business, actually, named after a donor who is CEO of a company that owns the Steak and Shake restaurant chain.)

Cross also warns about the mechanics of "revenue attribution." That is, while revenues are generated by the credit hour, there exists—or existed in 1996 when he wrote his analysis of RCM—no counterbalancing distinctions between the costs of delivering different kinds of instruction. So, for example, 450 credit hours equal 450 units of revenue whether 150 students are enrolled in a single 3-hour lecture course or 150 students are enrolled in five classes of 30 students each. It doesn't take much of an administrator to recognize which method of instruction is cheaper, uh, more cost-efficient, for the department; and, as we've described elsewhere, when a department hires an advanced graduate student or a part-time faculty member to give the lectures, the "efficiency" (i.e., bottom line) is even greater.

At least two questions, therefore, need to be asked on campuses where RCM has been installed: (1) Have enrollments in departments offering large service courses dropped as duplicate courses began springing up on campus? What other effects devolve from such duplication? (2) Have the numbers of lecture courses increased in departments that once argued passionately for the necessity of smaller classes? This is not to say that all

lecture courses are bad; quite to the contrary, we believe that students gain different benefits from various instructional settings: lectures, small class discussion groups, seminars, individual tutorials, and so on. But in what ways have revised budget procedures affected class offerings and thus a department's teaching practices?

Our colleagues in the School of Business and other schools on campus would want us to clarify that they are not the bogeymen and women of RCM, and they're right. The matter is far more complicated and there's plenty of culpability to spread around when academic values are undermined by financial calculations. We should also add that in some instances the mythologies springing from RCM are far worse than the realities. And there is also the ever-present difficulty of defining causality. The fact that economic hard times occurred for some units on campus *after* RCM was implemented does not mean that these results were *caused* by RCM. But RCM puts at risk the always difficult balancing act colleges and universities have performed between economic viability and academic quality.

These warnings are backed up by several of the conclusions in a report produced at one of RCM's leading institutions, "Responsibility Centered Management at Indiana University Bloomington" (1996): "The incentives inherent in RCM have resulted in increased attention to income generation and cost containment"; "There is concern that the system seems more oriented toward quantitative measures and may not respond as well to measures of quality"; "Some feel that the system may be one factor causing an erosion of the spirit of collegiality and cooperation . . . at IUB." None of this impinges on the primary recommendation: that "The current version of RCM be maintained with minor modifications."

SW

See **the corporate university, downsizing, outsourcing, part-time faculty.**

Robber Baron Universities (ˈräbə(r) ˈbarən ˌyünəˈvərsəd·ēz)

Times are not bad everywhere in higher education. A few schools remain flush with cash, despite their claims to the contrary. Why is it that many of our very best colleges and universities lie to everyone about their financial health? Why at the same time do they set out to impoverish almost all their employees except for a select group of faculty and administrators? What has turned the top tier of schools into blind profiteers indifferent to their educational mission and to the moral values that once defined higher education in America?

Their names—which include Harvard, Yale, and Princeton—used to suggest the most altruistic motives in American culture. Now, for those most closely associated with higher education, these same names frequently signify human exploitation and unbridled profiteering. They have made it a matter of policy to pay most of their employees as little as possible, even if that means that graduate student teachers, adjunct faculty, and cafeteria workers alike cannot make ends meet on their salaries. And these institutions constantly cry poor, even claim to be operating in the red, despite turning a profit every year and despite huge endowments that could make them humane and productive places to work.

Of course the vast majority of colleges and universities are on very tight budgets. But schools like Harvard, Yale, and Princeton have huge budget surpluses and endowments in the *billions* of dollars. In 1998 Harvard's endowment was eleven billion, while Yale and Princeton got by with merely five to six billion each. Reinvesting their profits to build ever-larger endowments, they meanwhile increase tuition, break unions, and hire young teachers at poverty wages. Yale, to take this madness one step further, even lets its buildings crumble in order to hoard still more and more of its cash. The red and the black at Yale represent a kind of corporate anarchism—accounting gimmicks without real world referents.

Sound financial planning would lead any institution to prepare for future cost increases and to guard against hard times. But at some of our schools this practice has now gotten out of control and left reason behind. Yale seems to have decided it should have enough cash reserves to move its campus should the polar ice caps melt. Meanwhile, tuition-paying parents and lower-grade employees pay the price. And by lying about their finances—crying poor when they are astonishingly wealthy—these select schools make everyone in higher education look dishonorable and untrustworthy. The standard our "best" schools are setting is the worst one possible.

It is time for those closest to the problem—especially those employees most exploited by these unethical reinvestment policies—to take matters into their own hands, organize for change, and insist that higher education recover the ethics that once guided its mission. Top-tier higher education has adopted the robber baron values of late nineteenth-century capitalism: treat workers as disposable and do everything possible to maximize profits; behave like nothing else matters. But other things *do* matter, or at least that's why many of us entered higher education in the first place.

S

Scholarly Books (ˈskälə(r)lē ˈbu̇kz) We have heard that they are dying. We have heard that they are dead. We have heard that they will live forever in cyberspace. The truth is that no one knows what the scholarly publishing scene will be like in ten years. But present trends can only support bleak predictions. A 1998 letter from a major university press seeking a manuscript evaluation from a reader included the following passage: "Although [this book] is clearly work of publishable quality, 'publishable' isn't necessarily enough, given today's shrinking market for academic books, particularly books in literary criticism. We'd want to feel confident that the book is of superior quality and that it would interest more than a handful of specialists." If those are bracing words, consider that several university presses have more succinct responses to inquiries from English professors: "We no longer publish literary criticism."

Trained as specialists, hired on the basis of this training and their ability to demonstrate its results in the form of academic publication, many young scholars have begun to despair. Others have no idea what economic realities they face. If scholars are too scholarly, too specialized, a press cannot sell their work to enough people to recoup its costs. What defines a scholarly book now? A book may make its way into print if it intervenes widely in a discipline, but a contribution to a small subdiscipline may have no future. How many disciplines will be diminished as a result, and how many young academics will be sacrificed in the process?

University presses—still the main venues for scholarly books despite a few trade publishers like Routledge now able to market those scholarly titles with sales potential of 3,000–5,000 copies—have persisted in the form known to present generations for over half a century. Some were founded earlier—Johns Hopkins University Press in 1878, the presses at Chicago and Harvard in 1891—but the present range of presses and num-

bers of titles published are largely a postwar phenomenon. Whether the system can survive in its current form is doubtful.

As recently as the mid-1970s a good university press could count on selling about 2,000 hardbound copies of any book it published. Now it can only depend on selling 200–300 hardbound copies, almost all to libraries. In 1975 such a press might have had 600 or more standing orders from libraries. The terms were simple: send us every book you publish along with a bill. We called one such publisher in 1997 to see how many standing orders it had left. The answer? One. As of 1997, distinguished presses like Cornell or Stanford were at times writing contracts for authors that read "We will publish your book in an edition of 300 copies." Some expensive reference books are now published in still smaller editions. On the basis of patterns of budget reductions and expectations of increased dependence on interlibrary loan programs, it is reasonable to predict another 20 percent reduction in library sales over the next several years.

No university promotion committee has yet, to our knowledge, started asking *how many* copies of a book have been published. Is that a relevant question? Certainly at some point the size of the edition has an effect on availability and impact. Nor do library books always last forever. Some libraries buy paperbacks, which survive five "reads." A hardbound will withstand twenty, fewer if it's shipped around the country. If only you and your grandmother can buy the book you've published, is it likely to change the world? We know, we don't know your grandmother. Well, hope springs eternal among every publisher's acquisitions staff, for whom the next best-seller is always about to go into the mail.

The truth is that academic book publishing has been hanging by a thread for years. The economics of decreasing sales and increased costs for short publishing runs have been heading for a collision for a decade. Many innovations have kept the enterprise partially alive. Computerized typesetting by commercial firms cut costs by 15 percent. Now in-house computerized typesetting by publishers themselves has saved another six or seven dollars a page. Short-run scholarly titles not likely to be reviewed in popular newspapers or magazines have lost their book jackets. Another couple of dollars saved. Preestablished design formats and dramatically smaller typefaces that crowd more and more words on a page have cut costs still further. The much-vaunted value-added service of copyediting, a wonderful service to authors, has been severely curtailed; it's still done, but much less thoroughly than it was twenty years ago.

Simultaneous hardbound and paperbound editions have helped prop up declining sales to individuals, but the cost recovery per paperback copy is much lower.

The effects of all these innovations have been largely counterbalanced by declining support or increased costs in other areas. Federal government support for publishing university press books, once a notable part of both National Endowment budgets, has been nearly eliminated. The Mellon and other foundations have canceled programs supporting scholarly book publication. And some publication costs have risen dramatically. Book paper costs, for example, have seen huge increases over the last decade.

Many scholarly publishers have changed both the scope of their lists and their acquisitions policies as a result. Some have boosted sales by developing specialized lists in areas like regional publishing, which gives them a niche where they can compete successfully for titles that may sell 3,000 rather than 300 copies. Most presses now do careful market analysis on a manuscript before even submitting it for review. In the 1970s that practice was unheard of at a scholarly press; the only question was whether a book made a contribution to a field. Now most university presses—except for a few with major subventions or a profit-making alternate product like a widely used test or textbook—must ask whether a given title will sell enough titles to justify publishing it. Many books are rejected out of hand because of their sales potential rather than their quality. Publishing academic books in contemporary media or mass culture is already much easier than publishing them, say, in Augustan satire, though we have so far no way to assess the profoundly *uneven* opportunities young scholars enjoy in seeking a publisher.

In hiring a new faculty member in a field where book publication is a requirement for tenure, universities are well advised now to ask not only whether a dissertation is first-rate but also whether it is marketable. A fine book that cannot be published will not get someone promoted at a research university. For that sort of market question to shape faculty hiring is both a new development and a depressing one.

Understanding why all this has happened is not difficult, but it is a story with numerous components. It's also a story with at least one villain: the British publisher Robert Maxwell. About twenty years ago he tried an experiment. He decided to see if scientific journals could be published at substantial profit. He hired a distinguished faculty member as editor at a substantial salary. Ditto for an editorial board, although prior to this such positions were typically unremunerated. They invited their distinguished friends to contribute their latest work. Overnight the journal became

prestigious and influential. Then he raised the price and started several more new science journals on the same model. Soon a journal that might have cost a library $200 was costing it $5,000–$10,000. Other publishers followed suit.

In the early 1980s research libraries began shifting a portion of their book-buying budget over to the serials division. Scientific and technical fields demanded their journals. After all, they were the ones bringing grants and profits to campus. The university owed them the lion's share of its resources. Over time, university libraries typically shifted a third or more of their book-buying funds over to journal subscriptions. The engineers clamored for still more money; the humanities faculty took no notice. Libraries bought fewer books; publishers increased prices, depressing sales still further. Many academic libraries have given up any pretense of maintaining comprehensive collections, relying instead on providing books through interlibrary loan. Not only does that delay access and shorten the life of a book; it also eliminates the centuries-old custom of discovering books by browsing the shelves.

In the 1990s costs for electronic resources began to make additional inroads into library budgets. Costs for computerized catalogues and campus terminals had already required large start-up investments, but most of the recurring costs for those items could be stabilized and eventually absorbed by budget increases. Increasing expenses for on-line services, CD-ROMs, and electronic document delivery were another matter; they have risen dramatically and their future cost is cause for considerable concern. Meanwhile, book-buying budgets have already taken another hit to fund electronic services and resources. Libraries now talk realistically of running two institutions simultaneously, a paper library and an electronic one.

Meanwhile, faculty members in the humanities at major institutions have maintained their ideological investment in a research culture centered on books without much awareness that the whole economic basis of that culture was disintegrating. Publishers talked with one another continually about the mounting crisis in scholarly monographs, but most professors remained blissfully unaware of its multiple components. Except for two series of articles in the *Chronicle of Higher Education*, one by James Shapiro and the other by Sanford Thatcher, there has been little effort by faculty to address the issue in print.

At a series of informational meetings held at the University of Illinois in 1997 to inform faculty about the library budget crisis, the behavior of the faculty told the whole story. Humanities faculty met separately (on a

different day) from scientists and engineers. Pie charts were distributed showing the massive funding shifts from books to scientific and technical journals. The humanities faculty sat quietly, dazed, politely accepting their fate. The engineers behaved like rabid dogs, jumping up and shouting, demanding more money be shifted to their journal subscriptions, denouncing the library for not taking care of their interests.

The impact of decreased book sales is already rippling through the publishing business. Literary criticism, once a boom industry, has disappeared from many lists. Those publishers who still maintain large offerings in the area typically have something else going for them. Oxford and Cambridge, for example, can still sell 900–1,000 copies of a hardbound volume of literary interpretation, but that's because of the lingering effects of ideology and colonialism. That is, they sell the same 300 library copies in the United States that Indiana University Press does, but they also sell to all the far-flung fading outposts of empire. There are still libraries in Zimbabwe and Kuala Lumpur that religiously buy Oxford and Cambridge titles. Whether anyone there reads them hardly matters.

We have no doubt that there are thousands of scholars across the country dutifully working on books that no publisher would dream of printing. We also know that young scholars are having more trouble getting their books accepted. Everything is connected. The rabid engineers are making it harder to get tenure in English, not that they know or care.

That particular problem could be solved by attaching a $5,000 book publication subvention to every new humanities hire. That would cover the basic production cost of a 250-page book and make first books by unknown authors much more feasible. Given the total financial investment in salary and benefits for a new assistant professor of English during the probationary period—about $400,000—it is quite crazy to let tenure hang fire for the lack of one summer salary.

But book sales to individuals have also declined in numerous fields. There are several reasons for this. What sort of book, one may ask, do yuppies buy? One that will boost their own careers, one they have to use in their own work. They buy fewer books out of general cultural curiosity. The increasingly careerist nature of the profession has concentrated book buying in the hottest areas for publication, like cultural studies. Meanwhile the protocols of responsible and thorough scholarly citation have begun to disappear. Citation now adds glitter to scholarship; no one much cares whether anyone else said it before. Citation frequently aims for the rub-off effect of proximity to superstar glamour, rather than

recording a conversation or a collaborative enterprise. So the need to buy and read widely has decreased.

One other factor, invisible to most full-time faculty, has hit book sales hard in the more exploitive disciplines: part-timers often just cannot afford to buy a book. As disciplines like English have shifted more and more to drastically underpaid teachers, they have created an impoverished workforce that cannot afford such luxuries. You have to watch a part-timer take a book off a bookstore shelf and replace it repeatedly to realize how difficult it can be to buy a book when you do not have the money. On more than one occasion graduate students or part-timers have proudly shown us a list of 10–12 people signed up to read a paperback book in sequence. Over the last two decades, a large part of the potential book-buying audience in academia has been cut out of the action.

For a while it seemed the superstores would revive sales of scholarly titles, and indeed some presses have gained considerably from having their books available in many new locations. But the superstores also produce a boom-and-bust cycle that is hard for publishers issuing small editions to handle. The superstores tend to oversaturate a city with retail outlets, driving independent bookstores out of business and then closing some of their own outlets to bring product availability in line with the actual market. When a large store closes, it may simply box up all its books and return them to a publisher. If a number of stores close more or less at once, a university press may find its loading dock piled high with returns of unsold titles. Meanwhile, some stores control inventory by computer, and the computer may be programmed to return any book that doesn't sell after a few months. That's not long enough for reviews to catch up with most university press books, so the book may vanish from the shelves before anyone knew it existed. The combined effect of these returns often means that a book that looked like it was almost out of stock at the press suddenly reappears. Presses at first reprinted titles without realizing all their "sales" to superstores were really *loans*. But large-scale temporary sales also make it difficult for a university press to keep a book published in a small edition in stock at all.

Meanwhile, electronic publishing has yet to fulfill its promise. Costs of copyediting and designing a book for the Internet remain high, and few people want to read hundreds of pages on screen. Given the choice between printing out a pile of pages and buying a bound book, many

still prefer the book. All this may change with improved technology, and a new generation may arrive that simply does not revere the printed book, that expects to do everything on screen. Whether the prestige of electronic books will be as high, whether peer reviewing can survive the leveling effect of electronic publishing, whether electronic books will count for tenure, all this remains to be seen. But we wouldn't recommend taking an extra five years to finish that book if you want to see it in print.

CN

Sexual Harassment (ˈseksh(əw)əl həˈrasmənt)

Let's begin with two narratives of the male gaze, the first possibly trivial and the second serious indeed. Both occurred about ten years ago, when sexual harassment policies were in the process of being formulated and institutionalized on college and university campuses. The first narrative concerned a female student at the University of Toronto campus swimming pool who concluded that a male faculty member was staring at her. Finding his attention unwelcome, she reported him and his alleged "unwanted staring" offense to campus authorities. At once the university's relatively new but already creaky disciplinary apparatus took up "the case." After the predictable "investigation" and displays of advocacy, it was decided the penalties need not be capital. The faculty member would be subjected to reeducation and barred from using the swimming pool. When we heard this story at the time, it seemed to represent an almost comic disjunction between the perceived offense and the adjudication process. Surely this was an incident that could better have been discussed face to face, not by calling in the troops and unleashing disciplinary proceedings fraught with the potential to deny accused parties fair treatment.

But the other narrative was more complicated, disturbing, and unfolded over months; though it took place at my own university, I knew nothing about it when it was happening. The student protagonist, then in her first year of graduate school (she is now on the faculty of another institution), found she was being followed by one of my senior colleagues. She would be working at the library and realize he was standing an aisle or two away in the bookstacks, half-hidden, staring at her. Or she would look up from her library carrel and see him ten or fifteen feet away, perhaps behind a file cabinet, staring steadily at her. If she moved, he and his relentless, unreadable gaze would follow; he always kept his distance and never spoke a word. To her growing distress, he kept

it up for months, disrupting her concentration and actually frightening her when the library was nearly deserted late at night or when she left to walk home. She was so unsettled she could not bring herself to confront him, report him, or even talk about him to her friends. He was a senior faculty member, with several books to his credit, she a first-year graduate student; moreover, the behavior was so weird. She finally began carrying a can of Mace in her purse and keeping a hand on it when she left at night. After a year or so, the haunting stopped. She never learned why.

Today, looking back upon a narrative that at the time she did not fully recognize *as* a narrative, she considers herself to have handled it as well as could have been expected, and to have survived more or less intact. Yet though the faculty member has now retired, she wonders if he stalked others, perhaps less calm by temperament than herself, who suffered more, perhaps even came unhinged. For myself, I wish I had known at the time. And I wish she had used the Mace.

Through narratives like these, we have tried to arrive at pertinent generalizations about sexual harassment on campus. Yet in taking up this topic as part of a series of commentaries on key academic issues, we need to position ourselves more carefully. We have written elsewhere about the exploitation of graduate students, unionization, speech codes, critical and cultural theory, political correctness, and the job crisis. But we have never addressed the topic of sexual harassment—or the so-called sex wars of which sexual harassment policies are a peculiar if largely uncredited legacy. For one thing, we cannot tell these stories well, we cannot narrate them effectively, unless we can acknowledge the problems in doing so. We tell these stories with an inescapable moral fervor about punishing the guilty and exonerating the innocent and presumed innocent as though we are convinced we know the difference. Second, like other stories that many of us tell and retell as participants in the institutional economy of academic life, the stories here are potentially contaminated with a certain relish and voyeurism. The supercharged topic of sexual harassment makes errors and distortions particularly costly. A final problem, now standard media boilerplate in the coverage of the most celebrated cases (Anita Hill and Clarence Thomas et al.), is that these situations are often astonishingly complex, shot through with inconsistency and murkiness, and open to *Rashomon*-like interpretive challenges. As we identified and followed up selected cases, whether through media coverage, interviews, or official documents, voices emerged on all sides of the issue; many witnesses seemed overinvolved and compromised, and

few accounts seemed wholly trustworthy and nonmanipulative. People whose job it is to work with sexual harassment cases encounter this all the time. They also learn that there are no fixed rules for distinguishing victims from villains, or even genuine victims from fake ones. When they finally come forward, the most deeply injured victims may be so anguished that their narratives are radically unstable; others, equally traumatized, may seem implausibly composed.

Let us take for granted, then, that "the truth" of many individual cases may ultimately elude us and that the stories that circulate are fraught with the problems we have mentioned. Let us also take for granted that for decades brutal sexual harassers operated with impunity, and neither serious nor nonserious sexual harassment cases were typically pursued. Feminists have pointed out that sexual harassment could not be properly addressed until it was recognized and named; as Gloria Steinem famously put it, "before sexual harassment was given a name, women just called it 'life.'" The material history of that process of definition is relevant here and helps us understand the current environment. Recall, for example, that by the late 1970s, academic feminism had begun to establish a strong foothold in the humanities, but it was as yet a professionally marginalized intellectual commitment. Feminist assistant professors might, for example, be urged to avoid publishing in *Signs* and instead seek more traditional, less "politicized" venues. Feminism's administrative presence was equally marginal. If mechanisms for dealing with sexual harassment are often crude and damaging today, they were then largely nonexistent. Sexual harassment in the workplace generally and the academy specifically was barely emerging, let alone serving as a topic of public conversation. Lyn Farley's book on sexual harassment in 1978 helped introduce the term, reinforced when Catharine MacKinnon's influential *The Sexual Harassment of Working Women* was issued the following year.

But if feminist scholars led the way in defining and establishing the concept, administrative concern has depended heavily on legal implications. The 1964 Civil Rights Act prohibited employment discrimination on the basis of sex, and Title IX of the 1972 Education Amendments barred sex discrimination at schools receiving federal financial support. In the following decade the Supreme Court ruled (*Meritor Savings Bank v. Vinson,* 1986) that sexual discrimination included sexual harassment and, a key point, that supervisors were responsible for ensuring a nondiscriminatory workplace and could indeed be sued for harassment carried out by their employees—whether they were aware of it or not. Though the *Meritor* decision did not address whether a classroom should be consid-

ered part of "the workplace," it certainly established an argument that would apply to a university campus, and higher education administrators pricked up their ears. As it became clear the following year that victims of campus sexual harassment could sue their institutions for compensatory and punitive damages, formal quasi-judicial procedures were instituted on many campuses.

Through the broad feminist theorizing of gender relations and politics, key legislation, growing numbers of women in all fields of higher education, and the powerful rhetoric of the MacKinnon/Dworkin antipornography crusades, the concept of sexual harassment was defined and popularized. Campus administrators and university attorneys joined in efforts to develop and institutionalize policies and procedures. Media attention to high-profile cases in the 1990s put the topic on the public agenda.

In the course of its institutionalization, sexual harassment has moved in two somewhat contradictory directions. Bureaucratic campus procedures, influenced heavily by legal considerations, have tended to aim primarily at protecting the institution rather than honoring academic principles or discovering the truth. Accused faculty members too often face politically unsympathetic panels and procedures that deny them basic rights like an opportunity to confront their accuser. Conversely, a faculty member who hires an outside lawyer and sues can sometimes successfully force an administration to back off. At the same time, the concept of sexual harassment has been modified, broadened, and linked to an array of larger social agendas. Much of this expansion is troubling, and is increasingly divisive; not only do feminists disagree with one another, so do progressives and conservatives (sexual harassment policy is perceived very differently, for example, by moral conservatives, libertarians, or antifeminists). Especially controversial are efforts to expand sexual harassment policies to encompass campus speech and consensual relations, for they conflate what are very different kinds of acts.

One source of conflation was the Catharine MacKinnon/Andrea Dworkin antipornography crusade of the 1980s. In contributing to a feminist legal theory of workplace harassment, MacKinnon had earlier argued that sex between persons of different power status could never be truly consensual. In the still more aggressive attack on pornography, Dworkin in effect argued that sex between men and women can never be consensual because in a patriarchal culture they are never equal, that men always have power over women. Effectively diminishing quid pro quo as a key element of sexual harassment, Dworkin's monolithic vision represented

all heterosexual activity as a coercive expression of power. Simultaneously, the "hostile environment" dimension of sexual harassment became entangled with the crusade against a "pornographic culture," implicitly criminalizing all overt sexual expression. That the link between "sex" and "sexual harassment" was readily forged did not surprise "pro-sex" veterans of the sex wars like Carole Vance, Lisa Duggan, and Nan Hunter. What could not, perhaps, have been predicted was the almost casual ease with which, in that politicized, heavily interpreted context, any expression of sexuality on university and college campuses became potentially actionable. Administrators, it seemed, perennially terrified of campus sex scandals, found the MacKinnon/Dworkin approach tremendously appealing. With the support of feminists and others determined to do the right thing for women, generic sexual harassment policies could, with considerable ideological and legal justification, communicate a mandate of dazzling bureaucratic simplicity: sex—get rid of it.

In 1987, for example, the University of Illinois at Urbana-Champaign held a daylong workshop on sexual harassment. In addition to plenaries and panels, separate breakout sessions were organized for faculty, students, and nonacademic staff. A Michigan attorney specializing in sexual harassment law conducted the session for faculty. In the course of an articulate, knowledgeable, and persuasive presentation, he presented a series of examples to define sexual harassment and distinguish it from other forms of conduct. One such "hypothetical" concerned a female undergraduate in an English literature course who was startled when the male instructor, lecturing on a novel the class had just read, argued that despite its overt content the novel's real theme was sex. As his lecture continued, the student grew more and more baffled and uncomfortable and finally raised her hand to question this interpretation. As the lawyer told it, the student felt that the instructor then ridiculed her in front of the class, both by implying that the sexual interpretation was obvious and by challenging her to defend her own interpretation. "He made her feel stupid, like she was too naive to grasp the sexual interpretation," the lawyer added, "and that constitutes potential sexual harassment." At this point a faculty member asked the lawyer whether the example represented sexual harassment because the sexual interpretation of the novel made the student uncomfortable or because the instructor's handling of her question was insensitive and made her feel stupid. His answer: "Same difference!" So much for academic freedom.

These ideological conflations confuse administrative procedures and make them immensely problematic. Long terrified of dealing with the

issue, administrators are now eager to apply simplistic policies that miss the complexity of human emotions and commitments. It is unsettling to watch intelligent people line up on opposite sides of these cases without substantive knowledge of their individual character. So we need a conversation about this matter that is less overshadowed by contempt and intimidation from both the right and the left.

It is crucial that more people, and this includes men, speak out on this topic with whatever frankness they can muster. The topic is deeply important, yet many male faculty—out of paranoia, rage, or a sense of feminist solidarity—have been reluctant to engage with it in any detail. In failing to speak, we have left most of the policy development to true believers and administrators, and allowed—at our own universities and elsewhere—the emergence of a disquieting institutional tendency to disregard serious cases and pursue minor infractions zealously and theatrically. Most of the sexual harassment "cases" publicized in the *Chronicle of Higher Education* seem to involve relatively trivial incidents, the swimming pool indignity rather than the chronic secret starer in the library stacks.

The challenge we face is to reverse this tendency to dramatize trivia and cover up real abuse. This is thus mostly an essay about the inadequacies of sexual harassment policy despite two decades of campus attention to it. Like others who have written about sexual harassment, we have grounded our discussion in specific cases. These sometimes astonishing stories will help us, we hope, disentangle several different categories of events, underline the inadequacies of conventional efforts to adjudicate and resolve serious cases, and yield some relevant generalizations about the entire topic.

Two well-publicized cases involving classroom behavior provide our next examples. In a case at the University of North Carolina, resolved in 1997, a drama professor was accused in a series of anonymous letters of classroom sexual harassment. According to another faculty member there whom we interviewed by phone, who told a story we could not fully confirm, an early complaint accused the faculty member of racial and sexual harassment after he scolded African American students who were late to rehearsal for a play he was directing. Punctual arrival—for rehearsals as well as performances—being a major commandment in the theater, the faculty member greeted their tardiness with a warning: "If you boys can't come on time, maybe you should consider not coming at all." An unsigned complaint claimed that "boys" was a racial insult and "not coming" a veiled castration threat. Complaints based on other incidents followed. Because these initial complaints were made anony-

mously, UNC followed policy and declined to pursue them. Eventually a group of students offered alternative charges in signed letters and an investigation was initiated. This involved months of disciplinary hearings and included testimony by many students and faculty. By the time the case was finally dismissed, local newspapers, which never fully researched the story, had long since judged the drama professor guilty. The *Daily Tar Heel* in an 8 October 1997 editorial applauded the students who came forward for their courage and pronounced their claims of mistreatment accurate. The *Chapel Hill Herald* went further, arguing in a contradictory 7 October editorial that although "our Constitution and Bill of Rights guarantee Americans the right to a fair trial, which includes facing one's accuser," in this case "anonymity should not preclude a thorough investigation."

A case at Colby College has been described in detail by Ruth Shalit. There an untenured sociology professor lost his job when uninvestigated, informal complaints were placed in his tenure file by a department head and a dean. Though student evaluations of his teaching were in general eloquently enthusiastic, a number of women in one class reported that the assignment to write a paper applying political and social theory to their family experiences was personally invasive and constituted sexual harassment. Another student told the authorities that the professor had complimented her appearance and invited her to dinner. Asked to address these charges, the professor denied any impropriety, noting that, as a faculty resident of the campus, he was essentially required by the college to have meals with students. He pleaded for a formal hearing but was refused one. Indeed, he received no hearing of any kind nor any opportunity to question his accusers. Instead, the dean counseled the student who received the dinner invitation *not* to make a formal charge but rather to write up a summary of the accusations that would be inserted into the professor's tenure file. The student, accordingly, wrote the summary not as a formal charge but as a report, complete with detailed recommendations for punitive action. The upshot was that the professor was fired. Colby College thus officially registered its contempt for due process, integrity, responsibility to promote ethical practices among its students, and institutional respect for faculty, for serious sexual harassment, and for the truth. Yet these two administrators still hold their positions.

Both these cases focus primarily on pedagogical issues. Both, moreover, initiated campus panics that generated additional "testimony" from stu-

dents who may well have reinterpreted their learning experiences nega-
tively after the fact. In an atmosphere of public hysteria, accusation and
confession simultaneously become forms of solidarity and self-discovery.
In keeping with a widespread cultural rhetoric of victimization, a student
who enjoyed a course suddenly discovers "the truth," that he or she was
deceived, that class members were not beneficiaries but deluded victims
of abuse. Anguish is then manufactured and performed on public demand,
and the performances are all the more convincing for seeming to confirm
the accusations of abuse and hence to exonerate the administrative deci-
sion-making process.

Perhaps an administrator might be courageous enough to try to throw
out complaints like these without the fuss, but it's unlikely these days.
Rather, it seems to us, these two stories—together with the stories we
told at the outset from Illinois and Toronto—confirm the pattern we
described above: the chronic abusers' cases are neglected, the simpler
infractions aggressively disciplined. The one genuine victim in these
examples, we would argue, remains the graduate student stalked in the
library who declined to seek help from the system. The students involved
in the other incidents were perhaps on the receiving end of unpleasant or
challenging human behavior; yet we would hesitate to grant them genuine
victimhood. The classroom experiences—the potentially invasive research
paper assigned, the reprimand for tardiness, the sexual interpretation of
literature—come with the territory of education, an experience that is
not always pleasant. Moreover, these one-time offendees were quick to
seek redress, efficiently deploying all the resources of the bureaucratic
postmodern university. The Illinois graduate student, in contrast, was too
traumatized to come forward with a complaint. Her behavior fits a com-
mon pattern among victims of rape and sexual assault in which those most
deeply hurt or traumatized may be least equipped to seek formal redress.
The special professional humiliation potential involved in academic work-
place complaints adds another barrier to prosecution of serious cases.
Thus the litigious and politically conventionalized atmosphere on cam-
puses today encourages faux victims to come forward and testify to their
"pain." They are helped by a relentless bureaucratic structure that grants
forums and procedures for publicizing and theatricalizing complaints and
by the ritual participation of partisan constituencies who either support
or denigrate all claims across the board.

In claims of classic quid pro quo sexual harassment, where one per-
son's accusations about what happened between two people in private

typically stand against the other's denials, we would not confidently make this distinction between victims and nonvictims. With no evidence except conflicting testimonies, the facts of a case may be truly impossible to determine. But there is often broad consensus that the behavior alleged to have taken place is wrong. Put another way, we may dispute the actual facts of individual he said/she said cases, but we, the campus community, agree that unwanted sexual advances are inappropriate and often illegal.

But there are three other kinds of alleged harassment situations about which we have had little discussion and certainly reached no comparable consensus: claims of damage from rhetoric used in public forums or classrooms; claims by third parties of hostile workplace stress caused by knowledge of a relationship between two other people; and claims of damage or corroboration put forward by multiple witnesses after a case goes public and flames into moral panic. These are the situations that can produce what we are here calling nonvictims or faux victims.

Real victims often find public theater to be additional punishment. Faux victims who have not seriously suffered may more easily learn to perform victimhood to public applause. And the classroom is an especially inviting site for faux victimology. Students offended by an instructor's ideas, perspectives, or style sometimes bring charges claiming a hostile educational environment. In 1997 a complaint was filed by a student who found a course description offensive, presumably believing that the brief experience of reading it had catapulted her into a hostile environment.

Many complaints about classroom conduct are in fact complaints about academic freedom, a concept so important it should be introduced and reviewed regularly for all members of the academic community. As we note elsewhere in this volume, the discomforts of encountering new ideas have long been recognized, together with the need for teachers to be able to play devil's advocates, to challenge and even at times offend their students in the protected space of the university classroom. Lest instruction be eviscerated, the bar for tolerance in classrooms of higher education has traditionally been placed higher than in many other settings. It is crucial that we restore some broad understanding of this principle and the crucial role it has played in times of moral panic and political schism.

Again, of course, chronic cases of classroom-based abuse do occur, deplorable cases that the following exemplify: an instructor in African American studies who reenacted a slave auction in class, requiring a

female student to play the part of the slave while in his role as auctioneer he appraised her body in humiliating detail; another instructor whose sexist and racist remarks were documented in complaints and student evaluations semester after semester; and many instructors in academic fields where sexist practices were traditions in the culture (in large medical school lectures, for instance, slides of *Playboy* centerfolds would suddenly appear on the screen for periodic enlivenment of the—for decades—all-male student body). But here again, we suspect that serious repeat offenders are inherently harder to discipline than the unfortunate one-strike perpetrators whose offenses can be recounted in simple and theatrical punch lines with high media appeal. Dealing with serious sexual harassment requires the sustained and thoughtful attention of administrators; it requires inventiveness, compassion, anger, and sometimes the cold-blooded willingness to face human character in its more unsavory incarnations. It is not easy and does not benefit from cheap theater. The point about classroom practice, however, is quite different: numerous mechanisms have been developed over decades for discussing and resolving disputes about classroom practice, and within existing codes of conduct many alternatives are available for modifying or sanctioning faculty behavior that do not set in motion the elaborate machinery of sexual harassment policy.

A second category of problematic victimhood arises from third-party complaints, an especially conspicuous example of the power of sexual harassment policy to reshape and resemanticize our understandings of sex and sexually charged interactions. Pioneered by the University of Iowa's sexual harassment policy, third-party complaints permit someone not directly involved in a romantic or sexual relationship between persons of unequal power status to report it and seek disciplinary action against the alleged perpetrators. The rationale, with some variation from policy to policy, seems generally to be that the existence of anyone's sexual relationship potentially creates a hostile work environment for those around them and that even knowing about it may be damaging or traumatic. Most campus policies merely caution against or discourage relationships between persons of unequal power status; some policies have now dropped the "unequal status" stipulation and discourage romantic and erotic relationships between any two persons in the same unit, and others, including Yale, go so far as to explicitly prohibit such attachments. The broader the policy, particularly where notions of "consent" and "consenting adults" have been rejected, the more powerful are third-party complaints.

In one case from the 1990s an untenured male law professor at a flagship state university was given a terminal contract when a *former* law student, male, filed a complaint of sexual harassment. By then graduated and clerking for a state judge—by all measures doing well—the former law student wrote the law school dean to report his knowledge that the faculty member had had a sexual relationship with a female law student; he now claimed, in retrospect, that the knowledge had made his own educational environment intolerably hostile. At odds with the faculty member over other issues, the law school contacted the female student, also by then a successful graduate, who readily confirmed the relationship, emphasized that it was wholly consensual, and refused to file a complaint of any kind. She also informed the faculty member of the law school's query, which turned out to be one in a series of calls to women (not law students) he had dated. The dean then turned the matter over to the campus's sexual harassment officer, who interviewed the parties involved—including, at their request, several of the ex-girlfriends who wanted to register their objection to the law school's conduct, not the faculty member's—and concluded that the faculty member was young and had used bad judgment, but that this was not a case of sexual harassment.

There the matter could and should have ended, but the law school dean, a good Catholic with unforgiving moral values, was still offended. The faculty member was a popular teacher, an energetic organizer of speakers and conferences, and had compiled a distinguished publishing record. Yet he was also brash, outspoken, and nonconformist, with—according to rumor—unconventional sexual practices. Brushing aside the conclusion of the campus sexual harassment officer on the grounds that the College of Law must hold faculty to a higher standard, the dean pushed through a terminal contract the year *before* the faculty member's tenure review, a review he was likely to pass. So he folded his tents and departed, in deep shock over the whole sequence of events and certainly not his own best advocate.

There are several things to be said about this example. The faculty member may not have been a pure and shining victim. The woman who refused to file a complaint was no fan of his; she just did not feel he was guilty. And like the other women contacted, she was more disturbed by the law school's invasiveness than the fact of a relationship conducted in, she thought, private. Moreover, how can credence be given to the retrospective claim of third-party harassment? What is the evi-

dence for a hostile workplace? For damage or trauma? Finally, which cases are best handled quietly, through careful administrative negotiation, and which call for the full machinery of due process? The faculty member here was never formally charged with anything, and he was denied the studied evaluation that the tenure process mandates; thus his termination was negotiated with the upper administration without the faculty review he would have received the following year. In short, the termination of a tenure-track faculty member's appointment was set in motion by an after-the-fact complaint from a third party no longer on the scene, sustained in the absence of support from the official campus sexual harassment officer and in defiance of a campus policy not recognizing third-party complaints, and carried out with limited consultation or involvement of the faculty. Only a couple of decades ago, the cultural support for a penalty like this in such a case would not have existed.

What should have happened? The third-party complaint should, arguably, have been treated like any other negative letter from an alumnus—that is, with the respect and thoughtful concern that deans are paid to display—not as hallowed testimony from a victim of torture. As for the process, another case suggests an alternative framework for administrative negotiation.

In a large southern university a case of serial harassment went officially unaddressed for more than two decades. After the faculty member had left the university and all the responsible administrators had left office, the main outlines of the case became known in the department. An evangelical faculty member built close relationships with equally religious young students. Some he invited to his house and involved in church activities. Frequently he offered young women individual tutorials that required meeting in his office. Now and again these close relationships erupted into physical contact. "This is not sex," he told one young woman whose thigh he was stroking, "I'm doing this to bring us closer to God."

But these physical approaches occurred only after strong religious connections had been forged. The students admired him. He was a lay preacher who made his beliefs public. At times he seemed to preach in the classroom, as when he announced that UFOs were a sign from God. He held prayer sessions at his house. Now he seemed to be turning into a monster. Yet maybe they were in the wrong; perhaps they couldn't understand or appreciate the depth of his passion.

Stories circulated in the department over the years, and some anxious, ambivalent communications were received from students. But nothing was done until a strong-willed and deeply Christian young woman came to the department head to tell him in detail what the faculty member had done and to declare her conviction that it was wrong. Having heard the stories for years and fully understanding the implications for a unit executive officer of the hostile workplace ruling, the department head knew he must pursue the case. Working out a procedure developed through quiet consultation with campus authorities and university counsel, the department head brought the two parties together in his office. When the woman confronted the faculty member with her story, he confessed, literally fell to his knees, and begged forgiveness. God had wanted him caught and now wanted to show mercy.

Prepared to show him nothing of the kind, the department head turned to the files to assemble a case for revocation of tenure; to his great surprise, he found no record of the past. With no file, his options were now limited. But the tearful confession gave him sufficient leverage to make a move. He demanded the faculty member sign a promise to resign if another complaint was received, prohibited him from conducting independent tutorials and inviting students to his home, and, in a singularly inventive and unconventional move, assigned him to an office with a broad glass door that he was required to keep clear of obstructions.

The faculty member apparently held himself in check for a year, then backslid. He grabbed another woman, and this time another complaint was filed. The department head called him into his office to demand his resignation. Pen in hand, the offending faculty member suddenly hesitated. Should he get a lawyer? Behind the scenes, the student was actually deeply conflicted, even beginning to feel guilty about turning in this distinguished servant of God. It was doubtful she would stand up under the pressure of formal proceedings. The department head reached for the phone: "Your minister doesn't know about all of this, does he?" The faculty member signed his resignation letter. Given his earlier confession, denial would not be persuasive, and publicity would bring his church activities to an end.

In terms of administrative procedure, there are parallels between this case and the law school case cited above: in both cases, a single active administrator took charge of resolving matters. Neither acted entirely alone; each consulted higher administrators and either directly or indirectly obtained advice from legal counsel. But it was still largely one

administrator's initiative that brought each narrative to a conclusion. Yet from our perspective the law school decision came out badly, while the Elmer Gantry episode was worked out fairly. In the department case, according to a long anecdotal history and women's own words, there were multiple victims over time, while at the law school, according to the sexual harassment officer's perspective, there really was not even one genuine victim. In the department case, fair warning was provided in writing and with the faculty member's knowledge and acquiescence. In the law school case, the faculty member was terminated on the basis of a third-party complaint—with no decisive evidence of a significant history of harassment. Finally, the department head worked out a process of adjudication consistent with campus policy, while the law school dean, finding campus authority insufficiently punitive, devised a policy of his own and simply asserted it regardless of campus standards. These contrasts, it seems to us, help distinguish fair from unfair administrative action. While the process of building a case may allow a particular offender to escape the sudden-death penalties that a kangaroo court can impose, it provides time to investigate and meet the standards of campus policy and in no way prevents a unit head from imposing preventive restrictions on the basis of less decisive evidence.

The third kind of problematic case involves uncorroborated testimony, rumor, and clusters of complaints that seem to be motivated as much by ideological solidarity as by lived distress. Such evidence should not be allowed to determine significant career evaluations, especially tenure decisions. If, for some reason, uncorroborated sexual harassment complaints and rumors must be acknowledged, great care must be taken to ensure that the faculty member receives a full and fair hearing that follows AAUP rules in both letter and spirit. A tenure case presents a window of vulnerability and hence a tempting opportunity for the abuse of administrative power. Sexual harassment cases reported in the *Chronicle* and elsewhere include many such instances and underline the crucial importance of appointing honorable and compassionate administrators. Unfortunately, there are not enough to go around.

Most of the one-to-one teacher-student harassment episodes we have cited here would be found unacceptable under any broad campus code of appropriate professional conduct. No special "sexual harassment" lenses were really necessary to recognize the need to reprimand Elmer Gantry, the library stalker, and many of these other characters. Nor is such behavior readily defensible or off-limits on the grounds of academic freedom,

the right to free speech, the right to privacy, or other principles faculty members rightly hold dear. In the campus panics triggered by alleged classroom harassment, however, these principles may be more easily compromised. Again, vigilance and resourceful preventive action by individual administrators can address students' concerns thoughtfully and still protect faculty members from public outcries and higher-level administrative abuse. But in these cases the department head's dual role as administrator *and* faculty member is crucial.

A complaint received a few years back by the president of my university provides a good example. A male student complained that the female teaching assistant in his English course had distributed a "sexuality survey" that he found offensive. The president, evidently sharing the student's outrage, fired off a copy to the campus chancellor demanding explanation and immediate punitive action; the chancellor promptly transmitted it to the provost, who at least perceived it as an academic question and turfed it down to the Liberal Arts and Sciences dean. At last it reached the desk of the head of the English Department, who took the time to read the offending survey, talk to the teaching assistant and learn from her its context in the course as a whole, and talk with colleagues to investigate the survey's provenance. Unlike the president, he saw at once that the "survey" was satiric. Its numbered "items" included mock questions like "At what age did you first begin to suspect you were heterosexual?" His investigation revealed that this mock survey, originally developed as a sex education exercise, had been around for years and was routinely used in various campus courses—in health, human sexuality, medicine, sociology, and so on. It was clearly not intended as a document that students were actually supposed to fill out; rather, it was designed to raise consciousness about sexual diversity and highlight the extent to which we take some behavior for granted as natural and normal, while we expect other behavior to be explained or justified. The department head recounted all this to the dean (copies to the provost, chancellor, and president); reviewing the basic principles of academic freedom, he concluded by expressing some dismay that the president himself had not immediately invoked these principles or indeed communicated any sense that he knew they existed. It is worth noting that in this case the student complainant was part of an organized conservative movement on campus, with ties to Accuracy in Academia and to the *Orange and Blue Observer,* a generic conservative campus newspaper known for bird-dogging instructors and courses suspected to be "liberal."

The complaint, then, does not, in our view, legitimately reflect the experience of a victim.

In these three problematic categories of harassment complaints—classroom-related episodes, third-party complainants, and complaints driven by campus panics or ideological solidarity—it is no help that sexual harassment, like many other cultural practices in the academy, is often odd and unconventional, carried out self-consciously by people whose impulses may be out of control but still overlaid with bizarre invention and indirection. This confluence of libido and intelligence is further shaped by the special mixture of fear and arrogance that afflicts people in power who break the rules, from corporate executives to national leaders to university professors. The academic world further complicates the power dimension because power, at least among the faculty at large, is largely ignored or denied. The result is that sexual advances between unequal parties are often so unconventional as to be virtually surreal. No handbook will prepare you for this unanticipated reality of campus life. Unfortunately, sexual harassment policies and procedures are no better at distinguishing serious from nonserious cases that are weird than those that are more conventional. In the extended true story that follows, confirmed through numerous interviews, we have changed some details to preserve the anonymity of our informants.

At a large campus in the Northeast, a senior male faculty member accumulated a considerable anecdotal reputation for making odd and unconventional advances to female students and colleagues alike. The stories had begun to circulate in his first week on campus. Introduced to a department colleague in the cafeteria, he sat down to have lunch with her. Immediately he began telling her his sexual history. After several minutes of this he posed a direct question: "I bet you're the kind of woman who comes, again and again, with spasms?" Surprised, to say the least, she managed a straightforward "It's none of your business." He was not to be put off and began to hammer the table: "I told you all those things about myself and you won't even tell me one thing about you." She left, armed with yet one more bizarre story of crazed colleagues in academic life, a story she readily shared with her colleagues.

So it went for some years. The stories accumulated but formal complaints were never made. When things began to change in the 1980s, a woman graduate student finally bit the bullet and took her experience to the department head. Enrolled in the faculty member's seminar, she had received a note asking her to meet with him as soon as possible. The

words were a bit peremptory, perhaps, but still fairly conventional. What troubled her was that the note was written on a sanitary napkin wrapper. The note did not seem humorous to her: rather, taking the medium as the message, she felt it to be conveying sexual innuendo as well as a degree of psychological violence. She had not missed the fact that the wrapper had once contained a brand of sanitary napkin not available in stores; it was strictly institutional issue, and indeed was the brand stocked in the machine in the department's women's rest rooms. The wrapper could thus be seen almost as a kind of trophy acquired with stealth and used with deliberation, compulsion, and relish.

The department head, a gentleman of the old school and excruciatingly embarrassed by this report, summoned the faculty member to his office and confronted him with the note. "It means nothing," said the professor; "I'm a scholar, I don't think about these things, I just write notes on whatever paper is closest to hand." Incredibly, the department head accepted this explanation. "I see, I see," he said with some relief, "Well, all right; just please use some other writing paper in the future." Thus a gentleman's agreement was struck, and that was all. No warning was issued, no note to the file, no investigation of whether similar incidents had occurred despite all the rumors. The faculty member was tenured, a productive scholar the department felt it undesirable to lose. Plus, the incident was weird, an embarrassment the department head was eager to end. Still, his acceptance of the faculty member's absurd explanation seems astonishing, an example of the grotesque forms male bonding can take in academic institutions.

As the sanitary napkin wrapper incident made the rounds, it triggered reports of similar incidents, and finally the women in the department had had enough. Meeting among themselves to discuss the situation, they found that virtually all of them—faculty and graduate students alike—had been propositioned by the guy at one time or another—or whatever one would call these quirky, disturbing encounters. To a new assistant professor: "I hear you're from the Midwest. Is that true? I could drive you home sometime. We could put a mattress on top of my car and drive out together." To a faculty member in whose tenure review he was participating, after asking himself to her home one evening to discuss her case and then putting his hand on her thigh: "I'm a very lonely and misunderstood man. Let's talk about your case." She asked him to leave and the next day demanded he be taken off her review committee.

The whole catalogue, carried out over years, was presented to the department head, who now knew he must establish an incident file and

document these offenses, some so serious that they might eventually require revoking the professor's tenure. But that was not to be, for a subsequent department head, seeking perhaps to disguise his own inaction, purged the faculty member's file of all this material. After nearly twenty years of continuing aggression against women on campus, he was free to continue inventing and perpetrating new forms of solicitation and intimidation.

That he did. When a young woman in his field was brought to campus to be offered an assistant professorship, he was, incredibly enough, sent to the airport alone to pick her up. The route back into town passed through a few miles of partially restored brush and natural woodlands. After a few minutes he pulled the car over to the side of the road. "I think I see sunlight glinting off a tool in those bushes over there," he announced, "I collect old tools and that might be something I could use. Can you just check it out?" The young Ph.D. thought she hadn't heard him right. "It's awfully muddy, and I'm in heels." "Let's understand each other," he answered, "I'm the senior man in your field. If you take this job, I'm the one who'll decide whether you get tenure. We've got to get to know each other." Flustered, for this was hardly the kind of quid pro quo she'd been warned about, she considered her options for a moment and then complied. It turned out to be a large broken bottle of no value. Irritated, she returned to the car, and he started driving again, only to pull the car over a few minutes later and repeat the whole sequence. Having complied once, there seemed nothing to do but clamber across yet another muddy hillock, again to no avail. Her shoes now ruined, she was happy when they entered the town and just beginning to relax when he again pulled over, this time into the parking lot of a supermarket. "Come with me," he commanded, and then led her up and down the supermarket aisles, pointing out prices and comparing them favorably with prices where she lived in Manhattan. It was his idea of how to promote the local advantage, how to recruit. Canned peas were cheaper here.

Eventually the night seemed to be drawing to an end. He was assigned to drive her to her hotel after dinner and, true to form, he insisted on coming up to her room when they arrived. He then began talking shop and it was after midnight when she finally insisted, by this time forcefully, that he leave. But there was no way she could sleep. In fact this was her second job offer, so she exercised her options and despite the late hour called up the other school's department head, woke him up, and accepted the other position. Though she later told the whole story to the sexual harasser's department head, she declined to make a formal case of it.

Once again, Professor X was free to go on his way. Later he would write a series of pseudonymous but highly explicit letters to an admired female graduate student detailing all the things he would like to do to her; she kept the fact of the letters secret and then left them in a department desk drawer when she accepted a job abroad.

At long last, after the department had watched more than twenty years of his laying waste to women's lives, after his extensive and always idiosyncratic history of mixing sexual advances with assertions of power, a new department head finally did what was necessary to get him to retire. Even then, no formal charges were ever filed against this faculty member, and his retirement was not forced; it was subtly dangled before him until he was shaped and positioned to *want* it. His history of sexual harassment was not an issue in the negotiations; instead the department head disingenuously expressed regret at losing his services. The women he hurt, including many more than those few we describe above, including some who never recovered from his attentions, never pressed a charge against him. No proceedings were ever instituted. No trial took place. No one carried signs denouncing him, though he deserved that and worse. It took intricate and subtle attention to his personal psychology to remove him from the faculty. While it took far too long, finally the job was done.

Before that happened, his colleagues had found ways to limit some of the damage he was inclined to do. When, years after the first harassment of a job candidate, another young woman in his field was brought to campus to be offered an assistant professorship, other faculty made certain he had no chance to speak to her alone. When he got up to walk across the room to meet her at a reception, four of his colleagues rushed over to join them.

In effect, this form of collegial surveillance was another version of a warning system, and indeed female graduate students were regularly warned informally to avoid the faculty member in question. Warning systems are, however, less than perfect; they do not prevent serious and determined abusers from doing great personal damage. As it happens, we have so far based our analyses on incidents we have reconstructed ourselves, but we would not want to close this essay without letting at least one victim speak in her own words. This story also shows the serious limitations of informal warning systems.

Here is one of twenty personal narratives first published in the *Journal of Applied Communication Research* in 1992. The special issue—"'Telling Our Stories': Sexual Harassment in the Communication Discipline"—is

little known outside that specialized scholarly field. It gives an account of sexual harassment at its most harrowing:

> It has taken me about ten years to label what happened to me as harassment. In 1981, I transferred from the University of Iowa to another large midwestern university to be a graduate student in the Ph.D. program in Speech Communication. I transferred because this university was in my home town and my father was dying. . . . I believe it was the first time that I had talked with this professor. He was teaching one of the courses I was taking and identified himself as a leftist, progressive professor. I was in a very vulnerable state because of the situation at home and because I was new to the program. . . . I was also a feminist and a lesbian-of-sorts. . . .
>
> One afternoon I was hanging out with some graduate and undergraduate students and this professor and we all ended up having a few beers. When it broke up, a bunch of us were supposedly going to his house to continue "the party." . . . So I ended up at the professor's house with the understanding that others would come later. At his house, I agreed to have another drink, and he tells me that he is going to go upstairs and take a shower before everyone comes over. So I say okay, and I just sit down and proceed to wait for him to come back down. A little while later, he calls down to me from upstairs and asks that I should come up and talk to him, that he was done with his shower. I wasn't sure what to do, but decided I should just go on upstairs. I kept trying to tell myself that this was normal, even though I was uneasy. I went upstairs. He comes out of the bathroom and approached me and he has no clothes on. I was shocked, stunned, and very nervous. I remember thinking how strange this was and yet I felt like I needed to act like it was perfectly natural. I didn't want to act like it was unusual, or like I couldn't handle it. Then he started coming on to me. At first I just stood there . . . wondering why this was happening, wondering if I had somehow come on to him, wondering what was going to happen if I didn't respond to him, or tried to pull away, and what was going to happen at school, etc., etc. I don't remember exactly how it happened, but I ended up having sex with him in his bed. I was completely bewildered at this point. At the end of it, his girlfriend (an undergraduate student) called and he talked with her, and then told me he would give me a ride home. . . .
>
> I didn't know what to think about what to do or what to think about what had happened. I tried to talk to this professor a number of times to try to deal with the situation, I guess to normalize it, to make it less awkward and humiliating, but he was basically uninterested in talking with me about what had happened. I finally got him to agree to talk to me, but he told me to come to his house again. I got there, and told him I felt that what he had done was wrong and might even be construed as harassment. He thought that was stupid, and started coming on to me again. I remember being very upset and getting him to stop, but left with the feeling of incredible guilt and shame about what had happened. . . . Several months

later I went and talked to the ombudsperson about the situation, in very vague terms. . . . I did not feel I could formally report him, however, because I felt it was my own fault because I did not resist him and did not fight him off.

For the next ten years I felt the whole thing was my fault because I had had sex with him and did not tell him right off to leave me alone. I can understand now that by setting me up in his house alone, by giving me more alcohol to drink, by approaching me with no clothes on outside of his bathroom, and by coming on to me, he immobilized me . . . as time went on my shame and anger at myself settled in. . . . He took advantage of me, he made my time at this university very difficult and traumatic, and he helped to shatter my confidence in my ability to be an intellectual equal with men. . . . I heard later of other instances where he had done the same thing to other incoming graduate women. This marks my case not as an individual one, but as a case of a repeat sexual abuser who targets vulnerable incoming women as his sexual prey. . . .

Perhaps this faculty member, deluded by rationalization or actual illness, may have been able to convince himself this was consensual sex, but the graduate student never even consented to be alone with him in his house; she thought she was joining a group. Then he tricked her into coming upstairs and finally immobilized her with his nakedness. Faculty power is not an invariable absolute; an undergraduate who makes a false harassment charge can disempower a faculty member in a nanosecond. But here hierarchical power was magnified until it became unspeakable, obscene. The act to us seems a form of rape, not consensual sex. Had he propositioned her in the department, in the school cafeteria, we have no doubt she could have refused. When, fully naked, he suddenly imposed himself on her the shock was silencing; he placed himself outside any form of acceptable behavior and incapacitated any plausible response.

Although this incident was never formally reported to the university, graduate students and one or two key faculty members did develop a network to caution new students about the faculty member involved. In the absence of a formal charge, a warning system seemed the only viable option, since there was no way to bell the cat itself. These warnings almost certainly did prevent a number of women from being harassed, but over time a significant number of other women also suffered experiences like the one detailed here. Although many members of the department at issue would immediately recognize the story and certainly knew bits and pieces of similar stories, the faculty member was unfortunately

never formally charged or penalized. At least one colleague did advise him against his conduct, but it had no effect; the behavior was compulsive and rationalized. He was in fact a popular teacher and genuinely dedicated to helping his graduate students build their careers. His actions were thus substantially contradictory; he helped some students and assaulted others. He was at once an exemplary faculty member and a highly destructive one. After years of sexual approaches to young women, approaches that verge, like the one described above, on serial rape, he was finally married and curtailed his predatory behavior.

The warning system sometimes protected members of the departmental community, but it failed repeatedly in this case. Warnings are also risky to initiate, since the people giving them might be sued in some circumstances. Warnings can also be more difficult to give in other cases, especially where the offenses are substantially less serious than the one above. Consider the following warning given for a whole different category of action. In the mid-'80s a faculty member in a large school in the Northwest was having a conference with a young woman enrolled in her graduate seminar. After talking about the student's term paper she said there was something much more unconventionally professional she wanted to discuss. The faculty member felt compelled to give the student a warning, to help her get through something traumatic she expected to happen to her. The student was at once interested and worried, more so when the faculty member went on to ask her to treat the conversation as confidential. Things took a decided turn for the peculiar when she added that the warning was based on an educated guess, a hunch, an estimate of probabilities.

There is a senior member of our department, she continued, who has a habit of calling a female graduate student into her office every year or so and telling her she is not intellectually fit for graduate study and ought to drop out of the program. The claim, she asserted, was always inaccurate, but she had seen more than one graduate student completely disheartened as a result. She knew of at least two students who had quit the program after this devastating evaluation by a distinguished faculty member, including one she had talked to at length and tried unsuccessfully to dissuade from leaving. The earlier student's confidence was shattered and there seemed no way to restore it.

In time she realized it was always the same sort of student who was selected for this ritual purgation—someone physically attractive and well-dressed, inclined to wear a bit of makeup, and, above all, someone

outspoken and even a bit cheeky. It was always a woman. "You fit the pattern," she said, "and if it happens I want you to know it's not true. You're bright; you should stay in the program and get your Ph.D. If she calls you into her office and tells you you're worthless, I want you to know it's not true. In fact it really has nothing to do with you, and you shouldn't take it personally. It's her problem, not yours. This is a form of personal compulsion, not a professional evaluation."

The faculty member giving the warning did not really understand why her colleague did what she did. More seemed at stake, certainly, than just primitive sexual jealousy. Having been mistreated for years because she was a woman, now she was doing the same to other women. That pattern seemed familiar from stories of men who were mistreated as children and ended up repeating the behavior themselves. But that would not account for the careful, if unconscious, selection by character type and physical appearance. The faculty member in question seemed to be unconsciously policing the profession, purging it of a certain sort of femininity, a kind that threatened the balance of attributes she associated with an acceptable female faculty identity. Most of this speculation she did not pass on to the student being warned; there was no need. She just said the behavior was beyond her understanding and that she should dismiss it as irrelevant.

There's no question that the student thought the whole conversation bizarre. And yet a year or so later she came in to express her thanks. Everything had happened exactly as predicted. Moreover, instead of being shattered by the encounter she was prepared for it. She told the professor off and left her office. She ended up with an assistant professorship at a flagship state university, where she received a campus-wide teaching award, published two books, and is now tenured. Little more need be said about the quality of the female professor's "professional evaluation."

Although vindicated, the faculty member who gave the warning also felt her way of handling the problem was risky at best. She believed there was absolutely no question of approaching her colleague, who was a distinguished scholar with little capacity for self-reflection. Her response to the slightest criticism was always a massive counterattack. It seemed unlikely she was aware of her own behavior, certainly not aware that this was a kind of repetition compulsion, not an embodiment of professional judgment. It was only possible to repeat the pattern while blocking any knowledge that it *was* a pattern; it had to be rationalized as responsible behavior, even rationalized as the sort of tough professionalism necessary in a tight job market.

Still, the chosen solution was fraught with difficulty. Imagine what the colleague might have said and done had the student reported the warning to her. And what if the student had considered the warning itself offensive? She might have argued the warning made her uncomfortable, self-conscious, and less able to function effectively. As for the faculty member urging women students to drop out of the program, did her conduct constitute sexual harassment? Almost certainly not. But was it gender-based discrimination against women students? Perhaps, though it is not easily recognized in existing regulations. We are not at all convinced this could ever have become a formal case.

Yet several of the cases we discussed should have been pursued aggressively. If these cases never became actual cases, they are hardly unusual in that regard. For decades many harassment cases could only be narrated as histories of faculty violence and administrative inaction. *Often the faculty members who do the most damage to women students get away with it for all or most of their careers.* Despite substantially increased campus attention to the problem and vastly increased public awareness of the issue, *the inability to stop or punish serious, serial perpetrators remains the single greatest failure of campus sexual harassment policy.*

Administrators are often focused on protecting the institution and have no interest in understanding the people involved. In the past, protecting the institution most often translated into covering up a case; now it sometimes means carelessly assigning guilt and quickly seeking punishment without respecting people's rights. Politically appointed committees are also typically focused on promoting innocence or guilt, and indeed pure victims and pure villains do exist in these domains, at least as far as their actions in question are concerned. But determining guilt or innocence is frequently difficult, and sometimes, as in consensual relationships, there simply are no villains to be found.

Distinguished scholars are frequently less vulnerable to charges than others, but that is not the most important lesson to draw from any of these stories. As we said at the outset, what is increasingly clear is that sexual harassment in the academy is often unconventional and sometimes surreal. It does not always easily fit patterns that make problems easy to anticipate or cases easy to pursue. The conventional offer to trade sex for a grade is a lot less common than a whole range of improbable actions no one will include in campus guidelines. It is time to take responsibility for the messy, protracted cases where people are assaulted physically or psychologically. And it is time to abandon the vulgar and irresponsible show trials designed to feed people's political egos and terrorize a campus.

Consensual relationships should be left alone unless one of the parties requests intervention.

That is not to say that consensual relationships are always healthy.[1] The courts have proven otherwise throughout history. Marriage itself is frequently enough a violent institution. Nor is it to say that differential power relations and other inequities do not exist on campus and elsewhere. But we are not certain we know what a relationship between "equals" would be, especially over time. The relative authority and power that two people have in a relationship changes over time and in response to altered circumstances. Even stark differences of age and professional status do not guarantee fixed power differences. And the changes in differential power relations are not only personal but also historical; thus, as Jane Gallop demonstrates, students now in some ways have more power than they had in the late 1970s. The naming of the category of sexual harassment itself presents us with a shift in power potential, as does the corporate emphasis on the student as consumer.

Finally, as many have recognized, both the young and the old, both students and faculty, can initiate relationships, so assigning responsibility can be difficult unless we woodenly choose to ignore such complications and ritually assign guilt to the faculty member. People worry about students in a sexual relationship with a faculty member being shown academic favoritism, but such sexually based favoritism accounts for only an insignificant percentage of the unwarranted, often phantasmatic favoritism shown individual students every day on every campus on earth. Privileging every *sexual* effect just because it is sexual is an ideological practice, not a transcendent form of justice.

Most of us know some relationships between faculty and students that have gone badly and others that have gone well. Some of our best friends were once each other's students. Prohibiting intimate relationships will not stop them from occurring; while that alone is not sufficient reason not to bar them, it does limit what prohibition can achieve. Such relationships will continue to occur in part because passionate advocacy and intellectual seduction are inherent in much good teaching. They will continue in part because human chemistry does not respect job categories. They will continue in part because people have mutual needs that they can satisfy with one another.

No one in his or her right mind would want, say, to charge a faculty/student married couple with violating campus policy against sex between unequal partners or, for that matter, with creating a hostile educational environment for some lost, crusading soul who decided that his

or her peace of mind had been compromised by knowledge of their pre-marital relationship. Yet current regulations against student/faculty sex might make a retroactive campus "trial" logical if marriage is taken as evidence that an illegal relationship had previously existed in secret. And third-party complaints are essentially provable by the "victim's" testimony; lack of intent on the perpetrators' parts is irrelevant.

Neither frequency nor inevitability nor occasional long-term success, again, are sufficient justifications for allowing unacceptable behavior. Yet, in the end we must reaffirm the need to respect people's consensual freedom of association whether or not they associate in ways we find appealing. More importantly, to intervene in a successful consensual relationship in order to criminalize it and prosecute the participants is an act of inhuman cruelty and violence.[2] That is what some campus constituencies want us to do, but we believe they are wrong.

Indeed, as my collegue Kal Alston pointed out at a May 1998 University of Illinois forum about a proposed campus ban on consensual relations between people of unequal status, such bans do not even make it clear what sexual relations consist of. Is genital contact necessary? Is heavy petting prohibited? Another faculty member, however, had a simple solution for curtailing student/faculty relations: "Make it a matter of policy that the complaining student's word is always golden. Even when a student changes her mind later about a relationship she considered consensual at the time." Of course, such a policy would make false charges definitive and lead to faculty being wrongly fired, but for one senior faculty member it would be worth the price. I would certainly not honor reevaluations of consensual relationships after the fact, though abuses are possible when a relationship is disintegrating.

Like it or not, sexual conduct is not fully available to reason and propriety. We cannot remake it in the service of a secular theology. Puritanical regulations designed to turn the campus into a model arena of reasonable human conduct can only fail.[3] Our understanding will never wholly encompass our desires. But campus show trials designed to promote this larger agenda are even more dangerous. For they trivialize a domain where real violence is possible and genuine criminal activity is a daily occurrence. The real task for higher education is to discourage such acts or punish them when they occur, not to police the whole realm of human behavior.

CN

Spousal Hiring (ˈspaʊsəl ˈhī(ə)riŋ) Appointments for academic
partners did not become common until the 1980s. For many years anti-
nepotism rules kept many couples from being employed at the same insti-
tution. People gradually began to realize that in the male-dominated
academic world, prohibition of nepotism was mainly a barrier to women
having careers of their own. Some departments were so unreflective
about the matter that they did not even trouble themselves to disguise
their gender bias by crying "Nepotism!" When a young Yale Ph.D. wrote
the University of Illinois English Department in the late 1960s to say her
husband had been hired by the Philosophy Department and she would be
interested in any opportunities in English, the department simply
replied, "We do not hire women." In the 1990s Illinois has found jobs for
unmarried couples and same-sex partners.

There are many benefits to hiring couples. In a tight job market a cou-
ple often makes a long-term institutional commitment. Satisfactory jobs
for two people are notoriously difficult to find. At many isolated cam-
puses in small towns a couple, gay or straight, may be happy to stay, while
a single faculty member is often lonely and perennially eager to leave.
People forced to commute to maintain a relationship can rarely devote as
much time to their job. In the ideal situation a university gets two first-
rate faculty members and may get them for life.

But it is seldom easy to make spousal appointments. They mix strategic
calculation with some of people's deepest personal feelings and most
dominant neuroses. They make people uniquely vulnerable. There is vast
opportunity for emotional damage. They open opportunities for malicious
or embittered colleagues to cause pain. As late as the 1990s I have seen
an accomplished, well-published scholar proposed for such an appoint-
ment and then crudely dismissed as a "mistress." I have seen vindictive,
incompetent faculty band together to block a spousal appointment to
compensate for their own career failures. At one point, they were silhou-
etted against the twilight sky on the way to the dean's office—ten dowdy
academics consumed with moralizing indignation, adapting the final scene
from Ingmar Bergman's *The Seventh Seal* as they stumbled along behind
Death with her scythe. To those observers disinclined to make such an
upscale comparison, it seemed more a scene from an old and long-
running academic movie, *The Night of the Living Deadwood*.

Spousal hiring also risks unique resentments. Neither member of a
couple overlooked is likely to be able to admit it if one of them really
is not well qualified. No one understands it when someone else's partner

is hired rather than their own. When both members of an untenured couple are hired and one of them fails to get tenure, everyone is anguished and the wounded couple may have to stay in town. When a single faculty member is fired, he or she usually disappears from sight or goes to law school.

Yet certain rules can help limit both personal and institutional injustices. First, the initial hire must be unquestionably superior. It is unreasonable to demand that the partner be the very person who would be chosen out of a national search. Yet the partner must be someone good enough to be interviewed in an open competition, and it must be clear that he or she would improve the overall quality of the department. Otherwise, everyone will be haunted by second thoughts and guilt at participating in unprofessional preferential treatment.

What should never happen—though it continues to occur at our most distinguished schools—is to conduct an open, advertised search with the intention of choosing the spouse for the job. Everyone is cheapened by such a process, not only the search committee members forced to betray their own ethics but also all the other candidates who apply for the job and dream about it, believing they have a fair chance. Not to mention the expenses involved in applying for a job and flying to an interview. We have all known job candidates who have spent hundreds of dollars traveling to a convention for *one* interview. What if that one interview just happens to be part of a smoke screen to provide the appearance of an impartial, national, and legal search? Impoverished students or part-timers are then being asked to pay for a department's charade of fair play. Tenured faculty must refuse to participate in such searches and should promise to make them public if they are set in motion. That's one example of how tenured faculty can keep an institution honest. A university should have clear rules and procedures for spousal appointments and be forthright about them.

At the same time it is generally best to proceed cautiously and with a high degree of confidentiality until the partner's credentials are evaluated by key people and a full dossier is assembled. A small group of respected senior faculty can review a file in confidence and make a preliminary recommendation to proceed or not proceed. In that way a weak case can be stopped before a full department review is undertaken and people are unnecessarily humiliated. The same principles apply to letters of recommendation. One or two negative letters can kill any potential hire, but they can cause special anguish in spousal appointments. Once all the

papers are assembled and judged to justify proceeding, then all the tenured faculty should discuss the potential appointment. Wide departmental participation in other appointments may be unnecessary, but it is essential to maintain goodwill in a spousal appointment.

These appointments can be either more or less touchy when two departments are involved. Certainly claims about departmental pride, honor, and high standards—cheerfully abandoned on other occasions—may be asserted quite self-righteously if people feel imposed upon. Preliminary confidentiality can avoid major embarrassment to the department seeking the appointment.

Despite the difficulties involved, the willingness to consider appointments for academic couples is one of the welcome progressive developments in academia in recent decades. For it recognizes that people's humanity and their professionalism are intertwined and can be addressed together. And it has helped increase gender diversity and personnel stability on campus.

CN

Superstars (ˈsüpə(r) ˌstärz) The star system in academia has several historical causes and numerous sources of legitimation. As both Sharon O'Dair and David Shumway have pointed out, there are star systems, hierarchies, and celebrity figures in many other areas of American life. Some have been in place for more than a century. Others are creations of twentieth-century modernity. And some have obtained their intensified glamour and rewards only very recently.

Not all star systems are the same. Not every graduate student dreams of becoming the academic equivalent of Michael Jordan. Indeed, except for some highly paid university physicians, no academic could live for the rest of his or her life off the rewards of even the most spectacular ten-year career. A basketball superstar can. The star system in sports penetrates virtually every team, from the minor to the major leagues. But the overwhelming majority of academic departments have no stars and no aspirations to acquire them. At a small liberal arts college the respected figures on campus are as likely to be teachers as scholars. Departmental life in a liberal arts college, a branch campus of a state university (what one of our friends calls a "directionally named" institution), or a two-year college is most often not conducted with one eye focused on celebrity. On some campuses no one receives a high salary.

The star system in academia, however, does play a significant role on

research campuses. There it gains some of its frenetic, impulsive, and competitive character from celebrity in other domains. Academics find it easier to act like prima donnas because movie stars and operatic divas do. When rock stars put outrageous demands in their contracts, others try to follow. We know one visiting academic in 1998 who tried to have a clause put in her speaker's contract guaranteeing that she would not be taken to any campus building where she was not permitted to smoke. Small beans, though, when compared with what political superstars demand. When Colin Powell spoke at the University of Cincinnati in 1998 he insisted on traveling by private chartered jet, on limousine transportation on the ground, and had it written into his contract that he would neither answer questions nor sign books. It was basically the equivalent of a videotape performance with an added photo op.

As Sharon O'Dair has pointed out, however, academic stardom does have a structural place in the economy of large universities. There were prestige scholars in earlier generations. Northrop Frye at the University of Toronto became a distinguished faculty member with some benefits, like a private secretary, still rare today. M. H. Abrams at Cornell University became a millionaire on the royalties from the *Norton Anthology of English Literature*. But the postwar expansion of the American academy and the creation of a lower caste of graduate assistants and part-timers to teach introductory courses did underwrite a growing class division in the academy. At the same time, the postwar explosion of the research culture at upper-tier campuses provided a nationally recognizable basis for further hierarchical distinctions. Teaching reputations do not travel very well, but publications can go anywhere. What the *minnesota review* calls "academostars" multiplied in the Reagan/Bush era of the 1980s.

Academic disciplines have always had figures of special prominence and achievement; but now suddenly it seemed they were the only figures who mattered. If Marx and Freud were, in Foucault's formulation, founders of whole areas of discourse, now every subdiscipline had its small clusters of planetary bodies. Everyone else was a satellite. Academic superstars owned even the statements and insights they borrowed from others. Discourse flowed not only from but toward them.

The postwar growth of graduate programs heightened this culture, for it brought apprentice intellectuals into the university in large numbers. Undergraduates are as likely to admire and try to emulate their teachers; graduate students and young faculty will look as least as often toward publications by distinguished scholars. Suddenly superstars had an audience to admire them. Fandom arrived in academia. Gradually, as

Shumway argues, emotions of envy, ambition, and adulation entered the new structural place available to them. Of course students and young faculty could admire a discourse; they could entertain ambitions to enter a conversation. But wannabe followers in America sometimes find it easier to dream through the image of a person. And so it went. Academic superstars were born.

Yet now, as higher education moves more deeply into what is at least a long-term recession and perhaps a semipermanent one, its internal disparities of opportunity and reward—its hierarchies that run from wealth and privilege to impoverishment and exile—are coming under increasing scrutiny. Among faculty there is intellectual celebrity and substantial financial comfort at one end of the spectrum and marginal part-time employment at the other.[1] Among the lucky ones in higher education are those faculty members who combine scholarly renown with especially high salaries. Inevitably, these academic "superstars" are resented by many different groups, from those who have tried to win the same status and failed to those who cannot find a job, who have no status at all, and who thus have more than sufficient warrant to disparage all privilege and hierarchy in academia. At institutions with high teaching loads and little research support, intellectually ambitious scholars may resent highly successful scholars with benefits they can never equal. Moreover, not all of academia's best-known figures perform gracefully in their roles. Finally, James Sosnoski argues that teachers at lesser institutions are effectively tokenized by the master critics of the profession; canonical superstar status, he suggests, is used to suppress other people's salaries and turn them into a lower class of academic workers. Reputation for him is therefore an instrument of containment; administrators use it to set a standard of productivity that most faculty cannot meet, a standard that justifies low salaries and high workloads for those who fail the test. For all these reasons, it is time to reflect more honestly than we have before on the function and behavior of such superstars.

Let us consider four specific higher education stories of the 1990s. Here and throughout, we have sometimes (but not always) changed the gender of an anonymous person. In cases where names have been deleted we have done so to guard against the temptation to displace a systemic problem onto a few notorious (or admired) individuals:

1. A disciplinary organization has scheduled its annual fall convention for Chicago. In order to promote attendance and give some focus and intellectual thrust to the convention theme, a high-visibility fac-

ulty member from the University of Chicago is invited to give the keynote address. The topic will be one he regularly addresses. They offer an honorarium of $1,000, not bad for a few hours work. After all, even if he hits rush hour, the drive over and back will not keep him away from home overnight. He courteously agrees to give the keynote talk, but he has one request: "Could you increase the honorarium to $2,000?" Not quite willing to just say no but unwilling to be the victim of the academic version of a legal bank robbery, the organization's executive secretary instead suggests he'll do what he can but doubts it can go higher. The story ends happily, as Chicago's superstar accepts the opening bid.

2. A department head at a New York city university receives a phone call from a respected scholar at another Manhattan school. She will be on leave next year but will not be earning her full salary. Would the department head be interested in adding the glamour of her reputation to his roster for a year? Perhaps $30,000 or $40,000 would be reasonable? Well, he asks, what would you be interested in teaching. No, no, she replies, I'll be on leave. As the conversation evolves, it becomes clear she had planned to offer no services in exchange for the money; she was merely offering *the use of her name* for a year. Dimly realizing this wasn't going over well, she proposes holding office hours once or twice. The department head, having learned tolerance in his administrative capacity, says he has no money but will certainly pass the news around. She gets the message and continues to pursue possibilities on her own. As it happens, two of her former students are now teaching at a less distinguished midwestern school. They convince the administration that the prestige of having her name associated with them for a year is worth the expense. She receives a semester's salary without performing any meaningful services.

3. An accomplished faculty member holding a Distinguished Professorship at a university in New York normally teaches one course each semester. He decides the assignment is getting in the way of his writing and asks to change to a 2/0 teaching load. The university agrees but reminds him that such an arrangement will mean teaching at two locations, the graduate and undergraduate campuses, in the same semester. He thanks them for the warning and demands a limousine to take him between classes. The administrator declines, explaining that a public institution that provided a faculty member with limousine service

might not fare well when budget appropriations came up at the state legislature. A gentle recommendation about bus, subway, and taxicab services is met with anger, and the faculty member vows to begin looking for another job.

4. A distinguished scholar in Britain receives a series of offers from American universities. One is especially straightforward: we'll double your salary, add $25,000 for research expenses, and cut your teaching load in half. Many scholars in financially depressed British universities have accepted offers from American schools; one can hardly blame them for doing so. But in this case the faculty member decides to turn all the offers down and honor his personal and cultural commitments by remaining where he is. Meanwhile, contrary to American practice, he makes no threats to leave and gains little or nothing from the offers.

The first three stories are partly about self-importance and how recognition in academia instills it in individuals. The first story is also about greed, the second about self-delusion. The third perhaps introduces the *superstar as sacred monster,* a being approachable only in terms that confirm his or her superstar status, a person whose expectations for gratification and impatience at delay are decidedly infantile. The fourth story, beyond the reach of most American academics, is about forbearance in the presence of temptation. Would either of us behave as the first three faculty members did? No. Would we behave as the fourth faculty member did? This time, I'm afraid the answer has to be no as well.

The first story, about a minor negotiation over money, is one of the recurrent sites of boorish celebrity behavior in academia. It was also in the 1990s, for example, that another well-known faculty member (now in New York) agreed to give a keynote address at a regional conference for a fee of $1,500 plus expenses; after a few months the keynote speaker called back to renegotiate: "I've become more famous since we talked, and I think I should raise my fee to $5,000, but I'll settle for $3,000." One can, of course, set a minimum price for invited speaking engagements, which is something I try to do myself, but trying to bully people into renegotiating an agreement is unacceptable.[2] We could add many stories to these, but the first points they make are already clear: academic stardom does unquestionably produce some certifiably tacky and embarrassingly self-important behavior. All of it, however, pales before the antics of film stars, politicians, sports figures, rock stars, and other more grandly rewarded celebrities in American culture. These people not only earn

much more money; they also have larger fan clubs. It is also not easy to find versions of the fourth story above performed by the superstars of popular culture, so academia is sometimes notable for principled behavior not so evident everywhere else. One of our purposes here will be to ask how principled behavior might be applied to celebrity appointments in the academy.

All of the people featured in these stories do rank as superstars in the complex and ever-shifting realm of academic reputations. Not unlike movie stars, some academic celebrities gradually build reputations, while some burst suddenly upon the scene; some fall out of favor almost as quickly, though that partly depends not just on the quality of their own ongoing performances but also on the loyalty of their fans, who either do or do not cite them lovingly and repeatedly in their own lower budget scholarly productions. Citation, indeed, is somewhat like academia's version of applause; many journals will not stage your production unless you cite celebrities. Some superstars adapt to changing audience tastes and remain in the public eye, remaking themselves as the need arises. Others, superstars of long standing, on the other hand, may come to seem like monuments to paradigms past, as the leading edges of disciplinary debate leave them behind. Academic celebrity is not a uniform, consistent, or dependable intellectual category. Its only constant may be the financial rewards it often brings.

Inevitably, as the rewards in downsizing universities are distributed more narrowly and as the job market for new Ph.D.'s continues in its state of collapse, superstars are the subject of both criticism and resentment. *Newsweek* echoes what counts as popular common sense, reporting falsely that the salaries paid prestige faculty are one of the root causes of higher education's financial crisis. Some scholars argue that renown in the humanities is empty—a fraud and a fiction; it builds on itself, and its core is vacant: it's superficial, opportunistic, or histrionically overblown work that wins huge reputations.[3] Some meanwhile believe the salaries paid superstars have prepared the way for all the two-tiered wage scales in academia.

Is any of this true? We do not believe it is. First of all, in any given discipline—with the possible exception of medicine—superstar salaries amount to a tiny portion of the budget. The same is true for the salaries of the most highly paid faculty on any given campus. Nor do the salaries of the most highly rewarded people artificially lift the salaries of everyone else, though one might well wish that they did. The argument that superstar salaries are a significant financial problem for higher

education is a sham. In journalists' hands it is designed to fuel public rage and sell newspapers by trading on traditional resentment against intellectuals.

Campus resentment about superstar salaries often reflects envy and the choice of easy scapegoats rather than systemic analysis. What both campus critics and journalists tend to ignore is the huge and structurally significant disparity in *disciplinary* salaries. That's where the money goes; it's the location of higher education's real financial burden from high salaries. A new assistant professor of English at our own universities earns about $40,000. A new assistant professor in the business department earns about $75,000, more than the average full professor salary in the humanities. For many years the former had a Ph.D., the latter an M.B.A. The Ph.D. takes twice as long or more to earn. The English department faculty member may never reach $75,000 in his or her whole career. What's more, the business professor will receive several forms of supplemental income and salary augmentation that push the wage disparity even further—from consultation income to unusually generous travel and research support to special income enhancement near retirement.

No one likes to talk about this. Obviously the businessmen on boards of trustees who prefer English or French or art professors to be even lower paid adjuncts don't boast publicly about disciplinary wage disparities. Underpaid humanities professors usually don't complain about them either, certainly not so often or so loudly as one might expect—both because they feel powerless to change this system and because they are reluctant to adopt the economic and political vantage points necessary to explain it. The significant financial burden is not the English or philosophy professor who gets an outside offer but the lawyers and engineers and doctors and business professors who consistently earn two to *ten* times as much as their arts and humanities counterparts. But rather than attack the system that produces those disparities, it's easier to complain about one philosophy professor, a person moreover who is knowable and who has a name. The business professors across campus and the doctors in the medical school are often anonymous or invisible. I am told that in my own department the two highest-paid faculty members are often referred to as "the royalty." Since I am number three on the pay scale, earning in the low six figures and thus well above the department average, such comments are not ordinarily made in my presence.

Disciplinary differences are also conveniently ignored when people protest the other most visible benefit prestige faculty often obtain,

reduced teaching loads. One colleague at a nearby school pointed out to us that the greatest irony in appointing named chairs was that their first reward was to be taken out of the classroom; after all, he added, teaching is our main reason for being faculty members. His view partly reflects the distinctive mystification of teaching that is central to humanities department ideology. For faculty in the biological sciences here routinely teach one course per year, a 50 percent reduction of the usual already curtailed teaching load in the sciences. All that's really involved in reducing a senior humanist's teaching load to two courses per year is a claim that at least a few humanities scholars should receive the same research support that is standard in the sciences.

Faculty who don't receive such benefits may also like to say, "If only I could have gotten reduced teaching, I too could have a named chair." But people generally receive such status only *after* they have proven themselves to be exceptional researchers. If some excel on a level playing field, the resentment of others is likely to be self-deluded. Where the playing field is not level—neither at the outset nor throughout people's careers—is across disciplines. The cumulative advantages accruing to different disciplines are astonishing: higher salaries, supplemental summer salaries, research support that is not only substantially higher but also much easier to obtain, reduced teaching loads, extensive service from assistants and secretarial staff, constantly updated computer equipment, unlimited travel and expenses, and so forth.

It seems clear that stark disparities *between* disciplines, structurally in place for decades and steadily growing, not the spectrum of salaries *within* departments or occasional superstar salaries, are the first significant faculty parallel to two-tier wage structures elsewhere on campus, including two-tier wage structures among service employees. The long-standing disciplinary disparities have also helped rationalize campus-wide structural differences between salaries and benefits for tenure-track faculty and part-timers or adjuncts. These in turn have made outsourcing to temporary and part-time employees in maintenance roles more acceptable to campus administrators as well. But historically the large discipline-based salary differences have laid the groundwork for all the other "market-based" forms of campus exploitation.

The only other major structural disparity in faculty salaries is for those faculty members who become full-time administrators. Since administrators control the budget, there is more than a little temptation to secure the salaries of fellow administrators before worrying about anyone else. Of course, no administrator sets his or her own salary, but they do set

salaries for the other administrators they supervise, and administrative salaries have become a campus priority in part as a result. Indeed upper-level administrative salaries on some campuses have risen too far and too fast. On my own campus the salaries of administrators with major responsibilities seem quite fair; these people earn their incomes, often at jobs that are unpleasant, difficult, and exhausting. The pleasures of administration in times of tight budgets are not always overwhelming. But one doesn't have to look far before finding schools where administrators earn too much in relation to faculty members; Indiana University is one such school. At Urbana a dean of Liberal Arts and Sciences can earn about half again as much as one of his or her more highly paid faculty members. At Indiana the same administrator can earn $50,000 more, nearly twice as much as one of his or her senior faculty. These hidden administrative "superstars" are not always worth what they are being paid. Arguments that such salaries are market-based are problematic when administrators across the country effectively collude to set market rates for their own class of employees.

Superstar salaries for individual faculty are also to some degree market-based, in that a faculty member who leaps into the superstar salary range by way of an outside offer has proven his or her marketability. But such offers are often the results of arbitrary and uneven forces, especially in the current restricted market. In the 1950s, 1960s, and 1970s, when faculty mobility was much greater, outside offers were one reasonable way to confirm faculty members' national reputations. Now, with retiring faculty being replaced by assistant professors or part-timers, open senior positions are far fewer, and the pattern of only rewarding people who receive outside offers has become pernicious. In our fourth example above the faculty member at issue has a genuinely international reputation and has been sought after by a considerable number of institutions. But sometimes an outside offer is a complex mix of local needs and politics, intellectual achievement, and sudden changes in the field. A single highly circumstantial offer—one that other schools are unlikely to duplicate—will probably not propel a humanities faculty member to a $130,000 salary, but it can certainly make for a significant salary increase. Real superstardom, which in the humanities these days can produce an annual salary of $150,000 or more, usually requires what amounts to a national consensus about the quality and importance of a person's work.

But sometimes a person with a small quantity of highly visible publications can ride a new disciplinary development into something close to superstar status. When an emergent body of theory becomes a hot area

of research, its young leaders may have, say, only one book and a group of influential essays. Alternatively, a single book that fills a strong need in a popular area may lift an otherwise unaccomplished faculty member to high visibility. At a research university that might get an ordinary English professor tenure and a $50,000 salary. But there are numerous people around the country who have ridden a single influential book in a hot new field where tenurable faculty are scarce into salaries twice that amount.

There resentment festers, especially when a young Ph.D. with a comparable quantity of publications cannot get *any* job or when a comparably accomplished assistant professor cannot figure out how to afford both child care and car payments, let alone travel to a research archive. At that point superstardom or its close proximity seems genuinely irrational and unfair. And the behaviors reported at the opening of this essay—or infinite variations on them—are legion among the accidental superstar products of intellectual fashion. Our own practice has been to reject such appointments unconditionally; we will not support paying a high salary to someone with such modest accomplishments. But even our most distinguished universities sometimes make such appointments. Much would be gained by just saying no to that temptation.

One of the damaging effects of supporting opportunistic, premature superstardom is the general undermining of real merit-based compensation. If anyone objects to the superstar salary status of, say, Stanley Fish or Fredric Jameson, they are, unwittingly or not, objecting to the very notion of a hierarchy based on achievement, an objection that seems to us irrational in intellectual life. These people have earned their superstar salaries twice over; their objective achievements, visibility, and influence are well worth the price. You may disagree with their arguments and positions, as we have sometimes ourselves, but their impact over time is unarguable. On the other hand, some people both inside and outside academia may believe that all university salaries should be the same, that people's accomplishments are irrelevant, but that leveling argument is not merely egalitarian but also anti-intellectual. To put our cards on the table, we should admit that one of us has benefited from a merit-based salary system and the other has not, though both of us have argued for the principle of merit even when we were assistant professors and neither of us was receiving any of it.

Fish and Jameson, of course, have both been at Duke University, where the English and literature programs show the benefits of concentrated superstar hiring. (Fish is scheduled to move to Chicago.) Duke has

invested millions of dollars at the highest and lowest levels of its graduate programs in English and American literature and literary theory. It has hired multiple superstars at high salaries and created immensely competitive multiyear fellowships for graduate students. As a result, its national rankings have risen dramatically. But that is not the payoff that most impresses us. Our informal surveys of departmental Ph.D. placement rates, conducted over several years of research and writing on the job market, suggest that Duke's English Department has consistently had greater success placing its new Ph.D.'s in jobs than any other large department in the country. That is a benefit of inestimable value; it promotes a sense of professional well-being that few other programs can equal, and it suggests that categorically rejecting superstar hiring promotes departmental misery and failure.

Duke's experience also demonstrates what it costs for a department to make a dramatic improvement in its national rankings. Many administrators across the country castigate departments about their rankings, but precious few are willing to pay the bill for improving them. Of course the buyer's market for assistant professors means that any department smart enough to tell the difference can hire brilliant new Ph.D.'s. Certainly careful (and well-informed) reading of dissertations, combined with focused interviewing, can predict initial scholarly success. But no power on earth will tell you which new Ph.D.'s will be a Fish or a Jameson in twenty years.

The bottom line is this: you can improve the *quality* of a department dramatically by junior hiring. You can improve the quality of its teaching and the quality of its intellectual life. You can assure increased visibility for its scholarship. But high national rankings are dependent on having colleagues whose reputations go beyond their specific research area or subdiscipline. At the very least their work must be recognized and respected throughout the discipline. The only way to guarantee that sort of impact is to make senior appointments, the more well known the better. Even if you could identify the next Fredric Jameson coming out of graduate school, it would take twenty years for him to *become* Fredric Jameson.

Whether or not national rankings matter is another issue. They help bring in grants and attract the best students, as highly visible scholars do. Those are among the reasons, as Jeffrey Williams argues, why schools have an interest in superstar appointments. They also matter to administrators not only because they provide outside indications of departmental strength and thus evidence of whether departments have used resources

effectively but also in part because they make it easier to be ruthless in tight times: they justify giving still more resources to highly ranked departments and further eviscerating those ranked poorly. But a department itself should not confuse its ranking with its intellectual quality. Yet Duke's success on the job market is a powerful argument about the difference superstars and rankings can make.

Here too, however, hiring people with substantial accomplishments—both qualitatively and quantitatively—is one key to sustaining campus health and public confidence. By contrast, opportunistic fake superstar hiring spreads cynicism everywhere. A few years ago, for example, a young friend of ours at another school was considering two different offers. He had published a book and a cluster of admired articles in a hot new area of theory. One school was offering him a named chair, while the other was having difficulty agreeing that a full professorship was justified; its standards for its own faculty would have suggested a well-paid associate professorship. In the end, our friend received a counteroffer and stayed where he was. The school that offered the named chair was trying opportunistically to confer superstar status prematurely. Even people who supported the appointment would have come to resent it, especially when they realized that they or some of their colleagues were earning much less money despite having accomplished more.

Resentment is, for the most part, considerably reduced when the superiority of a superstar's accomplishments is clear. There are exceptions to that, however, and they deserve mention. One such resentment is over race. Some years ago Eugene Genovese complained about the salary differential granted African American faculty. Race is clearly one among many market factors that impacts salary and research support. There is major need for black faculty across the country, both as intellectual resources and as role models for students, but the supply of minority Ph.D.'s falls far short of demand. In 1995, according to Ingram and Brown's *Humanities Doctorates in the United States,* only 2 percent of humanities Ph.D.'s were African Americans. A scarce commodity in high demand often has an increased price, though in this case the market effect comes to a good deal less than the effect of an M.B.A. or a degree in medicine or law. The latter commodity, incidentally, is not scarce. For Genovese to complain about higher salaries paid minority faculty and not business faculty and lawyers is unwise not only because it takes one market factor out of its context but also because it risks promoting racism. But he did exemplify one strain of superstar resentment.

Of course the total number of black superstars in academia is minute, their financial impact nonexistent, but resentment against them is not uncommon. Henry Louis Gates at Harvard is perhaps the most significant case because of his high overall income and high public visibility. Gates's accomplishments would earn him a quite good salary anywhere, regardless of his race. In addition to having written widely influential scholarly work, he may well be the best popularizer of complex arguments in the humanities; what we mean is that his essays for the media have been adept at simplifying ideas without betraying them. He has also steadily built up African American studies at Harvard, a high visibility effort that might finally succeed in drawing more minority students into humanities Ph.D. programs. The bottom line is that Gates gives Harvard more than its money's worth. If he earns somewhat more because he is black, that is partly because his race and his talents combine in positioning him to be able to accomplish things of genuine importance. And he still earns vastly less than a large number of white physicians and business professors at universities around the country. Gates, of course, is also something of an academic entrepreneur, producing insightful interviews for the *New Yorker* and supervising numerous publication projects around the country. Much of his income comes not from his university salary but rather from all his other activities. Unlike the business professors who sell their services to tobacco companies, however, Gates's work is all for the public good. He is as close as academia comes to an entrepreneur on the side of the angels.

But of course Gates is a person of genuine prominence. Fueling the low-level but widespread uneasiness about minority salaries in academia are the special benefits younger minority faculty sometimes receive. The pattern is by no means universal, but some new African American or Chicano/Chicana Ph.D.'s can get recruitment packages that lift their salaries or research support from 10 to 20 percent above what comparably accomplished white faculty might receive in a given discipline, especially if more than one school is trying to hire them. But a new Chicana Ph.D. in English will still earn nowhere near what a new assistant professor of commerce or law will earn. Moreover, the small differential in minority salaries is entirely a market-based feature of scarcity. If minority Ph.D.'s were common enough so that competition to hire them was curtailed, any special benefits they receive would disappear overnight. Finally, in terms of sheer numbers, the overwhelming number of high salaries in academia go to white males. Resentment against minority salaries is thus unwarranted, but it will continue to be an undercurrent in

academic life so long as many academic salaries remain depressed and the overall job market remains disastrous. In the meantime, among those who harbor such resentment there is sometimes a false blurring of distinctions between genuine minority celebrities (and the salaries they can receive) and other minority faculty, whose benefits are far more modest. When we note that the salary bonuses scarce specialists in composition theory receive seldom seem to generate comparable bitterness, then we are compelled again to look to racism as an explanation for the occasional anger we hear.

On the other hand, the incapacity of some white faculty to deal with minority faculty does increase tensions over even modest minority benefits. Here and there across the country young minority faculty are being turned into sacred monsters who exist outside the normal academic socialization process. A nonsensical culture evolves where white faculty feel they cannot disagree with a minority colleague and must support any sort of demand, such as the demand that only African American scholars should teach African American literature. One extension of this logic would mean that only Shakespeare can teach Shakespeare, and he, alas, makes infrequent visits these days. Of course, minority members were not the first sacred monsters in academia. Senior white faculty have often enough occupied such roles and, indeed, still do. But it is particularly destructive to let this happen to young scholars who may not have the experience to recognize and resist the temptation when rock star identities are held out to them. In any case, here again the problem is not with affirmative action, with the effort to build a more diverse faculty, but rather with the stupidity and fear of those in the majority.

Nonetheless, we would like to see special race-based salary increments come to an end because their effect on academic culture is partly negative, but the way to accomplish that is not to terminate them now, a difficult goal in intensely competitive hiring, or to claim as some conservatives do that race should be irrelevant in hiring. Both minority and majority students need to have contact with minority faculty. To deny that need is to deny the role race plays in identity formation, in establishing and sustaining cultural hierarchies, and in national history. The way to end special treatment for minority faculty is to draw more minority students into doctoral programs and thereby change the racial mix of faculty job applicants, to change the market. The best parallel we know is with the recent increase of female Ph.D.'s in humanities fields like English and history. In English there are now so many first-rate women applicants for faculty positions that gender-blind applications would probably produce

roughly equal numbers of male and female faculty appointments. At some point, as we argue in the affirmative action entry, affirmative action can solve a problem and become irrelevant, though we are a long way from that goal where minority faculty are concerned.

Meanwhile, we believe frank statements about the nature of the market can diminish some of this anger by helping people to see the issues clearly and the material rewards accurately. The issues are a little more complex for senior celebrity appointments, however, because there more pressure will be placed on assessing the faculty member's contributions not only to department life but also to institutional prestige. This can be difficult to estimate accurately, especially in the short term, but some related considerations can help make for more successful appointments. One important criterion of success is whether the superstar makes a significant institutional and community commitment, something which can be evaluated according to a person's past performance. One flagship state university in the south appointed a named chair a few years ago who elected to live in another state and fly in once a week to meet his class. Worse still, his major publications were edited texts, a perfectly presentable and often essential scholarly contribution but not one likely to inspire students or one necessarily likely to lead to intellectually stimulating conversations with colleagues. His appointment, in other words, made no real difference in the life of the department. Its only purpose was to send a long vita with a local address to the administration. Even that payoff was limited, however, because the scholar had no significant disciplinary reputation outside his narrow area of research; there may not be much gain in a senior appointment that creates no waves noticeable elsewhere. Certainly, a record of intellectually stimulating research and a proven capacity to provide effective leadership are essential for someone receiving an especially high salary.

There are also, however, cases of widely resented superstars who do not actually earn superstar salaries. Andrew Ross's base salary at New York University is barely six figures, despite rumors to the contrary. In fact people were jealous of his "superstar" status before he had tenure at Princeton. Ross is partly a case of someone the media had to invent whether he existed or not—a white male left-wing cultural studies figure who could be safely attacked. The main source of his reputation in cultural studies is his series of heavily researched, intricately argued books, from *No Respect* to *Strange Weather* to *The Chicago Gangster Theory of Life* to *Real Love*. These are among the best books in cultural studies; they take up important, sometimes controversial topics, and they make

demanding, often subtle arguments whose political force is highly nuanced. More often than not, it is safe to assume that those who ridicule or rage against him have not troubled themselves to read this work, or to understand it.

In dealing with reporters Ross has certainly made the mistake of trusting people who were out to disparage him. *GQ* invented statements he never made; *New York* magazine's reporter spent a friendly day with him while intending all along to trash him in print. But he has also made errors of judgment; almost every time he has been ironic, reporters have willfully taken him literally, a practice that is to be expected from a hostile press. The result has been a media image of someone whose intellectual and political interests are superficial, when nothing in his books suggests anything of the sort. That is the danger for academics who accept or court media attention. There is no easy alternative, since most universities want their faculty to talk to the press, though it is certainly advisable to refuse further contact with reporters who prove themselves untrustworthy. In any case, short of being guaranteed press harassment, it's not clear how Ross has benefited from his celebrity status.

Of course, resentment does not require a rational basis, and many older, unsuccessful academics want a visible scapegoat for their own career failures. Some young reporters, themselves Ph.D.'s who could not find academic jobs, have their own burning anger to vent. And the thousands of unemployed Ph.D.'s, many immensely accomplished young scholars and teachers, can hardly be expected not to resent the profession's celebrities. Superstars are easier to hate than anonymous groups of privileged people, at least if you want to avoid the social, political, and economic implications of class analysis. And incompetent tenured faculty are also typically nameless unless they happen to be your colleagues. So people who seem to flaunt their privileges and self-importance, as some academic celebrities do, are at least visible targets. At the same time, universities have exacerbated the problem by making superstars out of people who haven't earned the salary or recognition. In fact we have far more often encountered bad manners from fake academic superstars than from real ones. It is as if, uncertain and uneasy about their reputations, they have to find increasingly more outrageous ways to prove they are loved without qualification. In the process they give everyone a bad name.

My favorite faux superstar of this sort was a colleague in another department who for years unilaterally declared himself a superstar in the hope of winning general assent to the title despite his rather modest

accomplishments. He would insert into almost every conversation a qualifier like "as a superstar, of course, I am inclined to view this issue . . ." He eventually had a certain success at this self-promotion, though his increasing tendency to behave like Norma Desmond certainly tried everyone's patience. In the end, the whole house of cards came tumbling down when he decided that low enrollment in his superstar courses was something like a human rights violation that should be dealt with by some outside agency.

He thus never earned himself a superstar appointment, but people do win them with less than impressive credentials. Such cynical prestige appointments produce other problems as well. Motivated by a desire to improve a department, some will support exaggerated salaries for people who haven't yet earned them but who show major promise. Often enough, even the people who support such appointments will end up resenting them if the people offered them accept, especially if the appointment seems to denigrate the work of other people with similar accomplishments. Meanwhile, such manufactured status—conferred by salary and title rather than by long-term disciplinary recognition—fuels all the self-deluded envy and resentment less successful academics can muster. Rather than face their own limitations, people will simply decide they are underrewarded because academia is devoted to shallow opportunism. So ill-considered high status appointments generate anger both from accomplished people who have not been well rewarded and from those who have less reason to feel badly treated.

There is indeed considerable injustice in the academic reward system and in the way disciplines confer celebrity status. Long-term superstardom is generally earned. It cannot be sustained without repeated high-quality production over time. But it tends to honor the kinds of work that are both most imitated and debated, the work that defines the leading intellectual edges of a field. High-quality work that is less glamorous may receive much less recognition and go relatively unrewarded. Of course, many completely unimaginative scholars, people who have never produced an intellectually exciting book or essay in decades of work, often see themselves as victims of unfair neglect. We know people who have never written a compelling *paragraph,* let alone a compelling book or essay, who consider themselves cheated of the high honors they deserve. Faddish, apoplectic superstar appointments clearly facilitate this sort of self-delusion.

The solution to that problem is not to stop rewarding people for genuine accomplishments but to stop rewarding them prematurely and to

call unacceptable superstar behavior by its true name. That would require both restraint and frankness from members of the higher education community, qualities that may not be instantly forthcoming, but qualities we are inclined to call for nonetheless. Certainly honesty at the departmental level early in the appointment process would be a good place to start. Administrators now often make cold calculations about which sort of dubious superstar appointments are more protected from frank evaluation and review; that is one way that affirmative action initiatives and superstar appointments sometimes intersect. The focus instead should be on the quality of a candidate's achievements. Celebrity will always be impulsively conferred by disciplinary subspecializations, but it need not be as quickly converted into a lifetime salary way above the discipline's campus average.

Finally, and perhaps most importantly, we believe it *is* morally corrupt to reward some categories of people while literally impoverishing others. To give a named chair to a stellar scholar while forcing cafeteria workers onto welfare and denying graduate assistants and part-timers a living wage is to betray every value universities have traditionally supported. That will increasingly be the pattern for prestige appointments at many financially pressed schools, which is another reason why such appointments need increased scrutiny. Already there are faculty members across the country paid $1,000 to teach a course and faculty members paid $100,000 to teach a course. That pattern also places a new burden on those negotiating for high-level senior positions, one for which our more exclusively self-interested superstars may be ill prepared—to negotiate not only for themselves but also for their future students and colleagues. A superstar, for example, might not want to accept a personal travel budget if other faculty and graduate students do not have any travel money at all. It is also essential that universities have multiple reward systems for different kinds of achievement, including substantial rewards for demonstrably stellar teaching. The general damage done to morale by limiting significant financial rewards to those who receive outside offers is considerable. At the same time, repeated achievement over time is real and meaningful. There are superstars who deserve the fame they receive within the small world of academia. But no academic honor is supportable unless all employees are treated fairly.

Perhaps it is also time to open a frank discussion about what the highest-level academic salaries should be. For the top salaries in higher education are too high and the bottom salaries too low. The result is a system that entangles hierarchical rewards with exploitation. While binding

agreements would not be appropriate, published position statements about the issue might carry some weight. The issue is not what academia can afford, since the financial implications of its superstar salaries are not significant, but what practices are sound and ethical in an academic context. We have no firm convictions about what top salaries should be, but when I hear of people earning more than $200,000 I begin to worry about the real and symbolic relation to salaries at the other end of the spectrum.

At many campuses, of course, it is the football or basketball coach who routinely pulls in $300,000–$500,000 a year in salary, plus a comparable amount in endorsements and other benefits. Still higher salaries are paid to many faculty members in medicine.[4] Here are a few such salaries from the 1995–96 academic year at Cornell University, figures that have already been superseded but that are nonetheless informative: O. Wayne Isom (chair, cardiothoracic surgery), $1,729,000; Zev Rosenwaks (professor, reproductive medicine in obstetrics and gynecology), $1,408,089; Gregory Harmon (assistant professor, ophthalmology), $988,016. Tulane University paid Mark Hontas, an assistant professor of orthopedics, $846,022. As always, assistant professors earn less, though not so much less that the average part-time lecturer will feel much sympathy for Harmon or Hontas. After medicine, the disciplines with consistently high salaries include business and law, with a significant number of law professors earning in the $200,000 range and business professors at top departments often earning that much or more, but scattered across the country are relatively highly paid faculty in numerous fields. Princeton University's better-paid faculty included these in 1995–96: Daniel Kahneman (professor, psychology and public affairs), $255,430; Gerard Washnitzer (professor, mathematics), $250,000; Anne Treisman (professor, psychology), $239,623. Rice University paid Richard Smalley, a chemistry professor, $299,434 in 1996, while they paid Kenneth Kennedy, a professor of computer science and mathematics, $268,838 the same year. Sylvia Nasar reported in the *New York Times* in 1998 that Columbia University had just hired economist Robert J. Barro for a salary of near $300,000, which will help raise the bar for top economists' salaries generally, even though Barro changed his mind at the last minute and remained at Harvard. Among the highest-paid business faculty were Northwestern University's Bala Balachandran, a professor of accounting information systems, and Artur Raviv, a professor of finance, who earned, respectively, $368,501 and $360,794 in 1995–96. By the time you are reading this, they should be earning over $400,000. But the

disciplinary power of business departments carries over into lesser schools as well. By 1999, the top business professors at the Illinois Institute of Technology and Southern Methodist University will be earning $200,000. Whether or not all these faculty worry about their salaries is impossible to say, but Rosenwaks's salary increased by $135,000 over the previous year, while Balachandran had to settle for a mere $70,000 increase from the previous year.

There is a certain appeal in letting the market simply go where it will, but that now appears to mean wealth and poverty with little in between. In the corporate world, CEOs take apparent pride in earning multimillion-dollar salaries while their lowest-paid workers struggle to survive. Yet we do not believe that pattern is one academic institutions should emulate. At Harvard, the chief manager of the university's endowment fund earns well over a million dollars a year. We do not doubt the endowment's profit in recent years makes his salary seem cheap at the price. But that does not make it healthy for academia to adopt such grotesque wage gaps.

Here and there across the country are academic superstars as well with salaries that exceed any realistic definition of need, academics in many cases of considerable achievement. But it may be time to begin asking whether even a scholar of unquestioned merit should earn an excessively high salary in academia. That may now be the American way, but perhaps it should not be the university way. Just how much some of the distinguished scholars we mention here by name earn we do not know. But if the salaries we've heard quoted for some of them are accurate, then it seems to us they are too high. That is not to say they aren't worth it; their institutions would be getting their money's worth if they were paid twice as much. But those same institutions or others like them are also brutally underpaying other classes of employees. In that context, the top salaries in place in 1999—$300,000 to $400,000 for business professors, $1,500,000 to $2,000,000 for university physicians—we consider nothing less than obscene. In the shadow of these academic salaries, moreover, one might say that *there are no superstars in the humanities.*

We sometimes wonder what an academic celebrity earning, say, $250,000 or $300,000 or more a year does when annual raise notices arrive. Do such people often worry about the size of their raise? Do they go in and complain when their salary grows by 4 percent rather than 5 percent. We know of one holder of a named chair in Florida who asked *not* to be given merit raises so that other lower-paid people could get them, but we have not heard many such stories. One model of what higher education means would suggest such stories should be common.

Instead, we find sentiments like those of Harvard professor of government Theda Skocpol, reported by Alison Schneider in 1998: "I suspect throughout academe that we're beginning to see the emergence of the winner-take-all market. I'm going to be part of it if I can. I'm ambivalent about it but I don't want to be left in the dust" (A13). At the very least we need to talk and think about these issues. For higher education only stands to lose if we cannot begin to see ourselves as communities with responsibilities for one another's welfare.

CN

See *merit pay.*

T

Teaching (ˈtēchiŋ) One of the first things a college teacher learns is that there is an astonishing level of collective wisdom and knowledge in a class of thirty students. It may not often be factual knowledge, or at least not factual knowledge about a wide range of historical topics, since that is not what our culture values much, but it is judgment and insight of a high order. There are always some individual students of exceptional intelligence, people whose stunningly original perceptions illuminate and haunt you and the class for years thereafter. In the midst of a discussion that mostly plays out the perspectives you have learned to anticipate from years of study, suddenly a student offers a fresh analysis that startles and transforms both your understanding and everyone else's. But another kind of knowledge exists that is reassuring and fulfilling in a different way: namely, the collective analysis a class is capable of offering. For these and other reasons, we might note, electronic learning can never fully substitute for the learning community a classroom creates.

This collective wisdom is apparent even in the least likely classroom. A group of freshmen in a composition class, not one of them really able to write well, few of them with a full command of the rules of English grammar, is collectively capable of a complete evaluation, critique, correction, and rewriting of any paper submitted for the course. The combined grammatical and stylistic knowledge in the room is all anyone would ever need. Of course one has to begin by reviewing basic principles of grammar and practicing collective revision and rewriting on neutral passages—that is, sentences and paragraphs without student names attached to them—but thereafter the class that pools its talents is more than ready to read more thoroughly and carefully than any instructor can. As you work through a paper in discussion, some student will correct one sentence, another will revise another; soon every imaginable

improvement will be made, alternatives will be debated, and a model of the comprehensive stylist will be presented to everyone in the room.

A comparable collective wisdom applies to interpretive tasks as well. What any given undergraduate can write about a social practice, an historical event, a symphony, a philosophical essay, or a poem will always be limited. Yet the total interpretive wisdom revealed in a classroom discussion can be genuinely impressive. What's more, it embodies multiple vantage points that no instructor can represent alone. Discussion also involves peer correction of errors and refinement of unpersuasive theories, processes often far superior to the imposition of the instructor's expertise. The benefits of this kind of learning are considerable. Students get to participate in the social negotiation of understanding and wisdom; they get to see what sort of complex insights they can aspire to. They learn in ways they cannot learn on their own. E-mail discussion groups can replicate much of this give-and-take, but they are not always ideal for focused discussion of a single text or issue, which can benefit not only from the intensity produced by time constraints (the fifty-minute-hour effect shared by psychotherapy) but also from the guidance of an instructor.

There are, to be sure, many other pleasures involved in teaching, including the universal one of witnessing young people experiencing the shock and delight of intellectual recognition. But there are specific sorts of cultural work accomplished in classrooms that cannot easily be accomplished elsewhere. Young people thereby learn the complex relationship and difference between individual and collaborative work or reflection, between individual intelligence and group knowledge. In the classroom they may also see more clearly the constraints imposed by prejudice and group coercion. These lessons are maximized when people talk face to face.

Class discussions are not, however, the only kind of education universities should offer. Small groups in face-to-face interaction are one of the great benefits of residential instruction, but well-organized courses presented by dynamic lecturers are equally important. Students in a good lecture course get to see how a learned faculty member presents coherent perspectives at length, how one mind organizes a subject area. They also receive a model of the committed intellectual life, perhaps of passionate reason at work. Obviously, some of the same benefits can be had from books, but the firsthand experience of a faculty member disseminating knowledge, working through arguments and ideas, and actually performing intellectual commitment over time is distinctive and partly irreplaceable. If students are to see themselves as potential intellectu-

als—or even as thoughtful citizens—they need to take a certain number of first-rate lecture courses; sometimes even one such course, which displays the fruits of individual research and synthesis, can inspire a student to choose a similar career.

Not all faculty members can perform both these roles equally well, let alone all the other kinds and levels of teaching necessary in a college or university. The teacher who is good with a small group of first-year undergraduates may not be ideal for graduate students. Not everyone is adept both at giving large lectures and at teaching seminars. Skill in intimacy with a small group does not always translate into practiced charisma before a thousand students in a lecture hall. Successful teaching is often niche teaching. One of the purposes of the probationary period before tenure is to give a faculty member a chance to find his or her niche. Even a teacher who is talented at more than one kind of teaching may not be talented at all of them. If a faculty member cannot find a niche and be successful there, that is a reason to deny tenure. But teaching encompasses a variety of skills and capacities.

Teaching is also inherently a two-way street. In the best of circumstances, learning goes both ways. It is both a service and a privilege. In what other way of life can you assign a group of people certain books and essays, theories or research problems, week after week, year after year, and assume they will gather together to talk with you about them? Perhaps no other occupation guarantees you the right to talk intensely with others about the texts and issues that matter most to you. It is certainly far more difficult to get colleagues to read the same novel or philosophic essay and sit down to discuss it. If responsibilities come with that opportunity, so too do some of the great pleasures of the American workplace.

Yet college and university teaching is under severe stress now, and real doubt exists about whether it will retain any dignity as a career. The commitment that many make to this vocation resembles religious devotion; increasingly, being a college teacher literally entails taking a vow of poverty. The gradual shift from full-time to part-time faculty, a steady national trend, now means that about half of our college teachers are part-timers; another 15 percent are graduate students. These people are almost always drastically underpaid. Frequently their annual salaries are $10,000–$15,000, usually without paid health care or retirement benefits. Like migrant workers of the academy, many cobble together a livelihood of sorts by teaching courses at several area colleges. They have little time to keep up with their fields, little time to prepare new material, little time for office hours.

The one relatively burdensome task college teachers do is grade student papers. Freshman papers in particular are often not well written and over time the pleasures involved in grading them largely disappear. Because part-timers have to teach many more courses than full-time faculty, their paper grading burden becomes almost unbearable. It is common for part-timers who teach introductory composition courses—the largest single group of part-timers in the country—to grade 1,500 to 2,000 student papers each academic year. Those who find summer employment grade still more. They often end up earning less than minimum wage, and the sheer volume of student papers is numbing. Yet they have trouble meeting their most basic living expenses. Paying for rent, food, and clothing becomes a genuine challenge.

Only the extraordinary devotion people feel toward teaching explains their willingness to be so drastically exploited. The identity of a college teacher, formed during years of graduate study, is usually deeply instilled. Meanwhile, the country's need for and dependence on dedicated college teachers argue powerfully against their increasingly brutal exploitation. All the virtues of the classroom outlined above are put at risk by a teaching force that is overworked, underpaid, distracted, and exhausted. Nor will it help sustain their classroom authority when students finally realize college teaching is one of the lowest-paid occupations in the country.

Can anything be done about all this? The answer is undoubtedly yes. For the first issue is not how colleges can obtain more money but how they spend the money they already have. Full-time faculty now routinely tolerate the exploitation of their coworkers. When challenged, tenured faculty call part-timers apprentices—even, incredibly enough, at times when they already have their Ph.D.'s—or say, "They knew what they were getting into," or, finally, invoke their own powerlessness.

Yet tenured faculty who acted collectively—through their departments, their faculty senates, or their union representatives—could force their institutions to allocate resources differently. Pay less to the football coach and more to part-timers. Don't build the fancy new administration building. Use part of faculty and administrative pay raises to increase part-timer salaries. If polite protests meet with indifference, become less polite. In time, try being impolite. Hold a two-day walkout and teach-in about unfair labor practices on campus. Then proceed with other targeted work stoppages. Refuse committee assignments on principle. Go on the radio. Write letters to newspapers, parents, and legislators. If full-time faculty made campus exploitation enough of an

issue long enough, the inequities, which are now *increasing,* would begin to be addressed.

There is one difference we could all make tomorrow. We offer it as one answer, in this context, to the question posed at the end of *Uncle Tom's Cabin*: "But, what can any individual do?" Pledge to devote one session every semester—in each course you teach—to describing campus labor conditions in detail. Certainly faculty with secure jobs could make this commitment. Make sure students understand how the teaching they benefit from is financed and delivered. For a campus that makes heavy use of adjunct or part-time teachers, Barbara Wolf's twenty-eight-minute documentary film *Degrees of Shame: Part-Time Faculty, Migrant Workers of the Information Economy* (1997), available on videotape, would provide a good basis for a class discussion. Educating ourselves and others is the first step toward change. One geographer at an almost exclusively Caucasian campus in New England asks her students to analyze the racial differences in campus labor. During the day her building is filled with the white faces of students and faculty. When the sun goes down, the space is occupied by people of color on the cleaning and janitorial staffs. Of course, admitting to your students that you earn $10,000 or $15,000 a year as a part-timer will be difficult and embarrassing, but the present system is partly underwritten by ignorance. It must be dismantled.

CN

See *distance learning, faculty, mentoring.*

Teaching versus Research (ˈtēchiŋ ˈvərsəs ˈrēˌsərch) We have separate entries on both teaching and research, and we talk about the relationship between the two elsewhere as well. But we felt this perennial topic, sticking point, controversy, and basis for opportunistic moral panic deserved its own independent commentary. One of the standard slanders against higher education mounted in the press is that colleges and universities are abandoning teaching for research. This claim not only ignores the synergistic relationship between the two activities, the many ways that teaching and research support and benefit each other, but also dishonestly turns a segment of higher education into a representative of the whole industry. So let's state this as clearly as possible: *fewer than 10 percent of the 3,500 colleges and universities in the United States devote major institutional time or resources to research.*

Despite their small number, however, large research universities do

educate a significant number of undergraduates, so their view of their mission is important. A 1998 report from the Carnegie Foundation for the Advancement of Teaching, "Reinventing Undergraduate Education," faults universities for giving undergraduates short shrift. But it is unwise to generalize about undergraduate education at research universities, because the instructional culture varies so much from department to department. Departments serving large numbers of students in small classes—typically including English, history, and Spanish—tend to be deeply devoted to their undergraduates. Departments chasing after grants and contracts are often another matter; they may well minimize student/faculty contact. Changing the culture in those departments will be difficult, but it will not help to defame whole institutions.

It is true that teaching loads at many of our top research universities—there are fewer than 100 across the country—have declined since the 1960s. That change was overdue. Disciplines cannot advance without at least these few schools devoting significant faculty time to research. But the single funded mission of the overwhelming majority of American colleges and universities is teaching. Other schools give research lip service, but they usually do not give their faculty time to do much if any. At many small schools with heavy teaching loads, research simply means going to a conference now and then or maintaining a lifelong "project" that never actually gets done. Those faculty who do maintain real research commitments do so on weekends, on vacations, on sabbaticals, and during the summer. Schools with high teaching loads that lack reliable and regular sabbatical programs limit research possibilities still further.

So why attack the few institutions that support the work necessary to advance our knowledge across the disciplines? There are many reasons. Conservative commentators feel humanities research is too progressive, so they are willing to crush all of it in order to stop the part they don't like. Short-sighted businessmen get impatient with long-term basic research; they want new products with increased profits and nothing more. Faculty unionization advocates sometimes disparage research to win allegiance from victims of merit salary systems or from faculty at lower-tier schools who resent research universities. Politicians and reporters engage in research bashing in order to trade on historic and continuing populist anti-intellectualism. Moral panics about researchers abandoning their students garner votes for politicians and sell newspapers.

Our favorite moral panic was the *Chicago Tribune* series by Ron Grossman and his colleagues, which broke the "scandal" that a named professor at the University of Illinois was not required to teach undergradu-

ates. The faculty member in question was merely the inventor of nuclear magnetic resonance imaging (MRI), a breakthrough medical diagnostic technology. The *New York Times* picked up the news in William Honan's own research-bashing story a year later, though it admitted the professor did sometimes teach undergraduates anyway. How many lives did this faculty member have to save with his research before he could count on being left alone by the press? As Michael Bérubé and Cary Nelson pointed out a few years ago, the other example the *Tribune* cited as evidence of a national trend is the tragic story of a University of Chicago undergraduate who couldn't find Saul Bellow in his office. Neither the undergraduate nor the *Times* paused to reflect that emeritus faculty members over 75 years of age are not expected to hold office hours.

Meanwhile, college teachers *everywhere* pass on to their students the results of the research done at a much smaller number of schools. Those researchers themselves pass their discoveries on to their own students, albeit to fewer students than they would teach if their research time was canceled. If we destroy this very delicate system, all of American higher education will suffer.

The Teamsters Union (thə ˈtēmztə(r)z ˈyünyən) I have two reasons for including this entry, one practical and one personal. The practical one first. It amounts to a piece of key advice about the strategic withdrawal of adjunct, graduate student, or faculty labor. The other term for this activity is a strike. Mainly, no one much gives a damn whether you teach the Milton course. Everyone in the academy suspects this is true, and unfortunately for the most part it is. A strike may be the only way to bring a recalcitrant administration to the bargaining table, but a strike that merely forces class cancellations will probably not work. Moreover, many teachers prefer simply to move their classes off campus, so it may be impossible to cancel a majority of classes in any case.

So what does work? In my *Manifesto of a Tenured Radical* I give some examples of how a unified community in a college town can place substantial economic pressure on businesses and regional utilities during a strike, so I won't repeat that scenario here. But there is another critical component of many successful campus labor actions: cooperation from the Teamsters Union. A teamster picket at campus entrances will prevent most deliveries. Since stockpiling of many critical supplies is limited— increasingly so in an economy that saves money on inventory and storage

costs by scheduling frequent deliveries—the campus will rapidly run out of many necessary disposable commodities. More about this later.

In the 1970 graduate assistant strike at the University of Wisconsin, Teamster cooperation brought the administration to the bargaining table with serious concessions in three days. Among the constituencies putting relentless pressure on the administration were scientists and psychologists with animals to feed in their labs. Without steady deliveries of rat chow their experimental subjects were headed for the Dumpster and their research would be set back months or years. Ten years later graduate employees struck again without full Teamster support, and the strike failed. Such support of course cannot simply be requested at the last minute. It grows out of extended collaboration and mutual understanding. In the summer of 1997 graduate employee union activists here and there across the country headed to the local UPS offices to support the striking Teamster workers. They were doing so out of a social and political commitment, not in search of a quid pro quo, but practical benefits do flow from such histories.

My other reason for writing this entry is to tell a personal story. Its lessons are more quixotic. It may deserve its own sub-heading. Let's call it

Union Daze

It was the summer of 1971, and I was a twenty-five-year-old assistant professor barely about to begin my second year at the University of Illinois at Urbana-Champaign. Whether I was more fearless or foolish at the time I cannot say. Perhaps, barely past late adolescence, I felt I was invulnerable and would live forever. Certainly I felt confident of winning tenure. My first book was in press, something none of my cohort of recent hires could say, and I imagined tenure was a fair and rational, not political, process. Nearly three decades later I can confirm that most tenure decisions are actually made fairly and professionally. But not always. So I would not advise an assistant professor to do what I did. Yet I did survive, despite being turned down twice for tenure and receiving an "official letter of censure for insubordination" from my department head. Insubordinate I was indeed.

That year the faculty had finally lost its collective temper about the lack of state support for higher education and the series of pathetic raises it had received. "I resent two percent" was proudly stamped on buttons widely visible on tweed jackets across campus. Unheard of at many research universities, a serious union drive was under way, with repre-

sentatives of the AAUP, AFT, AFSCME, and the NEA on campus. Exactly how it happened I no longer remember, but word came down that one other union was interested in speaking to the faculty: the Teamsters.

The news reached me in the person of two of my English department colleagues, one a senior faculty member in my field and the other a burly graduate student with long experience on the New York docks. Both were accustomed to having their way, and I was fond of them in any case, but they were not especially coercive. What was startling was the news: the Teamsters were willing not only to represent the faculty but also to represent one large department. What's more, they felt no need to go through the administration. They were willing to bargain directly with the state legislature on behalf of a major department.

By now, decades later, a strategy like this would be impossible. Laws in place in many states specify how a faculty can seek and obtain union representation. But procedures were less well established in the 1970s. Meanwhile, the Teamsters had some experience on campuses. Here at the University of Illinois they represented truck drivers; at the University of Wisconsin's Whitewater campus they bargained for the faculty. They were interested, so I learned, in improving their image, evidently a long-term project, and thought representing faculty members was one way to do it. The regional office in St. Louis had worked out this departmental strategy in consultation with national organizers and with the Champaign-Urbana area local. Would I at least talk with them, my friends asked? They thought I could be an effective spokesperson. They also thought I was the only one who might do it.

With ninety-nine faculty members (now, twenty-some years later, it has barely fifty), English was the largest department in the humanities. Representing English would clearly have the most credibility and impact. I thought the idea had great publicity value but couldn't come to anything beyond that. My department colleagues were not about to sign up with the Teamsters. There was, however, one good reason to make the Teamsters visible on campus, or so I felt at the time.

Faculty members are a constitutionally cautious and conservative breed. They almost never take a revolutionary step. At a research university, even the AAUP, just making its first hesitant moves toward union activism at the time, appeared to be a radical option. I reasoned that the faculty would never accept any bargaining agent unless it seemed a sensible, prudent, middle-of-the-road option. With the NEA and the AAUP positioned as radical alternatives to the status quo, rather than as midrange choices among a series of options, unionization was going

nowhere. I felt the faculty needed a union to occupy the extreme radical end of the spectrum, an alternative they could reject in moving toward more modest change. The Teamsters fit the bill.

With that analysis in mind, I had my first meeting with local Teamster officials. There were lots of questions to ask and points to make, but two were uppermost in my mind. First, I would not be an official Teamster agent but rather only explain their offer to the faculty. Second, I wanted to write a statement of principles for the local president to sign. It would guarantee, among other things, that the faculty would define its own union structure and could retain a merit-based salary system if it chose. In the end, the statement I wrote was issued as a letter to the faculty over the local Teamster union president's signature.

Now, I asked, how do you expect to represent the English Department faculty? What can you do for them? The Teamsters were not hesitant in responding. "What've the faculty been getting in raises? One percent? Two percent? We'll get the English Department fifteen or twenty percent. That'll wake those professors up, don't you think?" I readily agreed it would. But, I asked, how can you possibly succeed? Now there was a pause. "Well," said the head of the local, "for example, you know that representative Joe Pekone from Peoria, he always votes against the university's budget?" He looked at me for recognition, and I nodded. I've long since forgotten which of our distinguished state politicians he named, so I've invented a name in the preceding quote, but I still remember what a barnyard the legislature was at the time. Then the punch line came: "We own the sonofabitch!"

Representing standard faculty uneasiness, I asked what would happen if we had to strike. Would the Teamsters support a strike by one department? And how could we win? Yes, the local president answered, they'd support a strike. "With one of our boys at every entrance no trucks will get through. There'll be no food for the kiddies to eat, no gas for those administrators to put in their fancy cars, and no toilet paper for them to wipe their asses with. The strike will last three days." Once again, I was at least partly persuaded.

Beyond that, our procedures were simple enough. Once the letter was written, I set about getting my colleagues to sign Teamster pledge cards. As is typical, they could sign other union's cards as well. The Teamsters wanted fifty-one from the English Department. I would report regularly, and they would answer questions and give advice as necessary. The organizer from Whitewater would come down and spend a couple of days on campus with me shortly.

From time to time the local union officials and I did meet, always in the same way. If I wanted a meeting, I'd call and let them know. In a day or two I'd get a return call. They always took the same form. No introduction, no identification, no small talk. "Holiday Inn. 2 P.M. Be there." A place, a time, and a command. It had a certain charm. So did showing up at the assigned location, for there was never anyone else there. The Holiday Inn restaurant would be guarded (is that the right word?) by two or three union employees at the door and corners of the building. When I entered, there was only one occupied table.

At our first meeting my graduate student Svengali came along, but I did not quite realize how essential he was to the whole business. At the next meeting I was alone and more nervous. My sentences as a result became more complex, with embedded clauses and obscure diction. It gradually became clear the Teamsters had absolutely no idea what I was talking about. Meanwhile I was too often at a loss to figure out what they meant as well. So thereafter Harry the former dock worker and fisherman, now occasional student of modern literature, came along. He was our translator, an early transit point for that more recently heralded rapprochement between labor and academia. I would say whatever I felt needed saying and he would follow with "What Cary's saying is . . ." The Teamsters in turn would speak their natural language, and Harry would translate for me. It worked, though it did not build confidence in any of us.

A large public meeting on faculty unionization was scheduled in October at the university's Lincoln Hall, though no one was sure the faculty was ready for emancipation. About a thousand faculty attended, and all the prospective unions had their representatives on stage save one. Since I was not actually a Teamster, I stipulated I would remain in the audience until it was my turn to speak. As it turned out, coming up from the audience was more dramatic anyway. For a few minutes it seemed the Teamsters carried the day. Or so the local newspapers claimed the next day. "The starting pay for a truck driver on this campus," the *Courier* reported me saying, "is $15,000. Many full professors don't make nearly that much. But we'd like to see some come close."

Meanwhile the card drive continued. I went after the easy ones first, to build numbers and momentum. Then the tough nuts had to be cracked. More faculty members than I would have imagined were willing to sign up. Conversations were detailed and often it took several interactions before someone would step over the line. But the numbers grew. After a few months an astonishing forty-nine English Department faculty

members had signed Teamster pledge cards. I needed two more before the union would head to Springfield, Illinois, on our behalf. I tried every argument I knew, and weeks went by. I still remember my final attempt with one resistant colleague. "You've answered every question I've asked," he allowed, "and satisfied every one of my concerns. But what about the questions I haven't thought to ask?" I suggested that was a metaphysical question and gave up on him.

The drive stalled at forty-nine. The first cards were signed in July 1971, the last ones in November. In time I consoled myself with several arguments. If I had managed to get the other two cards signed and the Teamsters *had* gotten a separate bill passed to pay English Department salaries, I might never have extricated myself from my new identity. Certainly widespread national publicity was a real possibility. A Chicago paper had already picked up the story. "Are the eggheads and the hard hats getting ready to bridge one of the major gaps that has split this country apart in recent years?" the October 1971 article began. "Nelson, whose hair hangs down to his shoulders and whose beard droops below his chest," the reporter continued, "has no patience for professors whose sense of elitism makes them wonder whether they should join forces with truck drivers." No union, let alone this one, had ever represented a single department. Would they honor their commitments? Would they really let us drop out if we chose? Would I be sleeping with the fishes in the nearby Sangamon River years later?

I went on with my life, and my career took another route, though twenty years later I would be testifying on behalf of graduate employee unionization at a hearing of the Illinois Labor Relations Board. Meanwhile I held onto those pledge cards. Some of the signers are now retired, a few were fired, and some are dead. Most were consistently cautious folks through all the years I knew them. But once in their professional life they did something that took courage. They signed that Teamsters pledge card.

CN

See *merit pay*.

Tenure (ˈtenyə(r))

Tenure is the expectation that a faculty member who has been through a probationary period and has passed a tenure review will remain employed until retirement, voluntary separation, or removal for cause. Tenure guarantees continuity of employment but not necessarily assignment of the same duties. A person could thus be removed as a department head but remain a classroom teacher; a person might be

reassigned to another department or division or in extreme cases removed from teaching and assigned lower-level administrative tasks.

These are the more familiar and contractual guarantees tenure offers; they began to become more common after the AAUP was founded in 1915. In institutional terms, however, they are not tenure's most important feature: *tenure is the form of job security for faculty members that protects their academic freedom and anchors the intellectual integrity and independence of the institution as a whole.* As William Plater puts it, "the tenured faculty literally *are* the university because they are the community of the university—the members responsible for its standards, its integrity, and its mission. . . . Tenure is thus the formal basis for our definitions of citizenship within the academic community" (693). "Tenured faculty," he adds, "are representative of both the entire academic workforce and the institution itself . . . they are accountable for the work of other members of the academic community" (713).

Of course, tenured faculty, as we point out elsewhere, are a dwindling portion of the higher education workforce. Despite his eloquent defense of the centrality of tenure, then, Plater believes it cannot be sustained for long unless tenured faculty redefine their responsibilities; hence the notion of accountability in the quotation above. In the increasingly corporatized university, Plater believes, a small core of tenured faculty will oversee both business contracts and the contract employees who do research or teach undergraduates. That system is already in place at some colleges where many introductory courses are taught by part-timers. In the telling phrase James Sledd uses to describe employee relations in rhetoric programs, the supervisory faculty become "comp bosses." The field hands do the actual teaching.

As all observers of this scene are aware, the untenurable field hands have already had their academic freedom curtailed. For Plater, the tenured faculty must now accept the ambiguous role of simultaneously constraining and preserving the limited academic freedom of lower-grade employees. In that scenario, the tenured faculty are at once agents of repression and guarantors of freedom. Tenure must thus no longer be merely a confirmation of past performance and achievement. Accepting tenure must entail accepting several roles for the rest of your career: staff supervisor, corporate facilitator, employee monitor. You must thus pledge allegiance to all present and future forms of corporatization and agree to be an entrepreneurial ally of the administration. In the university of the future the tenured faculty will be both the prison guards in the Panopticon University and the cheerleaders of the Business College. The

alternative, for Plater, is to see tenure die out with the dwindling generation that now holds it.

He may very well be correct, though we prefer to resist rather than accede to that future. Our own way of preserving tenure—a project that must be undertaken if academic freedom is to be preserved—is thus rather different: first, we must reeducate the university community itself about the role tenure plays in higher education. Then we must steadily improve the quality of the tenured faculty. It needs to be clear to all that tenured faculty are an essential resource higher education could possess in no other way. A public campaign about the need for full-time teachers should be ongoing. Finally, faculty need to seek contracts that limit the numbers of part-timers and adjuncts their institution can hire.

The formal system we have now does not need revision. Tenure is generally decided during the sixth year of a probationary period, though that final review may be preceded by preliminary evaluations as often as once every year until then. Tenure reviews at many schools were less than rigorous during the 1960s and early 1970s, and that has left a dwindling number of less effective faculty in some departments. Most of that group has now retired; the remaining members will be gone within a few years.

As Fritz Machlup pointed out many years ago, tenure does indeed inconvenience an institution when one of its departments has been "tenured in" at a lower than desired level of quality—since the institution may not be able to afford additional hires in that area and since the existing faculty may be incapable of making good appointments—but that limited inconvenience does not justify doing away with the fundamental guarantee of academic freedom. Moreover, there is reason to believe that the existence of tenure helps focus people on the necessity of making appointments carefully. A strict up-or-out system, one that fires people who have not fully proven their teaching or research capabilities during the probationary period, does occasionally overlook late bloomers, but that is finally a price we must pay for tenure's benefits.

The more thorough tenure reviews put in place at many schools in the 1970s included classroom visits by tenured faculty to review probationary faculty members' teaching, required course evaluations by students, and more careful scrutiny of outside evaluators from other schools. Many schools have also implemented increased publication requirements.

Increasing publications at research universities was entirely appropriate, since those faculty members generally have lower teaching loads to free some time for independent scholarship. The percentage of American

universities that actually reduce teaching loads to facilitate faculty research, however, is minute, less than 10 percent of the total number of colleges and universities in the country. Most American higher education is devoted exclusively to teaching and service, and the quality of teaching and service at the overwhelming majority of schools is the only real criterion for tenure. People who claim otherwise are grossly misrepresenting the case.

Some schools with high teaching loads have introduced what are essentially symbolic research expectations, namely that faculty give an occasional conference paper or perhaps publish a couple of chapters from their dissertation in scholarly journals. These requirements are easily met during the summer. A basic rule of fairness in setting tenure requirements is that major scholarly achievements—publishing a book for a humanist or maintaining a grant-funded laboratory research program for a scientist—require time. It is unethical for universities to add such requirements to their tenure expectations without giving faculty the means to accomplish them.

Unfortunately, a small number of schools have done just that—introduce research university publication expectations without building appropriate support into the probationary program. The only ways faculty in such institutions can meet the requirements for tenure are to win a research fellowship or take unpaid leave. Some research universities have also raised the publication bar too high. Requiring two completed books of a humanities faculty member undercuts the commitment to teaching unless the faculty member already has one completed book on arrival. In a time of decreasing opportunities for book publication in some fields, it is also rather malicious to insist on publication at one of the five or six most distinguished presses. Faculty and administrators have always preferred the lazy route of judging a book by the prestige of its publisher rather than by the more responsible method of reading it, a means of assessment that is increasingly unfair. Indeed, as we want to argue, introducing more stringent requirements for tenure is not the best way to improve the quality of the faculty.

That is not to say there is no problem with tenure. Some departments are routinely unable to make fair and professional decisions and have virtually all their recommendations overturned at the next level of review. There are departments whose recommendations both to grant tenure and to deny it are reversed in case after case. Such departments may well need to be prevented from hiring anyone until they can reestablish sane and professional procedures. There are also capricious and biased deans

and presidents who wield their power unfairly and out of fixed intellectual prejudices. Job candidates need to be warned of a department's track record in awarding tenure. In a few cases, of course, an entire institution makes it nearly impossible for its own junior faculty to win tenure; Harvard and Yale are the prime examples here.

Finally, although no one wants to admit it in academia, there is a more general problem with tenure. In many departments there are several thoroughly dysfunctional people hired years ago, faculty who repeatedly skip classes or otherwise fail their most basic responsibilities. Much more common still are enervated faculty who lack intellectual vitality or have long since stopped being up to date in their fields. Faculty members who haven't read current scholarship in decades are legion. What is to be done?

Those asking the question most urgently include graduate students and new Ph.D.'s who cannot find jobs. There are large numbers of underemployed Ph.D.'s—earning $10,000–$14,000 a year or less—who have more work published or accepted for publication than some tenured faculty at research universities will ever complete in their entire lives. No wonder tenure seems to many of them an injustice. There are tenured faculty at research universities who earn four to five times as much and teach less than half as much as their more accomplished potential competitors in the ranks of part-timers. Some of these less productive tenured faculty might well be assigned another couple of courses.

Legislators and journalists from time to time argue instead that the abolition of tenure is the only solution. As Plater writes, "most public commentators prefer that current faculty teach more, and a peevish few would also abolish tenure to level the playing field" (689). Some unemployed or underemployed Ph.D.'s echo their complaints, though we believe their resentment is misplaced. For we have no doubt the abolition of tenure would be disastrous. Tenured faculty have the protection they need to speak frankly and controversially. Along with campus unions, they can offer an effective counterbalance to administrative power. Could we have written this book if we were worried about losing our jobs? Tenured faculty also have the time, expertise, and institutional loyalty necessary for curriculum development, recruitment, and long-term planning. The gradual whittling away of tenure that is now under way, as tenure-track faculty are replaced with exploited part-timers, is already undermining the quality of many departments. It will also erode the ability of faculty to criticize—or even question—administrative decisions that place profit ahead of learning. However little academic freedom part-timers have,

they would possess none at all without the presence of tenured faculty on their own or other campuses across the country.

Only the security of tenure allows the faculty to maintain a degree of control over its duties and intellectual independence in teaching and research. As the corporate mentality penetrates further into higher education, administrators will assume they should assign and control all faculty work. Academic freedom and tenure together provide a measure of self-determination unique in the American workplace. Thus the price we would pay for destroying the system to eliminate the small percentage of incompetent tenured faculty would be considerable.

On the face of it the problem seems insoluble. On the one hand we have faculty incompetence or marginality; on the other, an untenured faculty with no force, influence, authority, or protection for intellectual freedom. Better to tenure some marginal people, some might argue, than give the faculty even less underpinning for personal courage than they have now.

Most of us in higher education recognize that real dysfunctionality can often be handled. Tenured faculty are sometimes fired and quite often persuaded to take early retirement when they are seriously dysfunctional. Critics of tenure often say that the very small number of tenured faculty who are fired every year proves that the system doesn't work. But at many schools the formal process to remove tenure proves unnecessary. Many people who are failing at their jobs either improve their performance when warned or in time realize that they should step down. A perceptive department head who begins a careful conversation about performance can usually resolve the problem in a year or two. The number of faculty members who choose to resign in this way is considerable.

The second group, who do their jobs but do them poorly, is more intractable. Often they represent tenure decisions that should have gone the other way. People recognized there were weaknesses in the case, but collegiality, friendship, or self-deception carried the day and they were granted tenure. Over the last several decades many institutions have toughened tenure procedures as a result, and that has certainly helped. But firing people is painful; you have worked with them for over half a decade. In our collective fifty-plus years of professional experience, we have helped deny faculty members tenure numerous times and never once regretted it professionally, but the actions still haunt us personally. Worst of all, we know there was an alternative.

The alternative? Do not hire marginal or second-rate faculty in the first place. Make certain that the candidate's inclinations and abilities meet the research and teaching expectations of the institution. That is, we believe,

the solution to the tenure problem. The best tenure decisions are made by hiring committees. If you hire a brilliant and energetic recent Ph.D., you will rarely go wrong. Five or six years later, the tenure decision is often no decision at all; it is a celebration. Most of our undesirable tenured faculty should not have been hired in the first place.

Obviously, new faculty can fail to fulfill their promise. They can have nervous breakdowns; they can become ill. Life is hardly predictable. But we are convinced that these problems are very rare. If you hire someone who has a vital intellectual life, a dynamic classroom personality, and a doctoral dissertation that is already a rich and accomplished piece of work, that person will almost always be a valued colleague twenty years later if he or she chooses to stay. The eagerness to stay can never be guaranteed—faculty members can lose their ardor for a place for many reasons—but the hiring process does suggest whether a person *wants* to join a department.

No one wants to admit it: the main problem with tenure is incompetent hiring. The solution to the tenure problem is to admit this uncomfortable fact and do what has to be done to insure that only first-rate faculty are hired.

We have regularly seen honest, well-meaning colleagues go through a pile of job applications and identify some of the weakest candidates as first choices for interviews. These faculty members are generally not sufficiently familiar with current research to distinguish good work from bad. They mean well, but they have no place on a hiring committee. The best doctoral research is most often done at the leading edges of a field. You have to be reading or working there yourself to judge those candidates accurately. People alienated from the intellectual life of a discipline cannot help a search, which is one reason administrators aren't very good at making faculty hiring decisions.

A search committee also can be made dysfunctional by administrative determination to place representatives of all department constituencies on it. The best such committees can hope for is often the compromise candidate who is reasonably compatible with the differing political and intellectual commitments of the members.

We have also seen insecure colleagues try to hire people who will not threaten them intellectually. The most intellectually vital people usually try to hire their peers. Second-rate faculty often try to hire third-rate colleagues. People who willfully seek to hire beneath themselves have no place on a hiring committee.

But of course almost all faculty members want a chance to hire new

colleagues. Almost everyone believes he or she should take a turn at this task. Some consider it a kind of inherent right and privilege of tenure. It is time we admit the truth and educate one another accordingly: hiring new faculty is a very specialized task. It may well be the case that only a minority of the faculty are up to the job. Indeed, certain dysfunctional subspecializations in a department may be incapable of hiring even in their own area.

We recognize that only certain people could make good department heads, that not everyone would do a good job as an undergraduate advisor. We accept the fact that many other jobs in higher education and elsewhere require specific talents, skills, abilities, and qualifications. But the myth persists that anyone can hire a new colleague.

Yet, as we mentioned earlier, we have all seen democratic procedures produce compromise candidates who are not the best choices available. In large departments that vote on new appointments, many faculty do so without reading candidates' work and without any broad knowledge of the field of applicants. They form a quick impression during a campus visit and become irreversibly wedded to it. Some departments that hire by democratic consensus are never able to hire the best candidates. Year after year they settle for the presentable, unexciting choice that leaves everyone comfortable; intellectual work with a critical edge inevitably unsettles someone. Still worse, however, are hires decided by committees composed of people not qualified to do the work. The best hiring is done by small committees of knowledgeable people who work very hard, read widely in candidates' scholarship, interview aggressively, and debate candidates' merits among themselves intensively. Not everyone can or will put in the time necessary to do the job well. The person who spends long hours creating a course schedule or advising students may not be equipped or eager to spend long hours reading thousands of pages of writing samples and dossiers. Unfortunately, democratic hiring practices can suggest that opinions about candidates are easy to form and the decisions easy to make. That impression needs to be corrected.

Yet assembling select hiring committees is not always a popular way to hire. Some people will feel excluded from the process. And the process is obviously subject to abuse, most often when incompetent or malicious administrators appoint mediocre or lazy hiring committees. But both public confidence in higher education and our own commitment to quality require that we do this critical job as well as possible.

Convincing people that hiring has to be done by small groups of highly

qualified people can be difficult. Simply imposing it on a department can be divisive and fuel people's sense of resentment. The only long-term option is to discuss the problem openly and build both self-recognition and consensus on the issue. There are many things best done democratically, but hiring is not one of them. We realize that our resistance to democratic hiring may seem antithetical to the largely democratic politics of our other entries, so we emphasize this key qualification to what may seem an elitist argument: people do need to come to a democratic consensus about how hiring should be done. One of the reasons we included this essay in the book is to give people a document they can use to initiate such a discussion.

A department cannot sustain collegiality over hiring, however, unless the other kinds of services people perform are consistently valued and recognized. Each faculty member should be encouraged to recognize that he or she is doing the work they are most qualified to do. In that atmosphere an honest discussion about hiring practices has at least some chance of success.

It is also possible to take collective pride in the work of a small committee and certainly possible to take pride in its long-term results— increasing the quality and intellectual vitality of the department. Administrators will also eventually reward departments that consistently do outstanding hiring. And a history of outstanding hiring is the best way to guarantee administrative support for future appointments.

Tenure, then, is not broken and does not need fixing. In far too many departments across the country, however, faculty hiring *is* defective. In the current market, with so many excellent new Ph.D.'s available, it is particularly outrageous to settle for second best and so unnecessary. The solution to the problem of tenure is to hire first-rate people in the first place.

CN

See *America's fast-food discipline, academic freedom, faculty, part-time faculty.*

Tuition (t(y)ü'ishən) Tuition is too high, everyone knows that, right? As the entry on *debt* in this book shows, students, particularly graduate and professional students, are falling into a pit of loan payments so deep that some will never be able to climb out. Many critics of higher education, concerned by rising tuition costs, have at times resorted to the invention of cute phrases and analogies to portray the problem. In a par-

ticularly strident essay in *Time* magazine, "Why Colleges Cost Too Much," Erik Larson describes what has been called the "Chivas Regal effect": an ethos in the 1980s that "evolved among university officials—and parents—that equated price with quality" (49). If the cost of an Ivy League education was soaring past $20,000 and then $30,000 per year, then lesser schools ought to keep pace by raising their tuition rates as well. That's the "Chivas Regal effect" at work. Tuition at the University of Pennsylvania, the institution more or less vilified in *Time*'s essay, went from $3,790 in 1976 to $21,130 in 1997. The total cost of a year at Penn? $31,582, according to *Time,* though other estimates like that provided by *The Princeton Review: The Best 311 Colleges, 1998 edition* (1997) differ by as much as 10 percent (the *Princeton Review* calculates tuition at Penn to be some $2,200 less than the figure *Time* gives).

But how widespread a problem are $20,000-plus tuitions? How common is it for projections of the costs of attending a particular institution to vary by as much as 10 percent? The discourse on tuition costs, on how much they have risen and why, and on what it all means to the future of higher education is often confusing, contradictory, and misleading. Less excitable than Larson and attempting to offer a context for the prevailing mythos that soon every student will be paying $1,000/week to attend college, Louis Menand in a 1997 essay published in the *New York Times* observed that out of some 2,215 four-year colleges and universities in America, only 36 charge $20,000 or more in annual tuition and fees. And, he added, more than one-quarter of these 2,215 schools are public institutions that charge on average $2,860/year ("Everybody Else's College Education" 48). Over five million students who attend community colleges pay less than half of this amount. Of course, as Larson pointed out in *Time*, if the University of Pennsylvania with its $2 billion endowment wanted to help its students meet their financial obligations— or Harvard with its now $11 billion endowment, two billion more than when Larson wrote his essay, was moved to a similar act of generosity— with just a 1 percent expenditure of its vast reserves it could reduce tuitions considerably. With a 2 percent expenditure of its endowment, Harvard could cut tuition in half (Larson 54).

Data in the 1998 edition of *The Princeton Review: The Best 311 Colleges* suggest a more temperate view than that offered in Larson's jeremiad. At the same time, though, the economic picture is more severe than Menand implies, especially insofar as the costs of attending an elite private college or university are concerned. Contrary to Menand's contention that in 1997 tuition and fees reached $20,000 or more at only thirty-six schools,

the *Princeton Review* estimates that nearly seventy institutions charged this amount. Tuition at some eighty-seven more exceeded $15,000/year (almost half of which in 1997 were actually over $18,000). One should assume, therefore, that by the new millennium, tuitions and fees alone at well over 100 of the top-rated private colleges and universities in America (and lesser-ranked schools as well) will exceed $20,000 a year.

The picture at public institutions, however, as nearly everyone recognizes, is far different, giving the lie to the exaggeration, even hysteria, inherent in many discussions of rising college costs. The majority of college students pay nothing close to the highest figures listed in the *Princeton Review*: $29,340 (Middlebury), $29,190 (Colby), $28,000 (Bates), $25,800 (Bennington), and so on. In fact, the tuitions of over fifty of the public institutions listed in the *Princeton Review* are less than $3,500/year for in-state residents: Texas A&M ($1,020), the University of Florida ($1,882), the University of North Carolina–Chapel Hill ($2,150), and many schools in the Big Ten (Iowa, Indiana, Illinois, Wisconsin). So, for example, a student who wants to live in Amherst, Massachusetts, can pay $2,004 to attend the University of Massachusetts–Amherst, $21,640 at Amherst College, or $23,485 at Hampshire.

While tuitions are obviously much higher today than they were a generation ago, the ratio between the costs of private and public school educations, calculated at in-state rates, has remained pretty much the same. The late 1960s were that "cheap college time" when the average tuition and fees at private schools in America was about $2,000 a year (Lipsky and Abrams 111); and, remarkably, those at many public schools for an in-state resident were about one-tenth of that. One of the authors of this book, a freshman in 1969, would have paid a little over $200/year to attend the flagship institution in his state (had he been as shrewd as his twin brother, that is, and not attended a public school out of state). In complaining about skyrocketing tuition at private institutions, David Lipsky and Alexander Abrams employ what might be called the "Ford Mustang Paradigm." They explain that in 1970 the Mustang, still retaining its cool image cultivated in the turbulent sixties, retailed for about $2,721; a quarter of a century later, shorn of its chic and much more commonplace, it sold for $11,000. By the mid-'90s, a year at most Ivy League institutions soared to well over $20,000. Lipsky and Abrams are right to point to the Guaranteed Student Loan Program, begun by President Johnson in 1965, as inaugurating what now has become an accepted notion: namely, that one borrows money, in many instances lots of money, to attend college. They even insinuate a kind of causal relationship between the program and ris-

ing tuitions: once college administrators realized there was government guaranteed money out there to be had, tuitions began to climb. Perhaps—we wouldn't put it past administrators. Yet there is fairly good evidence to suggest that this acceleration in the cost of a college education, at least for many students, has slowed somewhat.

As high as the cost of four or five years at the most privileged schools in the country has soared—and as expensive as an education anywhere can be—public education in America is hardly gouging its students. This fact needs to enter discourse on exorbitant tuition costs whenever figures like $20,000 or $30,000 get thrown around. On the contrary, at many public institutions, as it was thirty years ago and as we have suggested above, the cost is scarcely one-tenth of this amount for in-state residents.

Such data still demand attention, as they received from both the National Commission on the Cost of Higher Education and the American Association of University Professors, which drafted a statement to the commission in October 1997. Providing what we regard as essential context for any deliberation on tuition costs, the AAUP statement discusses the escalating demand for and rising costs of delivering a quality undergraduate education at a time when "public-sector financial support has flattened" ("Statement" 2). Acknowledging statistics reported by the U.S. Department of Education in 1995 that show tuition as increasing by a factor of five in the past twenty years, the AAUP reminded the commission that inflation alone would have "tripled the price of tuition and fees during that time" and offered a useful table indicating the extent of this rise in costs:

Average Undergraduate Tuition and Required Fees, 1974–75 and 1994–95

	Private Institutions		Public Institutions	
	Universities	4-Year Colleges	Universities	Colleges
1974–75 (current $)	$2,614	$1,954	$599	$448
1974–75 (constant $: 1994 $)	$8,140	$6,086	$1,865	$1,395
1994–95	$14,510	$10,698	$2,982	$2,507
Inflation factor:	3X	3X	3X	3X

The AAUP statement further argued that the average cost at public four-year colleges in 1997–98 ($3,027) can be reduced by half if the

tax credit allowed by the federal Hope Scholarships is admitted into the calculation. There is nonetheless a widespread perception that tuition is higher. The American Council on Education's 1998 report "Too Little Knowledge Is a Dangerous Thing" details results of a 1997 survey that found Americans estimated in-state tuition for a four-year public college to be $9,694, over three times the actual amount.

This is not to argue that public education is dirt cheap; for most Americans, a college education is a major expense. But, unlike those families paying enough tuition to elite private colleges and universities to buy a house, most Americans are buying four years of higher education equivalent in price to that of an economy car (and we're not talking about a Ford Mustang either). Why? All but a few cynical critics of college and university faculty tend to agree that the answer is *not* because faculty are getting rich. Just the opposite is quite obviously the case when the size of the growing army of underpaid part-time faculty is compared with the piddling number of highly paid academic superstars, as so much of this book has tried to demonstrate. More important to recognize, most tenured and tenure-track faculty aren't making salaries anywhere equivalent to those of other professionals. Carol Frances, for example, argues that faculty purchasing power "declined dramatically—by close to 20 percent—in the 1970s." Increases in salary during the 1980s tended to make up some of this lost ground, which means that by the mid-1990s "faculty salaries had been restored only to levels that were reached twenty-five years earlier" (Frances 16). By contrast, as the AAUP statement argued, administrative costs at the corporate university have increased by 60 percent since 1980, while instructional costs have increased by only 39 percent. Inflation, growth in programs and physical plants, and other factors have also contributed to the rising costs for American colleges and universities. But you don't have to read such statistics and assertions to know this: just visit a university campus for a few days and talk to people. Read the campus phone book and compare it with one, say, a decade old; look at an older campus map and a more recent one. What you will learn is pretty obvious to those of us who have spent our adult lives on college and university campuses: there are more buildings and more professional-managerial types, complete with business suits and laptop computers, many of whom have never seen the inside of a classroom. Other administrators, once mediocre scholars or marginal teachers, earn salaries that have skyrocketed past those of even the most successful scholar-teachers on the same campuses.

Yet until administrations are put to the same tests of accountability increasingly applied to faculty, until their salaries are brought more in line with those of other laborers on campus, and until state and federal governments decide to slow down the construction of prisons and the hiring of prison guards—growth industries in many states during the 1990s— and begin to reinvest more substantially in public education, tuitions are likely to remain too high. But, again, they aren't $20,000 or $30,000 per year unless a family chooses to send their sons and daughters out of state or to one of a few select private schools. Although the propaganda might suggest otherwise, public education is still a pretty good bargain.

SW

Y

Yuppies (ˈyə·pēz) Yes, we have them on campus too. They've infil-
trated the faculty. The only difference is that these young professionals do
not have to be urban.

Since the 1980s, the rise of careerism and the entrepreneurial culture
in the academy has led to noticeable differences in the culture among
young faculty. Those who get tenure-track jobs at all see themselves fairly
as survivors. Moreover, their one job may be their only shot at a career. If
they lose it, they're on their way to law school, the unemployment line,
or—worst of all—the tattered adjunct army. Moreover, the academy
seems to a cold-blooded analysis to reward individual achievement and
nothing else. Every concession to community identity comes with a cost.

It sometimes seems that academic yuppies do a cost-benefit analysis
before they say hello in the hallways. Certainly gains and losses are cal-
culated before agreeing to serve on a committee, attend a meeting, or
perform any other professional service. Some such calculations are neces-
sary, to be sure, if time is not be frittered away, but some young faculty
display no institutional commitments whatsoever.

The generation of young faculty hired since the mid-'80s is effectively
the first to be born into the institutions we have created over sev-
eral decades. Some, though by no means all, arrive with a sense of per-
sonal entitlement that their predecessors can hardly recognize. The
young faculty of the 1960s and 1970s expected little and received less.
They were there to be used, not nurtured. Now for a yuppie every
service performed sometimes seems like an immense concession, despite
the fact that many departments now mentor young faculty devotedly
and guard their time and interests with some care. Colleagues reason-
ably expect some community commitment in return. Meanwhile, shame-
less requests for privileges and benefits never granted anyone have
become routine.

Not all yuppies, of course, are the same; they are individuals, not identical members of a group. Not all yuppies are yuppies twenty-four hours a day. Some are inconsistent yuppies, occasionally succumbing to humane impulses despite the better judgment of the self-interested surveillance of their own lives. There are those yuppies who consider themselves culturally and politically endorsed, who feel that their entitlement carries with it a demand for your acquiescence, and those who have naught but the ideology of Reaganism to underwrite their ambition. It is also true that some generational resentment is self-serving. Older faculty may tend too easily to discount the value of new research interests and new courses in a department. No faculty member meets the three-part model of teaching, research, and service in the same way, and most of us meet it in different ways in the course of a career. For new faculty in a large university department, teaching and research are the prime concern; service can often wait. But a small department may have different priorities.

Nonetheless, the power of naming here can identify a problem and highlight an issue. For there are two institutional difficulties with the continuing yuppification of the university. One is the further deterioration of the already fragile sense of community. The other is the blurring of the lines between full-time and part-time faculty. A full-time faculty member who tirelessly negotiates each and every responsibility, resisting as many as possible, begins to seem like a part-time contract employee, not a full member of the community. If full-time faculty do not offer something more to the institution, why hire them? Nothing wrong with hiring a yuppie to perform a task, but why bring one into the family?

The racheting up of tenure requirements in some schools is no help in making apparent yuppies full participants in department life, but that is not really a universal problem. A more serious problem is ignoring a person's social commitments in the hiring process. It is entirely possible to be a productive scholar, a successful teacher, and still define some areas of major community involvement. Certainly graduate student union activists juggle all these arenas and manage to adjust the balance often enough to satisfy all three. At the same time, some disaffected older faculty like to tell themselves that every "hyperproductive" young scholar is out for himself alone and routinely refuses any tasks that don't include personal rewards. That is just not the case. The professoriate has many ambitious scholars who are strongly devoted to the common good. Some are young and some are old. Do we have enough such people? Certainly

not. Should we hire yuppies without a heart? We'd recommend against it. Is there one question you can pose to determine whether an assistant professor is well on the way to becoming a yuppie? Yes: what does your department pay its graduate assistants or part-time faculty? "I don't know" is not a reassuring answer.

See **superstars, tenure.**

NOTES

Introduction

1. Arthur Levine, as quoted in James Traub's "The Next University." For a longer version of this passage see Levine's "How the Academic Profession Is Changing."

2. In *Generation X* Douglas Coupland defines a McJob as a "low-pay, low-prestige, low-dignity, low-benefit, no-future job in the service sector. Frequently considered a satisfying career choice by people who have never held one" (5).

3. See Cary Nelson's *Manifesto of a Tenured Radical* and his edited collection *Will Teach for Food: Academic Labor in Crisis* for additional analyses of graduate student unionization.

4. These "quotations" from the talks delivered at the annual Modern Language Association meeting are based on memory and are actually mimetic efforts to capture and satirize the core intellectual and political message and style of each speaker. These are not, therefore, direct quotations. For Guillory, also see his "Preprofessionalism: What Graduate Students Want."

5. This passage takes some satiric liberty with the titles of the Syracuse publications. The *Alternative Orange,* a print journal, is scheduled to be renamed *Red Critique* and published electronically. Cary Nelson is one of the people they have criticized.

Academic Departments

1. My information about conditions in Slavic comes from nearly three decades of conversations with its faculty and students. The department's unselective admission rates are unfortunately not unique. All across the country foreign language departments that offered prestige degrees in the 1960s and 1970s have fallen on hard times. I have confirmed admission rates of over 80 percent not only in Slavic departments but also in once proud departments of French, German, and Italian.

Academic Freedom

1. See "Academic Freedom and Tenure: Brigham Young University," *Academe* (September–October 1997): 52–68.
2. See James C. Mohr (1970), Mary O. Furner (1975), and Thomas L. Haskell (1996).
3. See William W. Van Alstyne (1990).

Affirmative Action

1. Robert Berdahl, Larry Faulkner, and William Trent took part in a panel discussion about affirmative action in admissions at the University of Illinois on 15 March 1998. We draw widely, but not exclusively, on the discussion, moderated by Michael Aiken, in what follows.

The American Association of University Professors

1. The National Council is composed of representatives elected by the membership from roughly geographical regions. Its members are unsalaried. Cary Nelson at present represents his district.

Apprentices

1. In "Preprofessionalism: What Graduate Students Want," John Guillory defines the "desires contingent on employment" that may properly be termed "professional": the "desire for security, at the least, then for interesting work, and often also for professional success, for prestige, and the rewards of prestige" (4). We apply the same standards elsewhere in this volume, in the entry on "Faculty" for example, in interrogating the conditions of the workplace for adjunct and part-time faculty.
2. In "The Production and Utilization of Science and Engineering Doctorates in the United States," William F. Massy and Charles A. Goldman assert that the "natural production rate of doctorates is driven by departmental needs for research and teaching assistants," not by the job market (1–4). As a result, employment prospects in such fields as mechanical and electrical engineering, mathematics, and economics are particularly bleak.
3. We want here to thank all the graduate students who generously provided information: Michele Glaros (Florida); Will Murphy, Ed Fox, Sheila McDermott, Jack Musselman, and Brook Remick (Indiana); Leslie Taylor (Iowa); Johanna Frank (Ohio State); Kathy Newman (Yale); Beth Tollers (Tennessee); and Chris Thinnes and Mike Miller (UCLA). We also want to thank Heather Riemer, UE Local #896-COGS, Iowa City; Nonie Watt, Indiana University Law Library; and Jeffrey Williams for their assistance; and Pat Brantlinger and Paul Strohm for their suggestions on earlier drafts of this essay.

4. In February 1996, members of the Modern Language Association received a letter coauthored by Sandra Gilbert, president, and Phyllis Franklin, executive director, outlining difficulties inherent in the drafting of Resolution 6, a censure of the administration of Yale University's treatment of GESO strikers. The letter and copies of recent resolutions were accompanied by four letters from Yale faculty and administrators, all of which aimed either to explain the conditions of employment at Yale or, in the case of letters from Linda Peterson and Ruth Bernard Yeazell, Annabel Patterson, and Margaret Homans, to refute specific language in the MLA Delegate Assembly's resolution, in part by impugning the motives and integrity of striking graduate students. We are quoting here from Homans's letter and will refer to several of the others throughout this essay.

5. See Marvin L. Goldberger et al., eds., *Research-Doctorate Programs in the United States: Continuity and Change*. Prepared for the National Research Council, this study states that the MYD (median year to degree) in Yale's Comparative Literature Department, the top-ranked department in the country, is 8.6 years. Among the top twenty departments, only Duke, Princeton, and Northwestern had lower figures in this category, and the median year to degree in some departments is much longer: Indiana (11.8 years), Minnesota (12.0), USC (12.7), and Rutgers (13.0), for example.

6. In *Nomadic Subjects* Rosi Braidotti describes a homeless, nomadic polyglot that in several respects resembles graduate students. For instance, the "polyglot as nomad in between languages . . . knows how to trust traces and to resist settling into one, sovereign vision of identity" (14). In less exotic terms, Braidotti also discusses the "migrant," a member of the "most economically disadvantaged groups," within the "new class stratification in contemporary Europe" (22). Are graduate students in America part of such a new class stratification, highly educated and unemployed, potentially rootless, and constantly on the move?

7. Here we are alluding to the title of George Lakoff and Mark Johnson's *Metaphors We Live By*.

8. "Graduate Associates," *The Ohio State University Graduate School 1995–96 Handbook*.

9. I say "striking" graduate employees here because it is important to note that not all TAs joined the strike. In *Lingua Franca*, Emily Eakin reports that of the 695 GESO members in the "months leading up to the strike," about 230 "graduate instructors in the humanities and social sciences resolved to hold back their students' grades" (53). Young puts the number of strikers at "approximately 250 on 2 January," which, ten days later, was reduced to about half that number (192). I should also point out that Young reaches a similar conclusion about many Yale faculty's functioning as management during the grade strike: "The faculty proved that, in order to maintain academic hierarchies, it was quite willing to be interpellated as an arm of the university administration" (192).

10. In a "Lesson in Limbo" George Judson cites the average salary of an English

professor at the University of Illinois as $47,500 and that of a TA as $10,336 (plus a tuition waiver).

11. My thanks to James Pittsford of Local #136 of the United Association of Journeymen and Apprentices of the Plumbing and Pipefitting Industry of the US and Canada, Bloomington; and David McNeely, coordinator of apprenticeship programs, Central Indiana Carpenters Unions, Indianapolis.

12. The Seattle Area Masonry Joint Apprenticeship and Training Committee, for example, stipulates 6,000 hours of on-site, compensated work; Local #32 Plumbers and Pipefitters in Renton, Washington, offer a 10,000-hour program for plumbers, steamfitters/pipefitters, and refrigeration fitters. Information on these and other apprenticeship programs is available on LABORNET.

13. See Goldberger et al., *Research-Doctorate Programs in the United States: Continuity and Change*, 257, 264, 254.

Attrition Rates

1. Barbara Lovitts's work on graduate student attrition has been supported by the Alfred P. Sloan Foundation. It is now supporting Lovitts and Cary Nelson's efforts to write up the results for a broad academic audience.

Company Towns

1. These and other similar figures were publicized throughout the popular press. Mine come from John F. Dickerson, "Give 'em a Raise, Bob." See also "The New Ruthless Economy," in which Simon Head notes that as in the 1930s, the present economy is creating "more losers than winners" (52). Specifically, wage earners, "production and non-supervisory workers," qualify for the former category; since 1973, their weekly earnings when adjusted for inflation have fallen some 18 percent. Eight out of ten Americans, according to Head, are losing in this economy (47), and my argument is that graduate students are experiencing the pressures associated with this decline.

The Corporate University

1. Confidence in Rochester's integrity is not enhanced by knowledge of its long history of ethically compromised medical and biological research. As A. S. Zaidi points out, their current corporate relationships come at the end of half a century of amoral service to government and industry. The founding years of the Rochester story are perhaps 1945–46, when eleven people were secretly injected with soluble plutonium-239 during a post–World War II radiation experiment carried out for the Atomic Energy Commission at Rochester. During the same period of time from one to three *truckloads* of

radioactive rats and rat feces were buried on the outskirts of the Rochester campus. Mary Jean Connell, secretly injected with enriched uranium during a 1946 stay in Rochester's Strong Memorial Hospital, won a $400,000 settlement half a century later. As Michael Wentzel reported, that same year, 1996, saw the death of nineteen-year-old UR sophomore Hoi Yan "Nicole" Wan during a medical experiment at Strong, after UR researchers administered four times the maximum dosage of lidocaine the UR had established in 1981. And 1996 also saw widely criticized animal researcher Ron Wood hired at Rochester, despite his prior citation by the Department of Agriculture for multiple violations of the Animal Welfare Act.

None of this should suggest that Rochester is altogether unique. According to one of our colleagues at the University of Iowa, a load of radioactive dogs from university labs is now buried near town. Nice place for a homecoming picnic, but tell the folks to bring their lead blanket.

Debt

1. This graph has been abbreviated somewhat by the elimination of a "Professional/Other" category. Otherwise, it replicates the data provided by the NRC.

2. According to the NRC's *Research-Doctorate Programs in the United States: Continuity and Change* (National Academy Press, 1995), the MYDs of many top-rated doctoral programs in comparative literature exceed eight or even ten years. These include Rutgers, 13.6; University of Minnesota, 12.0 years; University of Southern California, 12.7 years; and so on. Only a handful of programs had an MYD smaller than Yale's.

3. Massy and Goldman study the supply of and demand for Ph.D.'s across twelve disciplines in engineering and the sciences. According to their study, published by the Stanford Institute for Higher Education Research, the supply of Ph.D.'s exceeds employers' demand by 44 percent in mechanical engineering, 41 percent in electrical engineering, 33 percent in civil engineering, 32 percent in mathematics, and 23 percent in geoscience. Although the ratios are far better in some fields—4 percent in computer science, 4 percent in psychology, and (5 percent) in chemistry—Massy and Goldman estimate that the gap between supply and demand approaches 22 percent across the twelve fields (1–35 and 1–36).

4. We would like to express our thanks to Eugene Kintgen, associate dean of the Indiana University–Bloomington Graduate School, for providing these data.

5. In *Prospects for Faculty in the Arts and Sciences* (1989), for example, William G. Bowen and Julia Ann Sosa made such a prediction, one Bowen and Neil L. Rudenstine repeated in *In Pursuit of the Ph.D.* (1992). In discussing attrition rates

in "Institutional Policies to Improve Doctoral Education" (November 1990), the Association of American Universities and the Association of Graduate Schools of American Universities (coauthors of the policy statement) referred to "well-documented projections of severe shortages of Ph.D.'s beginning in just a few years" (2). Academic job seekers are still waiting for this shortage.

Disciplinary Organizations

1. At the request of my informant, I have altered the rhetoric of this quotation and left the campus unnamed; the arguments put forward remain the same.

Downsizing

1. Goldberger et al., *Research-Doctorate Programs in the United States: Continuity and Change* (1995) ranks 127 Ph.D. programs in English for the 1992–93 academic year. A few extraordinarily small programs may not have been mentioned, but the number 127 seems more or less accurate for the period 1993–95 studied by the MLA in this report.

2. For this reason, recent MLA president Herbert Lindenberger is to be commended for undertaking to educate himself and the association about graduate education and the job crisis.

Faculty

1. Our thanks to Carla Mowery of the American Sociological Association for preparing this chart. And perhaps these numbers "do lie," or tell an even more moderate story than other data. See Jack H. Schuster (1998), who, relying upon different data, maintains that part-time faculty constituted 42 percent of the total in 1992, not 33 percent as Table 1 suggests. It may approach 50 percent in the new millennium, Schuster predicts.

2. In this regard, the late Bill Readings's discussion of consumerism in *The University in Ruins* seems exceptionally relevant: "Consumerism thus is less of an ideological falsification of well-being than a mark that no benefit exterior to the system can be imagined, no benefit that would not be subject to cost-benefit analysis (was that vacation a good buy?)" (48). If this ideology obtains in the student body of the corporate university, then faculty will increasingly be called upon to defend their syllabi or grading: "I don't see the relevance of the history of the Civil War to my career ambition," or, my personal favorite in a course on European cinema, "I don't care for films like DeSica's *The Bicycle Thief* because the lives of poor people are just too boring."

3. Passages from James Sullivan's "Not a Calling: Of Rewards and Other 'Carrots' for Adjuncts" are quoted from the manuscript with his permission.

4. In its "Statement on Revision of the Faculty Tenure Code," the Board of Regents makes frequent use of these terms, for example: "We believe it is essential that the University have more flexibility in developing and implementing the programmatic changes likely to be needed to keep pace with changes in the world in coming years and decades." These changes, of course, include the weakening of tenure and, "to increase the flexibility of the University to depart from the general expectation" that faculty salaries will "generally increase or remain the same," the possibility of reducing base salaries "across a group or class of faculty" (4, 2).

5. The reference here is to D'Souza's often preposterous diatribe in *Illiberal Education: The Politics of Race and Sex on Campus*. If this question *were* central to the essay, however, I might begin with the Adam Lack case at Brown University, one publicized on the ABC television program *20/20*. In late January 1997, ABC reporter John Stossel visited Brown to "cover" this story. Lack, an undergraduate living in a fraternity house, discovered a woman in a nearby room who appeared ill. After he had helped her, as reported by the *Brown Daily Herald* (31 January 1997), the woman followed Lack to his room, they talked, and had sex. They exchanged telephone numbers the next morning, and Lack attempted to call the woman, who returned a second call a week later but was unable to remember what had transpired between them. Lack told her, and a month later he was accused of sexual mis-conduct. Brown's University Disciplinary Council subsequently found him guilty of sexual misconduct, and he was suspended from the school for one semester. He has since dropped out and sued the university. Investigating this incident, Stossel was met by members of the Coalition Against Sexual Assault, several of whom later wrote to the *Daily Herald* (3 February 1997, for example) protesting his "rude, inflammatory comments" and "attitude."

6. See also Bob Boice, "Classroom Incivilities."

7. All material on this case comes from either the *Indiana Daily Student* or the *Herald-Times* in Bloomington. This quotation comes from the latter paper, 30 November 1997, A8. Lee's response to the student judicial board's findings appeared in the *Herald-Times*, 10 February 1998, A1, A7.

Graduate Student Unions

1. My discussion of graduate student unions grows out of extensive conversations with union activists at a number of schools, including the City University of New York, the University of California at Santa Barbara, the University of California at San Diego, the University of Illinois, the University of Michigan, and Yale University. Discussions with students initiating union drives at the University of Chicago, New York University, and Ohio State University have also helped.

Part-Time Faculty

1. This suggestion would need to be worked out tactically, since the national list would be very large. The list might be assembled and distributed state by state to reduce the numbers and focus the disapproval on local conditions. One would also need to decide how much pressure to place on schools at the upper end of the part-time pay scale. The Art Institute of Chicago, for example, pays $3,000 per course. Obviously a "Harvest of Shame" that shows all institutions in the country as noncompliant would serve no purpose or even be counterproductive. At the same time, one wants all part-time salaries raised. So one might need to set the figure so as to exempt schools at the upper end from criticism but warn that the minimum ethical salary would be raised each year. A first step might be to focus on censuring schools that actually pay part-timers less than the minimum wage, based on time sheets showing contact hours, preparation time, grading, and so forth.

Sexual Harassment

1. The single most unsavory view of consensual relations between students and faculty is no doubt William Kerrigan's contribution to a dialogue "New Rules About Sex on Campus," published in *Harper's*. Kerrigan volunteered that worldly faculty could do long-term student virgins a great kindness by thoughtfully deflowering them. Whether Kerrigan was actually reporting his own behavior or just engaging in ill-advised bravado is open to question. He is certainly iconoclastic enough to have put this position forward just to stir up trouble, and our guess is that that is exactly what he was doing.

2. One modest (and appropriate) recommendation has been in place everywhere (either formally or informally) for decades—that faculty members should not be sexually involved with students they are directly supervising in a major capacity. Reading this principle narrowly, it would bar a relationship with a student taking a class or whose major research project you are supervising. In *Feminist Accused of Sexual Harassment* Jane Gallop cheerfully reports that she slept with two members of her dissertation committee one week in graduate school; we would bar those two faculty members from serving on dissertation committees for a fixed period of time. Contrary to convention, more than the risk of the arbitrary exercise of power over a graduate student, we would be concerned about the reluctance to exercise power in such a case. Graduate students writing dissertations need a mix of support and tough advice. A sexual relationship might well make it more difficult to be critical when necessary.

Some, however, want to extend the principle of implicit or potential supervision to cover all faculty members in a student's department, which seems to us unnecessary and conceptually confused. At some point, they argue, you might be serving on an exam or fellowship committee, or be placed in some other compromised position. In fact we are asked every year to make disinterested

professional judgments about groups of students that include some individuals for whom we feel strong loyalties. We are not convinced that the compromising effect of sexual intimacy is decisively different from all the other investments that accumulate as we work with people over a period of years. Once again, life is not perfect.

It is also worth noting that the widest prohibition models are largely white heterosexual enterprises. Those gay faculty and students who are less interested in long-term monogamy can find these restrictions repressive. And minority members on campus may find such regulations leave them with no potential for intimate relations. A senior African American faculty member wittily commented that if he was prohibited from having a close relationship with anyone but his absolute equal the campus had better hire a number of black female full professors because otherwise he was out of luck.

3. Jeffrey Toobin came to a similar conclusion in a 1998 essay: "Human sexuality combines, among other things, passion, nuance, irrationality, and lust. Any attempt to purge sexuality from any part of human life—including the classroom, the courtroom, and the factory floor—is doomed to failure. The legal system, it seems, would do better simply to try to measure real and identifiable harms. It is hubris to think that this most baffling realm of human life can be regulated with much precision or fairness. Sexual-harassment law will never end the battle of the sexes. Perhaps it will help make sure that women can do their jobs in peace. That's hard enough" (55).

Superstars

1. For an analysis of the employment crisis in higher education see my *Manifesto of a Tenured Radical*.

2. There is a lot of media grumbling about "jet setting" academic superstars receiving high fees for guest lectures, but it is mostly ill informed. Universities do not typically pay high lecture fees out of their general funds. They typically come from special endowments. Indeed, the highest lecture fees are generally paid by undergraduate student groups, not faculty or administrators. Public figures also receive vastly higher fees than academics. I received $2,000 plus coach air fare and hotel to give two Taft lectures at the University of Cincinnati plus meet with students in 1997. In 1998 Colin Powell received $70,000 for a one-hour talk in Cincinnati. I certainly felt I was treated well, but I don't feel much inclination to feel guilty about it.

3. See William Kerrigan, "The Falls of Academe," for a particularly embittered account of the hollowness of the superstars of recent French theory, with occasional asides about American scholars. Also see David Bromwich, *Politics by Other Means*, especially his chapter "The Case of Literary Study," with its account of a hypothetical candidate for tenure who is judged entirely by social and political, rather than intellectual, criteria.

4. These salary figures are drawn from the *Chronicle of Higher Education*'s survey of "Pay and Benefits of Leaders at 477 Private Colleges and Universities," itself based on information from the Form 990s filed with the Internal Revenue Service by most private institutions save those claiming religious exemptions. Since institutions only have to list the salaries of officers and the five most highly paid employees, those institutions with medical schools tend not to report salaries from any other disciplines.

BIBLIOGRAPHY

Allen, Charlotte. "As Bad as It Gets: Three Dark Tales from the Annals of Academic Receivership." *Lingua Franca* 8 (March 1998): 52–59.

Alston, Kal. "Hands Off Consensual Sex." *Academe* (September 1998): 23.

American Council on Education. *Student Borrowing: How Much Is Too Much?* Washington, D.C., 1994.

Appelquist, Thomas. "Graduate Students Are Not Employees." *Chronicle of Higher Education*, 18 April 1997, B6.

Arenson, Karen W. "Part-Time Faculty Is an Issue Now at CUNY." *New York Times,* 14 February 1998, Metro section, E1.

Aronowitz, Stanley. "The Last Good Job in America." *Social Text* 51 (summer 1997): 93–108.

Bartlett, S. J. "Barbarians at the Door." *Modern* Age 36 (summer 1993): 296–311.

Basinger, Julianne. "Increase in Number of Chairs Endowed by Corporations Prompts New Concerns." *Chronicle of Higher Education*, 24 April 1998, A51–53.

Becker, Lawrence C. "Affirmative Action and Faculty Appointments." In *Affirmative Action and the University,* ed. Steven M. Cahn, 93–121. Philadelphia: Temple University Press, 1993.

Benjamin, Ernst. "Variations in the Characteristics of Part-Time Faculty by General Fields of Instruction and Research." In *Working for Academic Renewal*. Washington, D.C.: American Association of University Professors, 1998.

Benkin, E. M. "Where Have All the Doctoral Students Gone? A Study of Doctoral Student Attrition at UCLA." Ph.D. diss., University of California at Los Angeles, 1984.

Berelson, B. *Graduate Education in the United States*. New York: McGraw-Hill, 1960.

Bergmann, Linda S. "Oedipus in Steerage: On the Pain of the Adjunct." *Journal of the Midwest Modern Language Association* 30 (spring 1997): 46–51.

Bérubé, Michael. *The Employment of English: Theory, Jobs, and the Future of Literary Studies*. New York: New York University Press, 1998.

———. "Intellectual Inquiry and Academic Activism." *Academic Questions,* fall 1997, 18–21

Bérubé, Michael, and Cary Nelson, eds. *Higher Education under Fire: Politics, Economics, and the Crisis of the Humanities*. New York: Routledge, 1995.

Bloch, Ernst. *The Principle of Hope*. Trans. Neville Plaice, Stephen Plaice, and Paul Knight. Cambridge: MIT Press, 1986.

Blumenstyk, Goldie, and David L. Wheeler. "Academic Medical Centers Race to Compete in the $3.2-Billion Drug-Testing Market." *Chronicle of Higher Education*, 20 March 1998, A39–40.

Boice, Bob. "Classroom Incivilities." *Research in Higher Education* 37, no. 4 (1996): 453–73.

Boufis, Christina, and Victoria C. Olsen, eds. *On the Market: Surviving the Academic Job Search*. New York: Riverhead Books, 1997.

Bowen, William G., and Neil L. Rudenstine. *In Pursuit of the Ph.D.* Princeton, N.J.: Princeton University Press, 1992.

Bowen, William G., and Julie Ann Sosa. *Prospects for Faculty in the Arts and Sciences*. Princeton, N.J.: Princeton University Press, 1989.

Braidotti, Rosi. *Nomadic Subjects*. New York: Columbia University Press, 1994.

Bromwich, David. *Politics by Other Means*. New Haven, Conn.: Yale University Press, 1992.

Bronner, Ethan. "California's Elite Public Colleges Report Big Drop in Minority Enrollment." *New York Times*, 1 April 1998.

Brooks, Peter. "Graduate Learning as Apprenticeship." *Chronicle of Higher Education*, 20 December 1996, A52.

Burstein, Paul. *Discrimination, Jobs, and Politics*. Chicago: University of Chicago Press, 1985.

Byrne, J. Peter. "Academic Freedom Without Tenure?" American Association for Higher Education New Pathways Working Paper Series, Washington, D.C., 1997.

Cahn, Steven M., ed. *Affirmative Action and the University: A Philosophical Inquiry*. Philadelphia: Temple University Press, 1993.

Cain, William E. "A Literary Approach to Literature: Why English Departments Should Focus on Close Reading, Not Cultural Studies." *Chronicle of Higher Education*, 13 December 1996, B4–B5.

Castillo, Ana. *Massacre of the Dreamers: Essays on Xicanisma*. New York: Plume Books, 1994.

Chait, Richard. "The Future of Tenure." *AGB Priorities* 1 (spring 1995).

———. "New Pathways: Faculty Careers and Employment in the 21st Century." American Association for Higher Education, New Pathways Working Paper Series, March 1997.

———. "Rethinking Tenure: Towards New Templates for Academic Employment." *Harvard Magazine*, July–August 1997, 30–31, 90.

Chait, Richard, and Cathy Trower. "Where Tenure Does Not Reign: Colleges with Contract Systems." American Association for Higher Education New Pathways Working Paper Series, Washington, D.C., 1997.

Chemerinsky, Erwin. "Is Tenure Necessary to Protect Academic Freedom?" Occasional Papers from the Center for Higher Education Policy Analysis, Los Angeles, 1997–98.

Cloud, John. "Sex and the Law." *Time*, 23 March 1998, 48–54.

Coupland, Douglas. *Generation X: Tales for an Accelerated Culture*. New York: St. Martin's Press, 1991.

Cross, John G. "A Brief Review of 'Responsibility Center Management,'" (photocopied report) University of Michigan, 18 October 1996.

Custard, Edward, et al. *The Princeton Review: The Best 311 Colleges, 1998 Edition*. New York: Random House, 1997.

Cwiklik, Robert. "How UPS Tried to Buy Into the Ivory Tower." *Wall Street Journal*, 6 February 1998, B1.

Damrosch, David. *We Scholars: Changing the Culture of the University*. Cambridge, Mass.: Harvard University Press, 1995.

Darnton, Robert. *The Great Cat Massacre and Other Episodes in French Cultural History*. New York: Basic Books, 1984.

Davis, Lennard. "Dancing in the Dark: A Manifesto Against Professional Organizations." *minnesota review* 45 and 46 (1996): 197–214.

de Russy, Candace. "'Revolting Behavior': The Irresponsible Exercise of Academic Freedom." *Chronicle of Higher Education*, 6 March 1998, B9.

Dewey, John. "Academic Freedom." In *John Dewey: The Middle Works, 1899–1924*, vol. 2. Carbondale: Southern Illinois University Press, 1976, 53–66.

Dickerson, John F. "Give 'em a Raise, Bob." *Time*, 26 April 1996, 62.

Dickson, David. *The New Politics of Science*. Chicago: University of Chicago Press, 1988.

D'Souza, Dinesh. *Illiberal Education: The Politics of Race and Sex on Campus*. New York: Vintage, 1991.

Dworkin, Andrea. *Pornography: Men Possessing Women*. New York: Dutton, 1989.

Eakin, Emily. "Walking the Line." *Lingua Franca* 6 (March/April 1996): 52–60.

Edmundson, Mark, ed. *Wild Orchids and Trotsky: Messages from American Universities*. New York: Penguin Books, 1993.

Ellis, John M. *Literature Lost: Social Agendas and the Corruption of the Humanities*. New Haven, Conn.: Yale University Press, 1997.

"Fact File: 495 College and University Endowments." *Chronicle of Higher Education*, 20 February 1998, A49–50.

Farley, Lyn. *Sexual Shakedown: The Sexual Harassment of Women on the Job*. New York: McGraw-Hill, 1978.

Finkin, Matthew W. *The Case for Tenure*. Ithaca, N.Y.: Cornell University Press, 1996.

Fischetti, Mark, and John Anderson, Malena Watrous, Jason Tanz, and Peter Gwynne. "Gas, Food, Lodging . . . Education?" *University Business* 1, no. 1 (March/April 1998): 44–51.

Flower, Ruth. *Professors on the Hill.* Washington, D.C.: American Association of University Professors, 1997.

Frances, Carol. "Higher Education: Enrollment Trends and Staffing Needs." *Research Dialogues,* Issue no. 55 (March 1998). New York: Teachers Insurance and Annuity Association.

Franklin, Phyllis. "Report of the Executive Director." *PMLA* 112 (May 1997): 443–56.

Furner, Mary O. *Advocacy and Objectivity: A Crisis in the Professionalization of American Social Science, 1865–1905.* Lexington: University of Kentucky Press, 1975.

Gallop, Jane. *Feminist Accused of Sexual Harassment.* Durham, N.C.: Duke University Press, 1997.

Gappa, Judith, and David Leslie. *The Invisible Faculty: Improving the Status of Part-Timers in Higher Education.* San Francisco: Jossey-Bass, 1993.

Gilbert, Sandra M., and the MLA Committee on Professional Employment. "Evaluating the Mission, Size, and Composition of Your Graduate Program," Appendix to the "Final Report."

———. "Final Report." Submitted to the MLA Delegate Assembly, 29 December 1997.

Goldberger, Marvin L., et al., eds. *Research-Doctorate Programs in the United States: Continuity and Change.* Washington, D.C.: Academy Press, 1995.

Greene, Kathanne W. *Affirmative Action and Principles of Justice.* Westport, Conn.: Greenwood Press, 1989.

Grossman, Ron, Carol Jouzaitis, and Charles Leroux. "Degrees of Neglect." *Chicago Tribune,* 21–25 June 1992.

Gruner, Elisabeth Rose. "Feminists Face the Job Market: Q & A (Questions and Anecdotes)." In *On the Market: Surviving the Academic Job Search,* ed. Christina Boufis and Victoria C. Olsen, 87–100. New York: Riverhead, 1997.

Guillory, John. "Preprofessionalism: What Graduate Students Want." *ADE Bulletin* 113 (spring 1996): 4–8.

Hamashige, Hope, and Tina Nguyen. "Parents' Annual Camp-Out Gives Kids a Chance to Enroll." *Los Angeles Times,* 11 March 1998, Metro section, B1, B7.

Haskell, Thomas L. "Justifying Academic Freedom in the Era of 'Power/Knowledge.'" In *The Future of Academic Freedom,* ed. Louis Menand, 43–90. Chicago: University of Chicago Press, 1996.

Head, Simon. "The New Ruthless Economy." *New York Review of Books,* 29 February 1996, 47–52.

Hinnefeld, Steve. "Thomson's Mexican Plants 'State of the Art.'" *Herald-Times,* 26 January 1998, A1, A5.

Hofstadter, Richard, and Walter Metzger. *The Development of Academic Freedom in the United States.* New York: Columbia University Press, 1955.

Honan, William H. "Luring Faculty Stars to Teach More." *New York Times*, 29 November 1993, A10.

Hutner, Gordon. "What We Talk about When We Talk about Hiring." *Profession 94* (New York: MLA, 1994): 75–78.

Indiana University Graduate School. "Student Loans, 1991–97: College of Arts and Science," 10 February 1998.

Ingram, Linda, and Prudence Brown. *Humanities Doctorates in the United States: 1995 Profile.* Washington: National Research Council/ National Academy Press, 1997.

Johnson, Tom. "A Proposal to Organize Non-Tenured Faculty: Our Time Has Come." *Against the Current,* January/February 1992, 23–27.

Jones, Howard Mumford. "The Pygmy and the Giant." *PMLA* 81 (March 1966): 3–11.

Judson, George. "Lesson in Limbo." *New York Times,* 31 March 1996, A4.

Kassebaum, Donald G., and Philip L. Szenas. "Relationship between Indebtedness and the Specialty Choices of Graduating Medical Students." *Academic Medicine* 67 (October 1992): 700–707.

Kerrigan, William. "The Falls of Academe." In *Wild Orchids and Trotsky: Messages from American Universities,* ed. Mark Edmundson, 151–70. New York: Penguin Books, 1993.

Kolb, Katherine. "Tales Out of School: The Story of Academic Adjuncts." *Journal of the Midwest Modern Language Association* 30 (spring 1997): 36–39.

Kozol, Jonathan. *Savage Inequalities: Children in America's Schools.* New York: Crown Publishers, 1991.

Lakoff, George, and Mark Johnson. *Metaphors We Live By*. Chicago: University of Chicago Press, 1980.

Larson, Erik. "Why Colleges Cost Too Much." *Time*, 17 March 1997, 46–55.

Leggon, Cheryl B. "The Scientist as Academic." *Daedalus* 126, no. 4 (fall 1997): 221–44.

Levine, Arthur. "How the Academic Profession Is Changing." *Daedalus* 126, no. 4 (fall 1997): 1–20.

Lipsky, David, and Alexander Abrams. *Late Bloomers: Coming of Age in Today's America: The Right Place at the Wrong Time*. New York: Times Books, 1994.

Lovejoy, Arthur O. "Academic Freedom." In *Encyclopedia of the Social Sciences*, ed. R. H. Seligman and Alvin Johnson. New York: Macmillan, 1930.

Lovitts, Barbara E. "Leaving the Ivory Tower: A Sociological Analysis of the Causes of Departure from Doctoral Study." Ph.D. diss., University of Maryland, 1996.

Machlup, Fritz. "In Defense of Academic Tenure." *AAUP Bulletin* 50 (summer 1964): 112–24.

MacKinnon, Catharine. *The Sexual Harassment of Working Women*. New Haven, Conn.: Yale University Press, 1979.

"Made in Vietnam: The American Sneaker Controversy." *Outside the Lines*, ESPN Television Network, April 1998.

Mamet, David. *Oleanna*. New York: Grove Press, 1992.

Marchese, Ted. "Not-So-Distant Competitors." *AAHE Bulletin* (May 1998), 3–11.

Martin, Emily. *Flexible Bodies*. Boston: Beacon Press, 1994.

Marty, Martin E. "Caught in the Crossfire between Academic and Religious Freedom." *Academe,* January–February 1998, 63–67.

Massy, William F., and Charles A. Goldman. "The Production and Utilization of Science and Engineering Doctorates in the United States." Stanford Institute for Higher Education Research Discussion Paper, Stanford, 1995.

Matthews, Anne. "Deciphering Victorian Underwear and Other Seminars." *New York Times Magazine*, 10 February 1991, 42–43, 57–59, 69.

McAllister, Ken. "The TicToc Manifesto." *Works and Days* 15, nos. 1 and 2 (1997): 281–85.

Mellor, John. *The Company Store: James Bryson McLachlan and the Cape Breton Coal Miners, 1900–1925*. New York: Doubleday, 1983.

Menand, Louis. "Everybody Else's College Education." *New York Times*, 20 April 1997, sec. 6, 48.

———. "How to Make a Ph.D. Matter." *New York Times Magazine,* 22 September 1996, 78–81.

———, ed. *The Future of Academic Freedom*. Chicago: University of Chicago Press, 1996.

Miller, Lewis H., Jr. "Hubris in the Academy." *Change* 22 (September/October 1996): 9–11, 53.

"The Modern Language Job Market: Available Positions and New Degree Recipients." *MLA Newsletter* 29 (summer 1997): A1–A8.

Mohr, James C. "Academic Turmoil and Public Opinion: The Ross Case at Stanford." *Pacific Historical Review* 39 (February 1970): 39–61.

Nasar, Sylvia. "New Breed of College All-Star." *New York Times,* 8 April 1998, D1, D3.

National Research Council. *Summary Report 1990: Doctorate Recipients from United States Universities*. Washington, D.C.: National Academy Press, 1991.

———. *Summary Report 1992: Doctorate Recipients from United States Universities*. Washington, D.C.: National Academy Press, 1993.

———. *Summary Report 1993: Doctorate Recipients from United States Universities*. Washington, D.C.: National Academy Press, 1995.

Neilson, Jim, and Gregory Meyerson. "Access to Grind: A Reply to Michael Bérubé." *minnesota review* 47 (fall 1996): 239–48.

———. "Public Access Limited." *minnesota review* 45 and 46 (fall 1995/spring 1996): 263–73.

Nelson, Cary. *Manifesto of a Tenured Radical*. New York: New York University Press, 1997.

————. *Repression and Recovery: Modern American Poetry and the Politics of Cultural Memory, 1910–1945.* Madison: University of Wisconsin Press, 1989.

————, ed. *Will Teach for Food: Academic Labor in Crisis.* Minneapolis: University of Minnesota Press, 1997.

Nelson, Cary, and Lawrence Grossberg, eds. *Marxism and the Interpretation of Culture.* Urbana: University of Illinois Press, 1988.

Newfield, Christopher. "Recapturing Academic Business." *Social Text* 51 (summer 1997): 39–66.

Newfield, Marcia. "Letter to the Editor." *CUNY Adjunct Alert* 1, no. 6 (March 1998): 2.

Newman, John Henry Cardinal. *The Idea of a University.* New York: Holt, Rinehart, 1960.

"New Rules about Sex on Campus." *Harper's,* September 1993, 33–42.

Nicolson, Marjorie Hope. "A Generous Education." *PMLA* 79 (March 1964): 3–12.

Noble, David F. "Digital Diploma Mills: The Automation of Higher Education." *First Monday: An Electronic Journal,* January 1998.

————. "The Selling of the University." *Nation,* 6 February 1982, 1, 143–48.

Norman, Debby. "Heavy Debt?" *Washington Journal,* 13 July 1995, 1, 17.

O'Dair, Sharon. "Stars, Tenure, and the Death of Ambition." *Michigan Quarterly Review,* fall 1997, 607–27.

Ohio State University Graduate School. *The Ohio State University Graduate School 1995–96 Handbook.* Columbus, 1996.

Palumbo, Paul, and Richard Taylor. "Letter to Graduate Director/Departmental Placement Officer," 25 June 1995.

"Pay and Benefits of Leaders at 477 Private Colleges and Universities: A Survey." *Chronicle of Higher Education,* 24 October 1997, A39–57.

Peters, Douglas P., and Stephen J. Ceci. "Peer-Review Practices of Psychological Journals: The Fate of Published Articles, Submitted Again." *Behavioral and Brain Sciences* 5 (1982): 187–255.

Peters, Thomas J., and Robert H. Waterman, Jr. *In Search of Excellence: Lessons from America's Best-Run Companies.* New York: Harper & Row, 1982.

Pfannestiel, Todd. "It's Not Just a Job, It's an Indenture: Graduate Students and the Academic Job Market." *Academe,* January–February 1998, 44–47.

Pinter, Harold. *Party Time* and *The New World Order.* New York: Grove Press, 1993.

Plater, William. "Using Tenure: Citizenship within the New Academic Workforce." *American Behavioral Science* 41, no. 5 (February 1998): 680–715.

Pratt, Linda Ray. "Going Public: Political Discourse and the Faculty Voice." In *Higher Education under Fire: Politics, Economics, and the Crisis of the Humanities,* ed. Michael Bérubé and Cary Nelson, 35–51. New York: Routledge, 1995.

Prior, Moody E. "The Doctor of Philosophy Degree." In *Graduate Education Today*, ed. Everett Walters, 30–61. Washington, D.C.: American Council on Education, 1965.

Readings, Bill. *The University in Ruins*. Cambridge, Mass.: Harvard University Press, 1996.

Rhoades, Gary, and Sheila Slaughter. "Academic Capitalism, Managed Professionals, and Supply-Side Higher Education." *Social Text* 51 (summer 1997): 9–38.

Robinson, Perry. *Part-Time Faculty Issues*. Washington, D.C.: American Federation of Teachers, 1996.

Rorty, Richard. "Does Academic Freedom Have Philosophical Presuppositions." In *The Future of Academic Freedom*, ed. Louis Menand, 21–42. Chicago: University of Chicago Press, 1996.

Rymer, Russ. "Back to the Future: Disney Reinvents the Company Town." *Harper's*, October 1996, 65–78.

Saporito, Bill. "Taking a Look Inside Nike's Factories." *Time*, 30 March 1998, 52–53.

Schneider, Alison. "Insubordination and Intimidation Signal the End of Decorum in Many Classrooms." *Chronicle of Higher Education*, 27 March 1998, A12–A14.

———. "Recruiting Academic Stars: New Tactics in an Old Game." *Chronicle of Higher Education*, 29 May 1998, A12–14.

Schrecker, Ellen. *No Ivory Tower: McCarthyism and the University*. New York: Oxford University Press, 1988.

Schuster, Jack H. "Reconfiguring the Professoriate: An Overview." *Academe*, January–February 1998, 48–53.

Scott, Joan W. "Academic Freedom as an Ethical Practice." In *The Future of Academic Freedom*, ed. Louis Menand, 163–180. Chicago: University of Chicago Press, 1996.

Shalit, Ruth. "The Man Who Knew Too Much." *Lingua Franca* 8 (February 1998): 31–40.

Shapiro, James. "'Books in Chains': Are Borders and Barnes & Noble Saviors or Adversaries of Academic Publications?" *Chronicle of Higher Education*, 20 December 1996, B8.

———. "How Faculty Boards Serve University Presses." *Chronicle of Higher Education*, 4 April 1997, B7.

———. "Saving 'Tenure Books' from a Painful Demise." *Chronicle of Higher Education*, 1 November 1996, B6.

———. "University Presses Shouldn't Emulate Commercial Publishers." *Chronicle of Higher Education*, 8 August 1997, B7.

Showalter, Elaine. "Diary." *London Review of Books*, 9 February 1995, 25.

Shumway, David R. "The Star System in Literary Studies." *PMLA* 112, no. 1 (1997): 85–100.

Slaughter, Sheila, and Larry L. Leslie. *Academic Capitalism: Politics, Policies, and the Entrepreneurial University*. Baltimore: Johns Hopkins University Press, 1997.

Smith, Barry. "Bringing the Humanities Down to Earth." *Academic Questions,* fall 1997, 58–62.

Smith, Lucy Toulmin, ed. *English Gilds* (1870). Rpt. for The Early English Text Society. London: Oxford University Press, 1963.

Snyder, Don J. *The Cliff Walk: A Memoir of a Job Lost and a Life Found*. Boston: Little, Brown, 1997.

Soley, Lawrence C. *Leasing the Ivory Tower: The Corporate Takeover of Academia*. Boston: South End Press, 1995.

Sorcinelli, Mary Deane. "Dealing with Troublesome Behaviors in the Classroom." In *The Handbook of College Teaching: Theory and Applications,* ed. K. W. Prichard and R. M. Sawyer, 365–73. Westport, Conn.: Greenwood Press, 1994.

Sosnoski, James J. *Token Professionals and Master Critics: A Critique of Orthodoxy in Literary Studies*. Albany: State University of New York Press, 1994.

Sowell, Thomas. "Power Without Responsibility." *Forbes,* 14 February 1994, 85.

Spacks, Patricia Meyer. "The Academic Marketplace: Who Pays Its Costs?" *MLA Newsletter* 26, no. 2 (summer 1994): 3.

———. "Voices of the Membership." *MLA Newsletter* 26, no. 3 (fall 1994): 3.

Sperber, Murray. *College Sports Inc.: The Athletic Department vs The University*. New York: Henry Holt, 1990.

Strohm, Paul. "'Lad with Revel to Newgate': Chaucerian Narrative and Historical Meta-Narrative." In *Art and Context in Late Medieval English Narrative,* ed. Robert R. Edwards, 163–76. Suffolk: D. S. Brewer, 1994.

Sullivan, James D. "Not a Calling: Of Rewards and Other 'Carrots' for Adjuncts." Paper presented to the Midwest Modern Language Association, Chicago, November 1997.

———. "The Scarlet L: Gender and Status in Academe." In *Will Teach for Food: Academic Labor in Crisis,* ed. Cary Nelson, 254–63. Minneapolis: University of Minnesota Press, 1997.

Sykes, Charles J. *The Hollow Men*. Washington, D.C.: Regnery Gateway, 1990.

———. *Profscam*. New York: St. Martin's Griffin, 1988.

Syverson, Peter D. "Latest NPSAS Data on Student Financing of Graduate Education Released: Bottom Line Is More Support, But More Debt." *Communicator,* March 1998, 8–11.

"Tenure Is Essential, Faculty Say." *Pickens Oconee,* 16 March 1995, C1–2.

Thatcher, Sanford G. "The Crisis in Scholarly Communication." *Chronicle of Higher Education*, 3 March 1995, B1–B2.

———. "Scholarly Monographs May Be the Ultimate Victims of the Upheavals in Trade Publishing." *Chronicle of Higher Education*, 10 October 1990, B2–B3.

Thompson, Karen. "Alchemy in the Academy: Moving Part-Time Faculty from Piecework to Parity." In *Will Teach for Food: Academic Labor in Crisis,* ed. Cary Nelson, 278–90. Minneapolis: University of Minnesota Press, 1997.

Tirelli, Vincent. "Adjuncts and More Adjuncts." *Social Text* 51 (summer 1997): 75–89.

Toobin, Jeffrey. "The Trouble with Sex." *New Yorker,* 9 February 1998, 48–55.

Traub, James. "The Next University: Drive-Thru U." *New Yorker,* 20–27 October 1997, 114–23.

Tucker, A. *Factors Related to Attrition among Graduate Students.* Cooperative Research Project, no. 1146. Washington, D.C.: U.S. Office of Education, 1964.

Tuttleton, James W. "The PC Prerequisite for Freedom." *Academic Questions,* fall 1997, 68–71.

Van Alstyne, William W. "Academic Freedom and the First Amendment in the Supreme Court of the United States: An Unhurried Historical Review." In *Freedom and Tenure in the Academy*, ed. William W. Van Alstyne, 79–154. Durham, N.C.: Duke University Press, 1993.

Weiss, Kenneth R., and Mary Curtius. "Acceptance of Blacks, Latinos to UC Plunges." *Los Angeles Times,* 1 April 1998, A1, A22.

Wentzel, Michael. "State Criticizes UR after Wan's Death." *Rochester Democrat and Chronicle,* 27 September 1996.

———. "Cut Research Risk, UR Told: Agency Orders More Oversight for Studies on Humans." *Rochester Democrat and Chronicle,* 8 January 1997.

Williams, Jeffrey. "Spin Doctorates." *Village Voice Literary Supplement,* November 1995, 28–29.

Wood, James L. "In California, a Dangerous Deal with Technology Companies." *Chronicle of Higher Education,* 20 February 1998, B6.

Wood, Julia T., ed. "Special Section—'Telling Our Stories': Sexual Harassment in the Communication Discipline." *Journal of Applied Communication Research* 20, no. 4 (1992): 349–418.

Yardley, Jonathan. "English, Wherefore Art Thou?" *Denver Post*, 5 January 1997, F1.

Young, Cynthia. "On Strike at Yale." *minnesota review* 45 and 46 (fall 1995/spring 1996): 179–95.

Zaidi, A. S. "Rochester, Radiation, and Repression." *Z Magazine,* April 1997, 11–12.

Zavarzadeh, Mas'ud. "The Dead Center: *The Chronicle of Higher Education* and the 'Radical' in the Academy." *Alternative Orange* 5 (summer/fall 1997): 57–60.

Žižek, Slavoj. *The Sublime Object of Ideology*. London: Verso, 1989.

INDEX

329